SMITHSONIAN
ATLAS OF SPACE

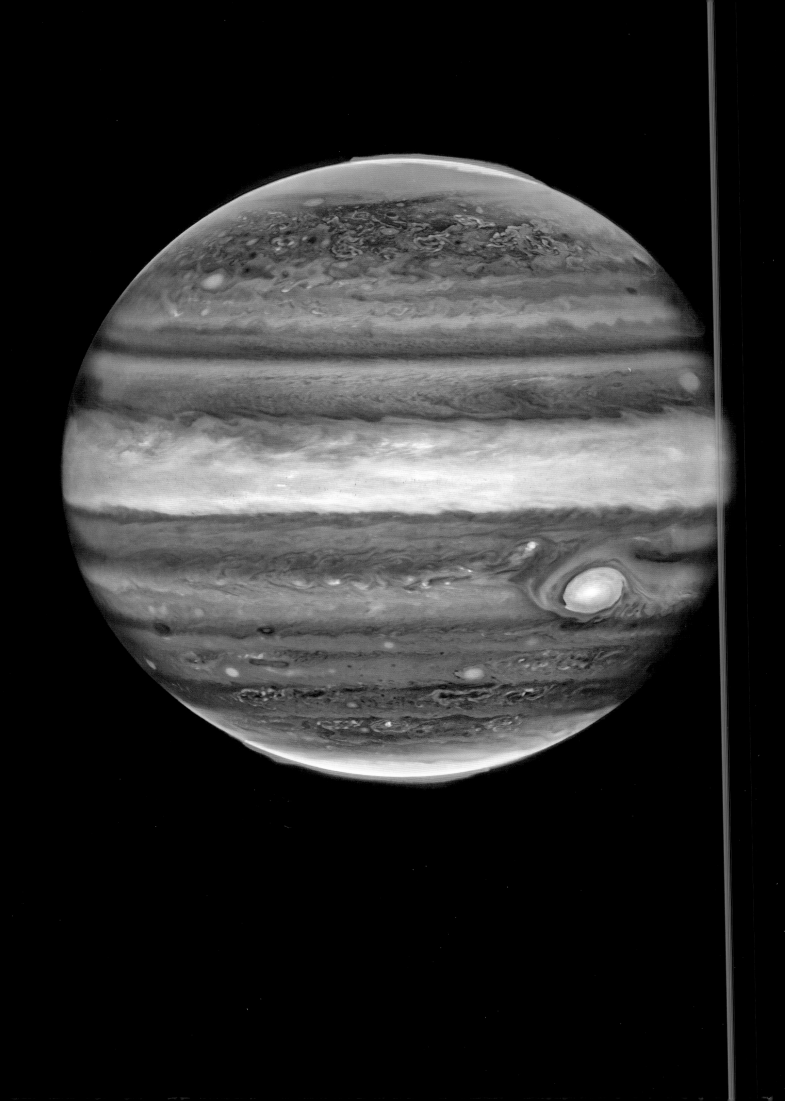

SMITHSONIAN ATLAS OF SPACE

A MAP TO THE UNIVERSE FROM THE BIG BANG TO THE FUTURE

ROGER D. LAUNIUS

Smithsonian Books
WASHINGTON DC

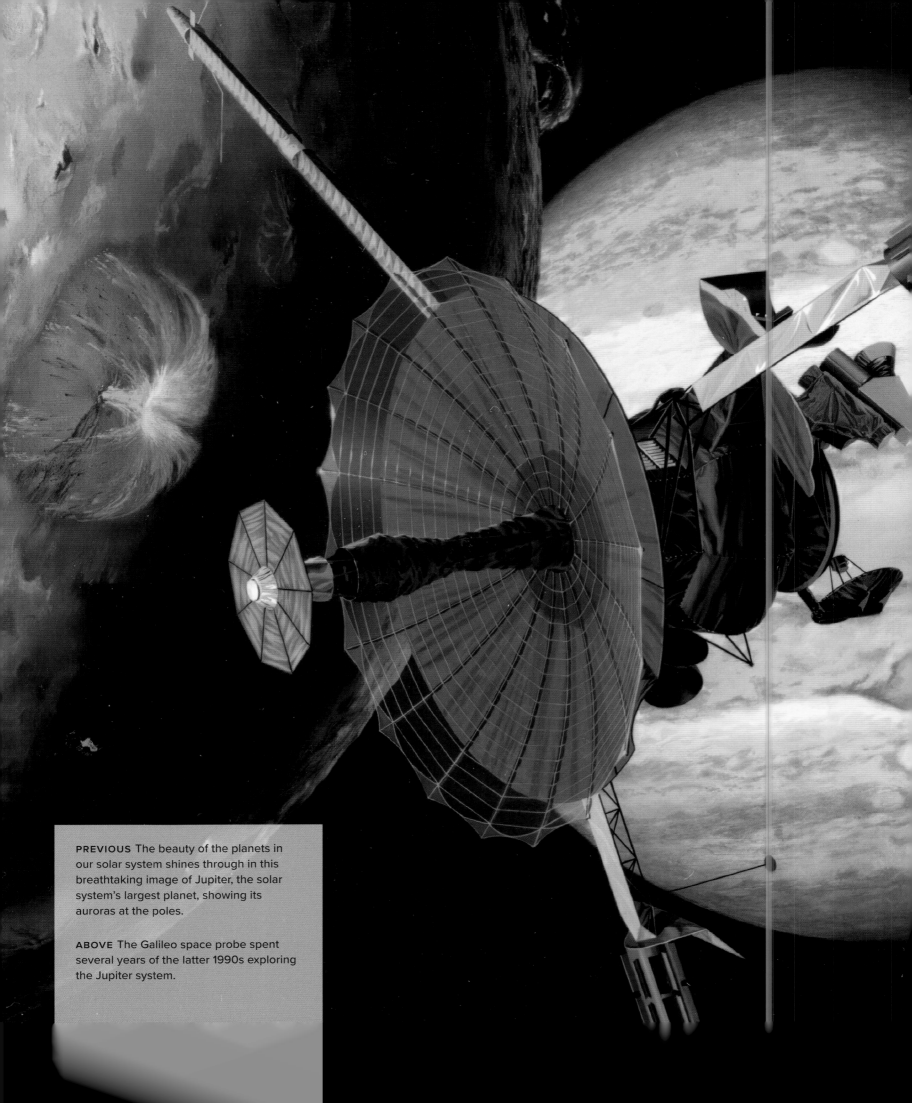

PREVIOUS The beauty of the planets in our solar system shines through in this breathtaking image of Jupiter, the solar system's largest planet, showing its auroras at the poles.

ABOVE The Galileo space probe spent several years of the latter 1990s exploring the Jupiter system.

CONTENTS

6 INTRODUCTION

10 OUR UNIVERSE
16 Ancient Ideas of the Universe
22 Models of the Universe in Western Civilization
28 Newton, Einstein, and the Mysteries of Space-Time
32 Hubble, the Expanding Universe, and the Big Bang Theory
46 Charting the Age of the Universe
54 A Stellar Metropolis That Began Forming After the Big Bang
62 The Mystery of Dark Matter and Dark Energy
68 The End of the Universe

74 GALAXIES AND STAR SYSTEMS
82 Galaxies by the Trillions?
94 The Life and Death of Stars
112 Supernovae, Neutron Stars, and Black Holes
126 Great Space Observatories and What We Have Learned
142 Exoplanets and the Possibility of Life in Other Galaxies
150 The Search for Extraterrestrial Intelligence

152 THE OUTER SOLAR SYSTEM
156 The Farthest Reaches of the Solar System
164 The Problematic Planet, Pluto
172 Taking a Grand Tour, and More
180 The Farthest of the Jovian Planets: Neptune and Uranus
190 Exploring Saturn and Jupiter
208 Comets, Asteroids, and Icy Bodies

220 OUR NEARBY WORLDS
224 Enticing Mars
228 Early Mars Missions
232 Landers, Rovers, and Flyers
248 Follow the Water: Expectations of Life on Mars
262 Robots to the Moon
272 Apollo and the Lunar Landings
292 Mission to Planet Earth
314 Venus: A Cloud-Covered Inferno
328 Scorching Mercury
336 That Lucky Old Sun

344 WHAT MIGHT THE FUTURE HOLD?
352 Sustained Lunar Operations
368 Continuing Mars Exploration
374 Becoming a Multiplanetary Species
390 Interstellar Exploration: Looking Beyond 2100

394 Index
398 Acknowledgments
399 Image Credits

INTRODUCTION

It is hard to believe more than a century has passed since Albert Einstein's theory of relativity, the Big Bang, and the expanding universe first gained currency. Until the twentieth century, astronomers were unsure that there was more than a single galaxy. Now we understand that there are millions, if not billions, of galaxies beyond the Milky Way. Black holes, exoplanets, and the possibilities of life—whatever its form—now dominate our considerations of the nature of the universe. What a difference a century makes!

The successes and challenges that scientists have wrestled with in their pursuit of truth about the cosmos have sometimes been invigorating, sometimes disconcerting, and sometimes surprising. Humanity departed this planet for the first time in the latter half of the twentieth century, with the first rockets reaching space in the aftermath of World War II. Sustained orbital activities began with the launch of Sputnik 1 on October 4, 1957, and human missions followed from 1961. Since that time, those seeking to unveil the mysteries of the universe have sent probes to visit every planet in the solar system, some of them many times, and pushed back the frontiers of knowledge about these bodies. Others have undertaken meticulous investigations of the heavens with ever more advanced Earth-based telescopes. Some have searched for life beyond Earth—without finding it as yet—and sought to understand humanity's place in the cosmos.

As news reporter Walter Cronkite gushed about space exploration in 2000, "Yes, indeed, we are the lucky generation." In this era we "first broke our earthly bonds and ventured into space. From our descendants' perches on other planets or distant space cities, they will look back at our achievement with wonder at our courage and audacity and with appreciation at our accomplishments, which assured the future in which they live." The best public response to space exploration remains that seen in Times Square during the landing of Curiosity on Mars in 2012 (see page 236), when the people camped out there to watch the big screens chanted: "Sci-ence, Sci-ence, Sci-ence!"

This atlas of space represents some of what we understand about the universe at this stage of our investigations. It focuses on the process of science that leads to greater understanding, offering a discussion of not just what we know about the universe but also how we know it. The exploration undertaken and the methods of discovery have fed a curiosity about our physical space. In the process of exploration, humans have learned much; most especially, we have begun to comprehend what we do not yet know. What we understand at present is incomplete, foreshortened, and in some instances just plain wrong. Those reading this book a hundred years from now will accept it as a report card on current ideas and understandings; hopefully they will recognize that our misconceptions are not the result of willful error, but of incomplete knowledge that will continue to be developed by sustained inquiry.

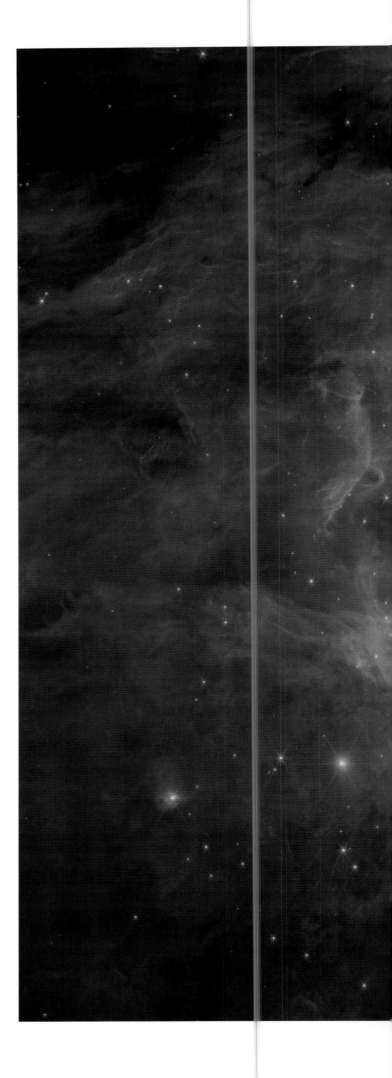

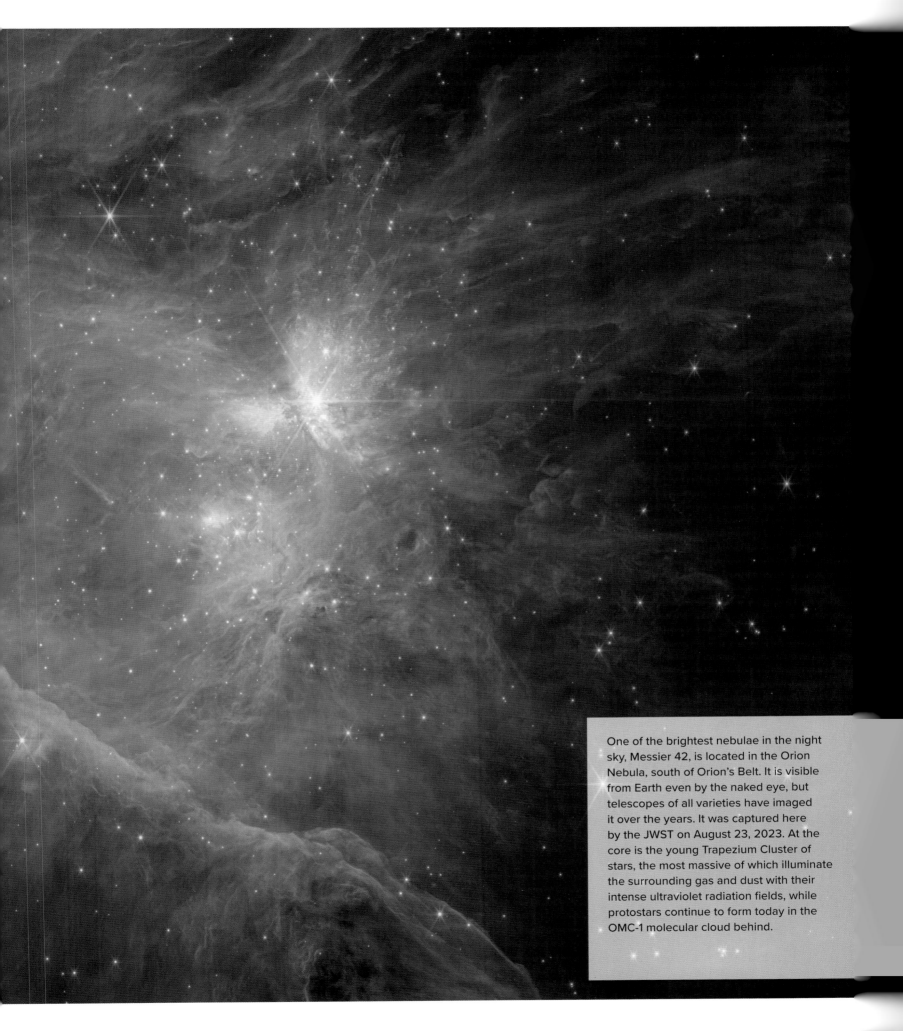

One of the brightest nebulae in the night sky, Messier 42, is located in the Orion Nebula, south of Orion's Belt. It is visible from Earth even by the naked eye, but telescopes of all varieties have imaged it over the years. It was captured here by the JWST on August 23, 2023. At the core is the young Trapezium Cluster of stars, the most massive of which illuminate the surrounding gas and dust with their intense ultraviolet radiation fields, while protostars continue to form today in the OMC-1 molecular cloud behind.

In the search for truth about the cosmos, humanity peers out from our relatively mundane planet and solar system to the universe's farthest reaches. At present, the gold standard for technology engaged in this effort is the James Webb Space Telescope (JWST), which has succeeded the Hubble Space Telescope (HST) as the most advanced space telescope operating in the visible light spectrum. Though only operational since 2022, it has already pushed back the boundaries of humanity's understanding of the cosmos. Scientists around the globe have used it, as well as many other scientific instruments, to reconsider our place in the universe. Imagery from the JWST and other telescopes appears throughout this book.

The five chapters that follow move inward, starting at the farthest reaches of the universe and moving through other galaxies and star systems to our outer solar system, then to the inner solar system. The final chapter reflects on what the future might hold for space exploration throughout the remainder of the twenty-first century. This "outward to inward" approach seeks to explore cosmology, the origins and evolution of the universe, the nature and our broadening knowledge of galaxies, and what we have learned since the Space Age about the major entities of the solar system.

This *Smithsonian Atlas of Space* offers an understanding of this subject in both words and images. The book's stunning

This composite view of irregular galaxy NGC 6822 combines data from the JWST's Near-Infrared Camera and Mid-Infrared Instrument. Together, the images show a dense field of stars with greenish-yellow clouds of gas and dust billowing across it. Bright galaxies of various shapes and sizes shine in red.

imagery—especially its space photography, maps (both those created especially for this work and those available from other sources), and schematics and diagrams—represents a significant effort to place what we know about this beautiful universe, and how we know it. In the pages that follow, I hope to make the immensity of the universe feel more intimate and understandable.

> "Until the twentieth century, astronomers were unsure that there was more than a single galaxy. Now we understand that there are millions, if not billions, of galaxies beyond the Milky Way. Black holes, exoplanets, and the possibilities of life—whatever its form—now dominate our considerations of the nature of the universe."

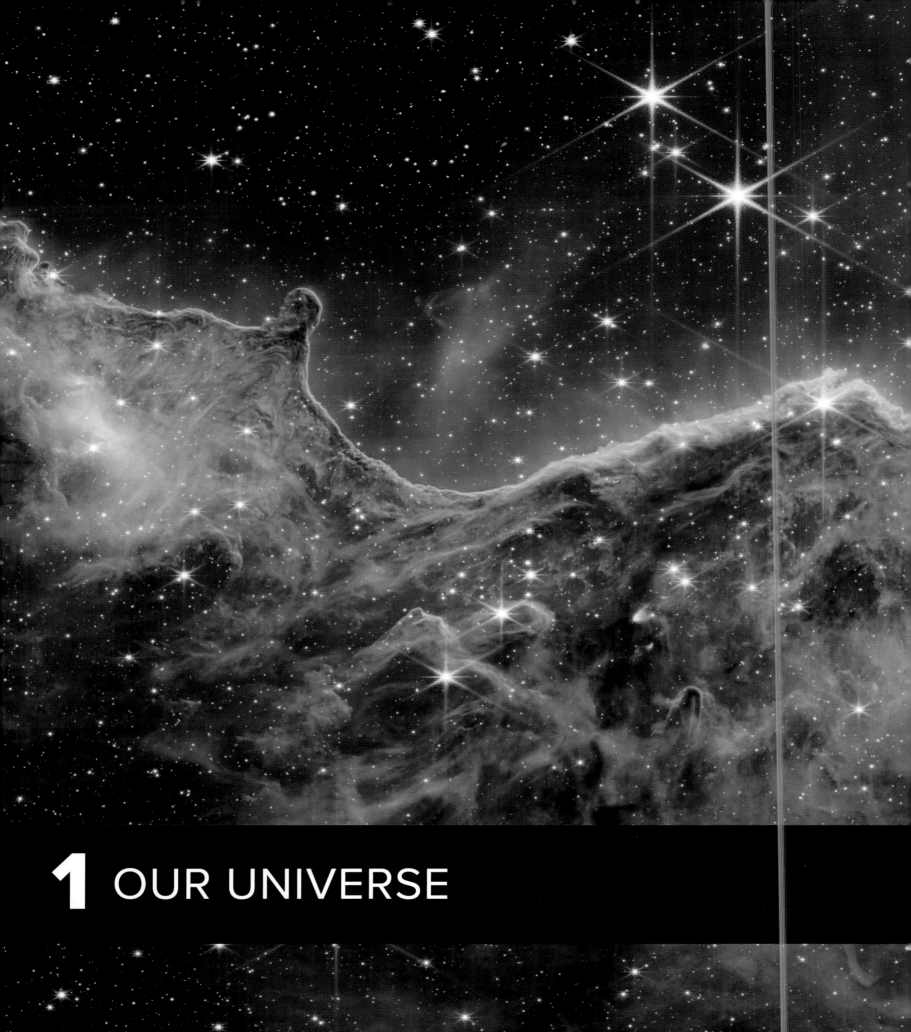

1 OUR UNIVERSE

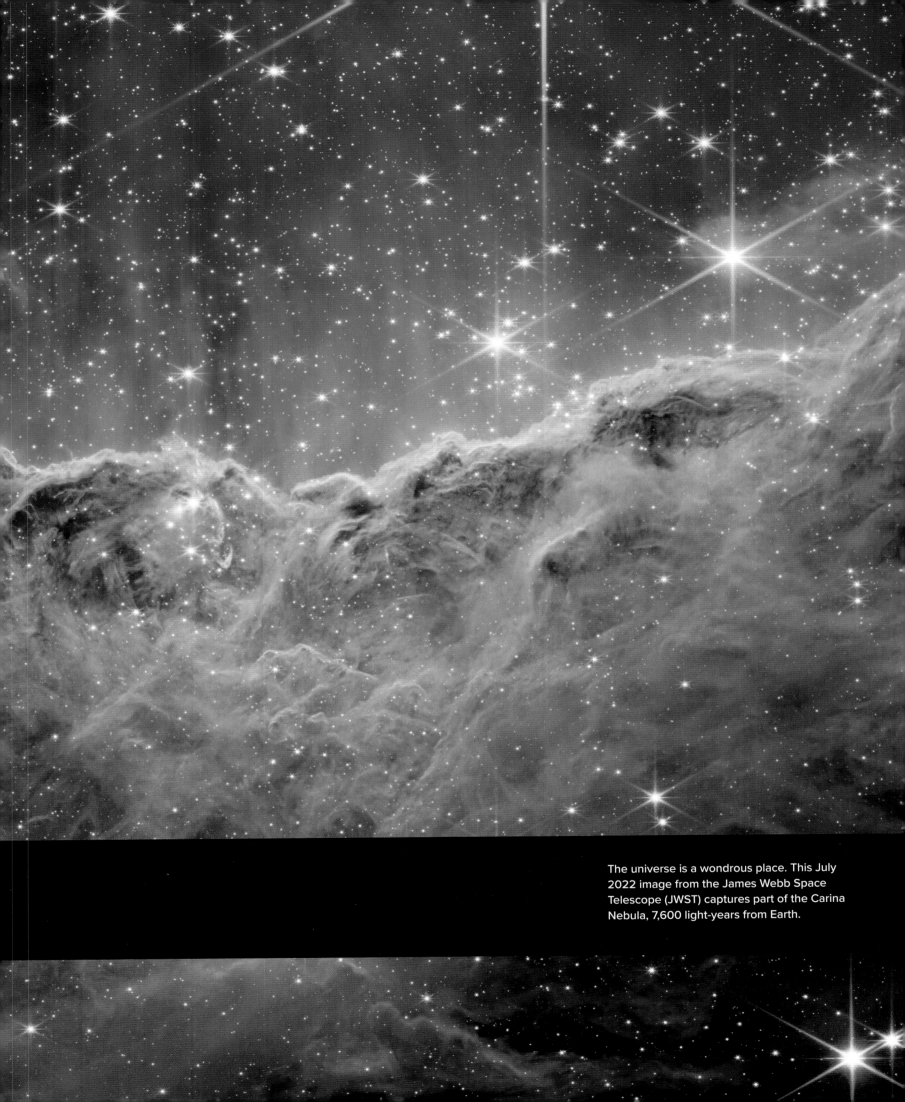

The universe is a wondrous place. This July 2022 image from the James Webb Space Telescope (JWST) captures part of the Carina Nebula, 7,600 light-years from Earth.

The vastness of the universe is unimaginable. Its shape is unknown; it may possibly be spherical or shaped like a flattened coin. Some cosmologists theorize that it may be one of many in a finite or even infinite multiverse system. There are a great many mysteries yet to be learned about the universe in which we live.

A spherical universe might be envisioned as a balloon with, in this analogy, us living at its center. Like the walls of a balloon as it is inflated, the surface area of the universe is expanding, its "edges" moving further and further away from the center point. Albert Einstein called this spherical model a "finite yet unbounded universe."

On the other hand, a flat shape could produce an infinite universe. NASA's Nobel Prize-winning cosmologist John C. Mather, Chief Scientist for the James Webb Space Telescope (JWST), suggested that the universe may be flat "like an [endless] sheet of paper . . . you could continue infinitely far in any direction and the universe would be just the same, more or less."

Within our ability to observe our universe—up to as far as 92 billion light-years away—there are perhaps 2 trillion galaxies, but we are left to wonder how much more universe is out there, beyond our viewing capabilities. We do know that the universe is 13.8 billion years old, give or take a few million years, and that it probably originated with what scientists call the "Big Bang," when a super-dense object smaller than a subatomic particle began rapid expansion. Our universe grows exponentially every day, with galaxies retreating from one another at ever-accelerating speeds. Why, is a question yet to be answered.

Additionally, only about 4.9 percent of the universe is composed of visible matter. The remaining 95.1 percent is made up of invisible dark matter and dark energy, which may only be theoretically studied. Since scientists know so little about dark matter and dark energy, the best they can do is extrapolate based on observations indirectly detected through the actions of gravity and other energy on visible matter. For instance, scientists understand through observation that our universe is expanding. But if the universe is made up of only galaxies, stars, and planets, gravity should be sufficient to hold things in place. Is dark matter and energy responsible for the expansion? This is yet another question to be pondered.

OPPOSITE NGC 346, a 200,000 light-years distant star cluster, was captured by the JWST's Near-Infrared Camera (NIRCam) on January 11, 2023. Images such as this reveal the fundamental building blocks of galaxies, stars, and even planets, helping us to understand the vastness of the universe, and to characterize its matter.

THEORIES ABOUT THE SHAPE OF THE UNIVERSE

The spherical universe is not infinite, but it has no end, in the same way that there is no point on the sphere that could be considered an "end."

The fact that our universe exists with the properties we observe today tells us that, very early on, the universe probably was very close to flat. If there were no dark matter or dark energy, a flat universe would expand forever but at a continually decelerating rate, with expansion evenually slowing to near zero.

Negative curvature of a universe is caused by a dearth of mass (manifested as gravity) to slow the expansion of the universe. In such a case, the universe will expand forever.

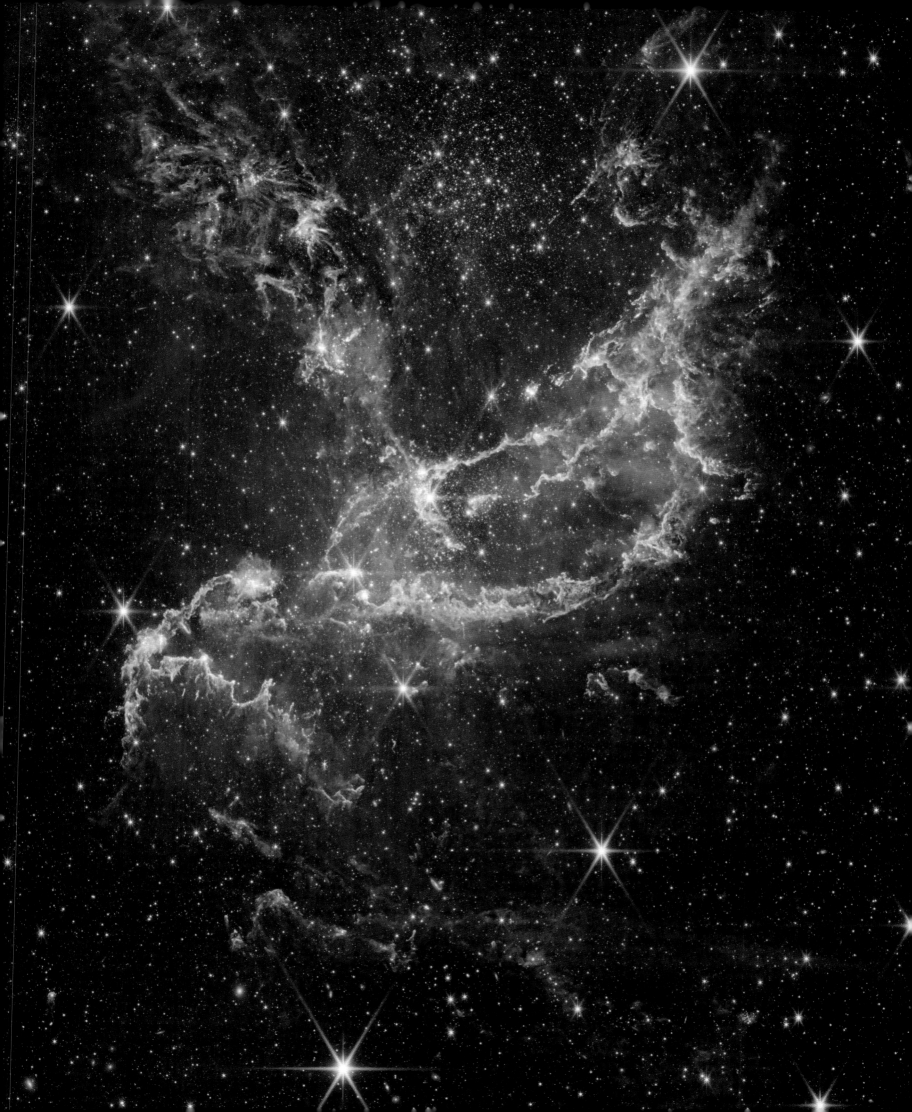

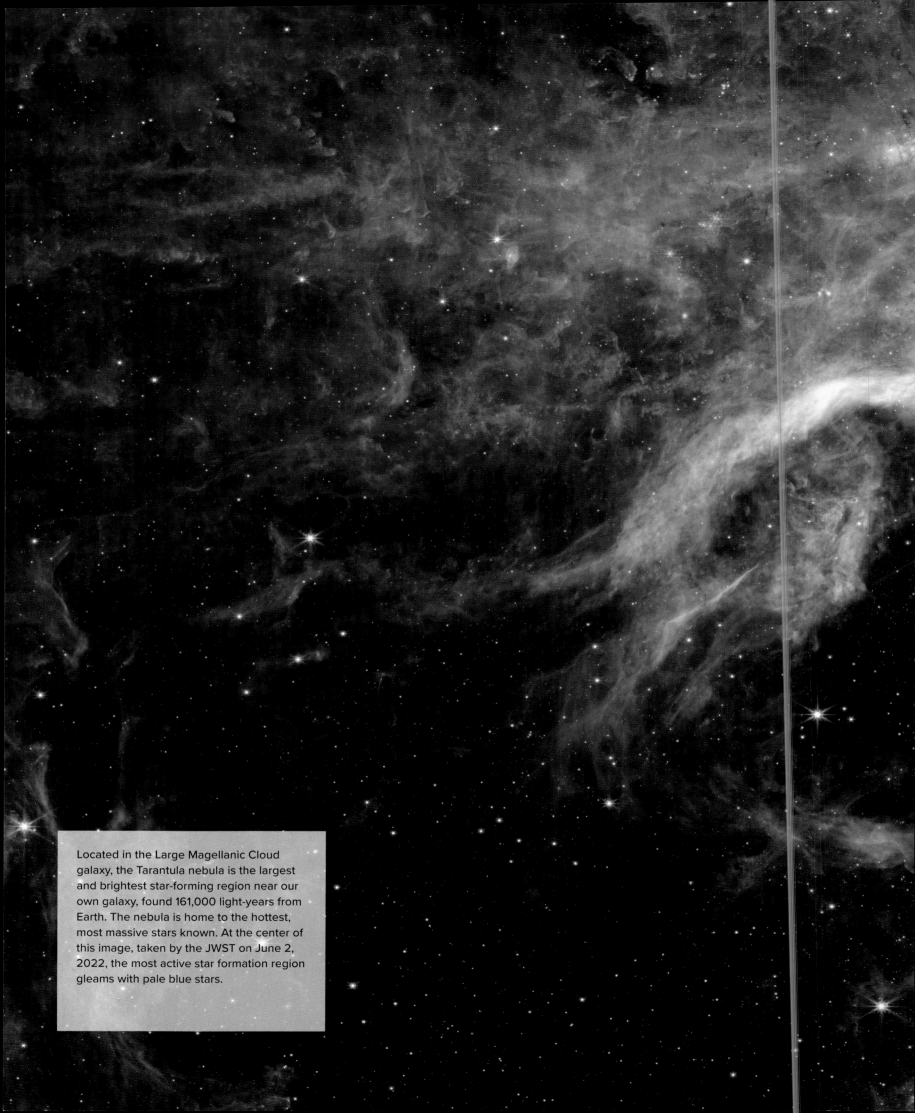

Located in the Large Magellanic Cloud galaxy, the Tarantula nebula is the largest and brightest star-forming region near our own galaxy, found 161,000 light-years from Earth. The nebula is home to the hottest, most massive stars known. At the center of this image, taken by the JWST on June 2, 2022, the most active star formation region gleams with pale blue stars.

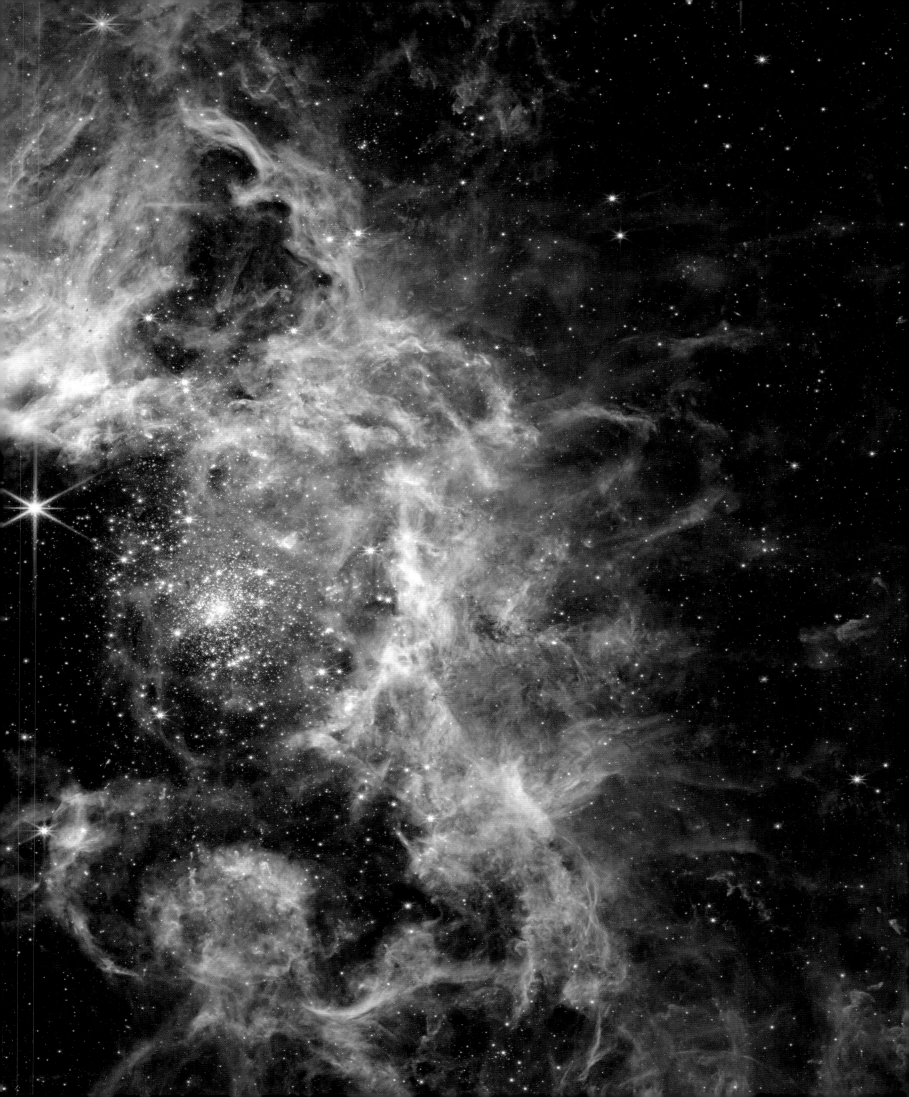

ANCIENT IDEAS OF THE UNIVERSE

Cosmology—the study of the universe, how it formed, and what laws govern its evolution—is as old as humanity. Every civilization has had its own ideas of how the universe emerged. While modern society may not find these ancient ideas compelling—and new theories of the evolution of the universe have displaced most, but not all, earlier ones—each theory was internally consistent with what was then known.

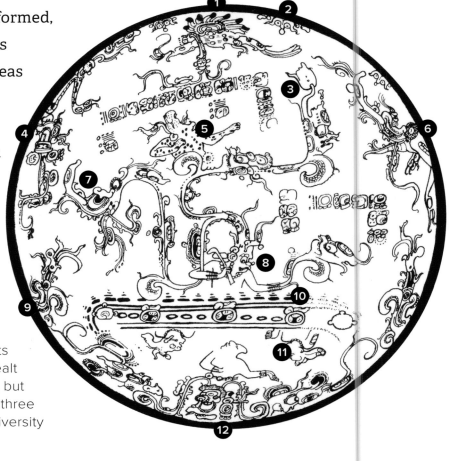

While every civilization had its own beliefs about the origins of the universe and its evolution, prior to the Scientific Revolution of the sixteenth century (when new instruments such as telescopes changed many perspectives), much ancient cosmology had roots in religion and mysticism. All of the ancient theories dealt with not only the origins and evolution of the universe, but also with the human experience of life and death. The three concepts of cosmology discussed here illustrate the diversity of these ideas.

MAYAN COSMOLOGY

The Mayan civilization originated in the first millennium BCE and still existed when Spanish conquistadors came to Mesoamerica in the sixteenth century. Mayan cosmology projected a stable universe with Earth at the center of all things, fixed and immovable. The flat world the Mayans envisioned had a god located at each of the four cardinal directions. Above was a heaven with thirteen layers—each represented by a further god—which contained the stars, Moon, and Sun. Below Earth's surface was the Xibalba, or the underworld, with nine layers, each presided over by a death lord. Individuals were rewarded or punished based on deeds and beliefs during their lifetime, an explicit religious conception of what happens to the soul upon death.

The Mayans were careful observers of the sky and tracked all the cycles important to their civilization's way of life. The Mayan solar cycle calendar, with 365 days, was an ancient marvel and still forms a model for the present calendar. They observed planetary cycles and celestial movements in order to recognize patterns, both for practical purposes, such as planting, and to foretell the future. All of Mayan life could be linked to these cycles and their relationship to the seasons.

Intended to hold blood that opens a portal to the Otherworld, an ancient Mayan tripod plate dating to 600-800 CE featured a painted representation of the Mayan Cosmos. Recreated in this sketch, the following elements are depicted:

1. Celestial Bird
2. Venus sign
3. The World Tree
4. Quadripartite God, the rear head of the Cosmic Monster
5. Jaguar Twin
6. Front head of the Cosmic Monster
7. Serpent of Vision as the branches of the tree
8. Chac-Xib as the Evening Star rising from the Underworld
9. Maw of the Underworld
10. Black waters of the Middleworld
11. Xibalbans
12. Bloody waters of the Underworld

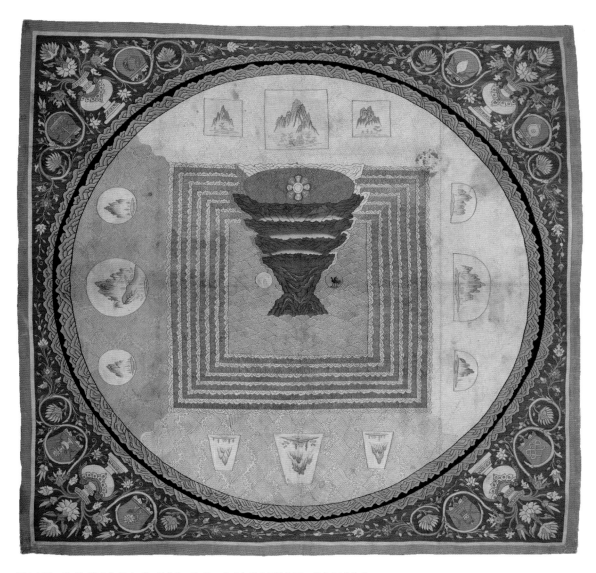

THE COSMOLOGY OF ANCIENT CHINA

The ancient Chinese explanation of the universe mixed religious conceptions, observations of the nighttime sky, and ideas from ancient philosophy into a basic explanation of the cosmos that served the needs of most people in the culture. The most accepted cosmology in ancient China—the Xuan Ye theory, first developed around 1300 BCE—argued for an astronomical view of the cosmos as an infinite space, with Earth consisting of condensed yin, and the heavens of yang, locked in an eternal dynamic relationship. These properties coexisted with each other, and relations between the human world and the cosmos beyond had to remain in balance.

To ensure the balance, sky-watchers equipped with the best measuring instruments available set up systems to predict celestial events—from solstices and equinoxes to the motions of bodies in the sky. Our understanding of Chinese conceptions of the cosmos has come from extended detailed accounts of the predictive systems constructed by early Chinese astronomers, especially the Han astronomical system (Han li)—officially adopted in 85 CE—whose processes calculate all solar, lunar, and planetary data for any given year thereafter.

This fourteenth-century tapestry features a Chinese cosmological mandala (circular image) with the mythological Mount Meru—considered to be the center of the universe—in the middle. The mountain is depicted as an inverted pyramid with a lotus. A rabbit, representing the Moon, and a three-legged bird, representing the Sun, are placed on either side of Mount Meru.

OUR UNIVERSE

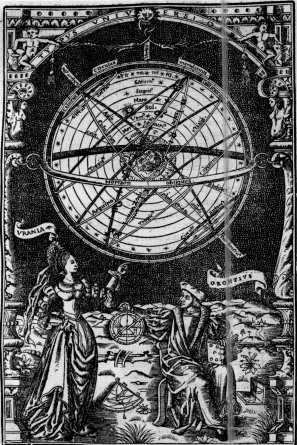

BABYLONIAN IDEAS OF THE UNIVERSE

The ancient Babylonians conceived of the universe as an oyster surrounded by water. They claimed that the sky was a dome which in turn both protected and hurled destruction of fire and water on the Earth. Each day, the Sun, Moon, and stars undertook a slow movement across this dome, entering from the east and exiting to the west. Like other ancient civilizations who studied these movements, the Babylonians calculated everything and predicted with great precision the movement of the planets and the change of seasons.

DEVELOPING IDEAS

While all of these conceptions of the universe possessed elements of reality, they were as much mythology as not. The ideas changed over time, operating in concordance and discordance with observations in the nighttime sky, challenges of knowledge based on other ideas and ideals, and influences from other cultures as time and circumstances changed. They may seem quaint by the twenty-first century standard of knowledge, but they reflected more than mere folklore. In another 2,000 years we may ask the appropriate question: How much of what we understood to be true about the universe in the twenty-first century is still correct, and how much has changed in response to new discoveries? Some of what we believe today will remain, but it is also probable that much will be replaced with new knowledge.

ABOVE The early Greek observers of the sky bequeathed to Western civilization its earliest understanding of the universe. From Apollo and his sun chariot to the gods and goddesses watching over various aspects of human endeavor, this persepctive was deeply mythological, captured in such illustrations as this one from the writings of French mathematician and cartographer, Oronce Fine (1494–1555), *De mundi sphaera* (Paris, 1542): "Illustration of Oronce Fine, Astronomy personified and an armillary sphere." An armillary sphere was a three-dimensional representation of the celestial sphere, with a framework of rings centered on Earth or the Sun representing the great movements of objects in the nighttime sky.

TOP LEFT The Babylonian universe consists of two seven-staged pyramids representing Earth, with humanity living on the upper side and those dead below. Gods oversee each of these realms, and the realm of the stars and all other objects in the nighttime sky represents all that beyond Earth. Babylonians believed the north pole of the heavens to be the true zenith of the cosmic system.

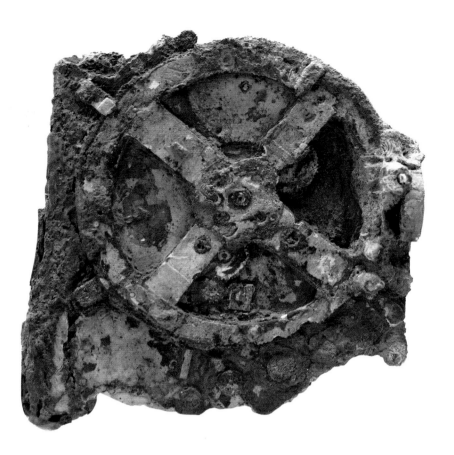

LEFT A main fragment of the Antikythera mechanism—an ancient computing system designed to predict astronomical positions and eclipses—recovered from a shipwreck off the Greek island of Antikythera, dating from the early first century BCE. The mechanism consists of a complex system of thirty-two wheels and plates bearing inscriptions relating to the signs of the zodiac and the months of the year. The study of the fragments suggests that it was a kind of astrolabe used for maritime navigation.

RIGHT A reconstruction of the front ring display of the Antikythera mechanism was created using the best evidence available about its purpose. The planets are shown by marker beads with pointers for the Moon, Sun, Line of Nodes, and Date. At the center is Earth, with a silver ball representing the Moon attached. Beyond that, the rings represent Mercury, Venus, the Sun, Mars, Jupiter, and Saturn.

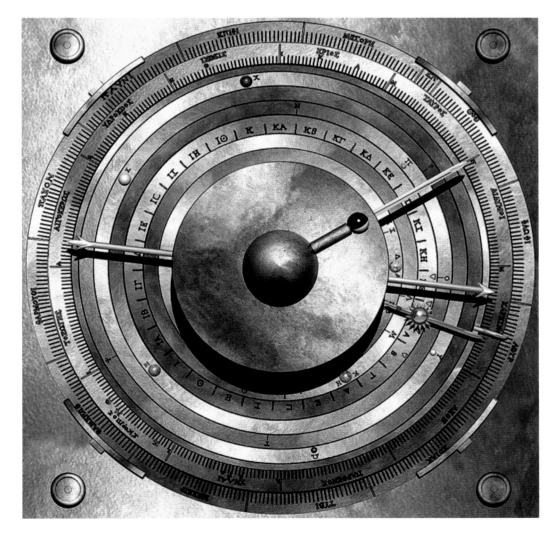

OUR UNIVERSE

Ancient civilizations were unable to see as clearly and deeply into space as we can in the twenty-first century. They would have been in awe, as we are today, of the complexity, beauty, and energy of the universe we seek to understand. This composite image of the Carina nebula (NGC 3324) was captured with multiple exposures by the James Webb Space Telescope (JWST) Near-Infrared Camera and Mid-Infrared Instrument in July 2022. The JWST represents one of the most advanced space telescopes in operation. It is rewriting knowledge of the universe.

"Within our ability to observe our universe—
up to as far as 92 billion light-years away—there
are perhaps 2 trillion galaxies, but we are left to
wonder how much more universe is out there,
beyond our viewing capabilities."

OUR UNIVERSE

MODELS OF THE UNIVERSE IN WESTERN CIVILIZATION

Like the ancients of other regions of the world, Western civilization tended to classify everything, including the structure and evolution of the universe. This search for order led to two grand visions of the universe in the Western tradition. Both made sense at their times, yet were, and remain, incomplete and in some sense erroneous.

Ideas from Greek and Roman mythology informed many of the ideas common among Europeans until the Christian era, but soon they were supplanted by more orderly—though, as we will discover, still innaccurate and incomplete—observations. The universe as conceived in Europe from the ancient through the medieval era and into the early Renaissance was predicated primarily on the worldview of philosopher and polymath Aristotle (384–322 BCE) and Ptolemy, a second-century astronomer and theorist. Aristotle believed the Earth was round and sat at the center of the universe, with the Sun, Moon, and planets revolving around it. The Ptolemaic model of the universe was also "geocentric," positing Earth at the center, but in this conception Earth was surrounded by crystalline spheres, with the Sun, stars, and planets embedded as jewels in these spheres. From innermost to outermost, the spheres followed this order:

1. Earth (central and unmoving)
2. Moon
3. Mercury
4. Venus
5. Sun
6. Mars
7. Jupiter
8. Saturn
9. Fixed stars
10. Primum Mobile, or Firmament

However, this explanation of the universe proved progressively more difficult to fit with the observations of astronomers. For a long time, they tried to modify the model to account for discrepancies and developed increasingly more complex explanations, the most important of which incorporated epicycles within the spheres. This geometric model resolved the observed variations in speed and direction of the apparent motion of bodies in the solar system. Especially important, it allowed for the apparent retrograde motion of the five planets known in the first centuries CE (Mercury, Venus, Mars, Jupiter, and Saturn). It also explained apparent changes in the distances of planets from Earth.

It took more than 1,500 years of serious questioning of the Ptolemaic model for it to be overturned. Three major assumptions proved incorrect: first, that Earth was at the center of the universe; second, that a perfect uniformity of circular motion governed the universe; and third, that objects beyond Earth were perfect and unchanging. Copernicus challenged each of these assumptions.

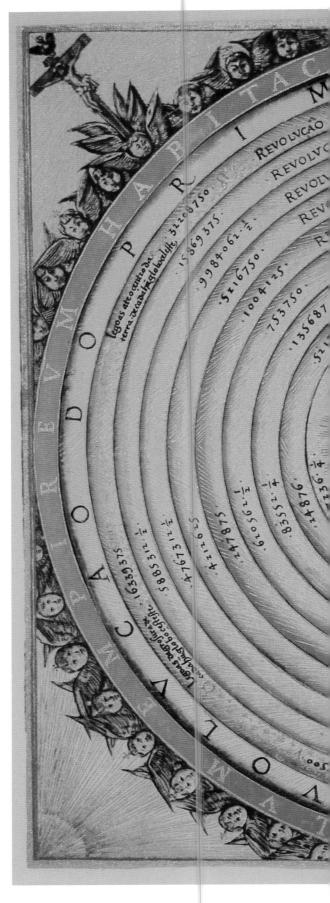

The Ptolemaic model of the universe as illustrated in *Cosmographia* by Bartolomeu Velho (Paris, 1568).

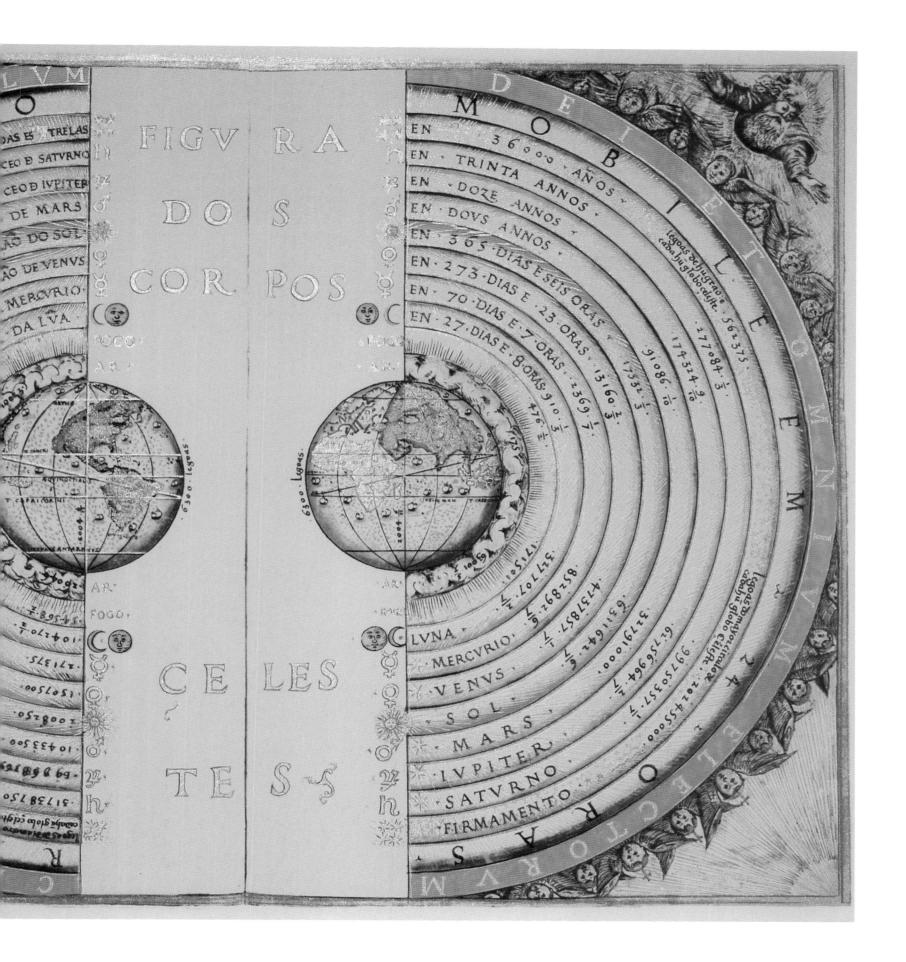

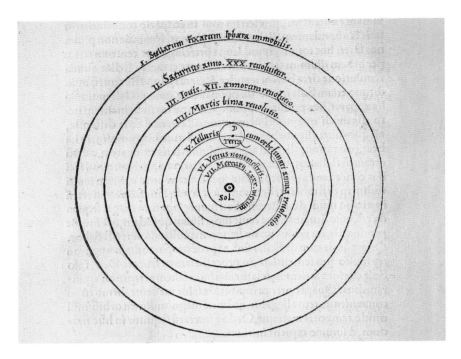

This depiction of the Copernican universe is from *De revolutionibus orbium coelestium* (*On the Revolutions of the Heavenly Bodies*) by Nicolaus Copernicus (1543). It offers a model in which the Earth rests at the center of the known universe with observable planets, the Sun, and the stars shown beyond.

NICOLAUS COPERNICUS (1473–1543)

Born in the Kingdom of Poland, then a part of Royal Prussia, Nicolaus Copernicus earned a doctorate in canon law and studied mathematics, astronomy, medicine, and the classics. While he understood that the Ptolemaic conception of the universe was inaccurate by his calculations, he was circumspect in his public statements about this finding. To avoid controversy, he did not publish until near his death in 1543, and was given the final printed pages of his *De revolutionibus orbium coelestium* (*On the Revolutions of the Heavenly Bodies*) just before he died. The Catholic Church did not officially censure Copernicus, although some wanted to, and so his ideas became a cornerstone of the transformation of knowledge about the universe thereafter.

In his book *On the Revolutions of the Heavenly Bodies*, Copernicus proposed that the Sun, rather than Earth, rested at the center of the solar system, because the irregular movement of certain planets could not be explained even with Ptolemy's epicycles. This "heliocentric" model of the universe resolved the flaws in the Ptolemaic system and found adherents throughout Europe by 1650. From innermost to outermost, Copernicus's model followed this order:

1. Sun
2. Mercury
3. Venus
4. Earth (with Moon orbiting)
5. Mars
6. Jupiter
7. Saturn
8. Stars beyond

This model was far from a complete view of the solar system, and certainly did not envision galaxies and other aspects of the universe beyond, but it represented a major transformation of knowledge.

Although Christian thinkers, believing that humanity was at the center of the universe, refused to accept the Copernican model until the seventeenth century, Johannes Kepler, Galileo Galilei, Isaac Newton, and others reinforced the findings of Copernicus. Commonly called the Copernican Revolution, this transformation of ideas represented a fundamental shift in our understanding of the universe until Albert Einstein in the early twentieth century (see page 28).

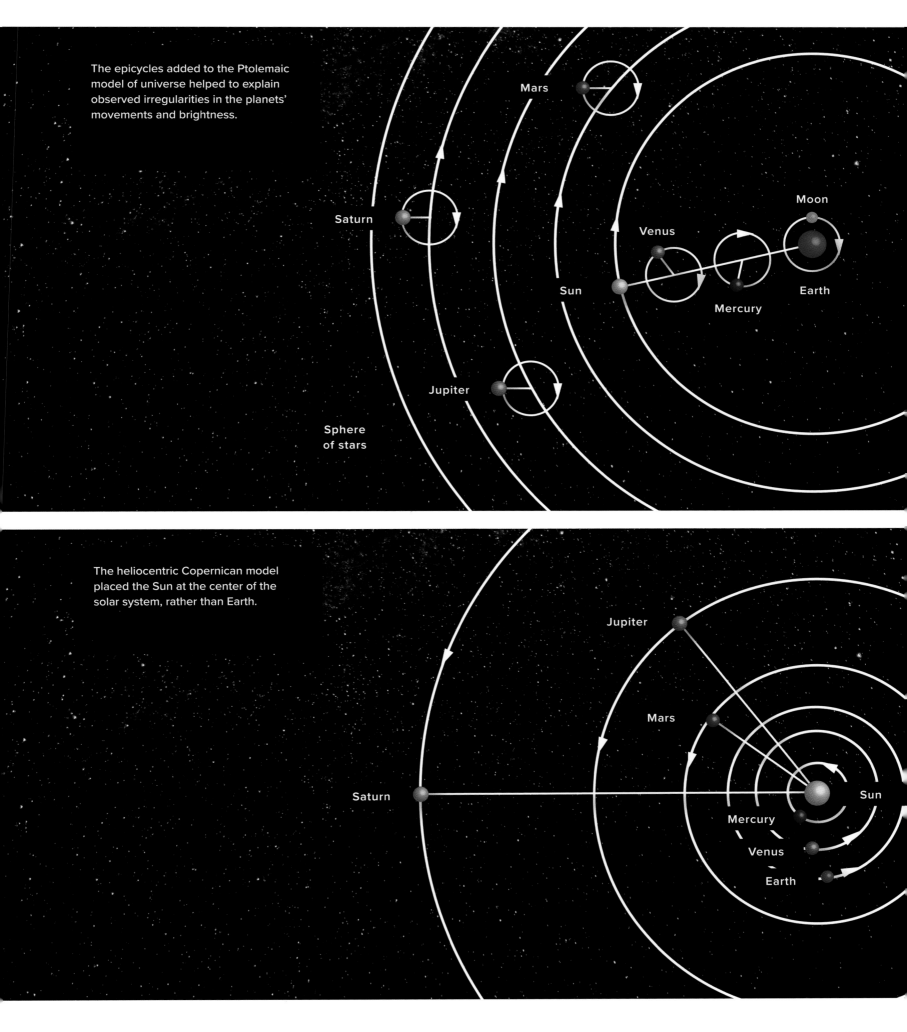

The epicycles added to the Ptolemaic model of universe helped to explain observed irregularities in the planets' movements and brightness.

The heliocentric Copernican model placed the Sun at the center of the solar system, rather than Earth.

OUR UNIVERSE

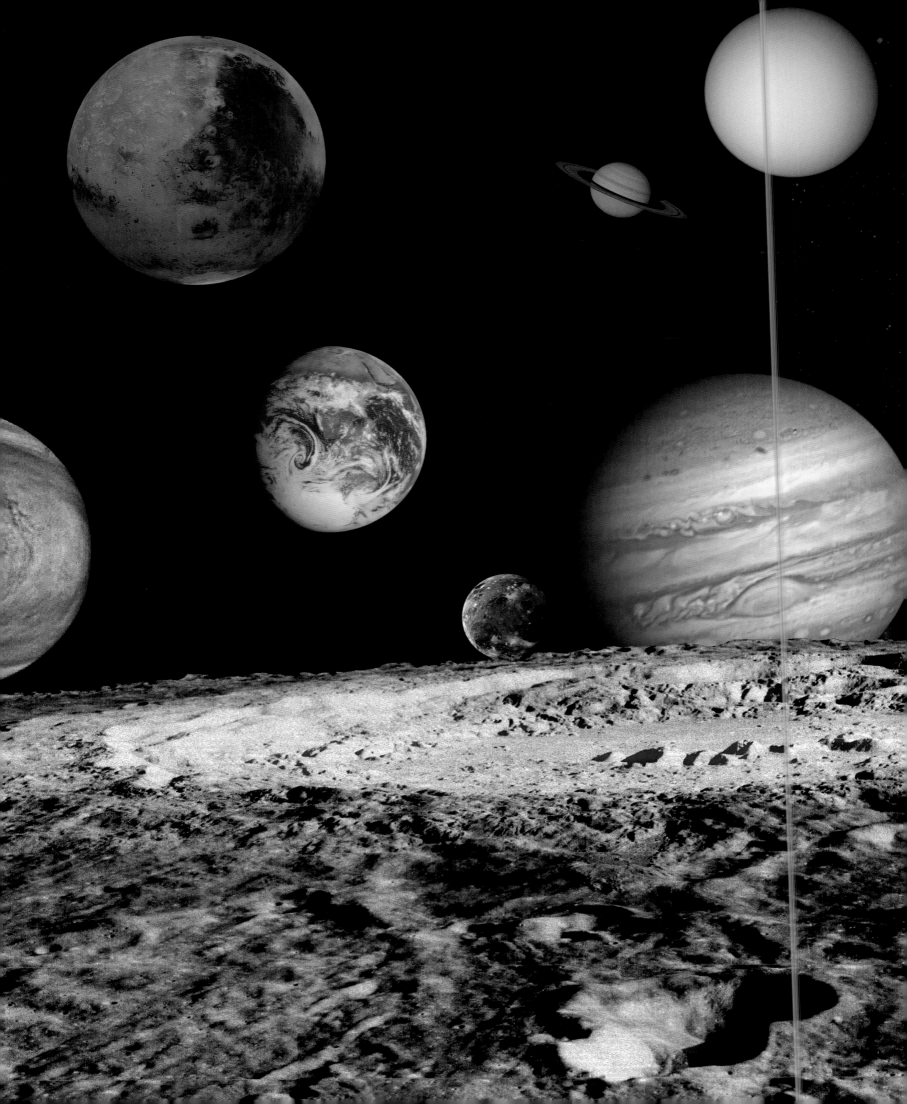

Taken by the Voyager spacecraft during their voyage to the end of the solar system (see page 172), this montage of images expanded significant knowledge about our corner of the universe. All of the planets, some of which had not yet been discovered when Copernicus worked, and four of Jupiter's moons are set against a false-color Rosette nebula with Earth's Moon in the foreground. This "family group photograph" suggests the power and beauty of the solar system, something Copernicus went far in opening understanding about.

NEWTON, EINSTEIN, AND THE MYSTERIES OF SPACE-TIME

Two towering figures in science have further transformed our understanding of the universe. Cambridge University mathematician Sir Isaac Newton helped lead the Scientific Revolution with his pioneering studies on gravity and optics, while German-American astrophysicist Albert Einstein also revolutionized science with his theories on relativity in the twentieth century.

Sir Isaac Newton (1643–1727) made pathbreaking discoveries in many areas, which he summarized in *Philosophiæ naturalis principia mathematica (Mathematical Principles of Natural Philosophy)*, published in 1687. The work stated his three laws of motion, which are fundamental to the idea of space travel—without knowledge of these laws, the core technology of spaceflight, the rocket, would not exist:

1. Every body continues in its state of rest, or of uniform motion in a straight line, unless it is compelled to change that state by forces impressed upon it.
2. The change of motion of an object is proportional to the force impressed; and is made in the direction of the straight line in which the force is impressed.
3. To every action, there is always opposed an equal reaction; or, the mutual actions of two bodies upon each other are always equal, and directed to contrary parts.

These discoveries explained the previously undefined relationship between mass and force.

Another towering figure in the rise of the Space Age (the period in which space travel has become possible) was Albert Einstein, a German-born theoretical physicist. Einstein found, in his theory of special relativity, that nothing could exceed the speed of light—approximately 186,000 miles per second (300,000 kilometers/s)—a theory confirmed by NASA's Gravity Probe B (GP-B) experiment in 2004–05. He also postulated that in a spacecraft traveling near light speed, a crew would age more slowly the faster they traveled.

Einstein also predicted the existence of black holes in space, and the potential of wormholes as shortcuts from one point in space-time to another.

THE IMPACT OF NEWTON'S LAWS ON SPACE TRAVEL

NEWTON'S FIRST LAW
This describes inertia. An object at rest (A) will remain at rest until a force acts upon it (B). The object will then remain in the state of uniform motion until another force acts on it (C). Understanding inertia is essential for spaceflight, as even in the absence of gravity, rocket propulsion must overcome a spacecraft's inertia to cause it to move.

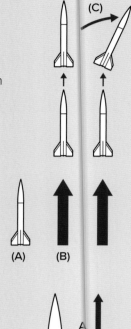

NEWTON'S SECOND LAW
A force of 0.22lb (1 newton) is required to move a mass of 2.2lb (1 kilogram) with an acceleration of 3.28 feet (1 meter)/second. These units are used to calculate the firing of thrusters to navigate spacecraft into orbit and across the solar system. Here, "A" equals forward motion, "F" equals the force moving the rocket forward, and "M" represents the drag holding back the forward motion. "F" must be greater than "M" for forward movement to occur.

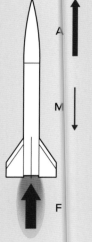

NEWTON'S THIRD LAW
This explains how rockets move spacecraft around empty space. By applying a force with thrusters, the reacting force causes spacecraft to move in the opposite direction.

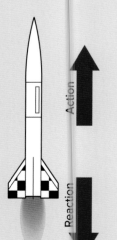

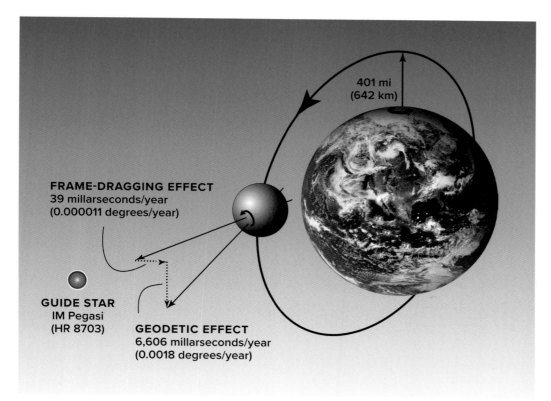

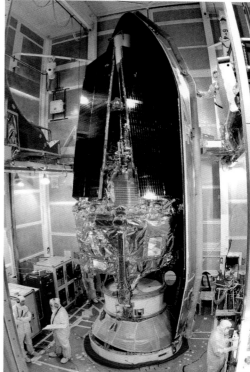

ABOVE Einstein theorized that space and time are relative entities, interwoven into a "fabric," which he called space-time. In Einstein's universe, the presence of celestial bodies causes space-time to warp or curve, and gravity is the product of bodies moving in curved space-time. Based on predictions of Einstein's theory, GP-B measured the geodetic effect: the amount by which Earth is warping its local space-time. In addition, and more importantly, it measured the frame-dragging effect of massive bodies like Earth, which drag their local space-time around with them as they rotate. GP-B orbited 401 miles (642 kilometers) above Earth. On board were four spherical gyroscopes, each roughly the size of a ping-pong ball, and the experiment measured the expected tiny changes in the direction of the spin axes with unprecedented accuracy. These gyroscopes precessed at a rate consistent with the gravitational predictions of Einstein's theories.

ABOVE NASA's technicians prepare GP-B atop the Delta II launch vehicle in April 2004.

ALBERT EINSTEIN (1879–1955)

Albert Einstein has legendary status in the modern world and resonance in popular culture. He did not start out that way. After completing his education, he worked as a patent clerk in Switzerland before successes in theoretical physics. His ideas on relativity were published in 1905, and his mass–energy formula, $E = mc^2$, may be the world's most famous scientific equation. For this work, Einstein received the 1921 Nobel Prize in Physics.

Einstein's contributions to theoretical physics proved exceptional. While the universe had been earlier thought of as largely static, as per Newton's research, Einstein predicted a constantly changing universe. Moving to Princeton University in the United States before World War II, Einstein continued his quest to understand the universe.

OUR UNIVERSE

Gravitational lensing of distant galaxies warps shapes and creates bright streaks of light. This effect occurs when a massive celestial object such as a galaxy cluster causes a sufficient curvature of space-time for light to be visibly bent around it, as if by a magnifying lens (see page 84). Here, a distorted arc spreading out near a distant galaxy known as the Cosmic Seahorse is greatly magnified by gravitational lensing. The image, taken by the James Webb Space Telescope (JWST) and released on May 28, 2023, depicts galaxies 6.3 billion light-years from Earth in the constellation Coma Berenices.

HUBBLE, THE EXPANDING UNIVERSE, AND THE BIG BANG THEORY

Only five centuries ago—not even the blink of an eye when compared to the age of the universe—humanity's vision extended little beyond Saturn. Our ancestors envisioned a universe both limited and orderly. The telescope changed that, and our universe expanded exponentially as we observed millions of objects beyond Earth, the solar system, and eventually the Milky Way galaxy.

Astronomer Edwin Hubble investigated the nature of what appeared to be patches called nebulae, glowing parts of the sky so-named by Ptolemy because they looked "nebulous," or cloudlike. For centuries, no one knew if nebulae were part of the Milky Way or something else. Debates ensued, based on the measurement of spectral shift for the Great Andromeda nebula. The distance of objects was gauged by their "redshift"—the further away the object is, the more the light that comes from it is stretched, and the redder it appears (see page 36). This discovery set off a worldwide search for answers.

Hubble published incontrovertible evidence for multiple galaxies in the universe in 1925 after analyzing a Cepheid variable star, a type of star that pulsates regularly and whose variations may be measured in brightness, diameter, and temperature to benchmark the scale of galactic distances. Hubble measured the brightness of the star over several months, and determined that it varied over a period of 31.45 days. Using that variation in brightness, Hubble calculated that the star was 900,000 light-years away, far beyond the Milky Way galaxy. He also found other variable stars, and published a paper in 1929 laying out the evidence that these objects were separate galaxies from the Milky Way, that there were millions of them, and that they were moving away from one another.

Hubble's discovery offered support to the Big Bang theory first theorized two years previously by Georges Henri Joseph Édouard Lemaître (1894–1966), a Belgian Catholic priest and theoretical physicist at the Catholic University of Louvain. Lemaître proposed that the movement of galaxies can be explained by an expanding universe, set off by what might best be characterized as a massive explosion of matter. Hubble's observations solidified the Big Bang theory as a reasonable explanation of the origins of the universe. It proved an elegant, convincing, and resilient theory which is still largely accepted by scientists, even as it is modified by observation and experimentation.

EDWIN POWELL HUBBLE (1889–1953)

Edwin Hubble was a towering figure in astronomy in the first half of the twentieth century. He made three critical contributions to cosmology:

1. Hubble proved that distant objects, then called nebulae, were too distant to be part of the Milky Way and so there were galaxies outside of our own.

2. He determined that the universe is expanding, shown by a Doppler shift toward the red end of the visible light spectrum, indicating that cosmic objects are moving away from us. An exceptionally useful measurement in astronomy, the Doppler effect signals a change in the frequency of a light or sound wave in relation to an observer encountering the source of the wave.

3. He showed that galaxies are moving at a speed in direct proportion to their distance from us, known as Hubble's Law. The law is usually stated as $v = H0D$, where "v" is the velocity of recession, "D" is the distance of the galaxy from the observer, and "H0" is the Hubble constant that links them.

In 1923, Hubble used this glass plate to ascertain the variation of a single spot in the Andromeda nebula. Comparing images of this same part of the nighttime sky, he noticed that the object's brightness varied, writing "VAR!" on the plate to indicate the discovery of a variable star. Hubble's realization that this variable spot was a part of a separate Andromeda galaxy rather than a nebula opened a door to understanding that the universe is expanding.

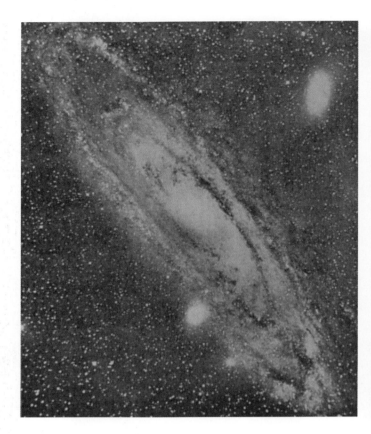

ABOVE The Great Andromeda nebula, photographed from the Yerkes Observatory in 1901. The Great Andromeda nebula was at the center of the debate over whether or not there were multiple galaxies in the universe. Hubble demonstrated beyond doubt that it was a galaxy unto itself, and that there were billions more beyond it as well.

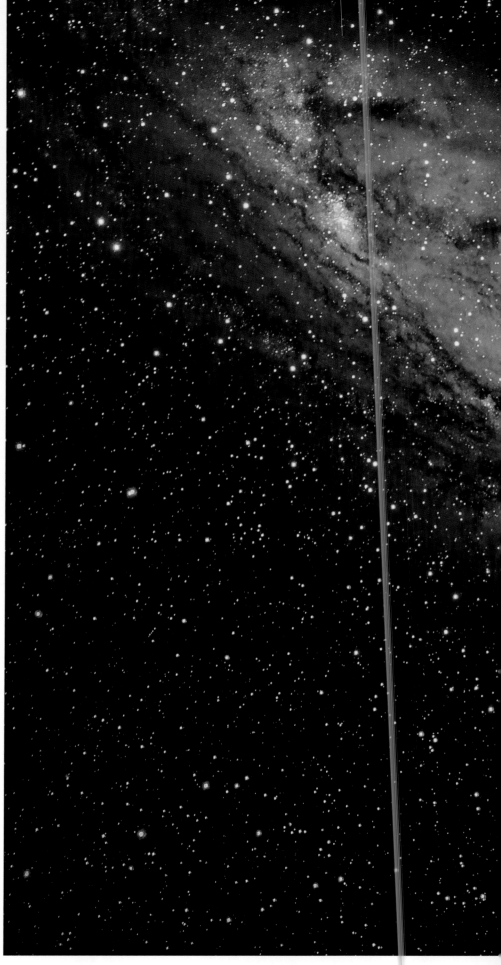

RIGHT The Andromeda galaxy (Messier 31), captured on July 9, 2019. The small Messier 32 galaxy is seen above and slightly to the left of the center of M31, and Messier 110 is below and to the left.

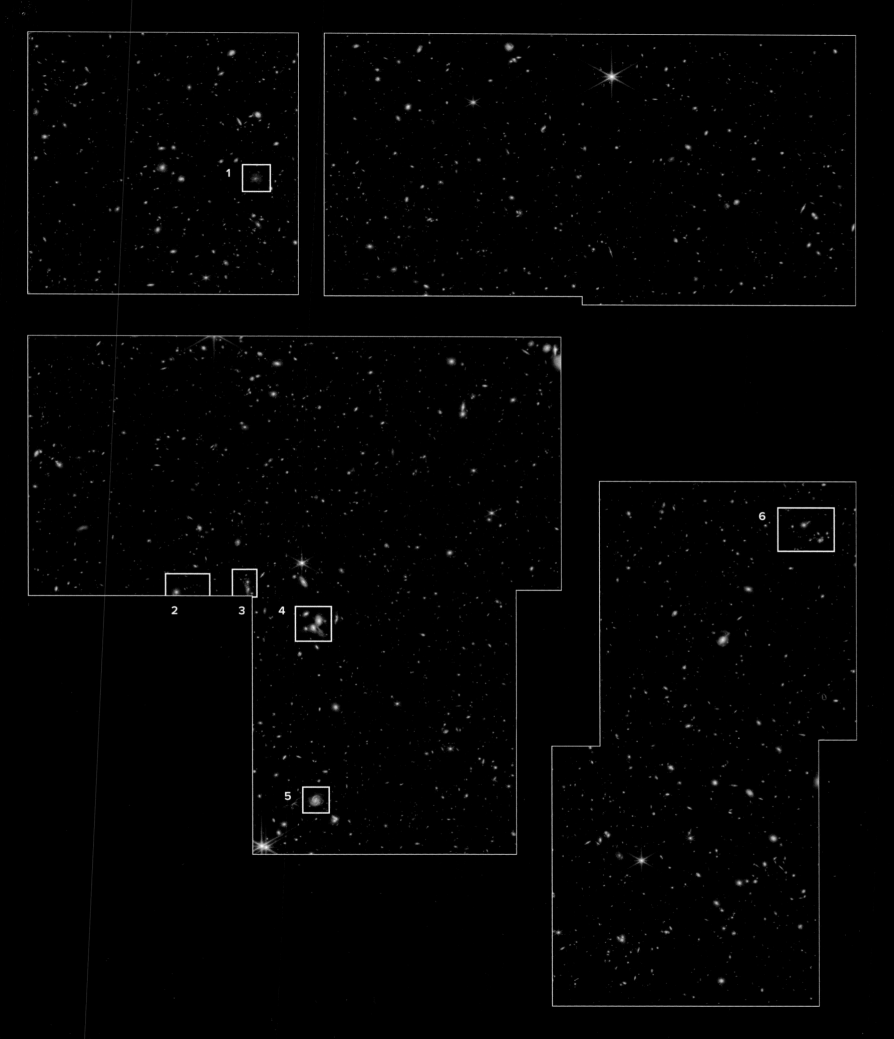

The Big Bang may be characterized as a "singularity" which, though it was no bigger than an electron, contained the totality of the matter of the universe. Its "explosion" set in motion the expansion of the universe and the formation of the matter in the objects currently observed in the cosmos. The galaxies that are ubiquitous in the modern sky are relative newcomers to the universe, formed a billion years ago. In total, cosmologists estimate there are 221,373 galaxies in the local universe, within 2 billion light-years from Earth. This timeline of the universe, from the Big Bang to the present, flows from left to right. The universe has passed through several "eras." Initially, the "Plank Era" occured from the Big Bang to approximately 10^{-43} seconds later. This is the closest we can come to the absolute beginning of the universe. Next came the "Gut Era" and the "Inflationary Era," still only 10^{-36} and 10^{-34} seconds respectively after the Big Bang explosion. Thereafter particles began to form, merging and changing over time to become the elements that make up our current universe.

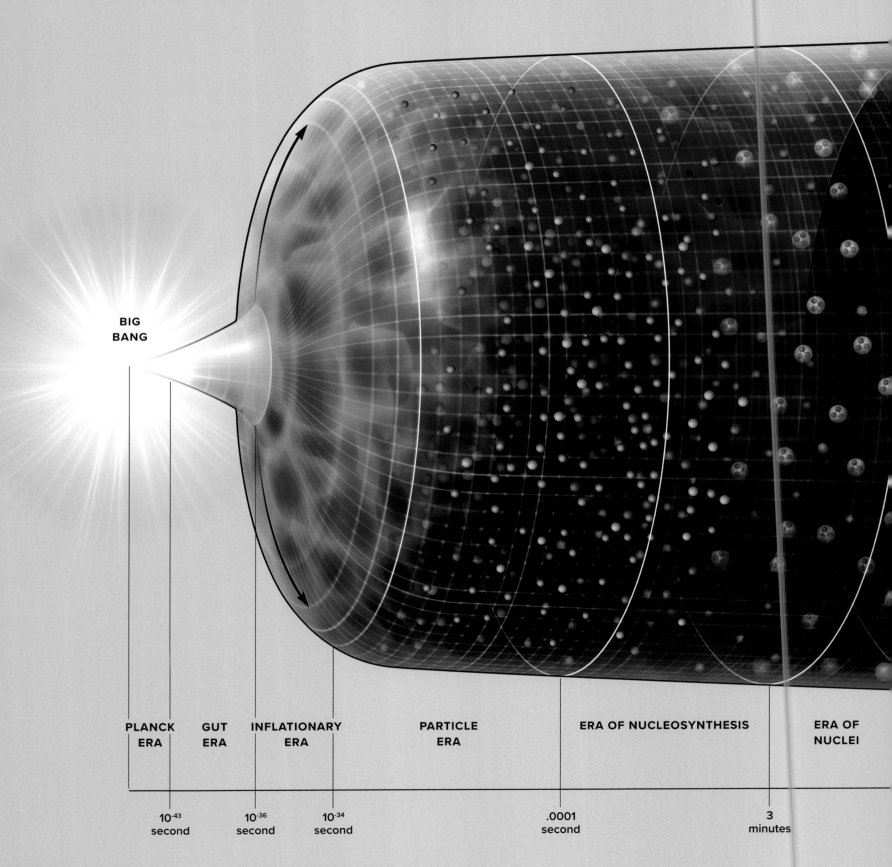

BIG BANG

PLANCK ERA	GUT ERA	INFLATIONARY ERA	PARTICLE ERA	ERA OF NUCLEOSYNTHESIS	ERA OF NUCLEI
10^{-43} second	10^{-36} second	10^{-34} second	.0001 second	3 minutes	

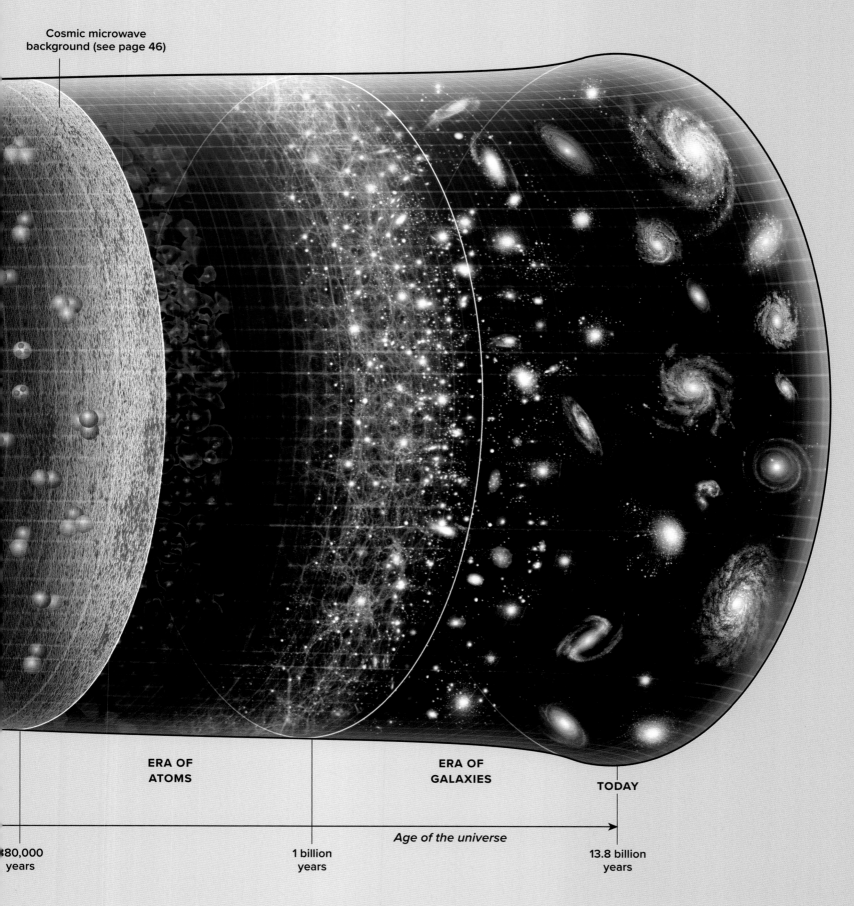

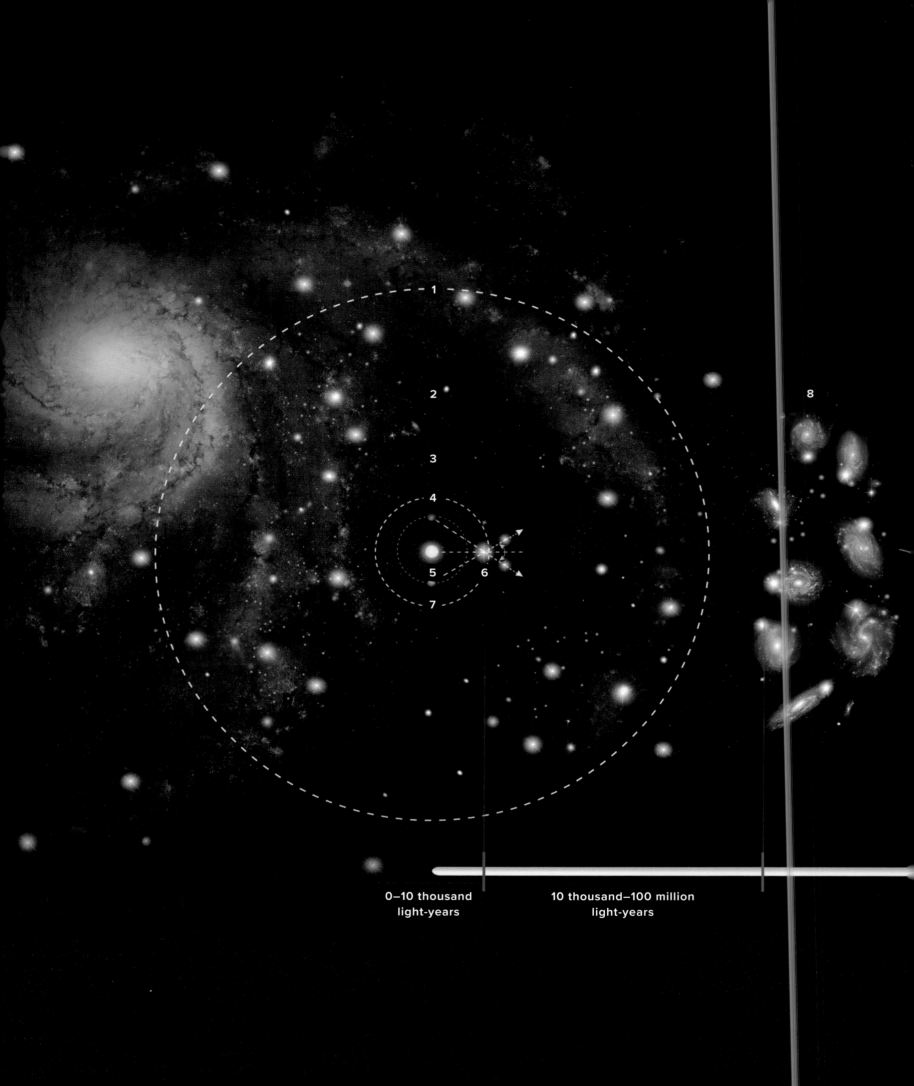

0–10 thousand
light-years

10 thousand–100 million
light-years

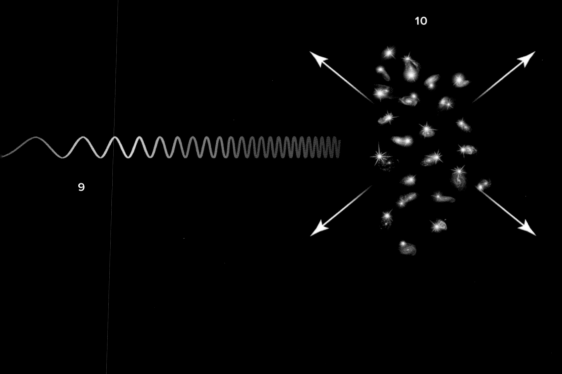

DISTANCE FROM THE SUN

100 million–1 billion light-years

How do astronomers calculate the speed at which the universe is expanding? The HST has provided more tools for doing so than ever before.

Observations of Cepheids (pulsating stars) at known distances from Earth have revealed a correlation between their average luminosity and pulsation periods. Using this information, astronomers can determine the distance of any Cepheid by measuring the time it takes to rhythmically change its brightness. To allow for greater precision in measurement, astronomers use two points at opposite sides of Earth's orbit of the Sun to take multiple readings of luminosity—the apparent shift in position of the star when measured from these two points is known as parallax. The distance from Earth at which stars can be measured in this way is termed the parallax limit.

Moving beyond the Milky Way (*center*), astronomers look for galaxies that contain Cepheid stars and exploding stars. Comparing the brightness of distant supernovae, astronomers then measure the distance where the expansion of the universe can be seen (in the redshift of bodies moving away from the Milky Way). They use these values to calculate the Hubble constant: a measure of how fast the universe expands with time. In 2016, using the HST which expanded the parallax limit, scientists measured about 2,400 Cepheid stars across nineteen galaxies and compared the observed brightness of both types of stars. The result was an improved Hubble constant value of 45.5 miles (73.2 kilometers) per second per megaparsec. (A megaparsec equals 3.26 million light-years.) More recently, the science team working on the European Space Agency's (ESA's) Planck spacecraft refined the Hubble constant even further.

1. New parallax limit
2. Parallax of Cepheids in the Milky Way
3. Old parallax limit
4. Earth in June
5. Sun
6. Cepheid
7. Earth in December
8. Parallax of Cepheids in the Milky Way
9. Light redshifted (stretched) by expansion of space
10. Distant galaxies in the expanding universe hosting Type Ia supernovae

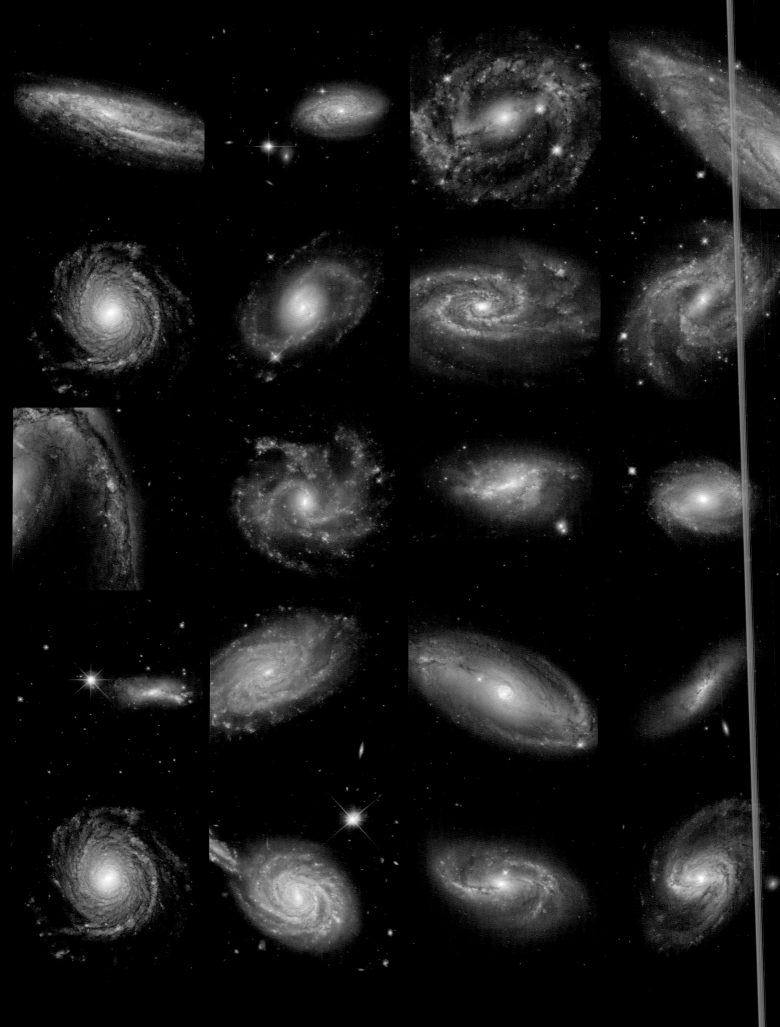

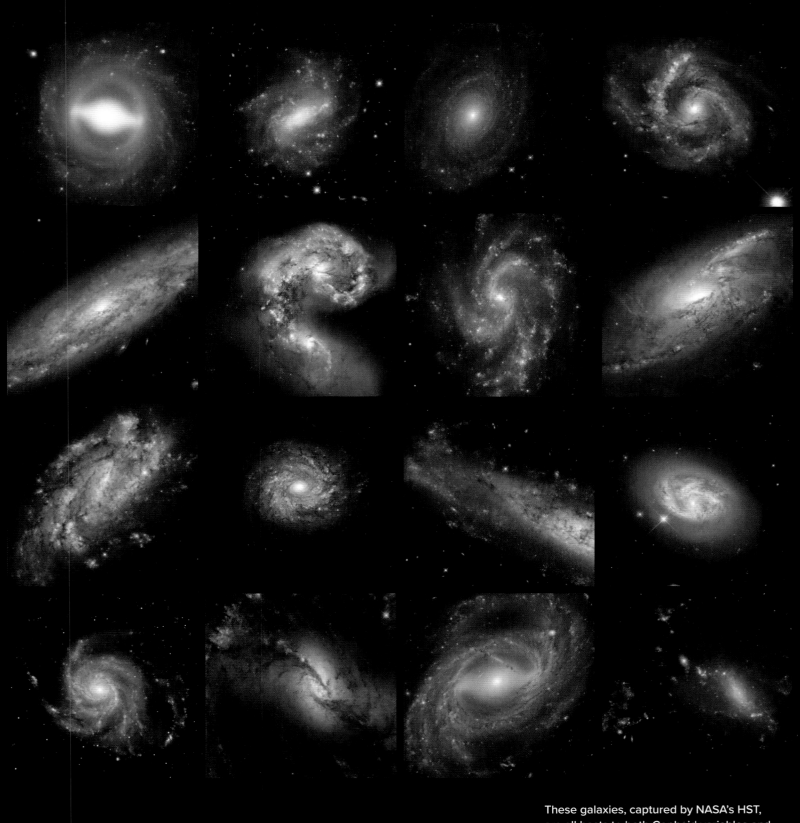

These galaxies, captured by NASA's HST, are all hosts to both Cepheid variables and supernovae. The Cepheids help to determine distance from Earth by measuring the changes in light and redshift. Measurements like these help to pin down the Hubble constant, the rate at which the universe is expanding.

CHARTING THE AGE OF THE UNIVERSE

Space travel provided an opportunity to expand far beyond the knowledge created by the discoveries of Hubble, Lemaître, and other astrophysicists of the pre–World War II era. Since the 1960s, a series of space observatories have extended humanity's understanding of the millions of stars and galaxies beyond the Milky Way.

The universe is 13.787 +/- 0.020 billion years old, and has expanded since its beginning. We know that because of the work of Hubble and a host of others who followed in his footsteps. Distant objects are receding as the universe expands, so the light from them is "stretched" out, altering its wavelength to the red part of the electromagnetic spectrum (see page 36). This light has been traveling toward Earth for billions of years. In other words, we see distant objects as they appeared when the light left them. Accordingly, NASA scientists sometimes characterize telescopes as a form of time travel. Perhaps not, but it is an enticing thought. What is incontrovertible is that as astronomers observe ever more distant objects, they can see into the early stages of the universe.

THE COSMIC BACKGROUND EXPLORER

One of the most significant spacecraft to help understand the origins of the universe was the Cosmic Background Explorer (COBE), which operated from 1989 to 1993. COBE searched for, and found, the cosmic microwave background radiation left over from the Big Bang at the very edge of the observable universe. COBE's discovery of the remnant heat from the initial superheated Big Bang was like uncovering the "fingerprints" left at a crime scene. Based on this discovery, investigators developed a much fuller theory of the origin of the universe.

COBE was not the first cosmic microwave background satellite— that distinction belongs to the Soviet Union's 1983 RELIKT-1—but it was the most sophisticated of these space probes. Later, NASA's Wilkinson Microwave Anisotropy Probe (WMAP, 2001–10), and the European Space Agency (ESA)'s Planck spacecraft (2009–13), undertook an All-Sky Survey (covering everything viewable from Earth), providing the best data yet on the origins of the universe. Precise measurements of the universe's cosmic microwave background also allowed refined estimates of the size, mass, age, composition, geometry, and even the fate of the universe—whether it will collapse in on itself or expand forever (see page 68).

COBE's principal investigators, the University of California's George F. Smoot III (b. 1945) and NASA's John C. Mather (b. 1946), received the Nobel Prize in Physics in 2006 for their work on

AGING GALAXIES

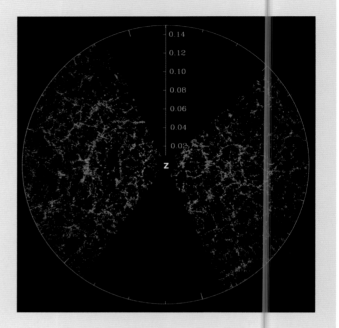

This illustration from the Sloan Digital Sky Survey shows the distribution of galaxies, with Earth at the center. Each colored point represents a galaxy, coded according to the ages of their stars—the redder, more strongly clustered points show galaxies containing older stars, and green are younger. The dark sections could not be mapped due to obscuring dust from our own galaxy. The outer circle is at a distance of 2 billion light-years or a redshift value ("z") of 0.15, shown in the scale here.

OPPOSITE, TOP A composite set of images from three NASA astrophysical observatories shows imagery in the microwave, infrared, and visible light parts of the electromagnetic spectrum. Positioned in the timeline below, they offer a map of the universe over time.

RIGHT This all-sky image was produced by the COBE science team in 1999. It is a low-resolution image of the sky, but obvious cold and hot regions are apparent. The large red band is the microwave emissions from our own galaxy. This image shows a temperature range of ±100 microKelvin.

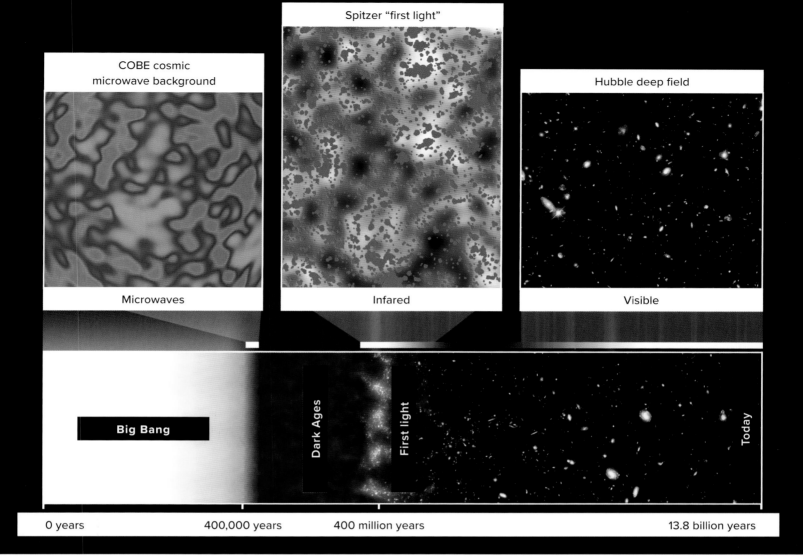

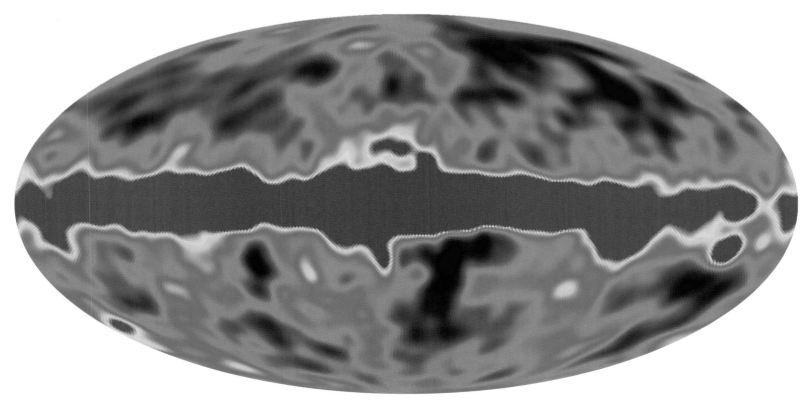

OUR UNIVERSE

this project. As the Nobel Prize committee stated, COBE "can be regarded as the starting point for cosmology as a precision science." Mather coordinated the project and had primary responsibility for COBE's measurements of cosmic background radiation. It was the first time a NASA scientist had received the Nobel Prize. Smoot was responsible for measuring the small variations in the temperature of the radiation.

THE JAMES WEBB SPACE TELESCOPE

One of the newest space observatories, the James Webb Space Telescope (JWST)—named for the NASA administrator between 1961 and 1968—orbits the Sun a million miles (1.6 million kilometers) away from Earth at Lagrange point 2 (L2), where almost no energy is required to maintain its location because gravity from various bodies evens out (see page 135). Explicitly a follow-on to the Hubble Space Telescope (HST), NASA scientists envisioned the JWST as an instrument that could discover the formation of the first galaxies. Its chief scientist, Mather, said of the JWST: "Our resolution is better than Hubble and we will see early galaxies when they were young by using infrared. Also, Hubble can't see the very first galaxies but we will be able to."

The JWST pushed technology farther than any earlier orbital observatory, something that contributed to several delays in deploying the instrument. Its primary mirror—made of eighteen separate segments of ultralightweight beryllium—unfolds

BELOW, LEFT The COBE satellite being prepared for flight at the Goddard Space Flight Center in Greenbelt, Maryland, in 1989.

BELOW ESA's Planck space-based observatory launched from ESA's French Guiana spaceport in May 2009 and operated until 2013 at Lagrange point 2 (L2) of our Earth/Sun system (see page 135), about 930,000 miles (1.5 million kilometers) from Earth. Planck has significantly expanded on what was learned from earlier space telescopes about the Big Bang and the expansion of the universe.

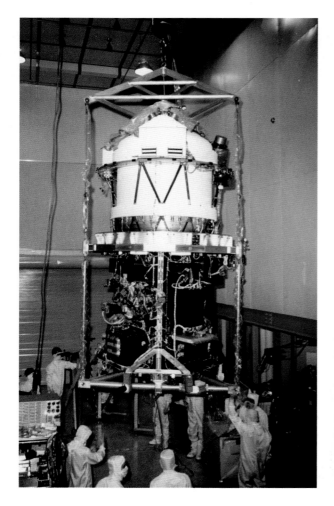
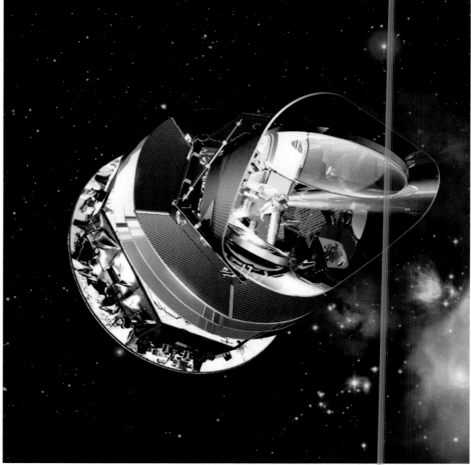

robotically and adjusts as needed once in space. It also has a tennis-court-sized sunshield to keep the telescope operating at optimum efficiency. Although it faced both launch delays and technological challenges throughout the 2010s, NASA launched the JWST on an Arianespace Ariane 5 rocket from French Guiana on December 25, 2021.

The JWST has already yielded data which has transformed our understanding of the universe. The first images were released in 2022 and it has notably discovered the formation of galaxies much closer in time to the Big Bang than ever seen before (see page 54), as well as black holes and other phenomena.

"The James Webb Space Telescope (JWST)—named for the NASA administrator between 1961 and 1968—orbits the Sun a million miles (1.6 million kilometers) away from Earth."

The capabilities of the satellites designed to measure ancient light left over from the Big Bang have evolved over time. The three panels below show a ten-square-degree patch of an all-sky map created by different space-based missions. Planck offered images with more than two and a half times greater resolution than WMAP, revealing the sharpest all-sky map yet made of the universe's cosmic microwave background.

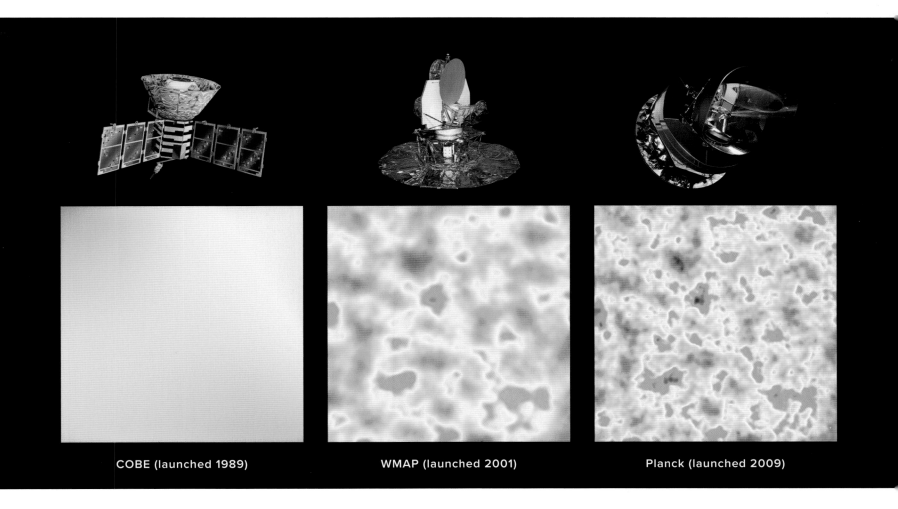

COBE (launched 1989) WMAP (launched 2001) Planck (launched 2009)

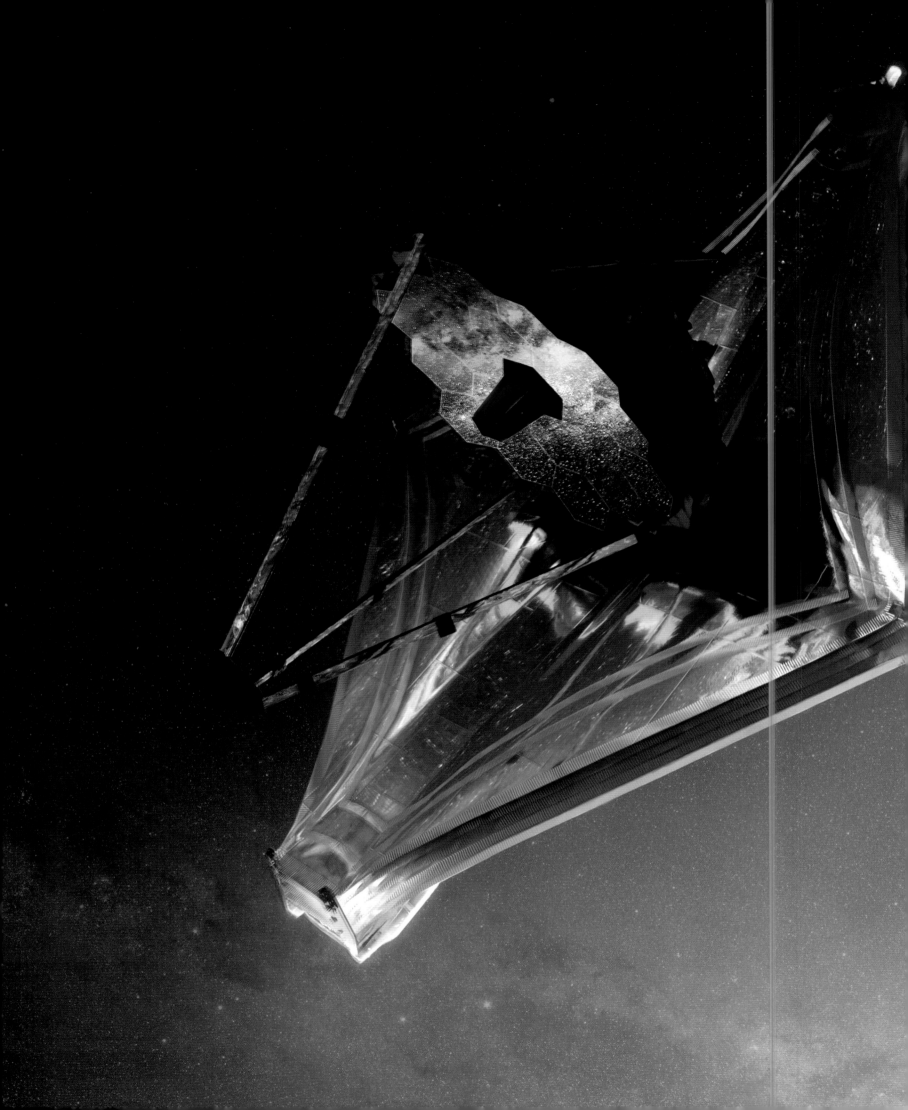

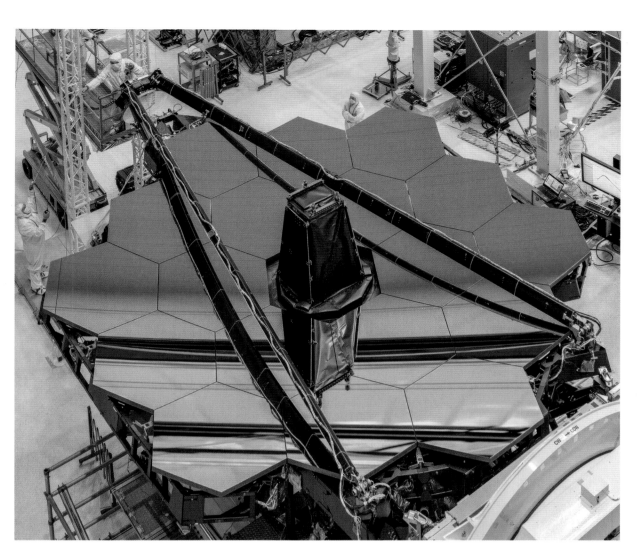

LEFT The JWST's kite-like sunshield protects the instrument, while its mirror captures the distant light of far-away galaxies. The black nose cone in the center of the larger mirror focuses the image and captures the data, and a secondary mirror rests on a long tripod.

ABOVE The revolutionary main mirror assembly for the JWST consists of eighteen hexagonal segments made of beryllium, which unfolded after the telescope was launched.

OUR UNIVERSE

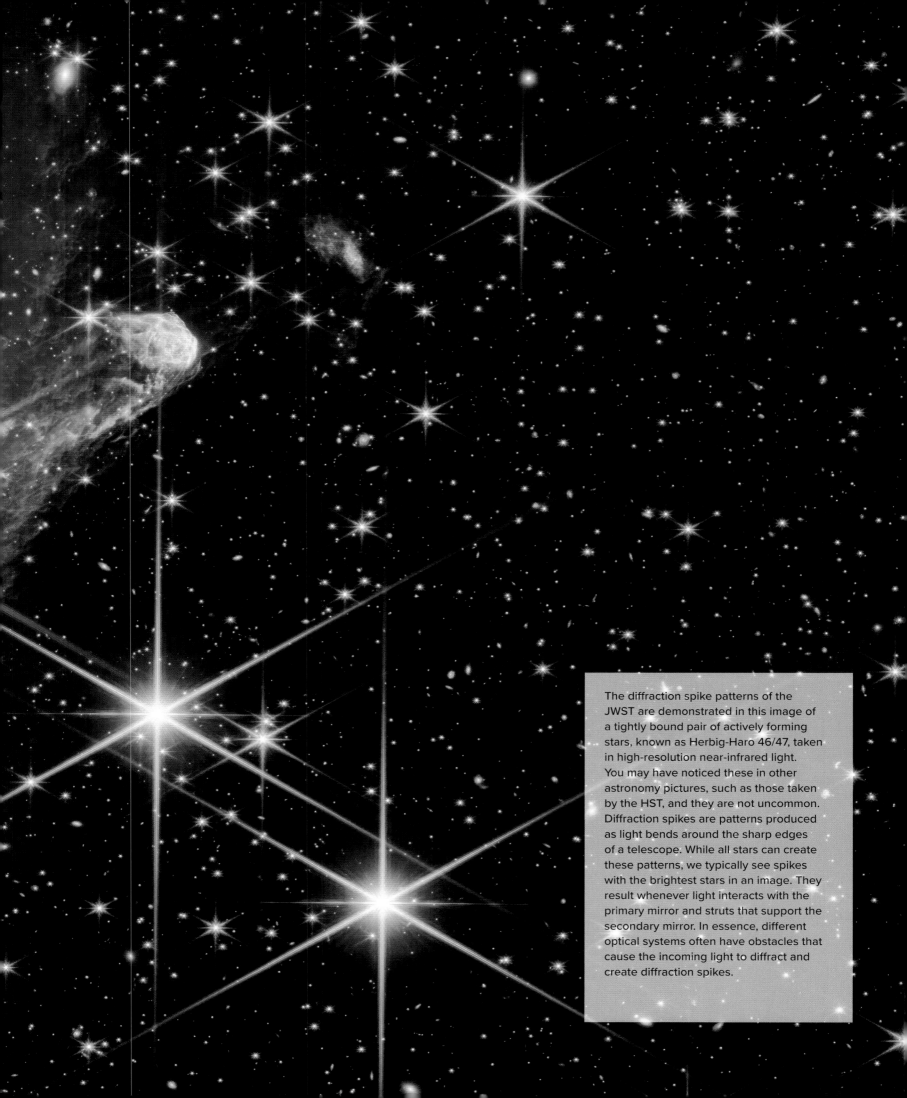

The diffraction spike patterns of the JWST are demonstrated in this image of a tightly bound pair of actively forming stars, known as Herbig-Haro 46/47, taken in high-resolution near-infrared light. You may have noticed these in other astronomy pictures, such as those taken by the HST, and they are not uncommon. Diffraction spikes are patterns produced as light bends around the sharp edges of a telescope. While all stars can create these patterns, we typically see spikes with the brightest stars in an image. They result whenever light interacts with the primary mirror and struts that support the secondary mirror. In essence, different optical systems often have obstacles that cause the incoming light to diffract and create diffraction spikes.

A STELLAR METROPOLIS THAT BEGAN FORMING AFTER THE BIG BANG

The universe, termed a "stellar metropolis" by NASA in 2005, is an immense place. Astrophysicists have recently determined it contains an elegant structure of stars, galaxies, and clusters that formed far earlier than previously believed.

Scientists reached this conclusion using observations from the European Space Agency (ESA)'s XMM-Newton space-based observatory and the European Southern Observatory's Very Large Telescope (ESO VLT) in Chile. Observing clumps of matter spread unevenly, Dr. Christopher Mullis of the University of Michigan commented in 2005, "We see an entire network of stars and galaxies in place at just a few billion years after the Big Bang, like a kingdom popping up overnight on Earth."

Located some 9 billion light-years from Earth, about 5 trillion miles (9.5 trillion kilometers) away, the light from the cluster Mullis and his team found in 2005 was so remote that it took 9 billion years to reach us. As the universe is 13.78 billion years old, this means that the cluster was creating galaxies only some 4 billion years after the Big Bang. In the words of Dr. Piero Rosati at ESO headquarters in Garching, Germany, "the universe grew up fast." Previously, scientists had believed that galaxies did not emerge until much later after the Big Bang.

Since 2005, astrophysicists have learned much more about early galaxy formation. From 2022, scientists using the James Webb Space Telescope (JWST) began searching for even more distant clusters of proto-galaxies and found them in abundance. They discovered galaxies formed up to 13 billion years ago, each showing a remarkable diversity of shapes. Analyzing some 850 galaxies, researchers were able to characterize them by shape: disks (like our own spiral galaxy), clumps, and irregulars.

Through repeated measurements and increasingly sophisticated observation methods, galaxies like the Milky Way were revealed to have formed within a billion years of the Big Bang, altering decades of earlier thought on galaxy formation. As astronomer Haojing Yan said in January 2023, "Our previously favored picture of galaxy formation in the early universe must be revised." Are there other galaxy clusters even farther beyond those recently spotted by the JWST in this "stellar metropolis?" Probably, and new ones that formed even earlier are being discovered by the JWST. This offers more clues about the shape, size, and extent of the universe.

HENRIETTA SWAN LEAVITT (1868–1921)

American astronomer Henrietta Swan Leavitt made significant measurements of the vast distances between various bodies in the cosmos, now known to be remote galaxies. She discovered the regularly changing luminosity of Cepheid stars, which played a crucial role in the work of Edwin Hubble on the expanding universe (see page 32).

Despite being a woman and deaf, Leavitt undertook a career at Harvard from 1893 as a "computer," making calculations supporting the work of professional astronomers. Over time she emerged as an astronomer in her own right and led the observatory's stellar photometry organization. In the twenty-first century, Leavitt became a popular culture sensation when Joyce Van Dyke wrote "The Women who Mapped the Stars," a play telling the story of Leavitt and her colleagues at the Harvard Observatory. It dramatized well the struggles of women working in a male-dominated discipline, as they experienced the adventure of discovery, the desire for recognition, and the yearning to open doors for those who came thereafter.

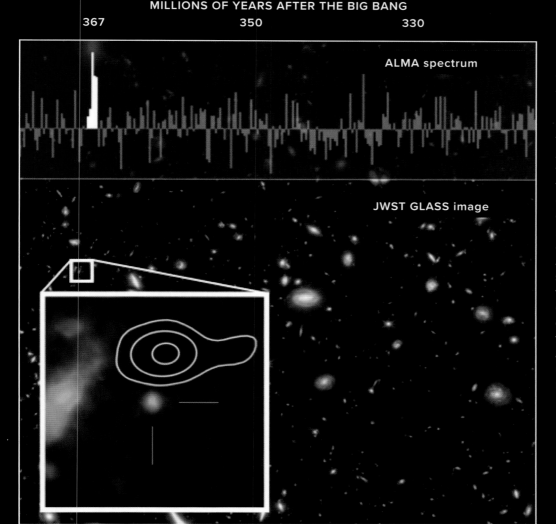

LEFT GHZ2/GLASS-z12 is an exceptionally distant galaxy that emerged very soon after the Big Bang. Indeed, it has been in existence for 97 percent of the 13.8 billion years of the universe. Located behind massive clusters of closer galaxies, it took scientists using both the Atacama Large Millimeter/submillimeter Array (ALMA) of radio telescopes in Chile and the JWST to determine its age. The data from the ALMA radio antennae (*top*) revealed an oxygen emission—the bright line on the left of the data schematic—close to the galaxy's position, beginning about 367 million years after the Big Bang. When matched with the JWST imagery (*bottom*), scientists realized the spectral data showed that ionized oxygen near the galaxy had shifted due to the expansion of the universe. The tiny box on the left side of the JWST image enabled a joint science team at Nagoya University and the National Astronomical Observatory of Japan to measure the cosmic age of this distant galaxy, publishing results in January 2023.

RIGHT This 2005 schematic diagram shows the distribution of galaxy clusters formed 9 billion years ago. Earth is located at the bottom point, with the top of the cone becoming increasingly distant, and capturing light from earlier in the history of the universe. Distance (redshift) is marked on the right axis, and the corresponding cosmic time back to the Big Bang is indicated on the left axis. The 2005 newly discovered cluster at redshift 1.4 (labeled "XMMU J2235") was a major finding well beyond the observation of previous studies (labeled "ROSAT Horizon"). With data gathered since the 2022 launch of the JWST, this diagram, though it has not yet been updated, could be pushed back to more than 13 billion years.

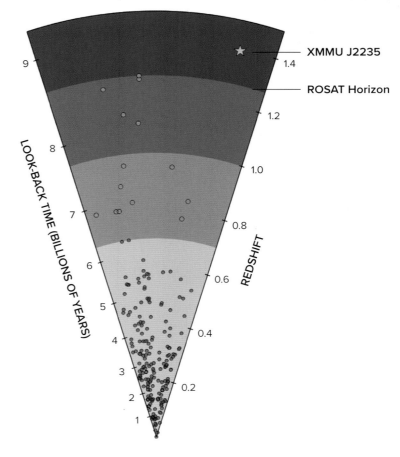

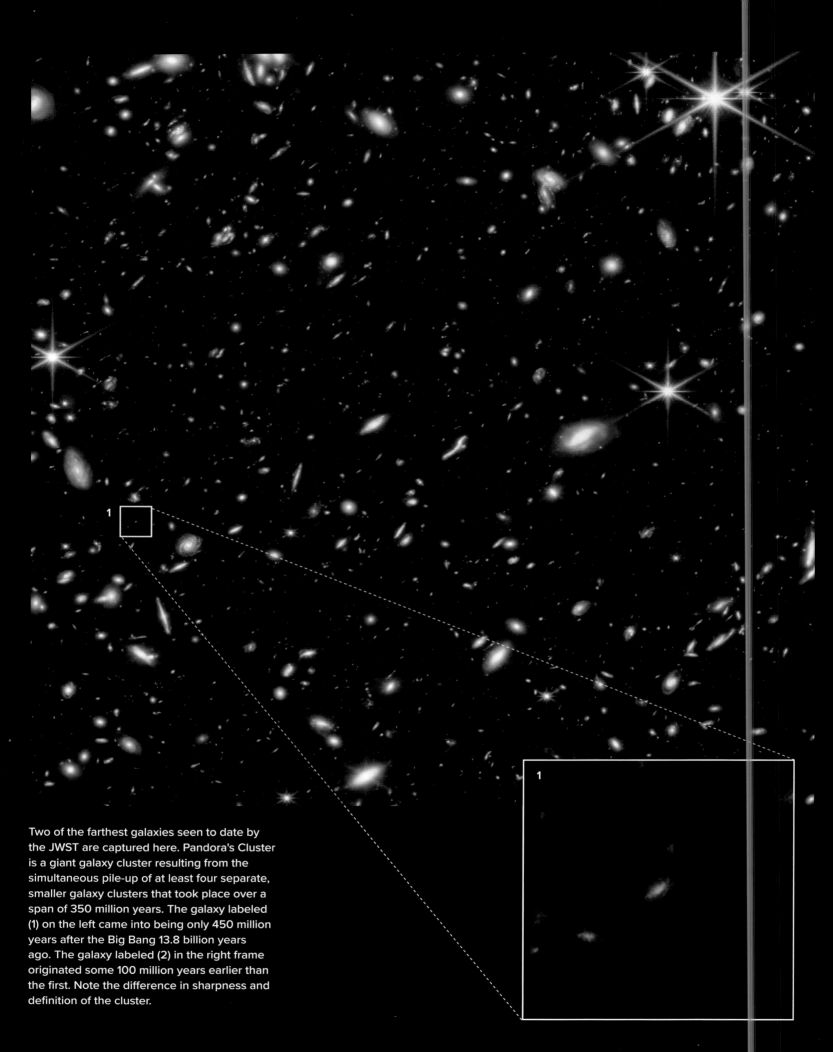

Two of the farthest galaxies seen to date by the JWST are captured here. Pandora's Cluster is a giant galaxy cluster resulting from the simultaneous pile-up of at least four separate, smaller galaxy clusters that took place over a span of 350 million years. The galaxy labeled (1) on the left came into being only 450 million years after the Big Bang 13.8 billion years ago. The galaxy labeled (2) in the right frame originated some 100 million years earlier than the first. Note the difference in sharpness and definition of the cluster.

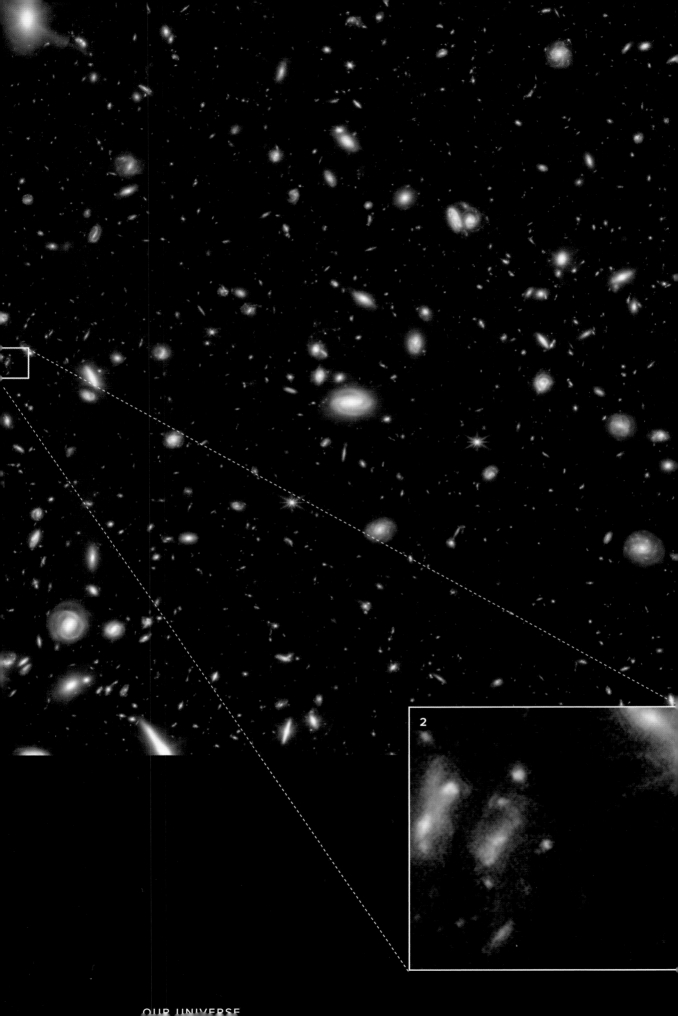

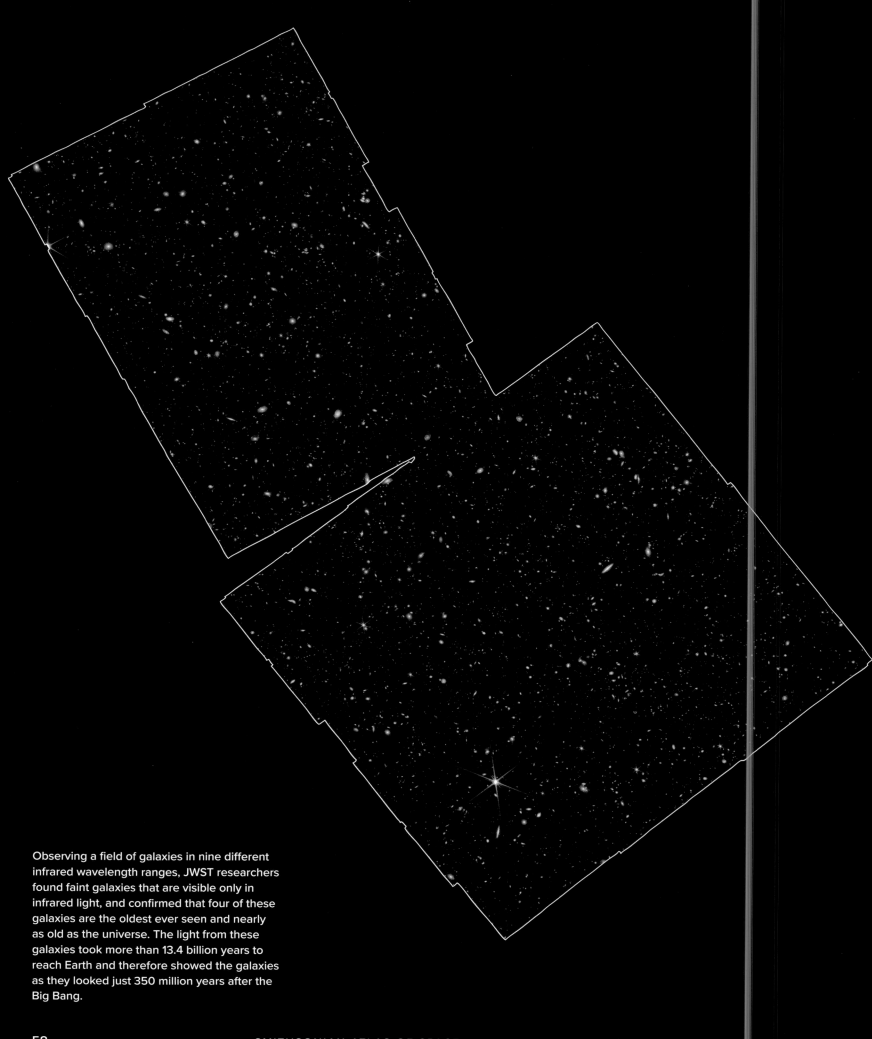

Observing a field of galaxies in nine different infrared wavelength ranges, JWST researchers found faint galaxies that are visible only in infrared light, and confirmed that four of these galaxies are the oldest ever seen and nearly as old as the universe. The light from these galaxies took more than 13.4 billion years to reach Earth and therefore showed the galaxies as they looked just 350 million years after the Big Bang.

The ESA's XMM-Newton Space Observatory's wide Earth orbit takes the spacecraft more than halfway to the Moon and back. The XMM-Newton was launched in 1999, but is still operational. Its specific areas of investigation include black holes, the life and death of supernovae, the gaseous space between galaxies in the universe, and, most importantly, the origin and evolution of the universe.

"From 2022, scientists using the James Webb Space Telescope (JWST) began searching for even more distant clusters of proto-galaxies and found them in abundance. They discovered galaxies formed up to 13 billion years ago, each showing a remarkable diversity of shapes."

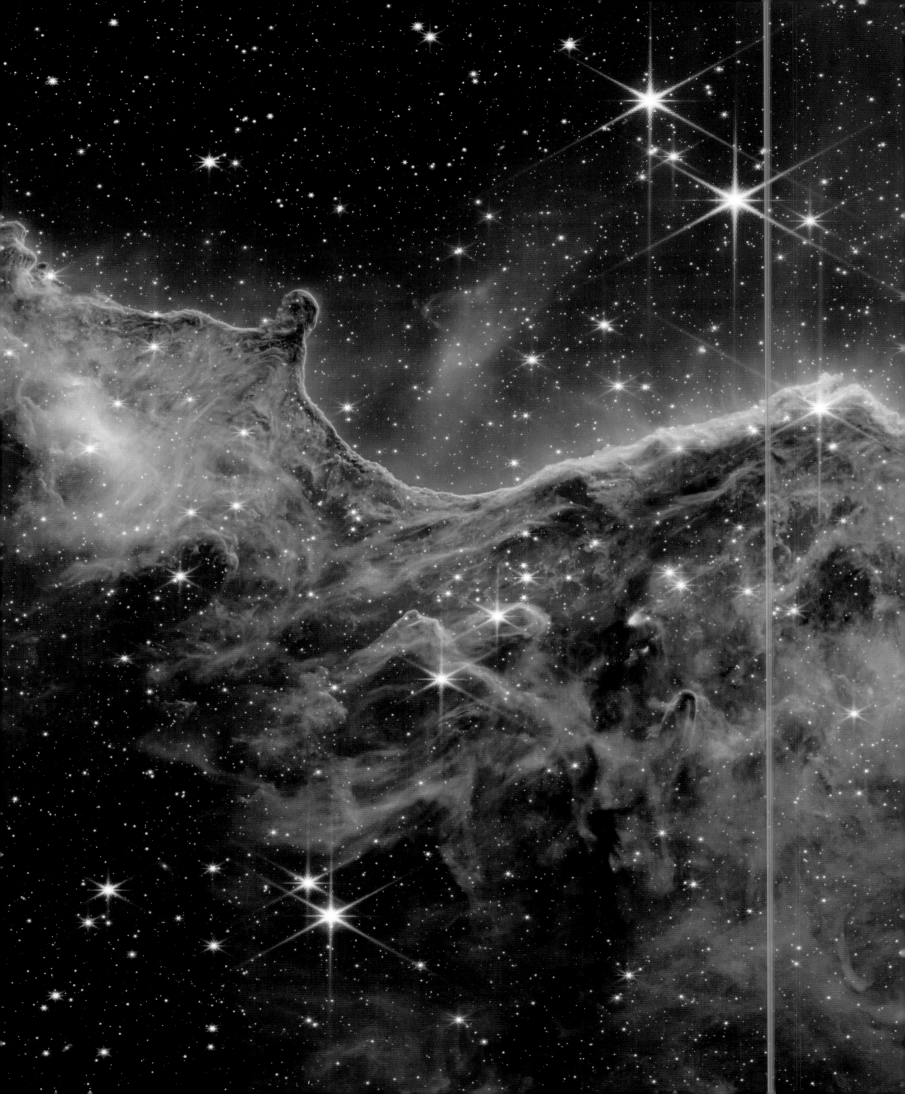

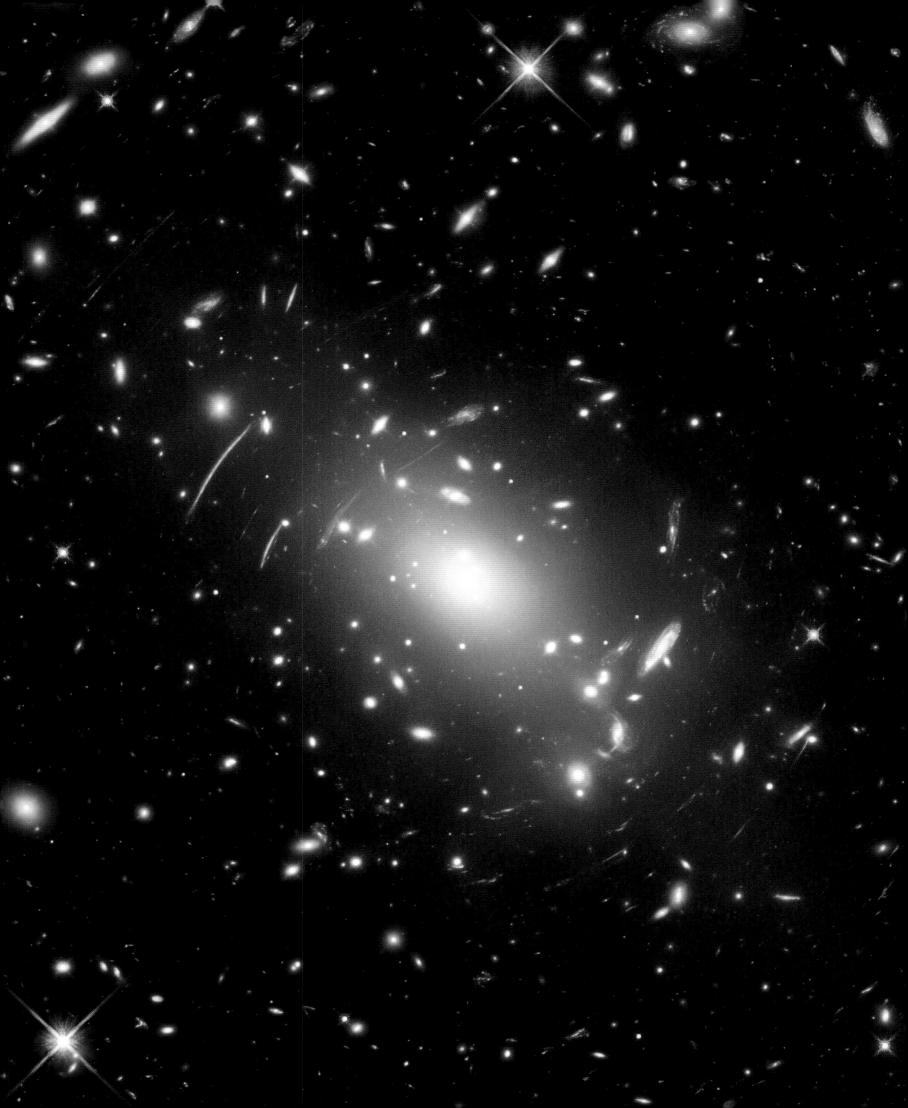

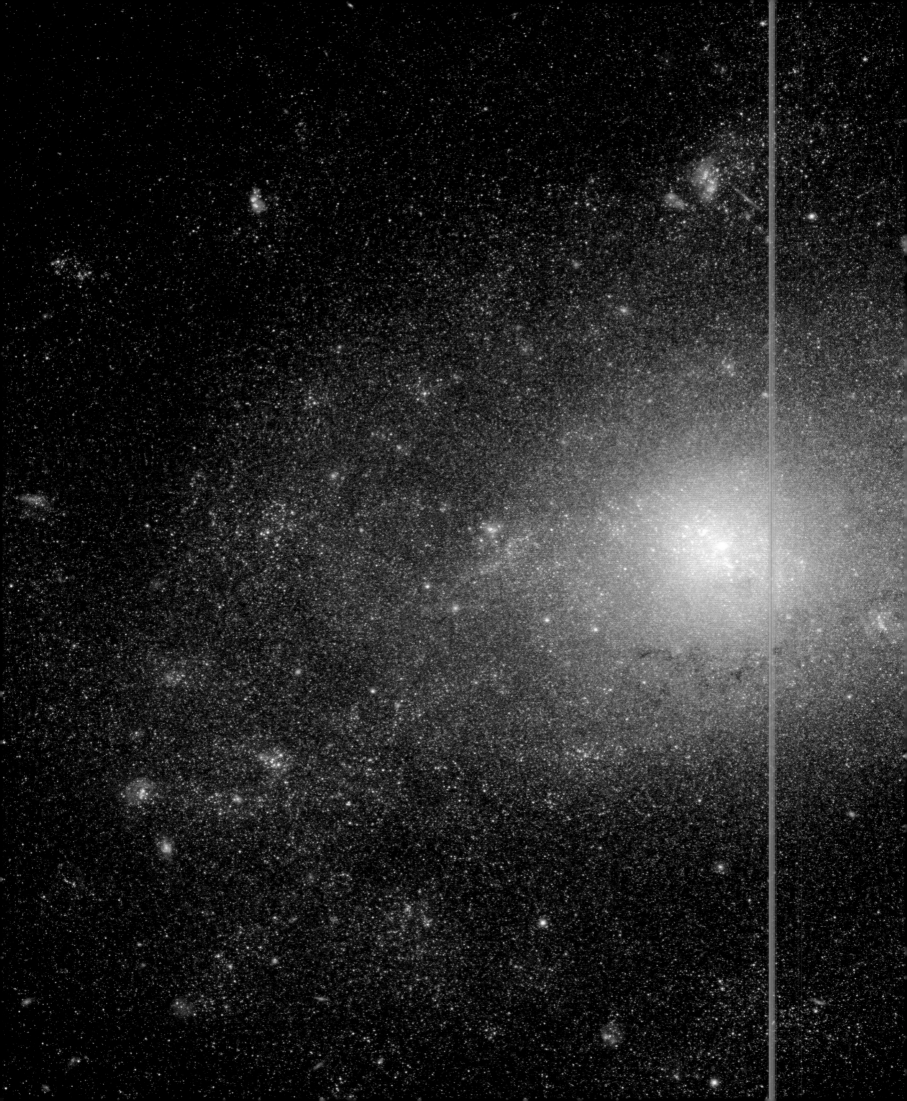

"The impact of the Hubble Space Telescope (HST) has been remarkable—observations over a thirty-year period have measured the expansion of the universe and offered a compelling explanation of the role of dark energy in the process."

The NGC 5585 spiral galaxy resides on the tail of the constellation Ursa Major. This image from the HST, released on September 21, 2020, provides evidence of abundant dark matter since the stars, dust clouds, gas, and other material contribute only a tiny fraction of the matter holding this galaxy cluster together. This is indirect evidence of dark matter at best, but there is a consensus among scientists that dark matter may well be the dominant "stuff of the universe."

THE END OF THE UNIVERSE

Is the universe going to end? It depends on who you ask, but most astronomers subscribe to at least one of several possibilities for its demise. The three most significant are what scientists refer to as the Big Freeze, the Big Crunch, and the Big Rip.

Propelled by the force of the Big Bang and the seemingly accelerating speeds generated by dark energy, some scientists theorize that the universe will expand indefinitely with a "Big Freeze" as temperatures reach the coldest possible. In this ending for the universe, its matter—and its gravitational pull—will be insufficient to counteract the expansion. Eventually, particles will drift into infinity, losing all energy to recombine into different types of material. This forever expansion may drop in terms of velocity over the eons but will never stop, and the universe will eventually become a form of nothingness.

The "Big Crunch" posits the opposite situation: there is enough gravity and matter in the universe to slow, eventually, the expansion begun by the Big Bang, and then to begin a contraction to a point at which all of the matter contained in the universe reaches another singularity, whereupon the whole process may begin again. The mystery of dark energy that seems to be accelerating expansion since the Big Bang leaves many scientists wondering how this notion of an oscillating universe might unfold.

Finally, the "Big Rip" theory assigns a more significant role to dark energy in the demise of the universe. It could pull the universe apart more quickly and violently as time passes, counteracting the effects of gravity and tearing apart the very fabric of the universe. In this scenario, galaxies are ripped apart, as are black holes, stars, and planets such as our own. This might take many forms; no one knows for sure.

Other theories are also being proposed, studied, and debated— sometimes adopted but also rejected as scientists learn more. There may even be multiple universes—alternative multiverses or mini-universes with differing laws of physics that could split off from our own. At present the answer to the end of the universe is unknown. It will at some point become knowable, if only because it begins to happen.

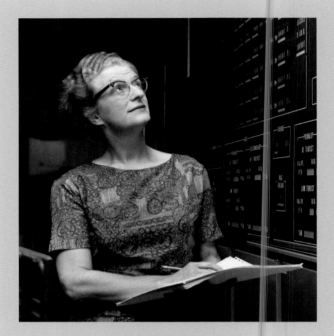

NANCY GRACE ROMAN (1925–2018)

Affectionately known as the "mother" of the Hubble Space Telescope (HST), Nancy Grace Roman earned a PhD in astronomy at the University of Chicago before working as an astronomer at the Yerkes Observatory. She loved her work, but deplored that there were no other women at her institution with tenure in astronomy, despite their many years of experience. Believing that her career would be stifled in academia, Roman took a position in radio astronomy at the Naval Research Laboratory.

In 1960 she joined NASA as its Chief of Astronomy and Relativity, and spent considerable time building support for space-based astronomy. When pitching the HST to members of Congress, she stated: "For the price of one night at the movies each year, each American would receive fifteen years of exciting discoveries." An underestimation, as the telescope has been delivering stunning science for more than thirty years.

After her passing, NASA named its next major space telescope project for the pioneering astronomer. The Nancy Grace Roman Space Telescope will launch in 2027 and explore dark energy, exoplanets, and infrared astrophysics.

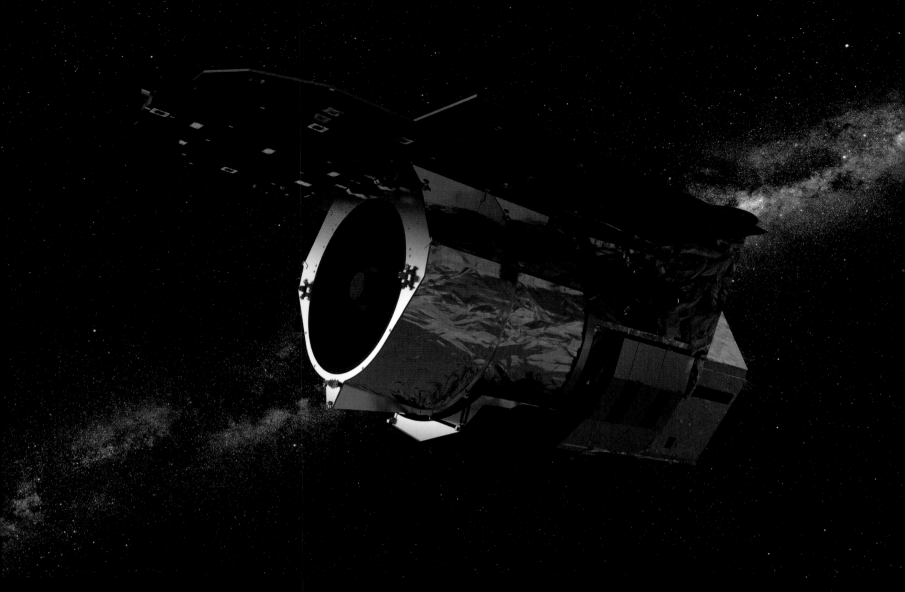

The Nancy Grace Roman Space Telescope may help solve the question of the fate of the universe. NASA developed the Wide Field Infrared Survey Telescope (WFIRST) to explore the nature of "dark energy," a critical element in the mystery of the end of the universe. Renamed the Nancy Grace Roman Space Telescope on May 20, 2020, this space-based observatory will map how matter is distributed in the universe, the forces acting upon it, and the place of black holes and supernovae in affecting the fate of the cosmos. Most importantly, it is intended to measure change over time of forces acting on the matter of the universe, including dark matter and dark energy.

"Propelled by the force of the Big Bang and the seemingly accelerating speeds generated by dark energy, some scientists theorize that the universe will expand indefinitely with a 'Big Freeze' as temperatures reach the coldest possible."

EXPANSION

Scientists have theorized three potential fates for the universe. Unstable dark energy could cause a "Big Rip," pulling things apart as the universe expands, destroying galaxies, stars, planets, and atoms. A "Big Crunch" might come as the expansion of the universe eventually slows, stops, and begins to contract. It would end in an implosion and compression. The third option most scientists discuss, the "Big Freeze," is one in which the universe endlessly expands, eventually cooling and becoming nothingness.

BIG RIP

BIG CRUNCH

Big Bang

Present

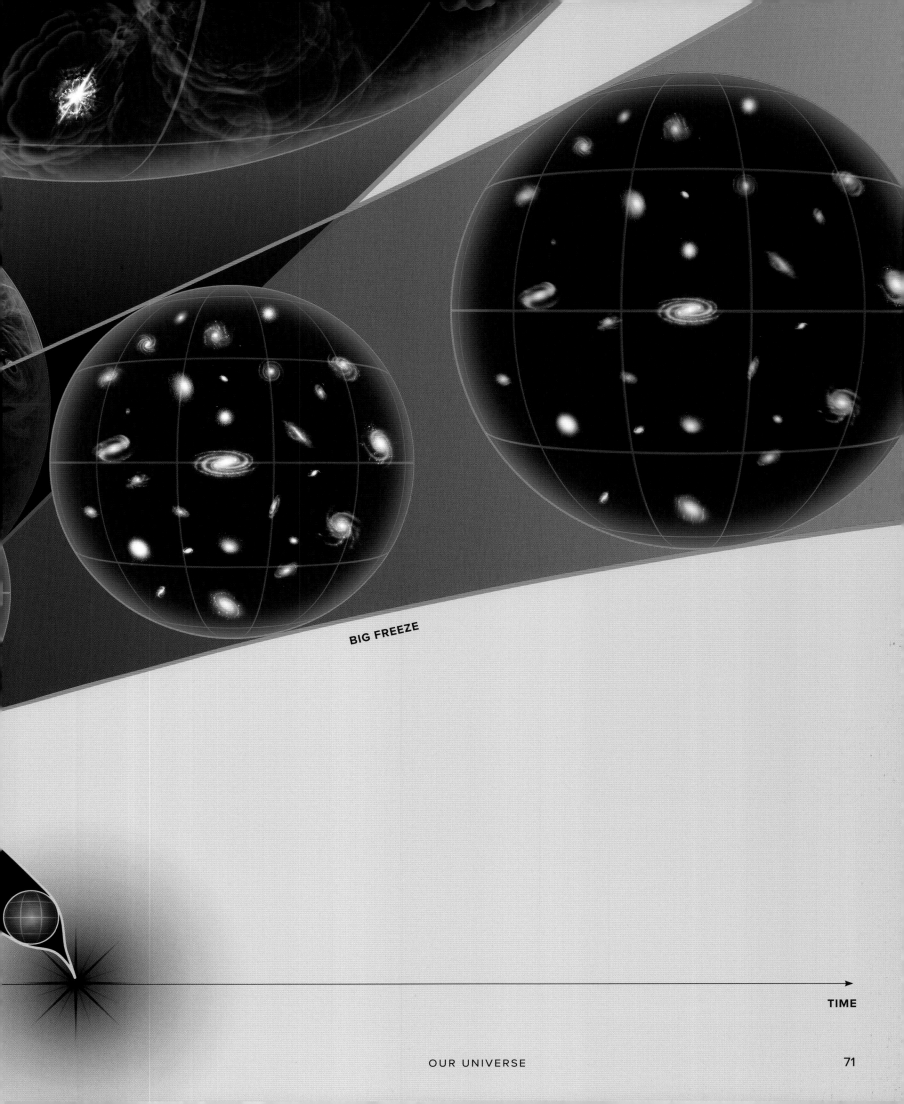

BIG FREEZE

TIME

OUR UNIVERSE

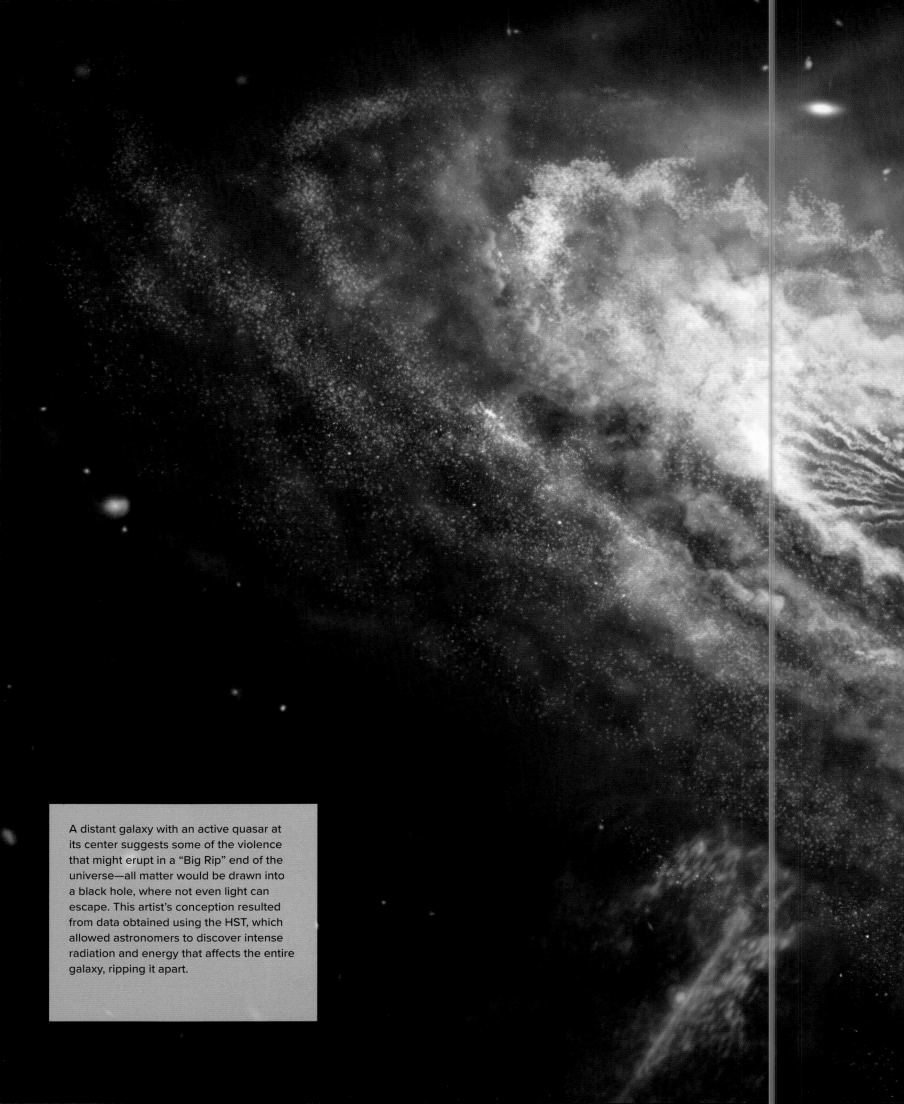

A distant galaxy with an active quasar at its center suggests some of the violence that might erupt in a "Big Rip" end of the universe—all matter would be drawn into a black hole, where not even light can escape. This artist's conception resulted from data obtained using the HST, which allowed astronomers to discover intense radiation and energy that affects the entire galaxy, ripping it apart.

2 GALAXIES AND STAR SYSTEMS

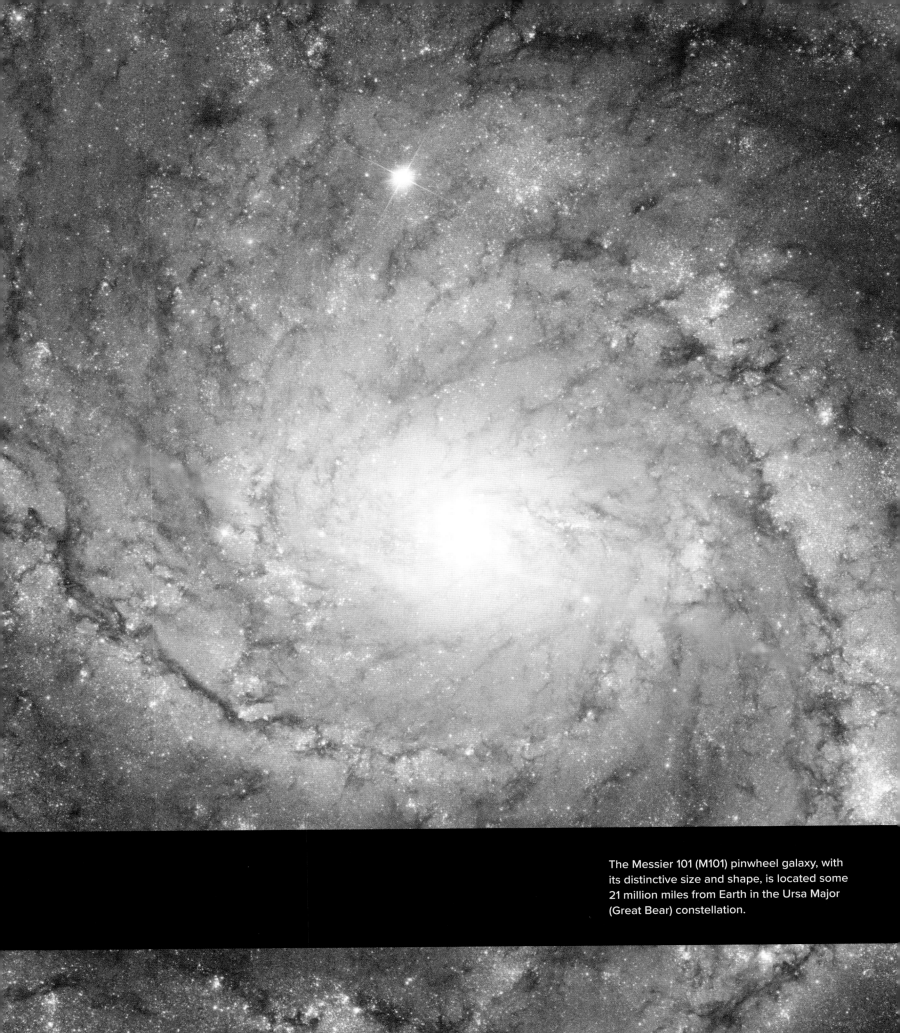

The Messier 101 (M101) pinwheel galaxy, with its distinctive size and shape, is located some 21 million miles from Earth in the Ursa Major (Great Bear) constellation.

It wasn't until the first part of the twentieth century that scientists realized that what we refer to as galaxies are actually outside of our own Milky Way. It proved to be a truly significant discovery. Since then, we have learned that the galaxies in our universe are collections of matter held together by gravity and apparently repelled by dark energy (see page 62), prompting the expansion of the universe. There are myriad types of galaxies, their appearance and composition different depending on their origins and evolution over billions of years.

Most scientists accept that galaxies began as clouds of dust which became stars, eventually forming into galaxies locked together by the force of gravity. The largest galaxies include millions of stars and may extend for more than a million light-years. The smallest are still massive, but may include only a few thousand stars in a tight gravitational field just a few hundred light-years in width. Most galaxies also contain supersized black holes deep in their centers, swallowing up matter with intense gravitational fields (see page 112).

Galaxies like our own Milky Way expel matter from their interior to the outer edge of their gravitational field, creating massive spiral arms filled with colonies of stars. Our own solar system is in one of these arms on the outskirts of the Milky Way, a galaxy spanning some 100,000 light-years. Closer to the center of this galaxy, stronger gravitational forces are in action. We exist in a special place in the Milky Way, one that is calm and sedate, though everything, of course, is in constant motion. For example, our solar system requires about 240 million years to orbit once around the Milky Way.

While the Milky Way is unique, at least to us, it resides in a neighborhood with more than fifty other galaxies, ranging in size and type but all moving about in response to gravity and dark energy. Our closest neighbor is the Andromeda galaxy, for many years thought to be a nebula in the Milky Way. It took Edwin Hubble and others in the 1920s to determine with surety that it was a separate and distinct entity, sparking a whole new realm of investigation and understanding in the one hundred years since.

RIGHT In a view of the Milky Way galaxy from above, the Milky Way's two major arms, Scutum-Centaurus and Perseus, appear to be attached to a thick, elongated middle fulcrum. Two other arms, Norma and Sagittarius, are also visible, but are certainly less distinct. Degree lines and light-year distance measurements give a sense of proportion for the Milky Way. Our own solar system is located between two minor Sagittarius and Perseus arms, with the Sun depicted just below the Milky Way's center.

"Galaxies like our own Milky Way expel matter from their interior to the outer edge of their gravitational field, creating massive spiral arms filled with colonies of stars."

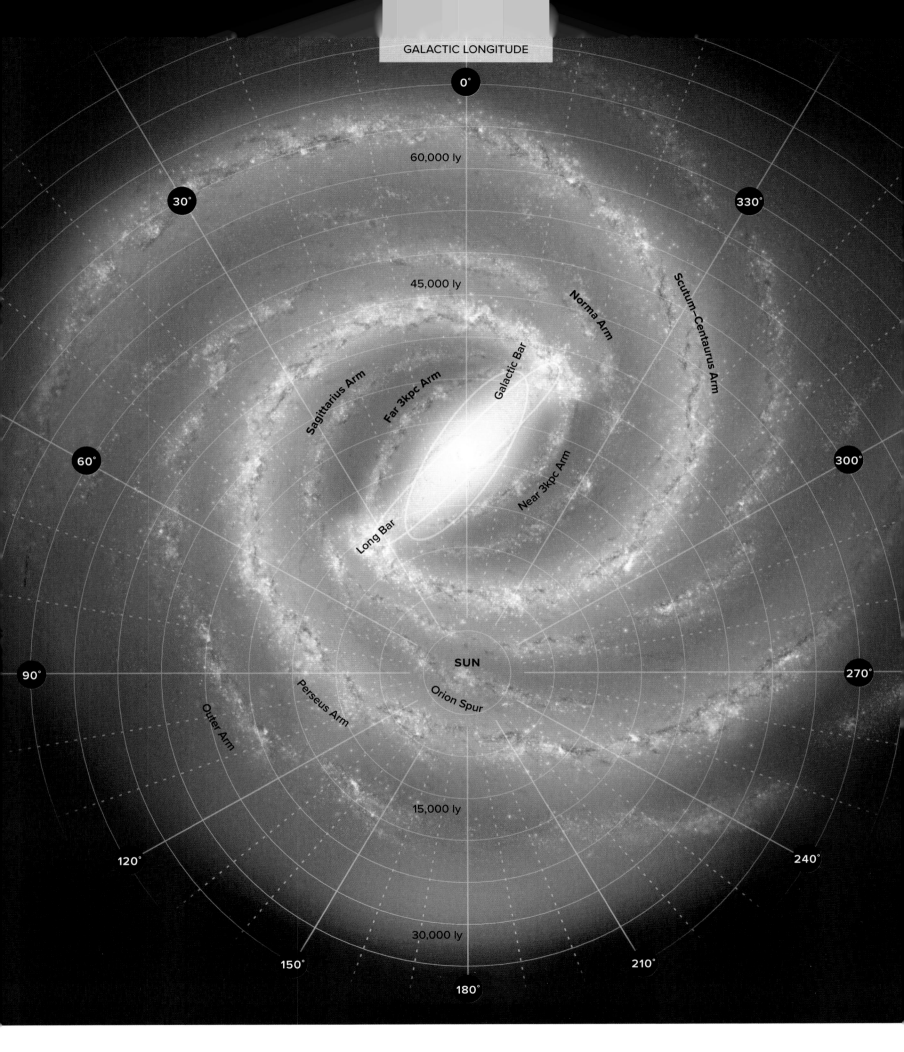

GALAXIES AND STAR SYSTEMS

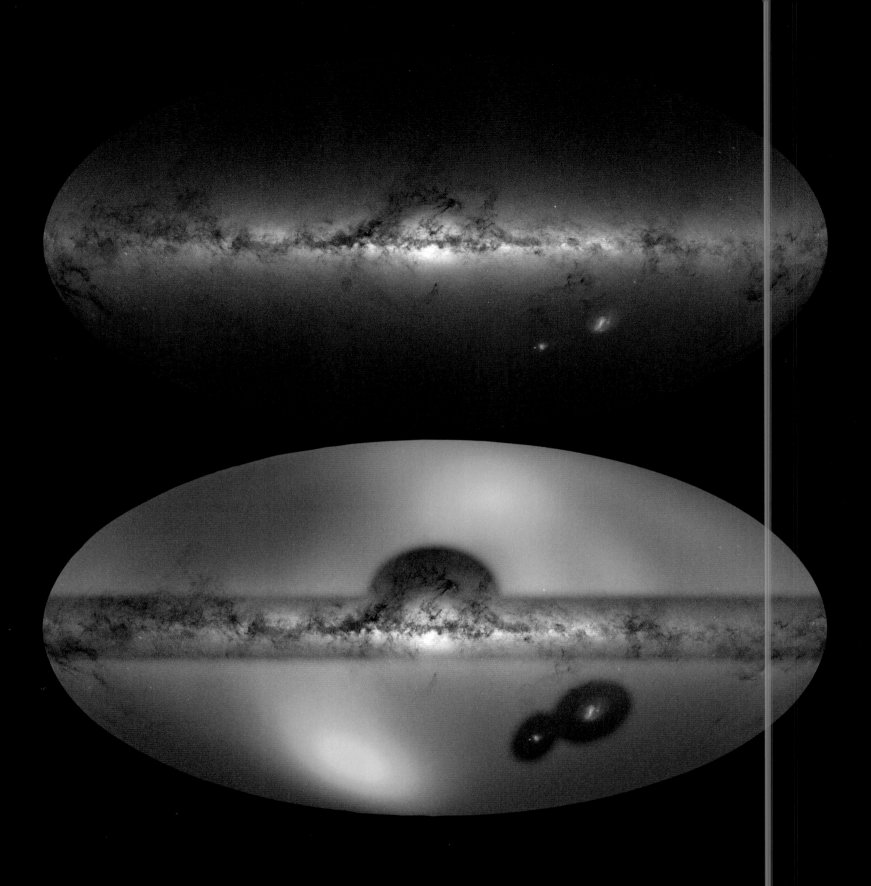

TOP Made up of many individual images taken by the Gaia space observatory, this striking side view of the Milky Way galaxy was released by the European Space Agency (ESA) in 2019.

ABOVE The Milky Way and the Large Magellanic Cloud (LMC) (a satellite galaxy that orbits the larger Milky Way) are overlaid on a map of the surrounding area, spanning 200,000–325,000 light-years from the Milky Way's center. Made up of many individual images taken by the Gaia space observatory, the darker blue areas represent a low concentration of stars, with stars becoming more numerous and brighter in the lighter blue areas. Scientists have discovered that the LMC's gravity has pulled our galaxy's disk significantly off-center, creating a galactic halo surrounding the disk, shown at the top center of the image. The dark circles at the bottom of the image also suggest that parts of the Milky Way are splitting away, changing the structure of the galaxy over the eons.

RIGHT Sometimes called the "Halloween face" photograph, two colliding galaxies in the dual-galaxy system Arp-Madore 2026-424 (AM 2026-424) are captured by the Hubble Space Telescope (HST) in the process of destroying each other. Galaxy collisions are not uncommon, but this one shows a ring around both systems and the stretching of gas, dust, stars, and probably planets crashing into each other.

BELOW This composite image of the Andromeda galaxy, or M31, released on June 16, 2002, combines data from the ESA's Herschel mission, the Planck observatory, and two NASA missions. The red hues indicate the presence of hydrogen gas; the green color indicates intensely cold dust; and warmer dust is shown in blue. Collectively, this composite presents Andromeda's galactic dust as much more refined than previously understood.

GALAXIES AND STAR SYSTEMS

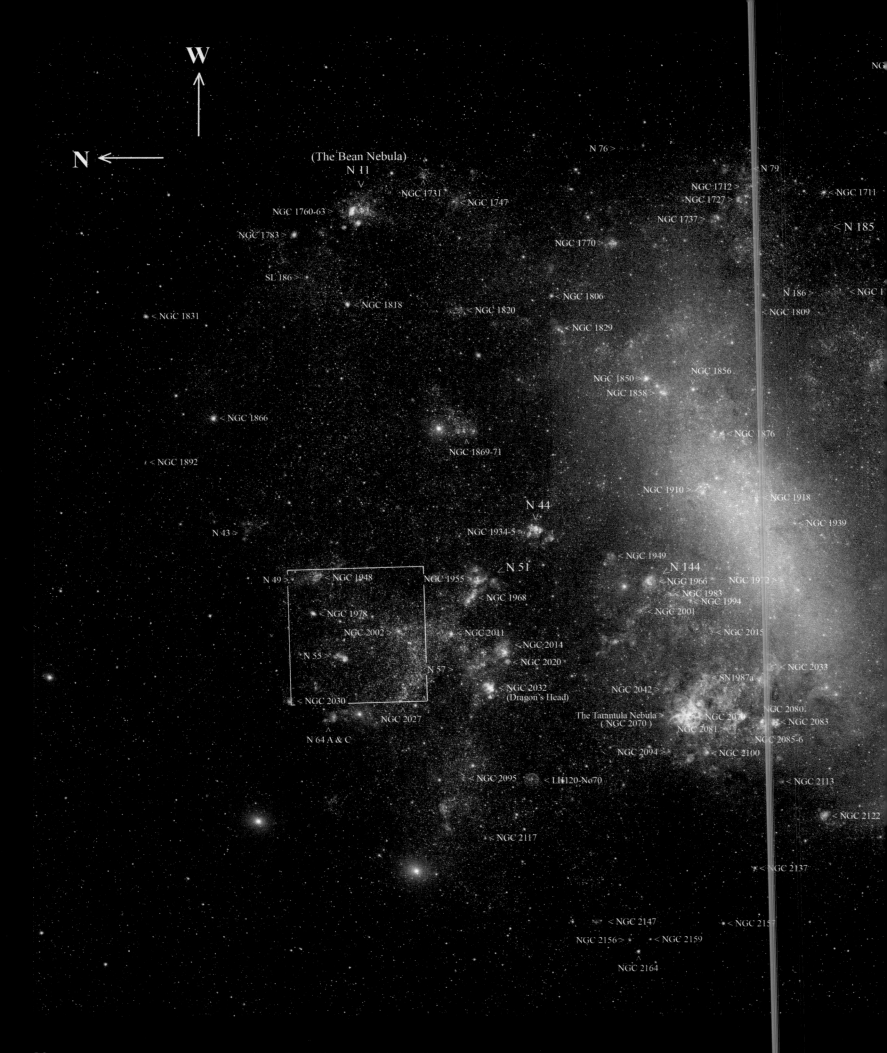

"Most scientists accept that galaxies began as clouds of dust which became stars, eventually forming into galaxies locked together by the force of gravity. The largest galaxies include millions of stars and may extend for more than a million light-years. The smallest are still massive, but may include only a few thousand stars in a tight gravitational field just a few hundred light-years in width."

The brightest objects of the LMC are marked with their astronomical designations, and the field of the MPG/ESO 7¼-foot (2.2-meter) telescope used to take these images is indicated by the white outline. The LMC has long fascinated astronomers because of its acute visibility from Earth. Not until the twentieth century, however, did scientists realize it was a dwarf irregular galaxy located on the border between the constellations Dorado and Mensa. It may well have spun off from a part of the Milky Way galaxy, and is now a part of about thirty galaxies in the vicinity that are loosely bound together by their gravitational pull.

GALAXIES AND STAR SYSTEMS

GALAXIES BY THE TRILLIONS?

Estimated at around 200 billion at the start of the Space Age, scientists now generally believe that there are as many as 2 trillion galaxies beyond our own. That is quite a change since the time of Edwin Hubble, when scientists were unsure whether the objects they were seeing from ground-based telescopes were part of the Milky Way or something else.

Based on observations from ever more sophisticated and capable telescopes, both Earth and space-based, scientists now believe there to be trillions of individual galaxies. The 2 trillion estimate may increase as newer technologies such as the James Webb Space Telescope (JWST) enhance observing capacity. Of course, some astronomers are more conservative in counting galaxies. Astrophysicist Mario Livio, of the Space Telescope Science Institute in Baltimore, Maryland, thinks that a more acceptable estimate could go as high as 200 billion. No one knows for sure. What is clear is that newly discovered galaxies are regularly added to the compendium. In 1995, for example, astronomers discovered an estimated 3,000 faint galaxies in a single frame of a delayed exposure of a part of Ursa Major previously thought devoid of galaxies. In 2020, using new instruments, an international team of astronomers analyzed data that found eight galaxy clusters in an area of space where none had previously been detected.

Our Milky Way is on a collision course with the nearest galaxy to it, the Andromeda galaxy. Astronomers estimate that they will collide about 4 billion years in the future. At that time those galaxies as we know them will cease to exist and our corner of the universe will change forever. Of course, humans will not be here to experience this. Our Sun will have already become a red giant by then, engulfing the whole of the solar system. In order to survive, humans had best be elsewhere.

A collision of the Milky Way with the Andromeda galaxy may occur some 4 billion years in the future. Here, NASA shows the night sky as it would appear as gravity draws the two galaxies together. Andromeda (*left*) fills the field of view, distorting the Milky Way galaxy (*right*) with its gravitational pull.

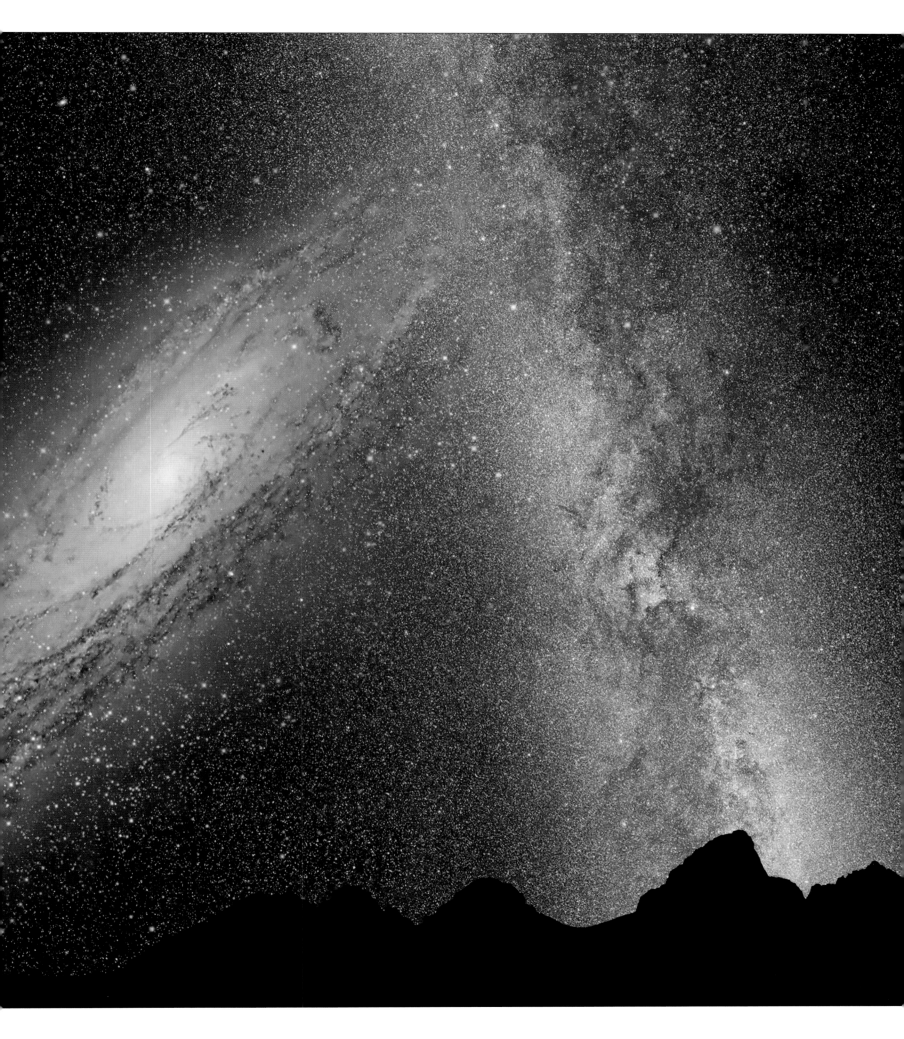

GALAXIES AND STAR SYSTEMS

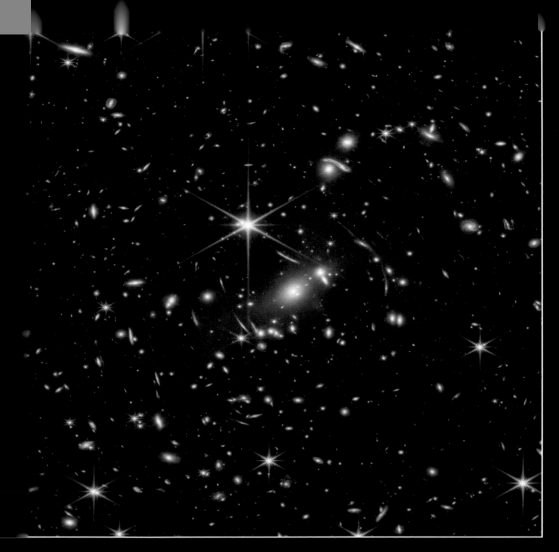

LEFT Galaxy cluster SMACS 0723, by the JWST, is teeming with thousands of galaxies unseen before the 2020s; in this infrared image are some of the objects ever observed.

RIGHT The JWST's results are breaking. Due to gravitational lensing, which when sufficient gravity bends light traveling past or through it (see p. below), this single JWST image, released in 2023, shows three different lensed images of the galaxy cluster RX J2129, located in the constellation Aquarius about 3.2 billion years from Earth. The images are not equal in size, position, or age. The light with the longest path offers the oldest image of the galaxy (2), in which the supernova is visible (the intensely bright light at top center). The next image of the galaxy shows it as it was roughly 320 days later than the first image, and the last image some 1,000 days after the first (1). In both of the later versions the supernova has faded from view.

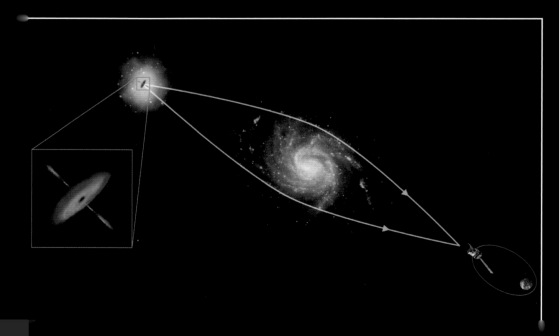

LEFT Gravitational lensing allows us to use the gravity of a galaxy to magnify galaxies farther away. Predicted by the general theory of relativity, light following the curvature of space-time is bent. As a result, light from an object on the other side of a galaxy or cluster of objects will bend toward an observer. The simplest type of gravitational lensing is depicted here. A single concentration of matter at the center, in this case the core of a galaxy, disturbs the light from a galaxy (left) and redirects it around it, enabling the imaging of a background galaxy (in this case by the spacecraft [right], with the Earth in proximity). When the lensing approaches perfect symmetry, a complete or almost-complete circle of light called an Einstein ring results.

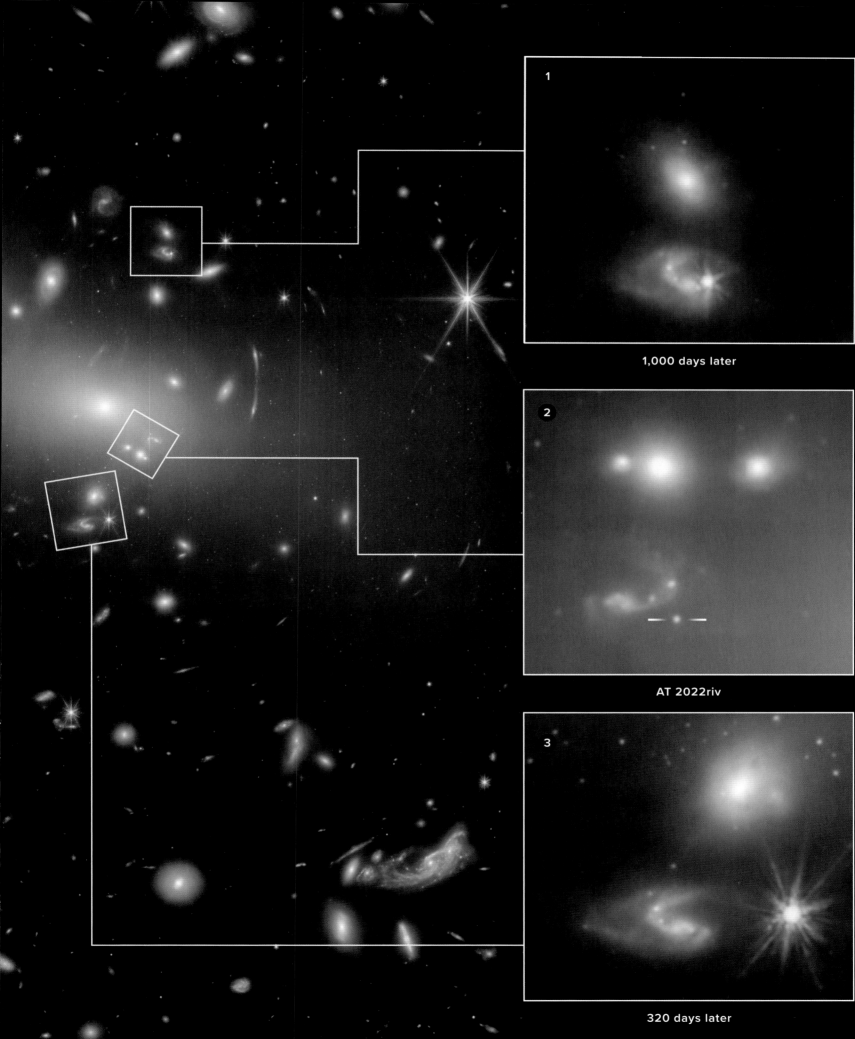

1,000 days later

AT 2022riv

320 days later

TYPES OF GALAXIES

Scientists have categorized four types of galaxies in the universe: spiral, barred spiral, elliptical, and irregular.

The most common type in the universe, **spiral** galaxies are twisted collections of stars and gas.

Simply put, a **barred spiral** galaxy has large bars emanating from its center along with the spiral star patterns common in spiral galaxies.

An **elliptical** galaxy has a generally ellipsoidal shape and largely reveals a smooth, featureless image.

An **irregular** galaxy is just what the name implies: a galaxy that does not have a distinct regular shape, unlike a spiral or an elliptical galaxy.

The Messier 101 (M101) spiral galaxy, also known as NGC 5457 and sometimes called the Pinwheel galaxy, is located in the constellation Ursa Major (The Great Bear), about 21 million light-years from Earth. This stunning composite image is made up of fifty-one individual exposures taken by the Hubble Space Telescope (HST) and several ground-based telescopes in 2006.

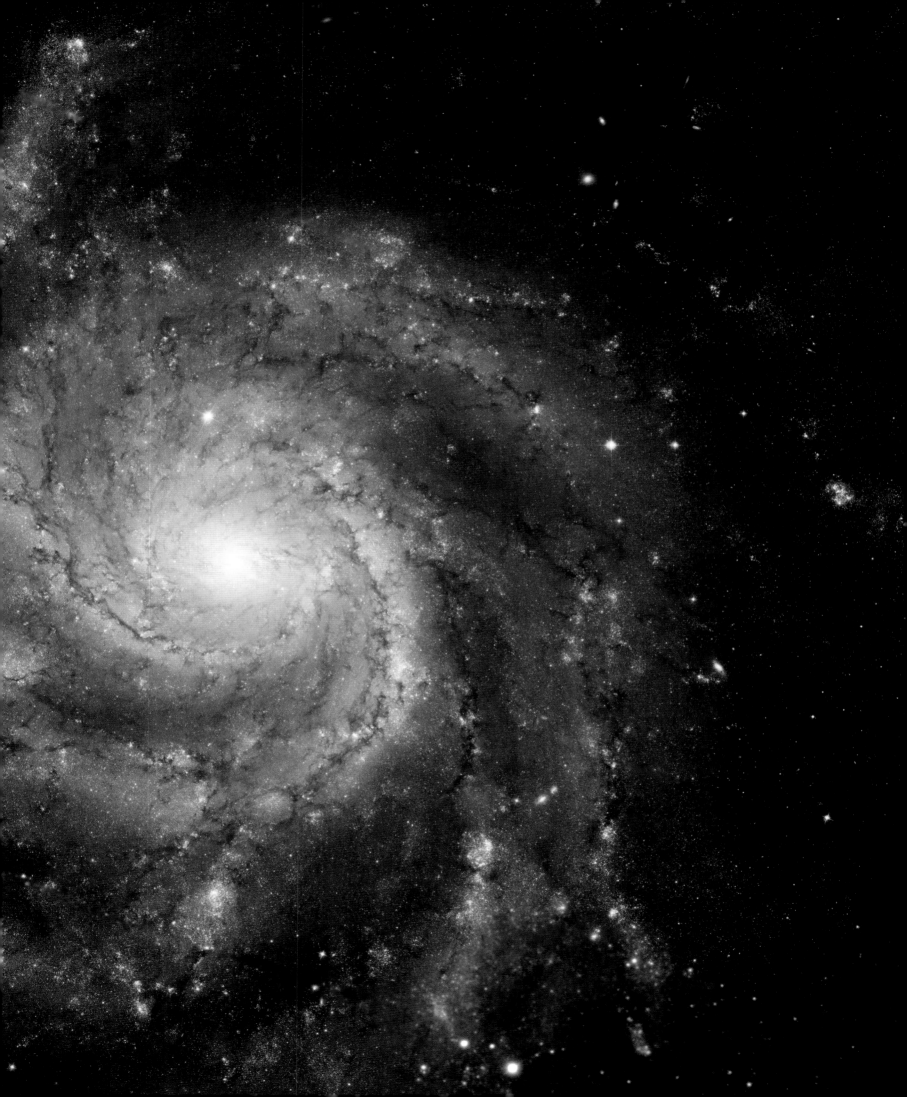

Located 212 million light-years from Earth, the barred spiral galaxy NGC 6872 measures 522,000 light-years from tip to tip, making it about five times the size of the Milky Way. This stunning composite image, released in 2013, combines visible light images from the European Southern Observatory's Very Large Telescope with far-ultraviolet data from NASA's Galaxy Evolution Explorer (GALEX) space telescope and 3.6-micron infrared data from NASA's Spitzer Space Telescope.

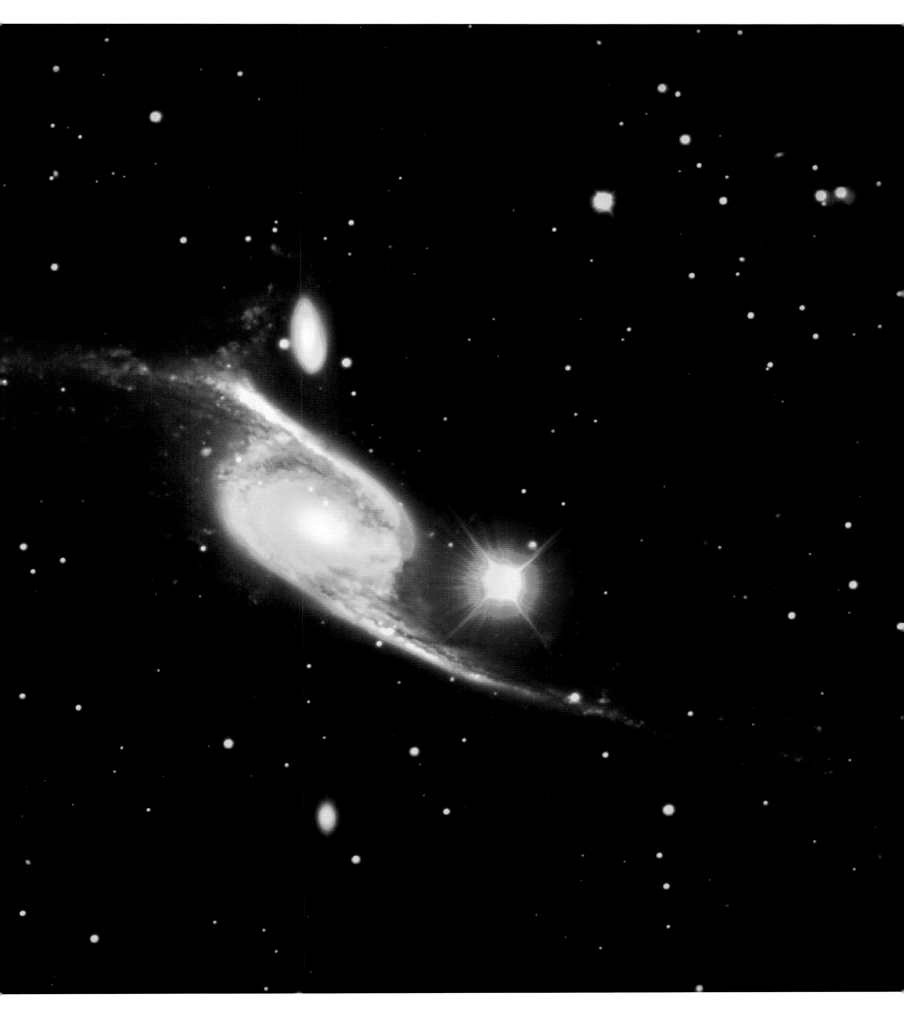

GALAXIES AND STAR SYSTEMS

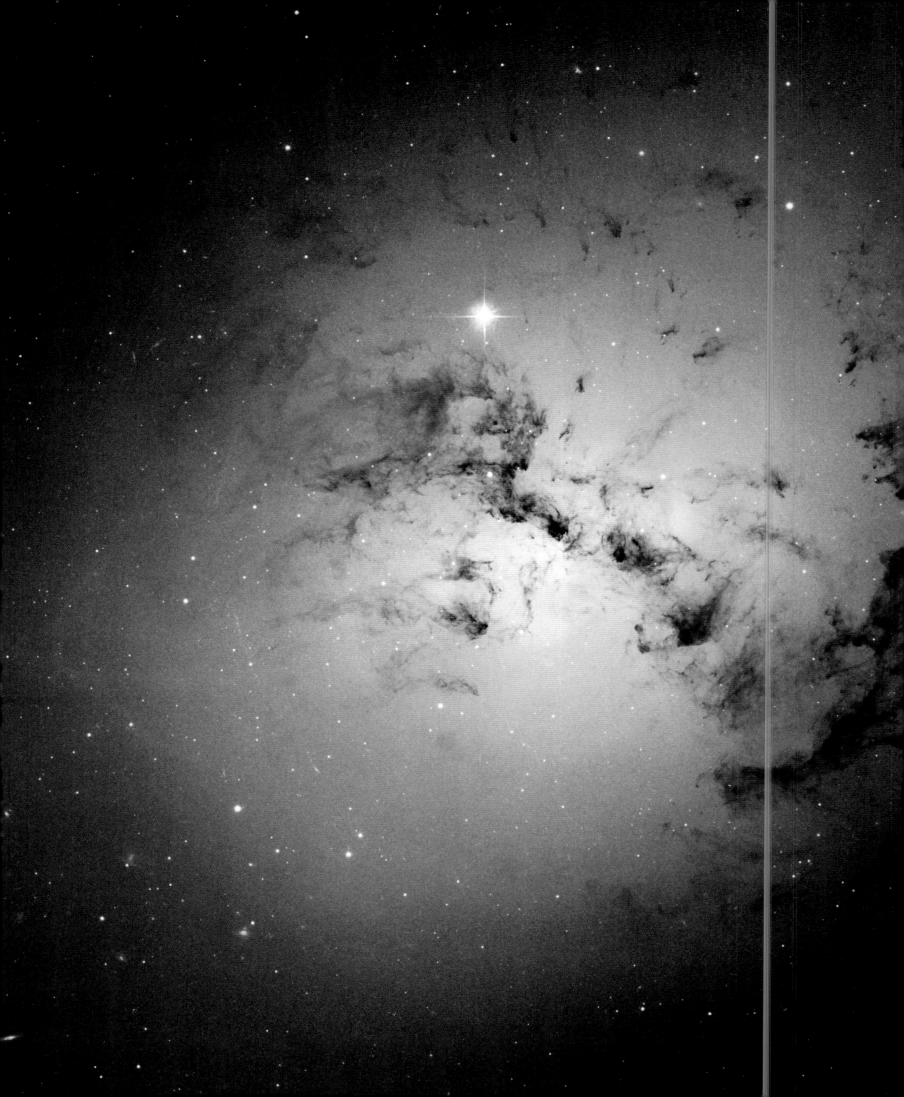

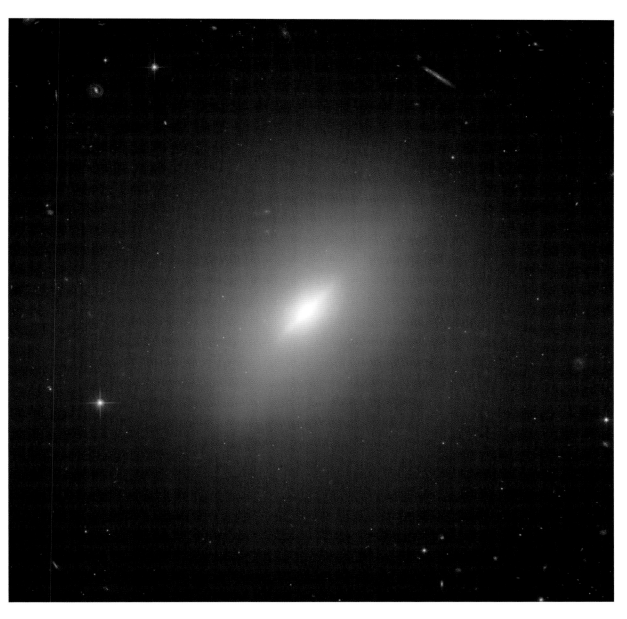

LEFT The elliptical galaxy may best be characterized as having an elongated shape and features containing complex blobs of cosmic matter. It often has few stars and is usually dominated by gases and protostars. The giant elliptical galaxy NGC 1316, depicted here in a 2002 image from the HST, reveals more intergalactic dust, gases, and star clusters than anything else. Astronomers are convinced that NGC 1316 is the result of a collision of two earlier galaxies.

ABOVE Because of the way it was formed, NGC 3610 became an elliptical galaxy through the merging of at least two disk galaxies some 4 billion years ago. During these violent mergers, most of the internal structure of the original galaxies was destroyed. Here is the result, captured by the European Space Agency (ESA) in 2015.

ABOVE AND RIGHT Irregular galaxies come in all shapes and sizes; their one common feature is that they are none of the other types. These images show the irregular dwarf galaxy IC 1613 in both ultraviolet (*left*) and in the visual spectrum (*right*). As seen, IC 1613, discovered in 1906 by astronomer Max Wolf and located 2.3 million light-years from Earth, is more readily studied in ultraviolet.

GALAXIES AND STAR SYSTEMS

THE LIFE AND DEATH OF STARS

Everything has a beginning, a middle, and an end—whether living or not. Scientists chart this process for everything in the universe, offering remarkable opportunities to learn about the cosmos and our place within it. Without question, stars are the most widely recognized astronomical objects. As the building blocks of galaxies, they are central to every aspect of the study of the cosmos. Scientists chart their origins, evolution, age, distribution, and eventual demise throughout the distant range of the universe.

Within 100 million years of the Big Bang, stars began coalescing in the nascent universe from clouds of dust, as a result of the energy of all the matter moving outward from the singularity. As material scattered, gravity pulled clouds together until they formed nebulae where matter, gravity, dark energy, and dark matter were sufficient to form solid bodies. A dust cloud such as the famous Orion Nebula presently seen from Earth is one such example of how gravitational attraction acts on the "stuff" of the region to churn it into knots with mass sufficient to form stars. Scientists often refer to these regions where stars are born as nurseries. Some stars develop stability, reaching a point where their elements ignite and their energy balances the other forces acting on them. Stars in statis may burn for millions of years, but others "flame out" in a short, violent existence.

The Milky Way galaxy in which Earth is located is one of those stable places in the cosmos—lucky for us, or life here would never have evolved. To form the Milky Way, millions of protostars interlocked through gravity to become fully formed stars in unknown numbers, developing planetary systems. Using three-dimensional computer models of star formation, scientists have recreated the process by which the constant movement of spinning and collapsing gas forms protoplanets, and often brings multiple star systems into interaction. Indeed, the majority of stars in the Milky Way are paired or in groups of multiple stars.

Depending on the size, type, and chemical composition of stars, they may take many different paths. Small "red dwarf" stars, the most numerous, found everywhere in the universe, often have only about 10 percent of the Sun's mass and emit far less energy at a temperature of between 3,000–4,000 Kelvin degrees. The largest stars, called hypergiants, may be over a hundred times more massive than the Sun, and have surface temperatures above 30,000 Kelvin degrees. They burn bright, as well as exceptionally hot, but they exist for

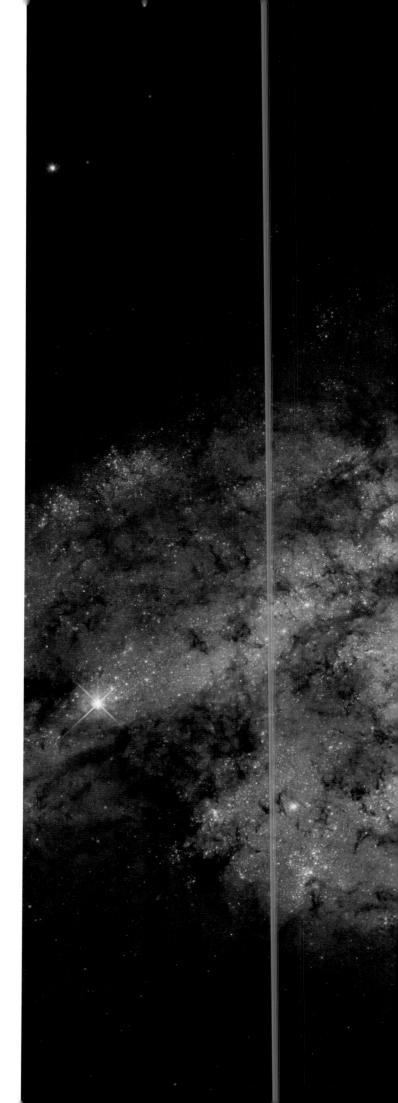

94 SMITHSONIAN ATLAS OF SPACE

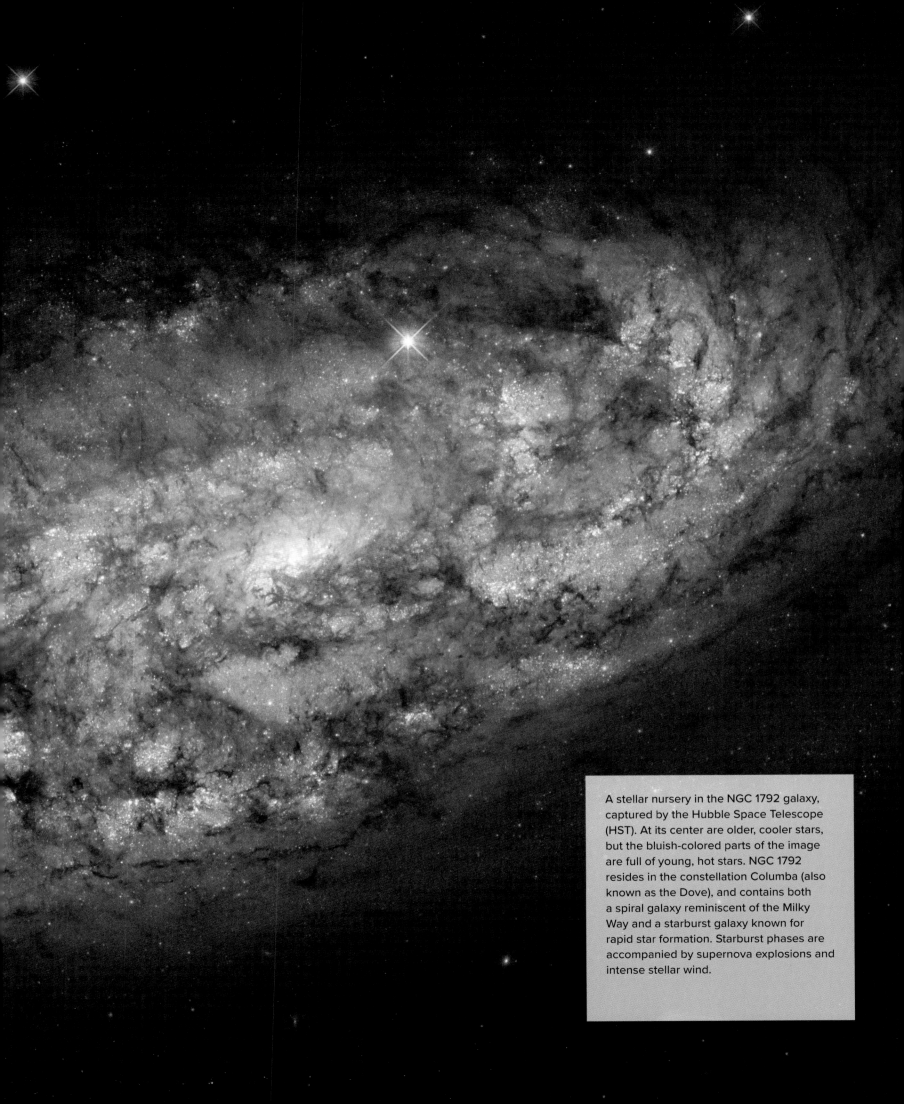

A stellar nursery in the NGC 1792 galaxy, captured by the Hubble Space Telescope (HST). At its center are older, cooler stars, but the bluish-colored parts of the image are full of young, hot stars. NGC 1792 resides in the constellation Columba (also known as the Dove), and contains both a spiral galaxy reminiscent of the Milky Way and a starburst galaxy known for rapid star formation. Starburst phases are accompanied by supernova explosions and intense stellar wind.

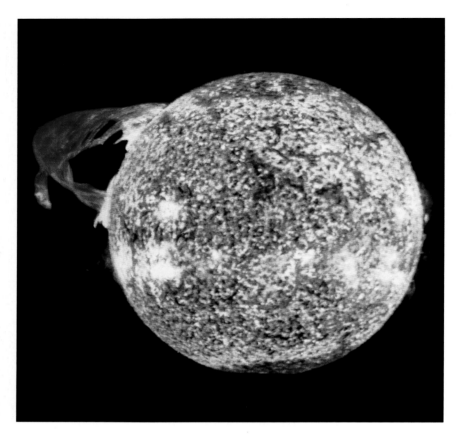

only a few million years. Using both ground- and space-based telescopes, scientists have identified VY Canis Majoris, a massive star approximately 2,000 times larger than the Sun. Another example, Betelgeuse, in the constellation Orion, is a red giant star a thousand times larger than the Sun. Scientists believe that hypergiants, seemingly rare today, may have been dominant in the earliest period after the Big Bang.

The Sun as the center of our solar system is a very common, immensely stable, and utterly unremarkable star. Based on observations by scientists, a star requires about 50 million years to be born and mature to the current state we see with our Sun. Classified as a yellow dwarf star, it is somewhat brighter than most of the stars in the Milky Way, and also slightly smaller than the average. A chemical engine of supreme elegance, the Sun contains mostly hydrogen and helium, but also some metals, with a diameter of about 865,000 miles (1.4 million kilometers) and a temperature of about 10,000 degrees Fahrenheit (5,500 degrees Celsius) at its surface. It is in constant but decidedly predictable movement, rotating every twenty five days at its equator and every thirty six days at its poles. Gravitationally locked in the Milky Way, it orbits the center every 230 million years. The Sun is destined to become a red giant some two hundred times its current size once its hydrogen fuel is depleted. It will then engulf the orbits of Mercury and Venus, and possibly even the orbit of Earth. Thereafter, the Sun will shrink into a white dwarf star. Presently in its mature phase, our Sun will live for approximately another 10 billion years.

FLYING CLOSE TO THE SUN

One of the early priorities for NASA when it developed the Skylab orbital platform on which three crews operated in 1973–74 was a solar telescope, known as the Apollo Telescope Mount, to study the Sun. Manually operated by the astronauts aboard Skylab, it used a film process to collect the highest quality images yet obtained of solar activity. The astronauts swapped out film magazines during spacewalks and oversaw all aspects of the observation. The data from this telescope is still being used to add to knowledge of the Sun. In this image, Edward G. Gibson is making the final spacewalk on February 3, 1974, to retrieve film from the telescope. Astronaut Gerald P. Carr took this picture; an umbilical/tether line is seen in the frame.

TOP LEFT Skylab's Apollo Telescope Mount captured a spectacular solar flare (a large eruption of electromagnetic radiation) spanning more than 365,000 miles (588,000 kilometers) on December 19, 1973.

RIGHT The bright variable star V 372 Orionis (*prominent at center*), as well as a smaller companion star (*upper left*) are gravitationally bound stars located in the Orion nebula, a massive region of star formation about 1,450 light-years from Earth.

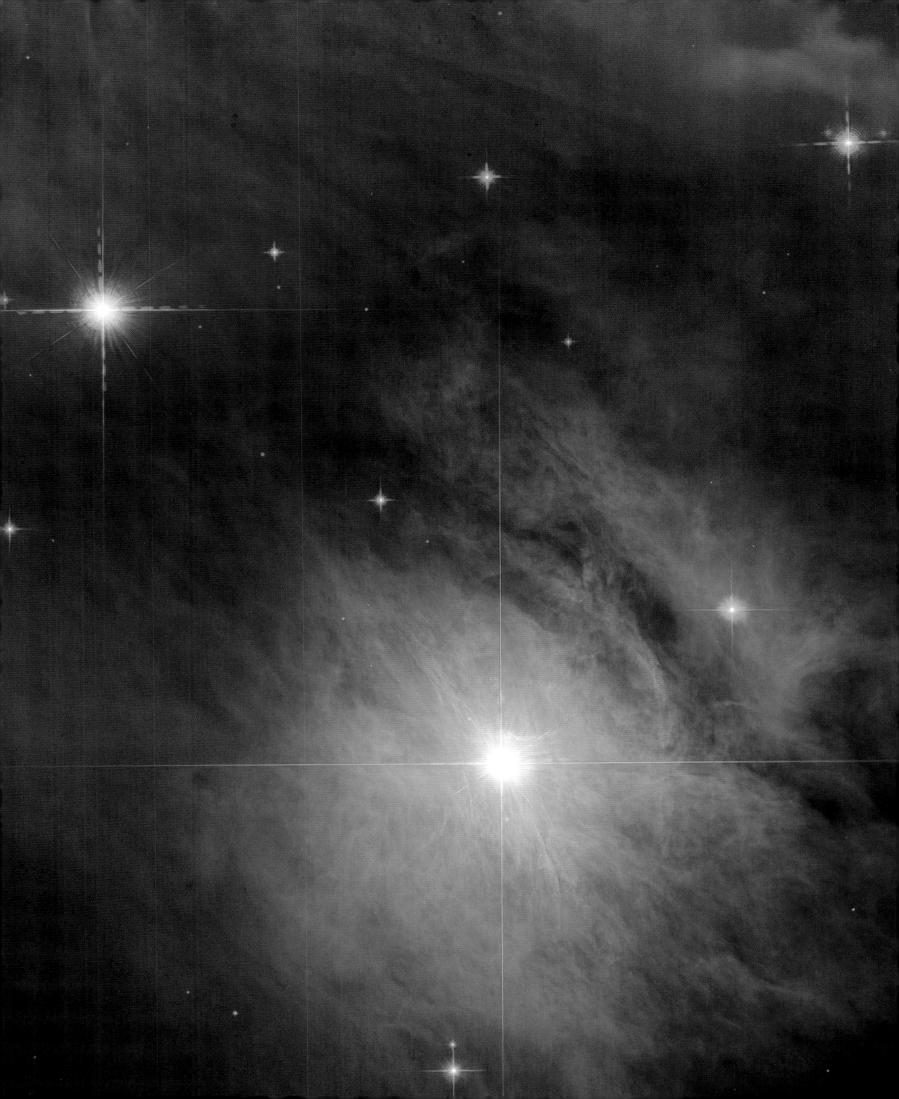

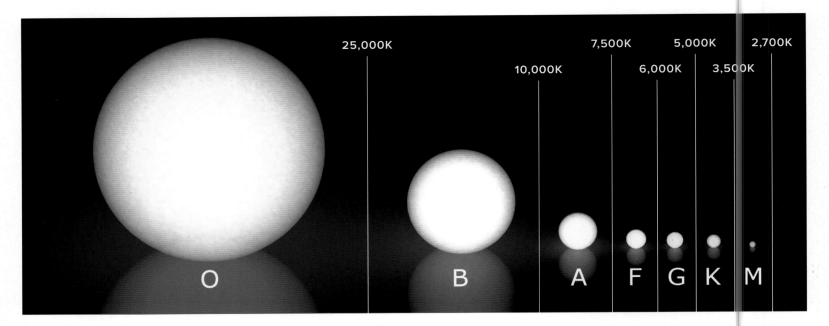

ABOVE What makes a star a star? Most important, it is a body bound together by gravity whose chemicals interact to create heat, light, and radiation. There are several types of stars, depicted in the taxonomic scale first established at the Harvard Observatory that characterizes color, temperature range (shown in Kelvin), and brightness (see below). Our Sun is known as a G-type star, near the middle of this spectrum.

RIGHT Images from three telescopes—NASA's Nuclear Spectroscopic Telescope Array (NuSTAR) (blue), Japan's Hinode spacecraft (green), and NASA's Solar Dynamics Observatory (yellow and red)—combined to create this image of the Sun on April 29, 2015. It pinpoints the most active regions during this time. Microflares are erupting from the surface, releasing energy and heat throughout the solar system. Observations of the Sun go back centuries, and as our nearest star it represents the most detailed information available on stars in the universe. While scientists may learn a lot about composition, luminosity, and other stellar characteristics from afar, the Sun is the quintessential object for close study.

Stellar classification	Effective temp. (in Kelvin)	Chromaticity	Comments
O	≥ 30,000K	blue	Very hot and extremely luminous, with most radiated output in the ultraviolet range.
B	10,000–30,000K	deep bluish white	Very luminous and blue. Supergiant stars often swing between O or B (blue) and K or M (red).
A	7,500–10,000K	bluish white	Common naked-eye stars, white or bluish-white.
F	6,000–7,500K	white	Characterized by weaker hydrogen lines and ionized metals. Their color is white.
G	5,200–6,000K	yellowish white	G-type stars, including the Sun, convert the element hydrogen to helium in their core by means of nuclear fusion, but can also fuse helium when hydrogen runs out.
K	3,700–5,200K	pale yellowish orange	Orangish stars that are slightly cooler than the Sun.
M	2,400–3,700K	light orangish red	By far the most common type of star, about 76 percent of main-sequence stars are class M. Generally have such low luminosities that none are bright enough to be seen with the unaided eye.

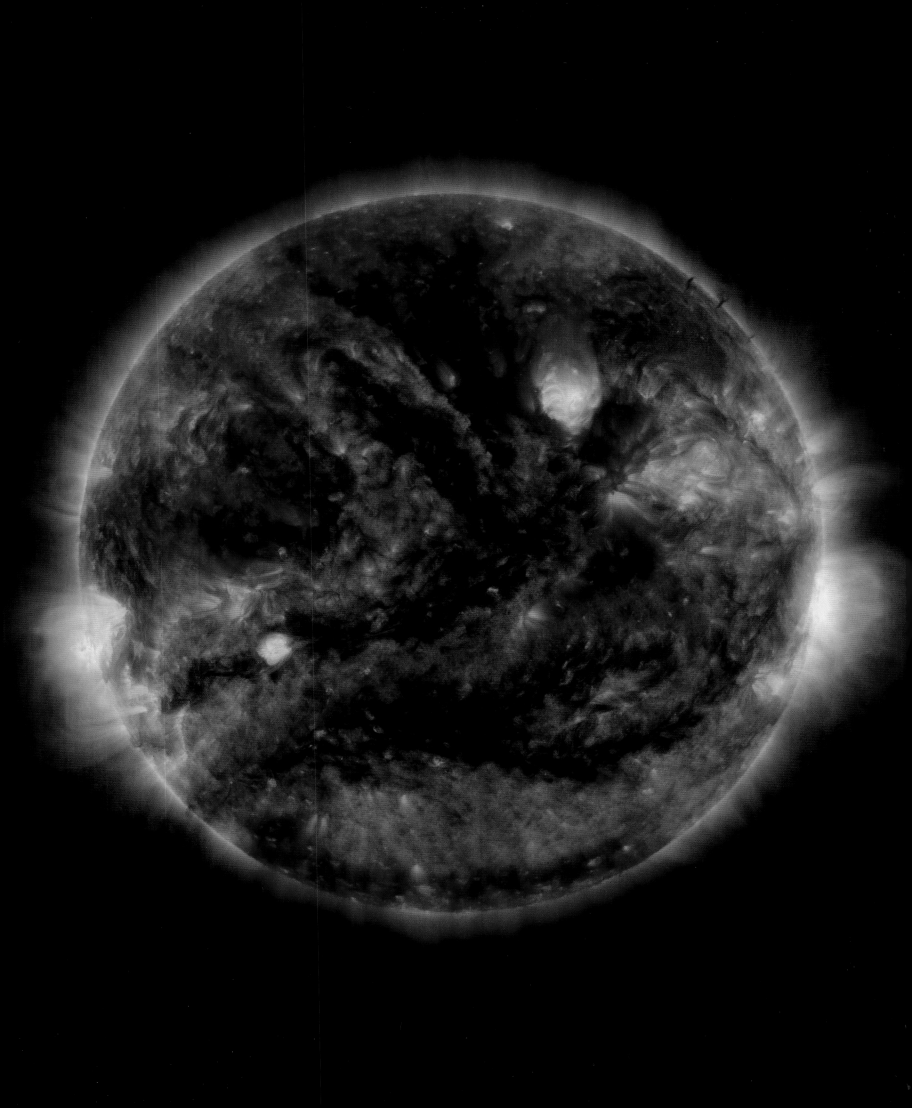

Blue supergiant

Red dwarf

Cloud of stellar dust and gas

Protostar

Brown dwarf

Sun-like star

From birth to their destruction, stars follow the same basic process, but mass determines their ultimate fate. First a gas cloud condenses into a protostar and, depending on its mass, it becomes a brown dwarf, a red dwarf, a blue supergiant, or a star like our Sun. Brown dwarfs do not have enough mass to get hot enough to ignite, and so cool over time and fade away. The most common type of stars, red dwarfs, burn until their hydrogen is transformed into helium, at which point they become white dwarfs. Sun-like stars tend to be more stable, burning until their hydrogen is depleted and swelling into red giants before their outer shells become nebulae. Thereafter, their core collapses to form a white dwarf. Since a white dwarf is very dense, it gradually collapses in on itself until it blows up as a type Ia supernova. A blue supergiant, an exceptionally hot, luminous star, will typically evolve into either a red supergiant (with less heat and light), a black hole, or explode into a type II supernova. A type II supernova may then become a neutron star, emitting radiation but very little light or heat.

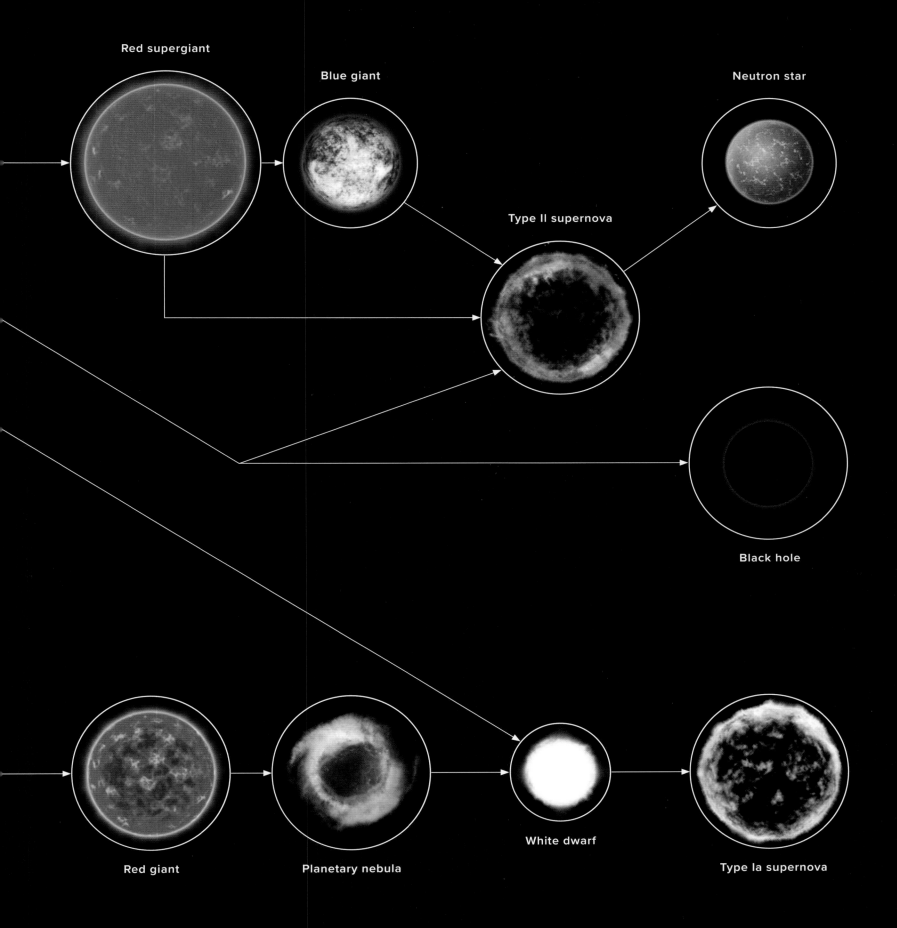

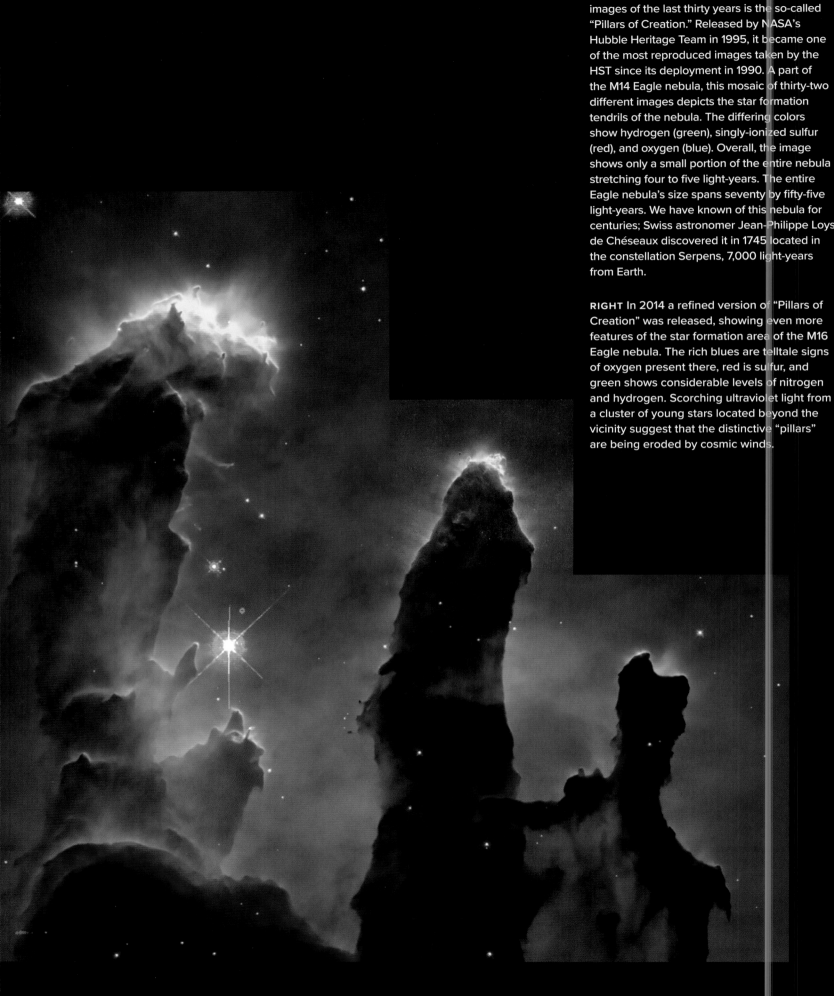

BELOW One of the most famous astronomical images of the last thirty years is the so-called "Pillars of Creation." Released by NASA's Hubble Heritage Team in 1995, it became one of the most reproduced images taken by the HST since its deployment in 1990. A part of the M14 Eagle nebula, this mosaic of thirty-two different images depicts the star formation tendrils of the nebula. The differing colors show hydrogen (green), singly-ionized sulfur (red), and oxygen (blue). Overall, the image shows only a small portion of the entire nebula stretching four to five light-years. The entire Eagle nebula's size spans seventy by fifty-five light-years. We have known of this nebula for centuries; Swiss astronomer Jean-Philippe Loys de Chéseaux discovered it in 1745 located in the constellation Serpens, 7,000 light-years from Earth.

RIGHT In 2014 a refined version of "Pillars of Creation" was released, showing even more features of the star formation area of the M16 Eagle nebula. The rich blues are telltale signs of oxygen present there, red is sulfur, and green shows considerable levels of nitrogen and hydrogen. Scorching ultraviolet light from a cluster of young stars located beyond the vicinity suggest that the distinctive "pillars" are being eroded by cosmic winds.

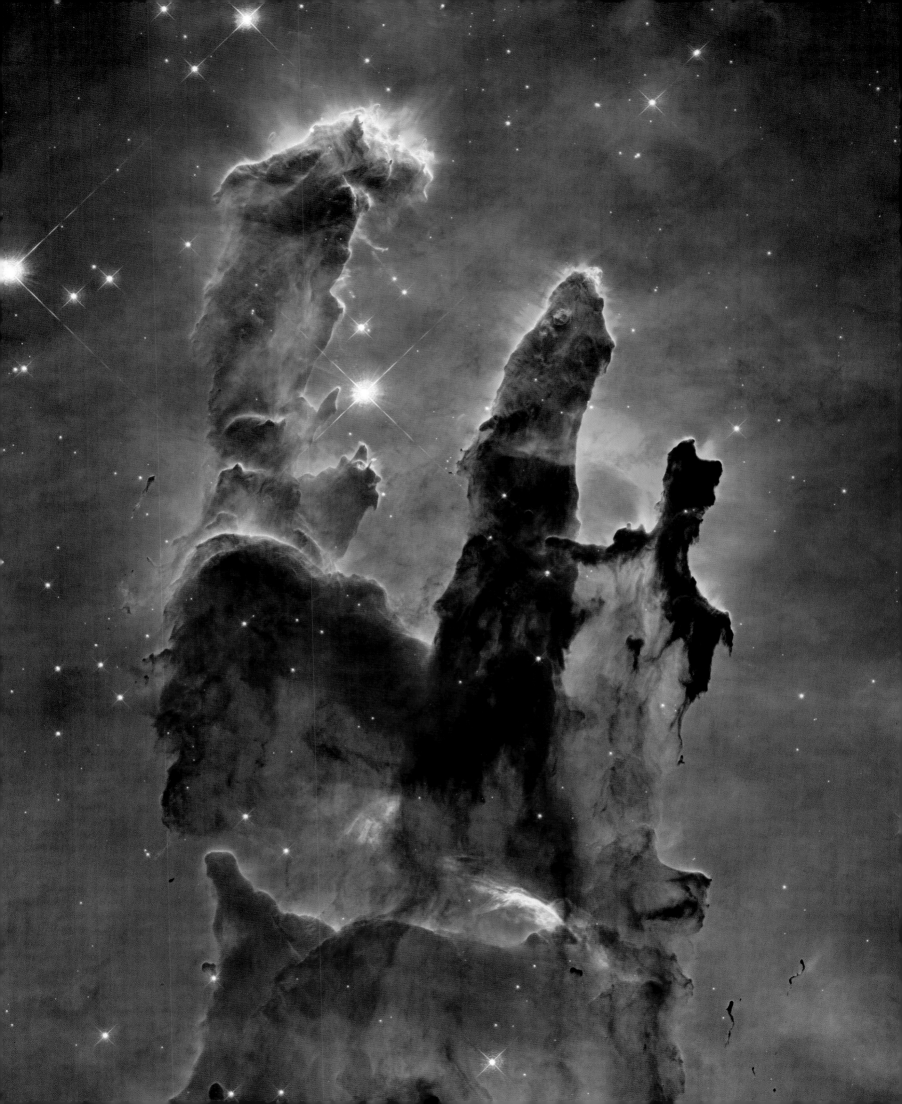

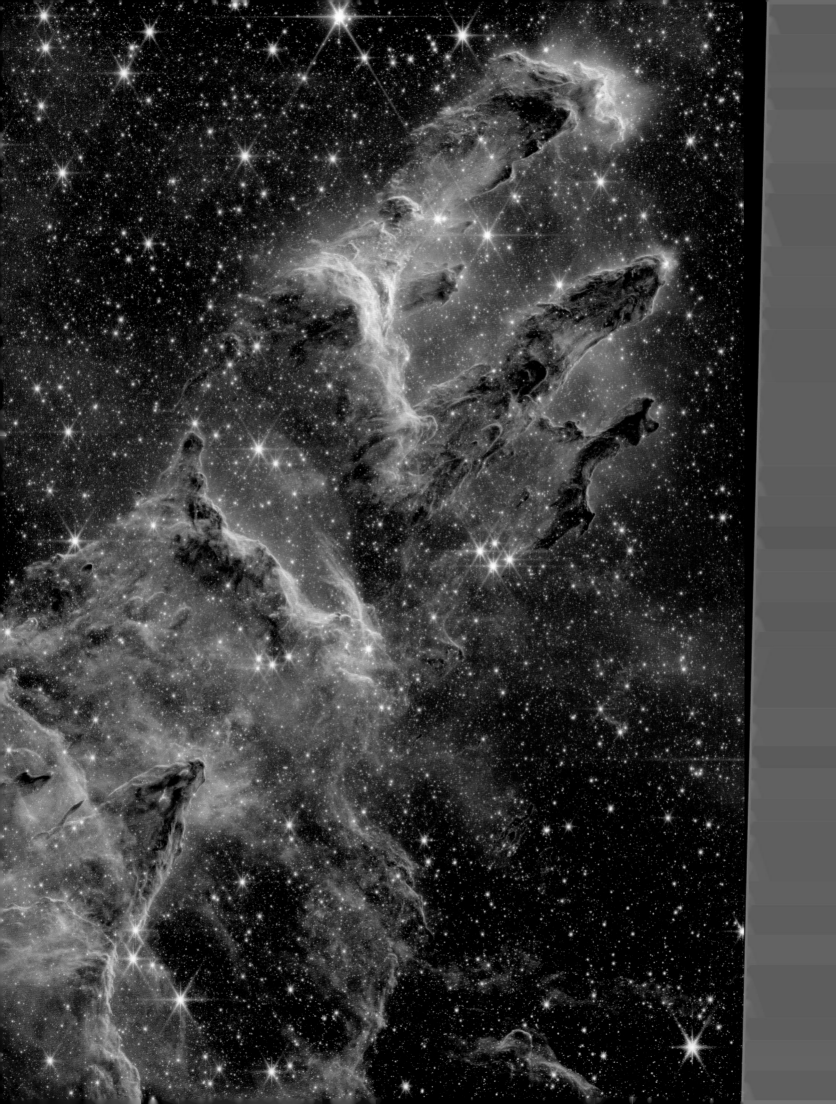

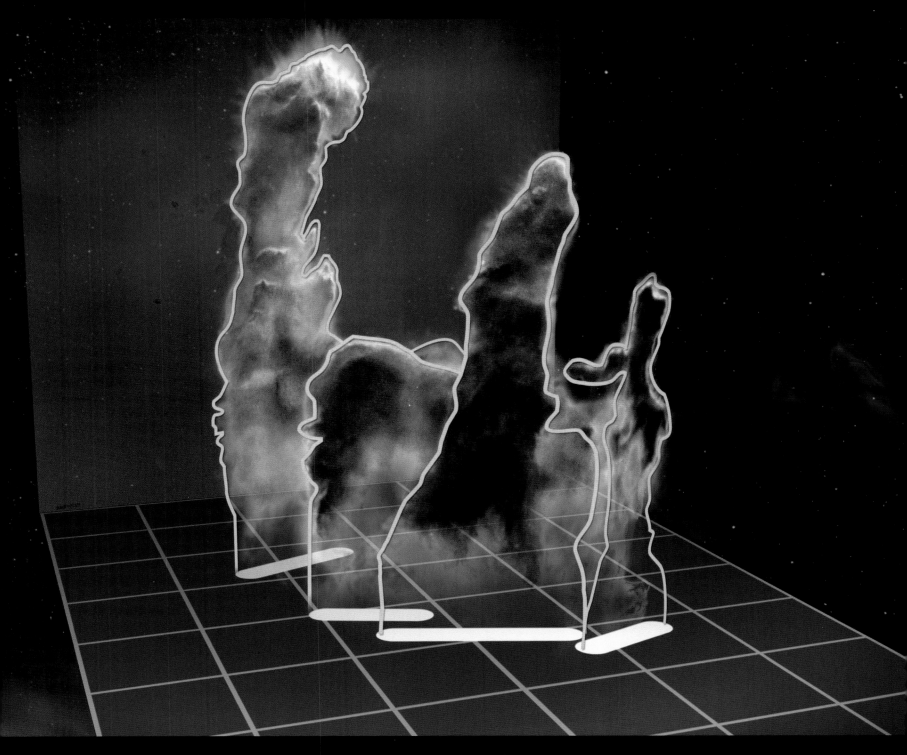

LEFT In yet another version of the iconic "Pillars of Creation" image, the James Webb Space Telescope (JWST) turned its powerful near-infrared-light cameras on the M16 Eagle nebula in 2022 with spectacular results. Gone are most of the vestiges of finger-like stellar nurseries, but there is more of a sense of arches rising out of a desert landscape. Most important, the bright red spots delineate the star formation center of the nebula.

ABOVE The "Pillars of Creation" received a new analysis when scientists used the Multi Unit Spectroscopic Explorer (MUSE) instrument on the European Southern Observatory's Very Large Telescope at the Paranal Observatory in the Atacama Desert in northern Chile, to produce the first complete three-dimensional view of it. These observations demonstrate how the different pillars of this celestial object are distributed in space.

GALAXIES AND STAR SYSTEMS

NASA scientists used the high-resolution, near-infrared JWST to reveal elegant detail of the outflow of a young star in the Herbig-Haro 211 (HH 211) region, on September 14, 2023. HH 211 is an analog of our Sun, just being born. The image features a series of bow shocks (a shockwave created by the collision of a stellar wind with another medium) in the lower left and upper right, as well as a bipolar jet (high-speed stellar wind gas ejected into two narrow streams). Streams of such luminous objects are common around newborn stars, formed through the interaction of stellar winds with gas and dust at high speeds. At this point in the star-birth process, the mass of these objects is only about 8 percent of the present-day Sun. Projections are, however, that it will eventually grow into a star like the Sun as gravity acts to coalesce all of these elements, as well as others not yet in the protostar's path. The bow shocks are not uncommon in star formation, although they will relent as gravity curtails them over time.

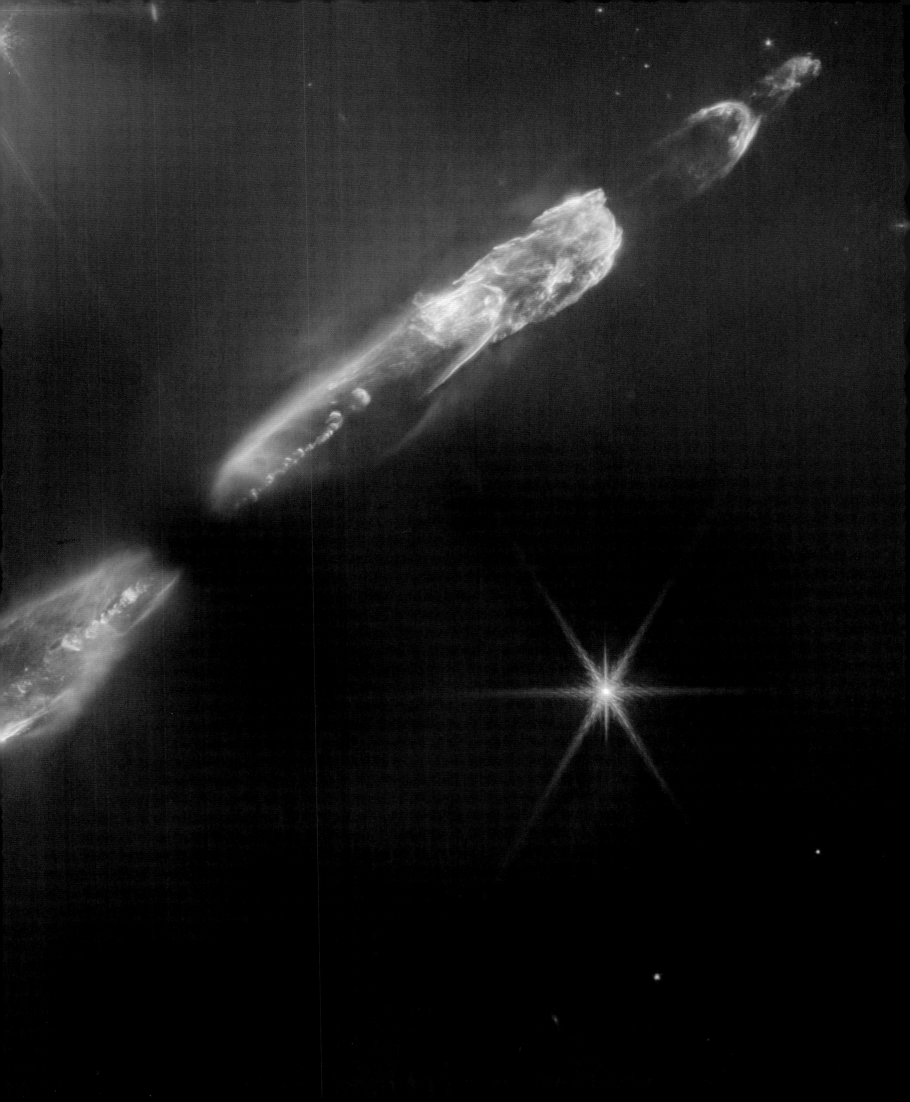

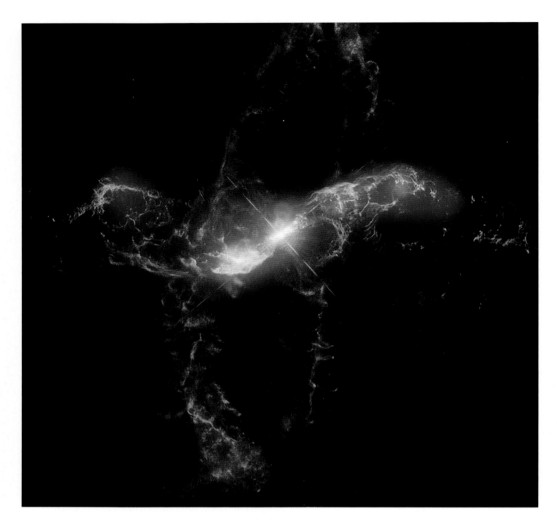

ABOVE In what may be best characterized as a dance of death, a dwarf star burning at a relatively cool temperature orbits a highly variable red giant star. As it does so, the white dwarf's gravity steals matter from the red giant, which, over time, will accumulate and trigger an explosion eons in the future. This stunning composite combines imaging from NASA's Hubble Space Telescope (red and blue) with data from the Chandra X-Ray Observatory (purple), which reveals how a jet from the white dwarf is striking material surrounding it and creating shock waves.

RIGHT Zeta Ophiuchi, a fascinating single star more than twenty times the size of the Sun, is located approximately 440 light-years from Earth in the constellation Ophiuchus. The third brightest star in that constellation, it appears to have once had a companion that went supernova more than a million years ago, ejecting Zeta Ophiuchi out of its stellar neighborhood at about 100,000 mph (160,000 km/h). Now hurtling through space, this composite image from the Spitzer Space Telescope (green and red) and Chandra X-ray Observatory (blue) show the intense heat of the star, as well as the debris left from the supernova. The heat-formed shock wave tens of millions of degrees in temperature is clearly visible. Released on July 25, 2022, this image shows the fate of some stars in the cosmos.

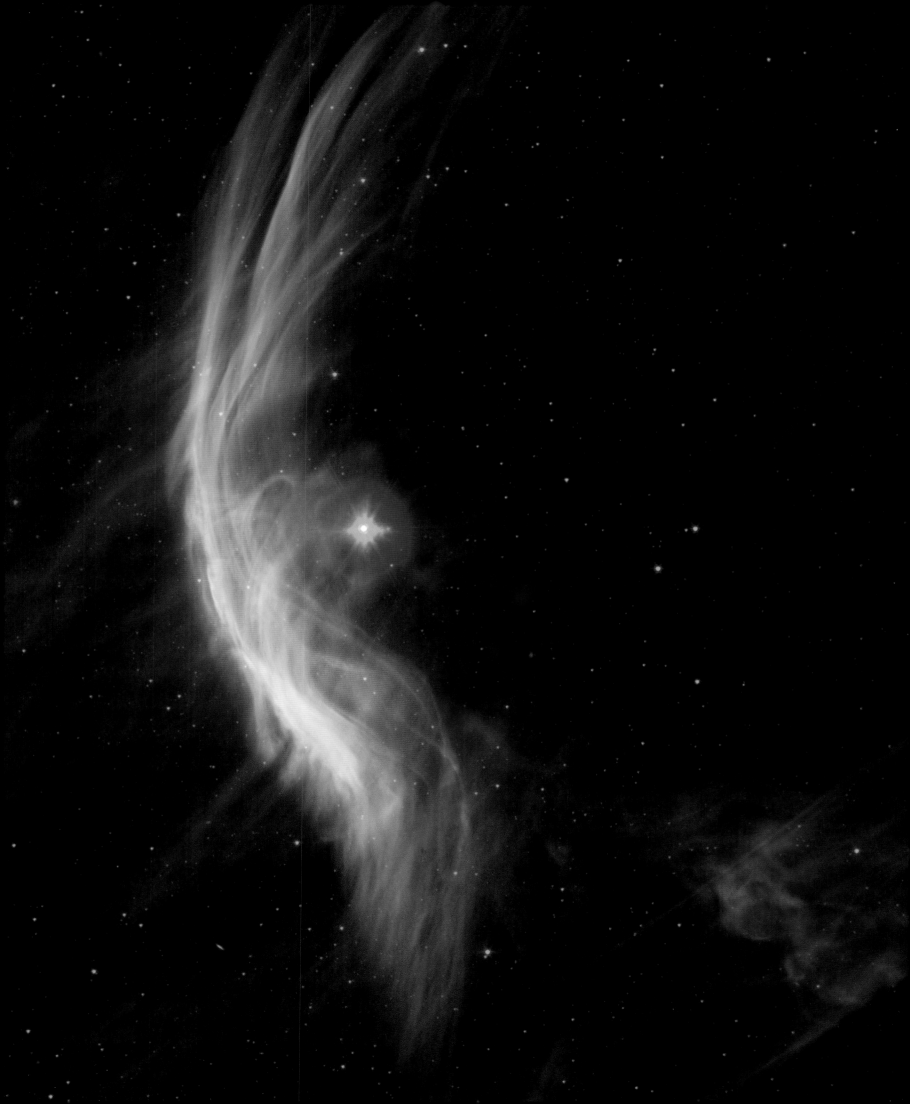

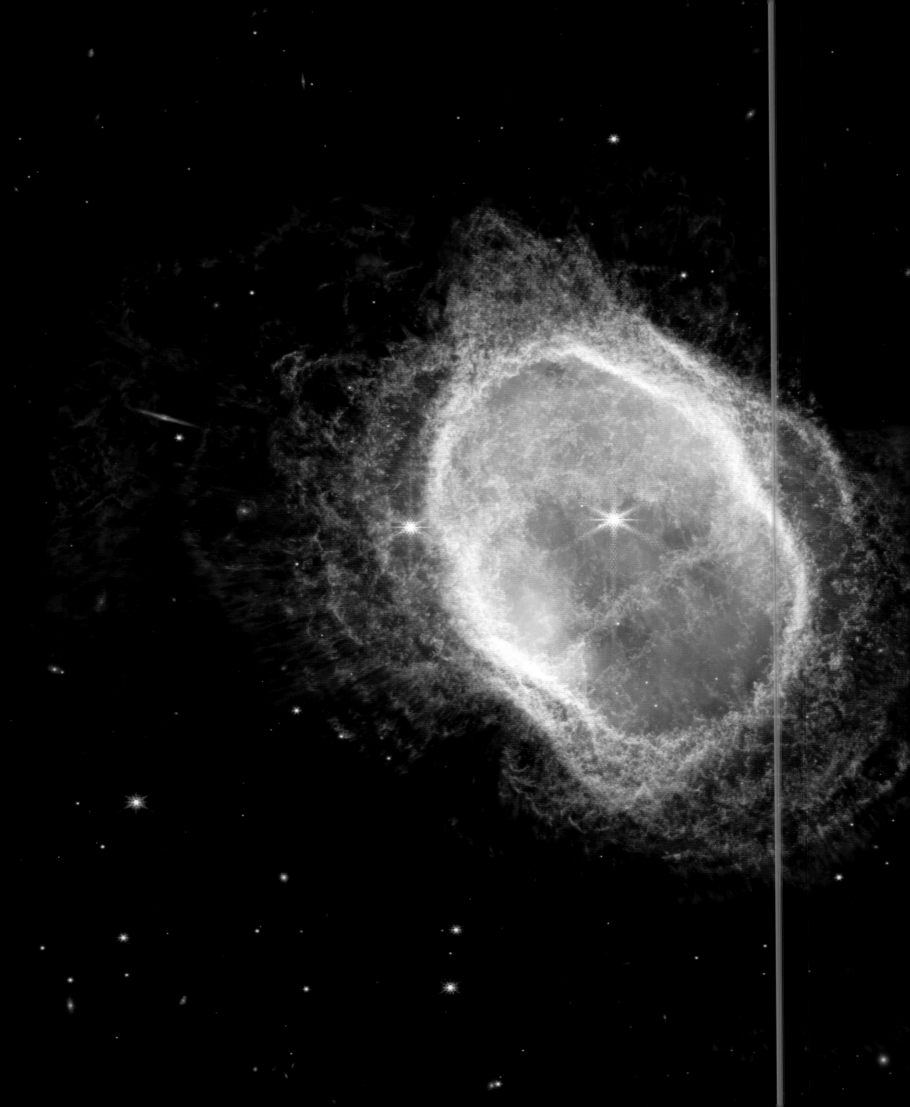

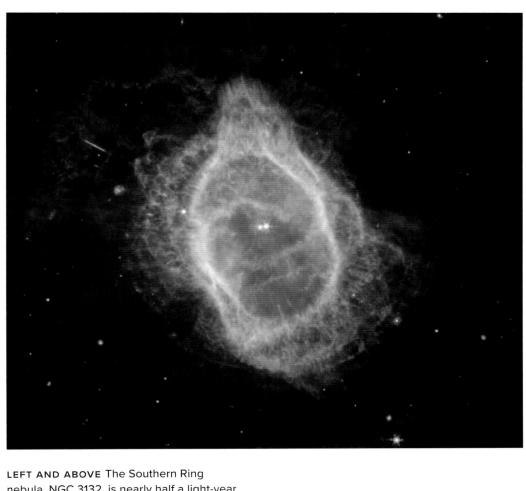

LEFT AND ABOVE The Southern Ring nebula, NGC 3132, is nearly half a light-year in diameter and lies 2,000 light-years away from Earth. It is captured here by the JWST's Near-Infrared Camera (*left*) and Mid-Infrared Instrument (*above*). The nebula's source is a white dwarf star, barely visible in the left-hand image at along one of the bright central star's diffraction spikes (*lower left*), but larger, brighter, and redder in the mid-infrared image (*above*). Over thousands of years before becoming a white dwarf, the star periodically ejected mass, shedding its layers which can be seen in the surrounding nebula.

SUPERNOVAE, NEUTRON STARS, AND BLACK HOLES

Some stars end in spectacular fashion. Three of those distinct ends are supernovae, neutron stars, and black holes. Each is violent, but in different ways.

Supernovae occur when a significant change to the core of a star causes it to explode. Most commonly it happens when a star exhausts most of its nuclear fuel, leading to an explosion of all the other energy left in it. Our Sun, which will become first a red giant then end its life as a white dwarf star, has insufficient mass to explode as a supernova.

Astronomers have observed supernovae for centuries. In 1604 Johannes Kepler, a German astronomer and mathematician during the Scientific Revolution, discovered the last observed supernova in the Milky Way. His finding confounded seventeenth-century astronomers; it contradicted conventional wisdom about the stability and eternity of the cosmos, offering evidence for a Copernican model of the universe with the Sun at the solar system's center and with other messy, observable phenomena.

Neutron stars have another type of ending altogether. Mostly these stars belong to a class known as pulsars; they rotate quite rapidly and as they do so they emit radio waves in a narrow beam that astronomers compare to lighthouse beacons (see page 120). At the end of the pulsar's life, gravitational collapse of whatever matter is left shrinks it into a tight wad. David Thompson, a scientist at NASA's Goddard Space Flight Center in Greenbelt, Maryland, explains: "With neutron stars, we're seeing a combination of strong gravity, powerful magnetic and electric fields, and high velocities. They are laboratories for extreme physics and conditions that we cannot reproduce here on Earth."

Black holes are among the most famous phenomena in the universe. Simply put, a black hole is a star or stars in space with a gravitational field so strong that nothing, not even light, can escape. Matter, energy, and probably even dark matter and dark energy are sucked into it. Black holes are present throughout the universe and seem necessary for its structure.

Astronomers have studied black holes for many years, and the quality of scientific instruments used has grown exponentially over time. We have learned much by tracking, measuring, and characterizing the forces in their vicinity; assessing their properties; and describing the particles moving near the speed of light in their vicinity. But the work has only just begun.

JOHANNES KEPLER (1571–1630)

The discoverer of a supernova that now bears him name, we know Johannes Kepler largely as an astronomer, but he was also a mathematician, natural philosopher, musical composer, and astrologer. His laws of planetary motion inform all aspects of modern spaceflight:

1. Planets move in elliptical orbits, with the Sun's gravity keeping them at a stable distance.
2. A planet travels the same distance of space in the same amount of time, regardless of where it is in its orbit.
3. A planet's orbital period is proportional to the cube of the length of the semi-major axis of its orbit.

Kepler also invented an improved version of the refracting telescope, often referred to as the Keplerian telescope, which became the foundation for the modern refracting telescope. He may also be characterized as the "godfather" of science fiction because of his posthumously published novel, *Somnium (The Dream)* (1634), that recounted a supernatural voyage to the Moon in which the visitors encountered serpentine creatures.

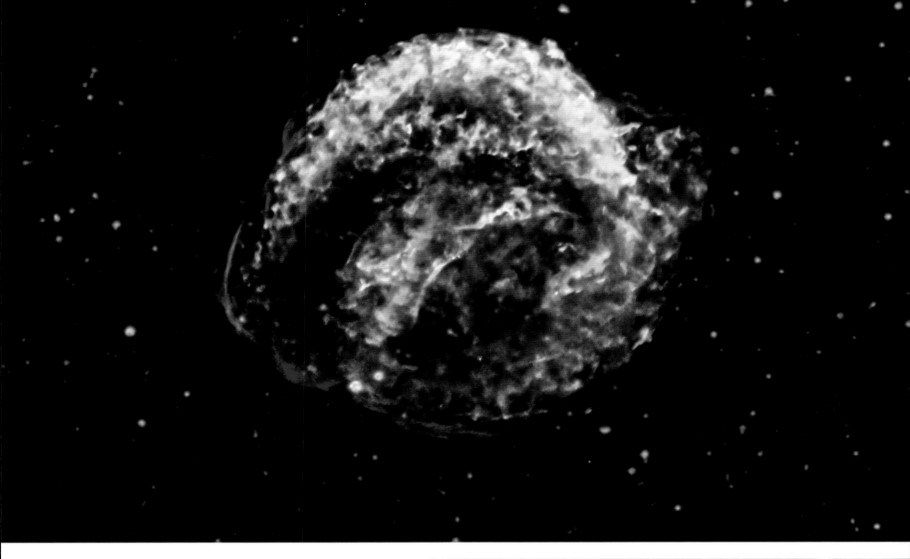

ABOVE Johannes Kepler's discovery of a supernova on October 9, 1604, added credence to the correctness of the Copernican model of the universe. This is a modern mosaic of Kepler's Supernova made up of three images, one each from NASA's Spitzer Space Telescope (taken in August 2004), the Hubble Space Telescope (HST) (August 2003), and the Chandra X-ray Observatory (June 2000). This bubble of gas and dust is the remnants of a stellar explosion, now expanded to fourteen light-years wide. It is currently expanding at 4 million mph (6.5 million km/h).

RIGHT Located about 160,000 light-years from Earth and captured by NASA's Spitzer Space Telescope and Chandra X-ray Observatory, the supernova N132D is a pinkish shell in the center of gas and dust, with the star field around.

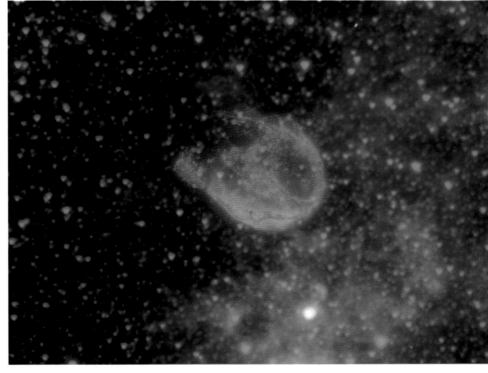

GALAXIES AND STAR SYSTEMS

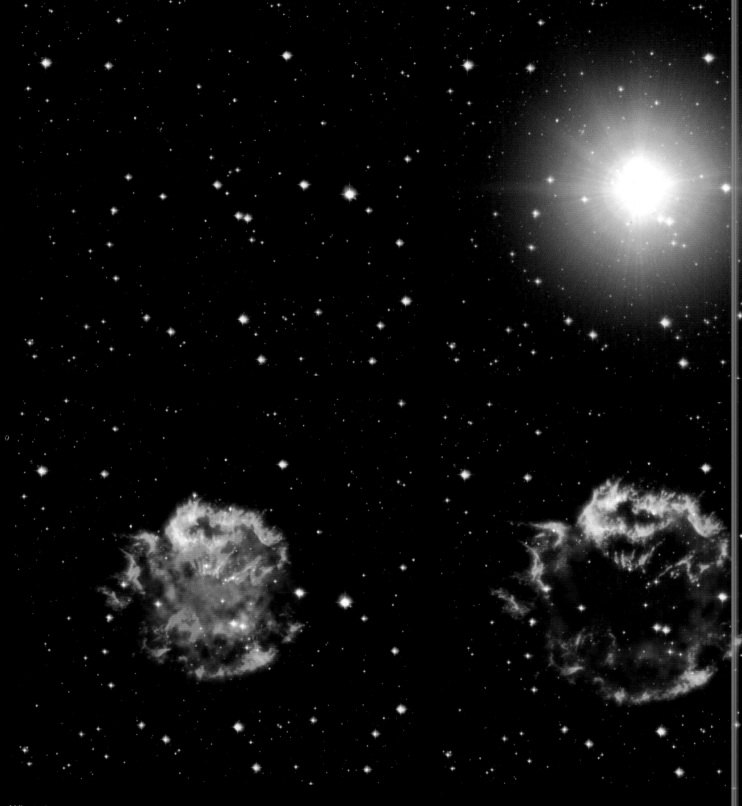

What does a supernova look like? This artist's impression shows eight stages of a supernova; from the star in a field of stars, through an intense explosion, to a succession of ever dissipating and cooling remnants.

GALAXIES AND STAR SYSTEMS 115

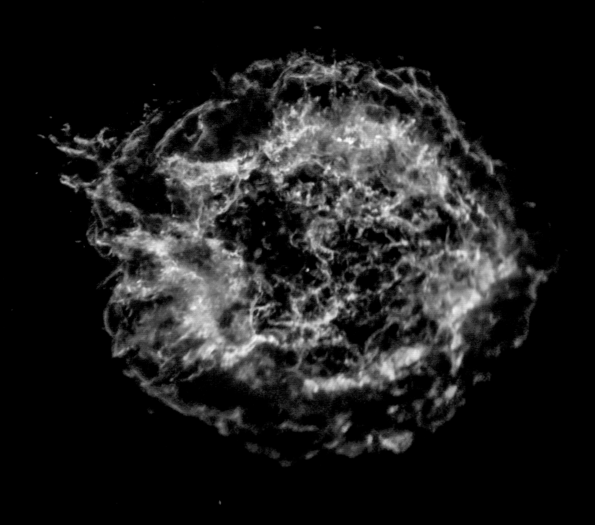

ABOVE This Cassiopeia A supernova remnant shows the debris field of a massive star that blew itself apart over 400 years ago. The image was created using data from NASA's Chandra X-ray Observatory.

RIGHT The Wolf-Rayet 124 (WR 124) star is conspicuous in the center of this composite image from the James Webb Space Telescope (JWST)'s near-infrared and mid-infrared wavelength observations. It depicts the manner in which these instruments balance the brightness of an exploding star with fainter gas and dust particles nearby, revealing the nebula's structure. The star's violent background, the result of a nebular explosion, depicts its construction and movement.

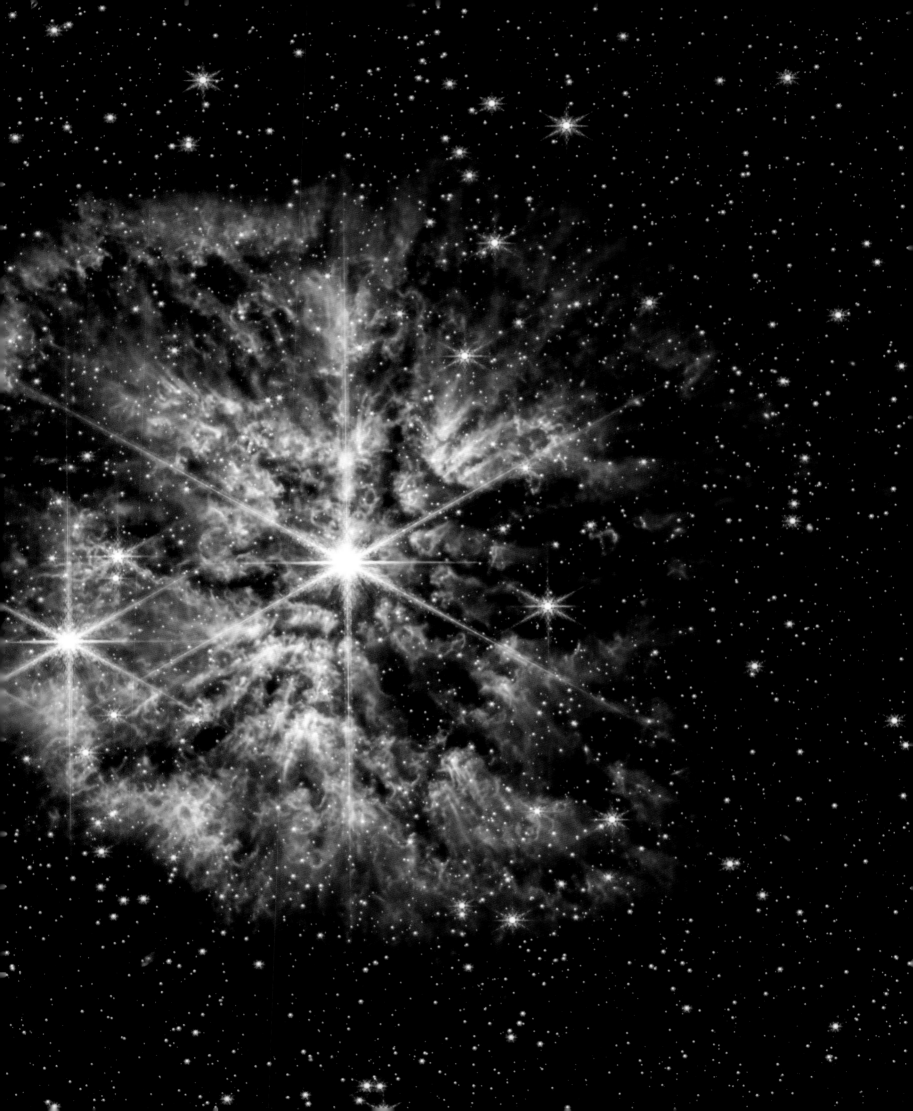

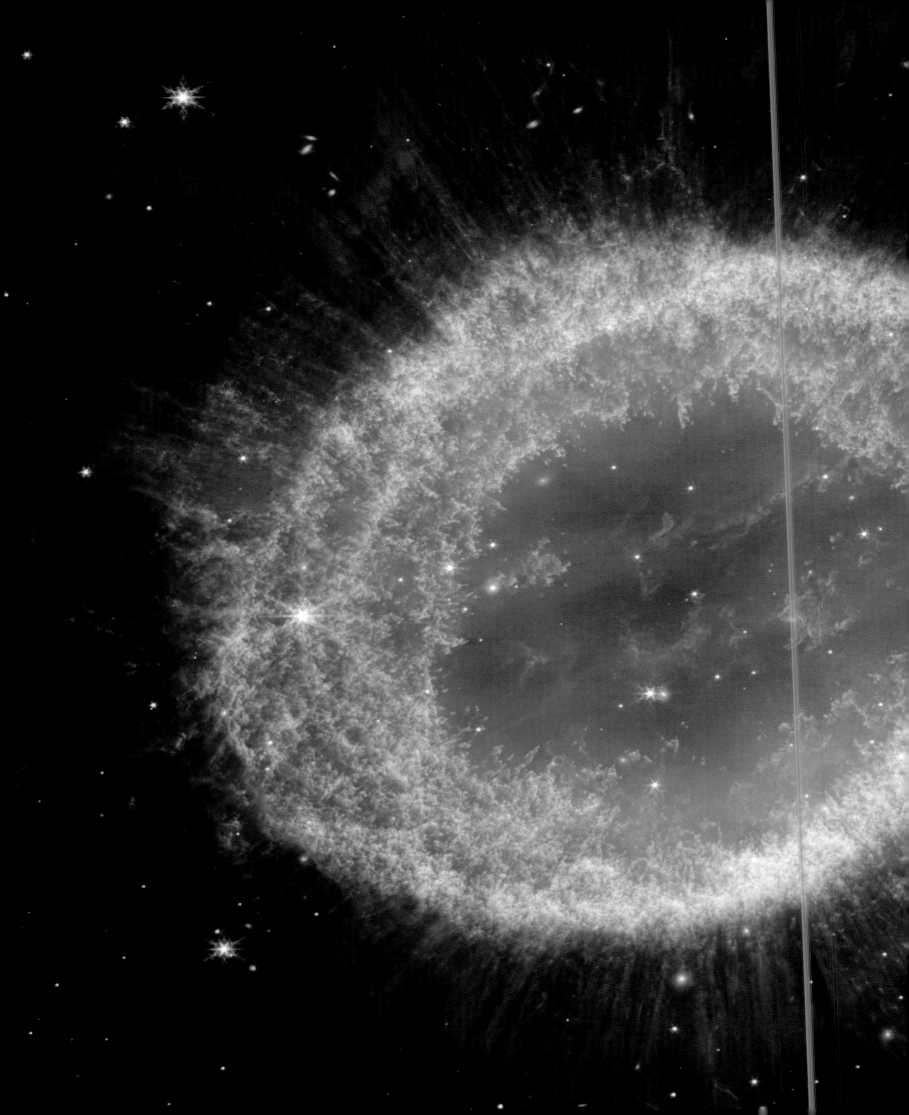

"Supernovae occur when a significant change to the core of a star causes it to explode. Most commonly it happens when a star exhausts most of its nuclear fuel, leading to an explosion of all the other energy left in it."

In yet another example of a supernova, Messier 57, about 2,600 light-years away in the direction of the constellation Lyra, was imaged by the JWST in 2023. Enveloped in a cloak of oxygen, it gives off a greenish tint as light passes through it.

DIFFERENT TYPES OF NEUTRON STAR

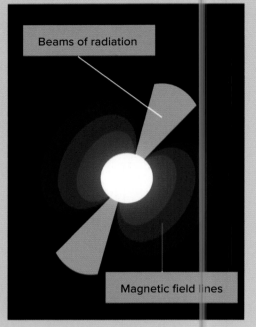

A **magnetar** is a neutron star with a particularly strong magnetic field, about 1,000 times that of a normal neutron star. That's about a trillion times stronger than Earth's magnetic field and about 100 million times stronger than the most powerful magnets made by humans.

Scientists have only discovered about thirty magnetars to date.

Most of the roughly 3,000 known neutron stars are **pulsars**, which emit twin beams of radiation from their magnetic poles. Those poles may not be precisely aligned with the neutron star's rotation axis, so as the neutron spins, the beams sweep across the sky, like beams from a lighthouse.

To observers on Earth, this can make it look as though the pulsar's light is pulsing on and off.

There are now six known neutron stars that are both **pulsars** and **magnetars**.

RIGHT Neutron stars are difficult to detect, but NASA's Neil Gehrels Swift Observatory captured the striking result of a merger of two neutron stars. This observatory was launched in 2004 and is able to detect gamma-ray bursts (GRB), a common occurrence in the universe, and gather data on them. This image, released on November 12, 2020, shows brightness some 10,000 times that of a classic nova. It appears as a bright spot (note the arrow) in the upper left of the host galaxy. The merger of two neutron stars is believed to have produced a magnetar, an extremely powerful magnetic field which illuminated the material ejected from the explosion.

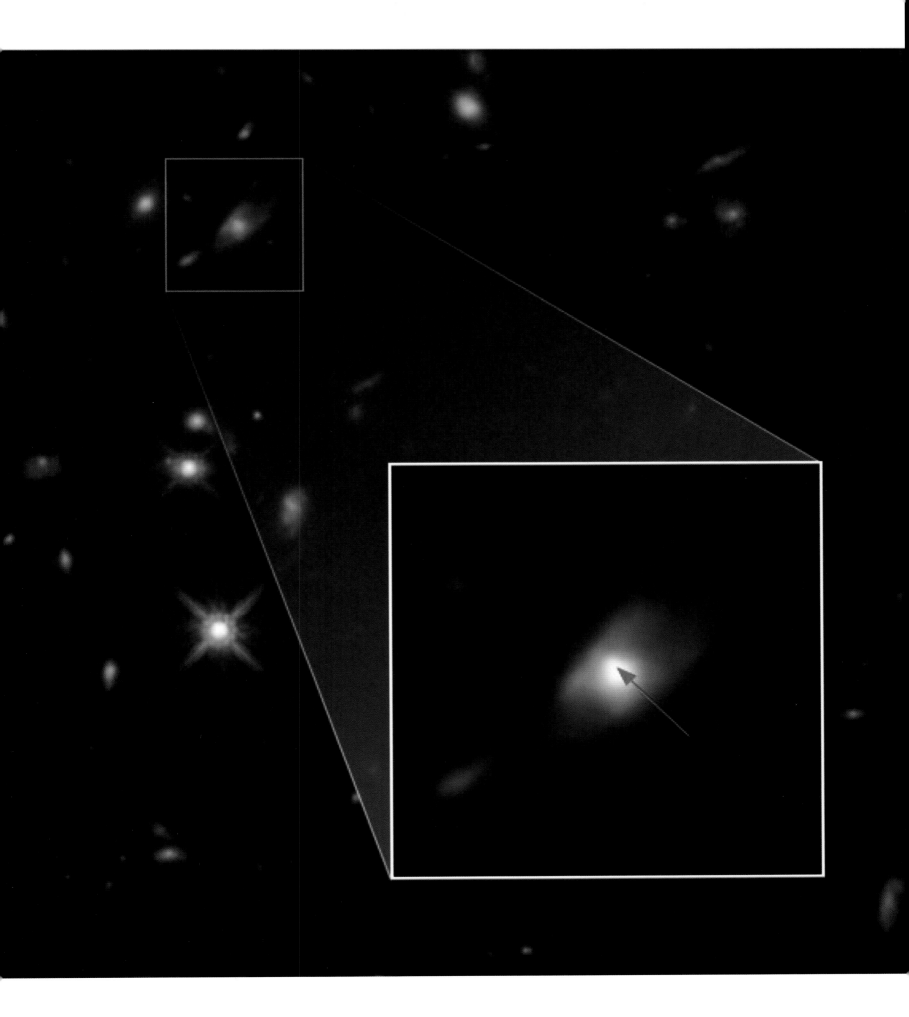

LEFT Astronomers chart the spin, or lack thereof, for black holes through the measurement of x-ray movement and distortions. Each of the spins—clockwise (prograde) or counterclockwise (retrograde)—give off explicit x-ray patterns.

1. Retrograde spin
2. Black hole
3. Accretion disk
4. No spin
5. Prograde spin

BELOW A supermassive black hole with a mass of about 4 million times that of the Sun lies at the heart of the Milky Way galaxy, in a region called Sagittarius A*, or Sgr A*. The black hole is surrounded by dense gas and dust, occupying the innermost fifteen light-years of the Milky Way. These components are overheated by strong ultraviolet radiation from massive stars that closely orbit the central black hole.

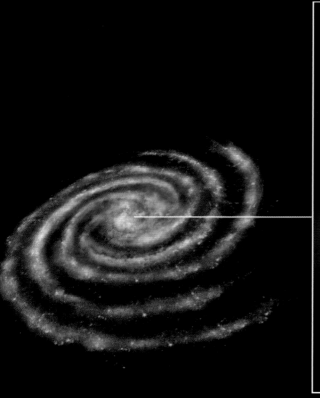

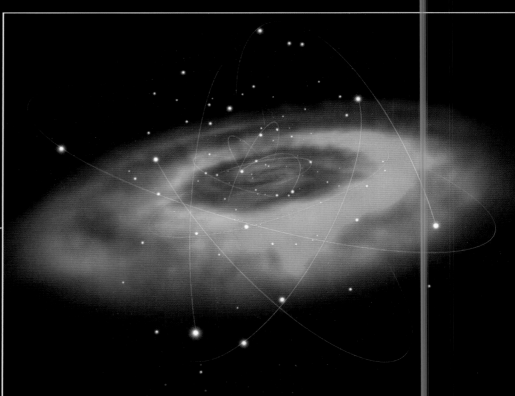

122 SMITHSONIAN ATLAS OF SPACE

ABOVE The collapse of a star into a supernova with more than three times the mass of the Sun triggers the creation of a black hole in which the gravity is so great that not even light can escape. The nascent black hole then begins to gobble up all of the matter in the vicinity, gaining strength and gravitational power through the process. Stellar-mass black holes are ubiquitous in popular culture, but until 2019 an image of one had not been captured. Scientists using the Event Horizon Telescope (EHT)—a collaboration of eight ground-based radio telescopes around the world—captured this image. The black hole's major features are easily recognized: a dark circle is silhouetted by an orbiting disk of hot, glowing matter. This supermassive black hole is located at the heart of the galaxy M87, about 55 million light-years away, and weighs more than 6 billion solar masses.

If two black holes come so close that they cannot escape each other's gravity, they will merge in a violent event to become one larger black hole. Nobody has yet witnessed a collision of black holes, but a team including astrophysicists from NASA's Goddard Space Flight Center have simulated a merger and the resulting emission of gravitational radiation.

GALAXIES AND STAR SYSTEMS

GREAT SPACE OBSERVATORIES AND WHAT WE HAVE LEARNED

With the dawn of the Space Age, astronomy underwent a tremendous transformation through the use of orbital telescopes operating across the entire electromagnetic spectrum. NASA's 2-billion-dollar Hubble Space Telescope (HST) was deployed in April 1990. Initially impaired, the HST later transformed space astronomy. But it was only the first of the great observatories.

Scientists, as well as others, expressed despair when the HST proved defective once placed in orbit. Everyone had expected Hubble to usher in an age of astronomical discovery unparalleled since Galileo turned his first telescope on the planets of the solar system, even allowing astronomers to view galaxies as far as 15 billion light-years away with greater resolution than ever before. Unfortunately, the telescope's key mirror had a "spherical aberration," a defect only one twenty-fifth the width of a human hair, which prevented the HST from focusing properly.

Due to the difficulties with the mirror, in December 1993, NASA launched the Space Shuttle *Endeavour* on a repair mission to insert corrective equipment into the telescope and to service other instruments. During a week-long mission, *Endeavour*'s astronauts conducted a record five spacewalks and successfully completed all programmed repairs to the telescope. The images returned thereafter were more than an order of magnitude (ten times) greater than before. The result has been enormously important to scientific understanding of the cosmos. Collectively, five servicing missions have extended the capabilities of the HST into the 2020s.

Among its many achievements, the most significant was the discovery that dark energy is actually accelerating the expansion of the universe. Scientists using the HST obtained the clearest images yet of galaxies that formed when the universe was a fraction of its current age. These pictures provided the first clues to those galaxies' historical development and suggested that spherical galaxies developed remarkably rapidly into their present shapes. The HST also observed Supernova 1987A, one of the most significant stellar deaths observed from Earth in the past four centuries. Finally, HST researchers have confirmed that black holes are more common than thought in the past.

TECHNICAL IMPROVEMENTS

Wide Field Planetary Camera 1

Wide Field Planetary Camera 2

The top image of the M100 Galactic nucleus, taken by the HST Wide Field Planetary Camera-1 (WF/PC1) in 1990, is juxtaposed with an image taken by Wide Field Planetary Camera-2 (WF/PC2) in 1994. The improvement after the servicing mission is striking.

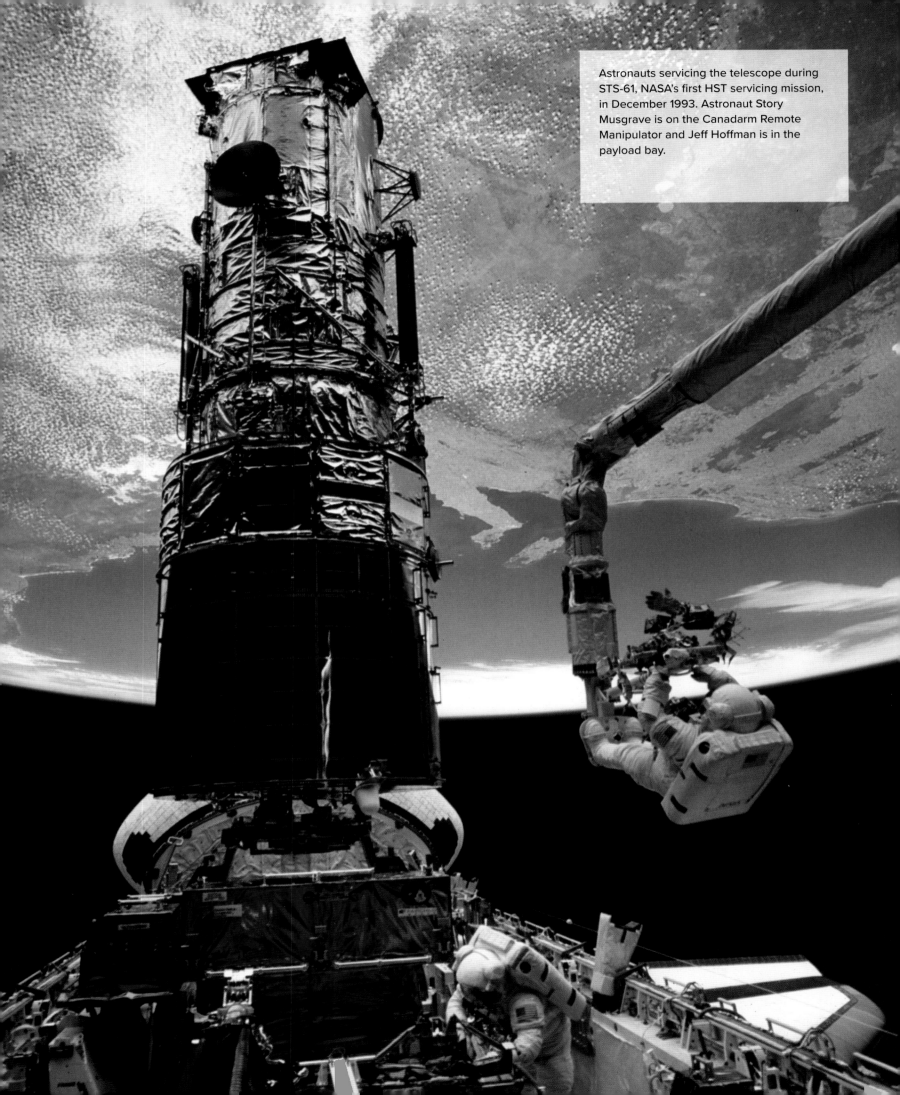

Astronauts servicing the telescope during STS-61, NASA's first HST servicing mission, in December 1993. Astronaut Story Musgrave is on the Canadarm Remote Manipulator and Jeff Hoffman is in the payload bay.

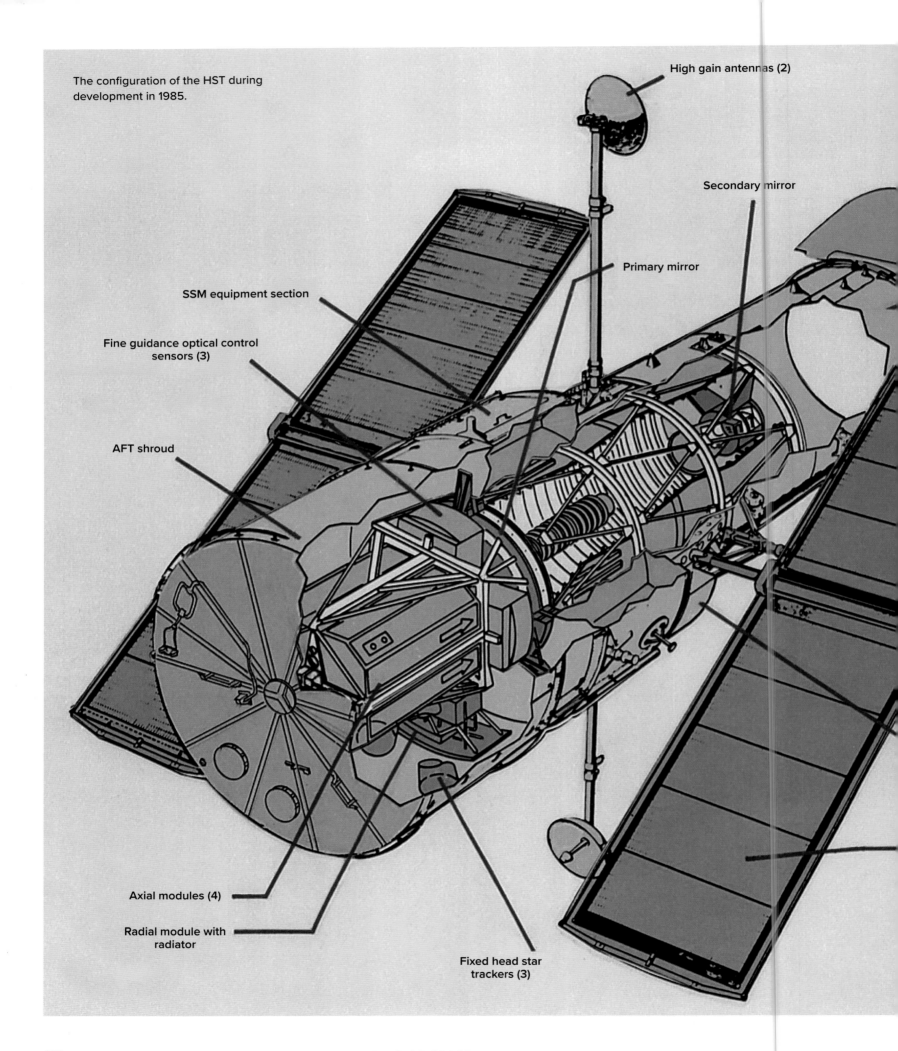

The configuration of the HST during development in 1985.

HUBBLE SPACE TELESCOPE SPECIFICATIONS

LENGTH 43.3 feet (13.2 meters)
WIDTH 13.8 feet (4.2 meters)
WEIGHT 24,490 pounds (11,110 kilograms)
POWER SOURCE Solar, 2,800 watts
LAUNCH VEHICLE Space Shuttle *Discovery*, STS-31
LAUNCH April 24, 1990
END OF MISSION Ongoing

"Scientists using the HST obtained the clearest images yet of galaxies that formed when the universe was a fraction of its current age. These pictures provided the first clues to those galaxies' historical development and suggested that spherical galaxies developed remarkably rapidly into their present shapes."

HUBBLE SERVICING MISSIONS

Mission Number	Shuttle Flight	Dates	Comments
SM1	*Endeavour* STS-61	December 2–13, 1993	First maintenance on the HST; astronauts installed equipment to correct the flaw in Hubble's primary mirror and other instruments.
SM2	*Discovery* STS-82	February 11–21, 1997	Astronauts installed new instruments to extend the HST's wavelength range to near-infared.
SM3A	*Discovery* STS-103	December 19–27, 1999	This urgent mission replaced the gyros on the HST to return it to use.
SM3B	*Columbia* STS-109	March 1–12, 2002	Astronauts replaced the HST's solar panels and installed the Advanced Camera for Surveys.
SM4	*Atlantis* STS-125	May 11–24, 2009	In a final servicing mission, astronauts installed the Cosmic Origins Spectograph and Wide Field Camera 3.

SPACE-BORNE OBSERVATORIES

Following the HST, NASA originated three additional space-borne observatories to conduct astronomical studies over different wavelengths in the 1990s. The Compton Gamma Ray Observatory (CGRO), named for Nobel Laureate physicist Arthur H. Compton, reached space on April 5, 1991, and operated until 2000. Its four instruments—Burst and Transient Source Experiment, the Oriented Scintillation Spectrometer Experiment, the Imaging Compton Telescope, and the Energetic Gamma Ray Experiment Telescope—explored the high spectral region of gamma rays that are commonly emitted by stars. Among other findings, CGRO conducted the most comprehensive survey yet of the Milky Way's center, discovering a possible antimatter "cloud" above the center, and definitively showing that the majority of gamma-ray bursts must originate in distant galaxies, rather than the Milky Way.

While intended mostly for research into high-energy radiation (gamma rays) to answer questions about cosmic evolution, the space telescope also proved useful for astrobiologists seeking to understand if life beyond Earth existed. In providing insights into the basic structure and distribution of high-energy radiation in the universe, it also offered significant data concerning the habitability of planets. Its data found use in models by researchers seeking understanding of the conditions in which planetary systems form and evolve as well as helping exoplanet researchers determine the types and locations of systems that could support habitable planets.

COMPTON GAMMA RAY OBSERVATORY SPECIFICATIONS

LENGTH 32 feet (9.75 meters)
WIDTH 24 feet (7.3 meters)
WEIGHT 35,999 pounds (16,329 kilograms)
POWER SOURCE Solar, 2,000 watts
LAUNCH VEHICLE Space Shuttle *Atlantis*, STS-37
LAUNCH April 5, 1991
END OF MISSION June 4, 2020

LAGRANGE POINTS

Lagrange points, some of the most useful locations in space, are found in groups of five where a region is gravitationally balanced between two large bodies (stars, planets, or large moons, for example). For any orbital system in which a small body orbits a more massive body, at these five points the gravitational pull from each of the bodies cancels the other out. Lagrange points are named for Italian-French mathematician Joseph Lagrange (1736–1813) who, building on the work of the Swiss mathematician Leonhard Euler (1707–83), identified the location of the five points. Of the five Lagrange points in a simple orbital system, three of them—termed L1, L2, and L3—rest along a straight line running directly through the two bodies. The remaining two points, termed L4 and L5, form the apex of two equilateral triangles, whose edges are equal to the distance between the two bodies.

Lagrange points are extremely useful in space exploration because, in the absence of gravity acting upon it, a spacecraft can maintain a stable position while expending minimal amounts of fuel. The L1 point that occurs directly between the two bodies is particularly important. The L1 point of the Earth/Sun system, for example, provides a perfect uninterrupted view of the Sun and is therefore the location of several solar observing spacecraft and solar wind experiments.

The L2 point of the Earth/Sun system was home to the WMAP spacecraft and is the current location of the JWST. L2 is ideal for astronomy, close enough to the Earth to allow ready communication with ground stations. It can also benefit from solar power arrays, and with the three brightest objects in the background (Earth, Sun, and Moon), it has a clear vision of deep space.

To date, there have been no artificial satellites placed in the Earth/Sun L3, L4, or L5 regions. L3 is on the opposite side of the solar system from Earth and is completely hidden behind the Sun. L4 and L5 may one day be useful, but as yet only asteroids exist in those regions. L5 was considered by astrophysicist Gerard K. O'Neill in the 1970s as an ideal location for large free-flying colonies in space. Perhaps, someday.

LEFT The European Space Agency (ESA)'s Gaia star survey spacecraft detects stars and takes measurements of their properties. Measuring the motion of each of these stars, astronomers are working to piece together the evolution and destiny of these bodies. As something of a census of stars, Gaia operates in a unique imaging mode. This image resulted from scanning a specific region of space on February 7, 2017, in an area called the Sagittarius I Window (Sgr-I) located only two degrees below the Milky Way's galactic center. It showed that the stellar density here is a high of 4.6 million stars per square degree. This imagery covers only about 0.6 square degrees, making it conceivable that there are some 2.8 million stars captured in this image sequence alone. The image appears in strips, each representing a single sky mapping image. Technicians then processed the image to bring out the contrast of the bright stars and darker traces of gas and dust.

RIGHT The five Lagrange points for the Sun-Earth system, shown from above the plane of the solar system. The Earth is circling the Sun in a counterclockwise orbit, with the L points remaining constant in distance from both. Satellites placed at the Lagrange points have a tendency to move slightly, but are unable to escape the gravitationally stable region around each of the Lagrange points.

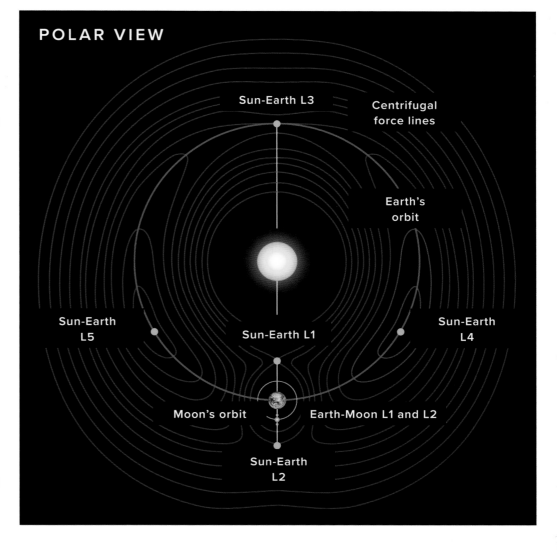

SUN-EARTH L1

1 INTERNATIONAL SUN-EARTH EXPLORER 3 (ISEE-3) (Explorer 59)
Launch date: August 12, 1978
Agency (Nation): NASA (USA)
ISEE-3 was the first spacecraft placed at a Lagrange point, operating for four years in a halo orbit at the L1 Sun-Earth point, approximately 1.5 million kilometers away from Earth (about four times the distance of the Moon) in the direction of the Sun. After the original mission ended, NASA commanded ISEE-3 to leave L1 in September 1982 to investigate comets and the Sun. Thereafter it entered a heliocentric orbit, and then made an unsuccessful attempt to return to halo orbit in 2014 with a flyby of the Earth-Moon system.

2 WIND
Launch date: November 1, 1994
Agency (Nation): NASA (USA)
Built as a comprehensive solar wind laboratory, the Wind spacecraft made several orbits through the Earth's magnetosphere. Wind went into a Lissajous orbit around the L1 Lagrange point in early 2004 to observe the unperturbed solar wind that is about to impact the magnetosphere of Earth. It was later inserted into a halo orbit about L1 in 2020, and is currently operational.

3 SOLAR AND HELIOSPHERIC OBSERVATORY (SOHO)
Launch date: December 2, 1995
Agency (Nation): ESA (EU), NASA (USA)
Orbiting near L1 since 1996, SOHO enjoys an uninterrupted view of the Sun. SOHO was designed for a mission lifetime of two years, but because of its spectacular successes, the mission was extended five times (in 1997, 2002, 2006, 2008, and 2010). It is still communicating with Earth.

4 ADVANCED COMPOSITION EXPLORER (ACE)
Launch date: August 25, 1997
Agency (Nation): NASA (USA)
With enough fuel to orbit near L1 until 2024, ACE has far exceeded its expected life span of five years and continues to provide data on space weather and give advance warning of geomagnetic storms.

5 DEEP SPACE CLIMATE OBSERVATORY (DSCOVR)
Launch date: February 11, 2015
Agency (Nation): NASA (USA)
The planned successor of the Advanced Composition Explorer (ACE) satellite maintains the nation's real-time solar wind monitoring capabilities, which are critical to the accuracy and lead time of the National Oceanic and Atmospheric Administration (NOAA)'s space weather alerts and forecasts. Without timely and accurate warnings, space weather events—like geomagnetic storms—have the potential to disrupt nearly every major public infrastructure system on Earth, including power grids, telecommunications, aviation, and GPS.

6 LISA PATHFINDER (LPF)
Launch date: December 3, 2015
Agency (Nation): ESA (EU), NASA (USA)
Arriving at L1 on January 22, 2016, LISA Pathfinder aimed to demonstrate, in a space environment, that free-falling bodies follow geodesics in space-time, by more than two orders of magnitude better than any past, present, or currently planned mission. LISA Pathfinder completed its mission and was deactivated on June 30, 2017.

7 ADITYA-L1
Launch date: September 2, 2023
Agency (Nation): ISRO (India)
The first space-based Indian mission to study the Sun reached L1 on January 6, 2024. The orbiter carries seven scientific instruments which will study the solar corona, the photosphere, and the chromosphere.

EARTH-MOON L1 AND L2

1 ARTEMIS MISSION (EXTENSION OF THEMIS)
Launch date: February 17, 2007
Agency (Nation): NASA (USA)
ARTEMIS was the first mission to orbit the Moon's Lagrangian points. The mission consists of two spacecraft, which both moved through Earth-Moon Lagrangian points and are now in lunar orbit, studying solar wind, the Moon's plasma wake, and the interaction between Earth's magnetotail and the Moon's own weak magnetism.

2 CHANG'E-5-T1 SERVICE MODULE
Launch date: October 23, 2014
Agency (Nation): CNSA (China)
The Chang'e-5 Test Vehicle, designed as a test of the strategy planned for the 2017 Chang'e-5 lunar sample return mission, arrived at L2 halo orbit on January 13, 2015.

3 QUEQIAO (CHANG'E-4 RELAY)
Launch date: May 21, 2018
Agency (Nation): CNSA (China)
Upon arrival at L2 halo orbit on June 14, 2018, Queqiao became the first ever communication relay and radio astronomy satellite operating at its location.

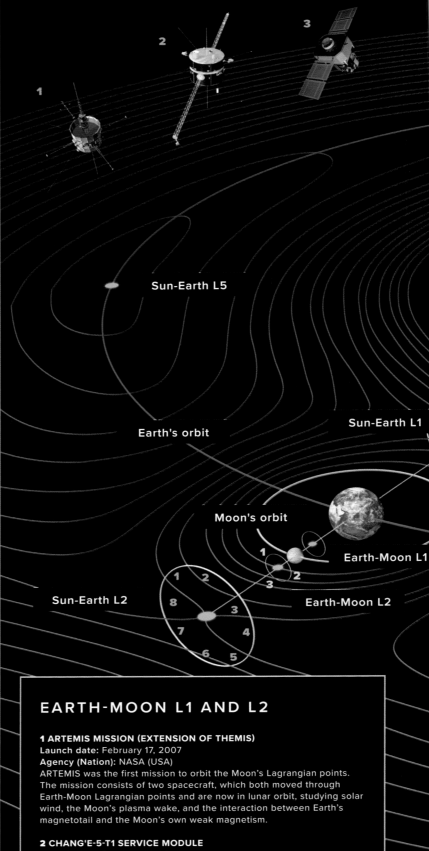

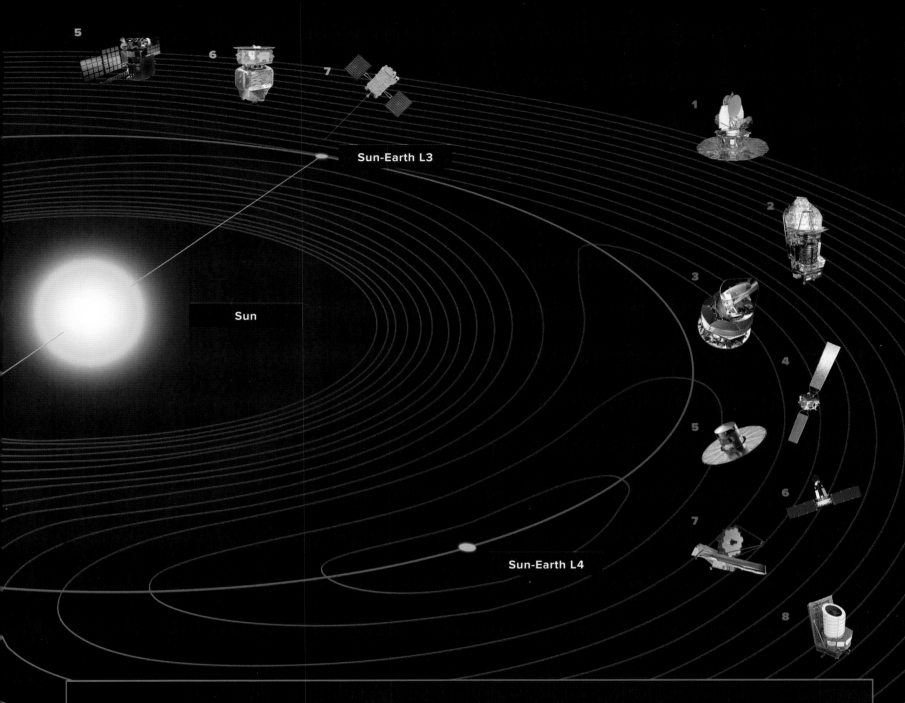

SUN-EARTH L2

1 WILKINSON MICROWAVE ANISOTROPY PROBE (WMAP)
Launch date: June 30, 2001
Agency (Nation): NASA (USA)
WMAP was designed to make fundamental discoveries in cosmology by measuring the background microwave radiation released approximately 375,000 years after the birth of the universe (see page 46). WMAP ended its mission in 2010 and was then sent to solar orbit outside L2.

2 HERSCHEL SPACE OBSERVATORY
Launch date: May 14, 2009
Agency (Nation): ESA (EU)
The Herschel Space Observatory arrived at L2 in July 2009, and ceased operation on April 28, 2013, moving to a heliocentric orbit. The mission's main tasks were the consolidation and refinement of instrument calibration, to improve data quality and data processing in order to create a body of scientifically validated data.

3 PLANCK SPACE OBSERVATORY
Launch date: May 14, 2009
Agency (Nation): ESA (EU)
Launched on the same rocket as Herschel, the Planck Space Observatory (see page 46) arrived at L2 in July 2009 to test theories of the early universe and the origin of cosmic structure. The mission ended on October 23, 2013, and Planck was then moved to a heliocentric parking orbit.

4 CHANG'E-2
Launch date: October 1, 2010
Agency (Nation): CNSA (China)
Chang'e-2 was part of the first phase of the Chinese Lunar Exploration Program. It conducted research from a 62-mile (100-kilometer) high lunar orbit in preparation for a December 2013 soft landing by the Chang'e-3 lander and rover on the Moon. After completing its primary objective, the probe left lunar orbit for the Earth-Sun L2 Lagrange point, to test the Chinese tracking and control network, arriving in August 2011. After successfully completing this test, the spacecraft departed in April 2012 to undertake an asteroid mission.

5 GAIA SPACE OBSERVATORY
Launch date: December 19, 2013
Agency (Nation): ESA (EU)
Still operational, Gaia's objective is to undertake a stellar census, mapping more than a thousand million stars throughout our Milky Way galaxy and beyond.

6 SPEKTR-RG
Launch date: July 13, 2019
Agency (Nation): RSRI (Russia), DLR (Germany)
The Spektr-RG space observatory is currently operational, studying interplanetary magnetic fields, galaxies, and black holes.

7 JAMES WEBB SPACE TELESCOPE (JWST)
Launch date: December 25, 2021
Agency (Nation): ESA (EU), NASA (USA), CSA (Canada)
The JWST, which arrived at L2 on January 24, 2022, and is still operational, detects near-infrared and mid-infrared wavelengths, allowing us to look much further back in time to the formation of the earliest galaxies (see page 48 and 54).

8 EUCLID
Launch date: July 1, 2023
Agency (Nation): ESA (EU), NASA (USA)
Designed to explore the composition and evolution of the dark Universe, Euclid arrived at L2 point on July 28, 2023, and began its survey on February 14, 2024. Over the next six years, Euclid aims to map more than one third of the sky.

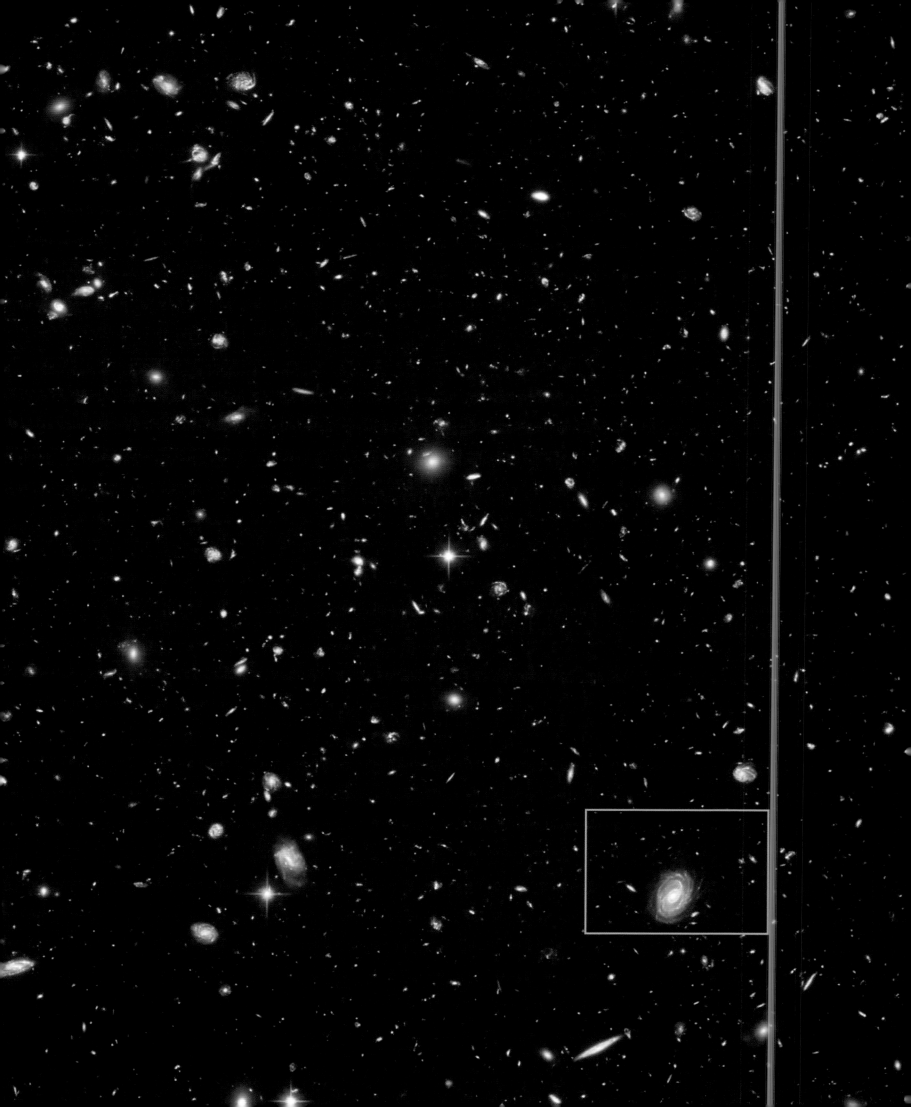

Data from two space observatories, Spitzer and the HST, was used to identify one of the most distant galaxies ever seen. On the left, galaxy HUDFJD2 is shown among approximately 10,000 others imaged in the Hubble Ultra Deep Field (HUDF). In the upper frame, right, is a blow-up showing where the galaxy is located (inside the green circle), taken with the Advanced Camera for Surveys Wide Field Channel (ACS/WFC). At center right, the same galaxy was detected using Hubble's Near-Infrared Camera and Multi-Object Spectrometer (NICMOS), although it is very faint in the near-infrared wavelengths. At the bottom right, the Spitzer Infrared Array Camera (IRAC) shows the same galaxy at longer infrared wavelengths. While the galaxy is highlighted here, the details of other objects are lost in the process.

1. Visible HST ACS/WFC
2. Infrared HST NICMOS
3. Infrared SST IRAC

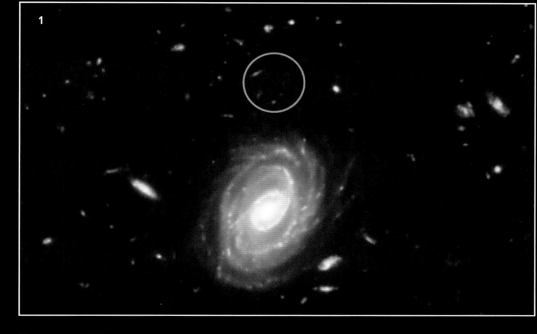

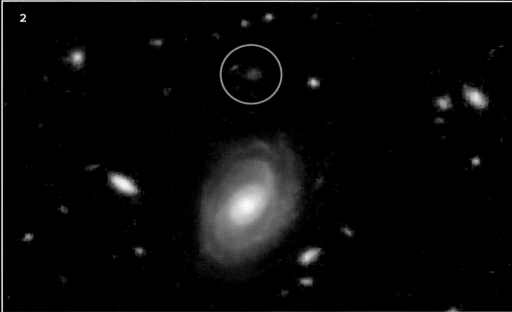

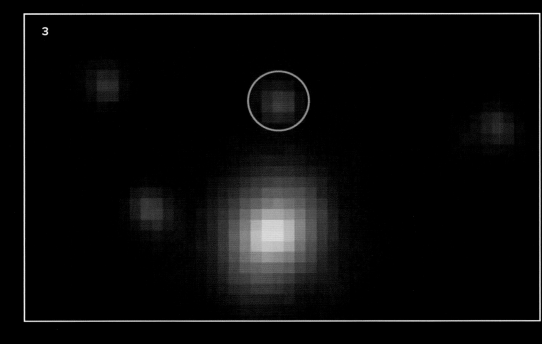

IN DEVELOPMENT

The American space program is not the only one investigating galaxies and star systems beyond our own. The ESA has a complex fleet of astronomy missions observing the universe throughout the electromagnetic spectrum. This timeline depicts individual spacecraft from various international agencies and their areas of investigation, from the launch of Cos-B in 1975 to current missions and prospects for the future.

Ariel (2029) Roman (2026)

ACTIVE

Webb (2021–) Euclid (2023–) Hubble (1990–) Gaia (2013–) Cheops (2019–)

Microwaves Sub-millimetre Infrared Optical

LEGACY

Planck (2009–2013) Herschel (2009–2013) ISO (1995–1998) Akari (2006–2011) Hipparcos (1989–1993) Corot (2006–2014)

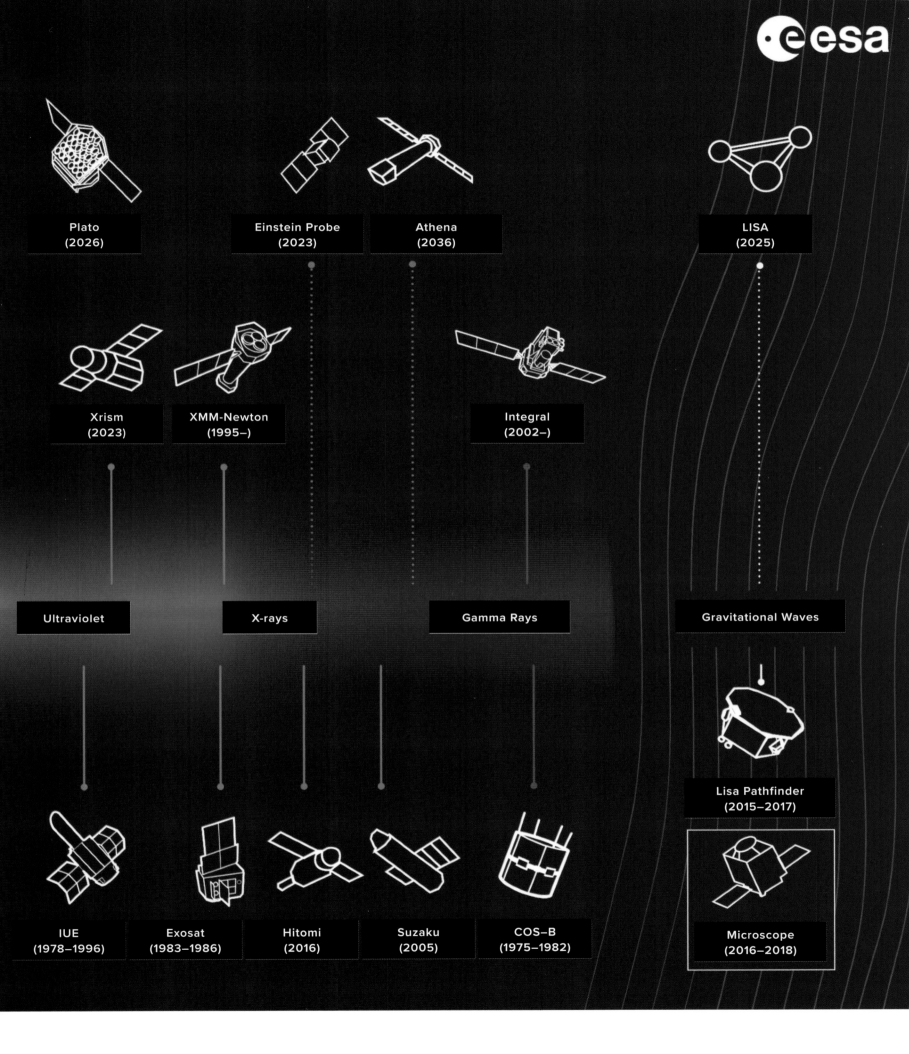

EXOPLANETS AND THE POSSIBILITY OF LIFE IN OTHER GALAXIES

While no evidence currently documents life beyond this planet, since the discovery of the first planets beyond our solar system in 1995 the search for more has advanced in ways previously unimaginable. Using new instruments, technologies, and techniques, scientists worldwide have detected and catalogued a rising number of planets around other stars.

An exoplanet, or extrasolar planet, is any planet beyond our solar system. The first exoplanet, 51 Pegasi b, later named Dimidium, was detected by Michel Mayor and Didier Queloz, of the Observatoire de Genève, Switzerland, on October 6, 1995. Fifty light-years away in the constellation Pegasus, this planet has a mass 150 times that of Earth.

By March 1, 2024, 5,640 exoplanets had been confirmed by two or more separate sets of observations. Exoplanet hunting is an international collaboration of thousands of scientists. Only after detection and confirmation by separate research teams is the discovery officially registered. There are also more than 10,130 detections that have yet to be confirmed. Most are gas giants (like Jupiter and Saturn in our solar system), but there are also more than a thousand rocky-type planets.

THE KEPLER SPACE TELESCOPE

Scientists made an important step in the direction of an Earth-type planet discovery with the launch in 2009 of the Kepler spacecraft. In 2013 it found Kepler-62f, a planet only 40 percent larger than Earth, located in the habitable zone of another star in the constellation Lyra, about 1,200 light-years from Earth.

Kepler, specifically built to find exoplanets using sensitive imaging technology and indirect light-curve measurement, was operated between 2009 and 2018, finding more than 2,600 exoplanets. Most importantly, Kepler revealed that there are more planets than stars in our galaxy and adjusted our thinking on the broad diversity of worlds beyond our solar system.

Although Earth-sized planets have not yet been discovered, the search continues. What might this portend for the future? Using advanced observation techniques, there is a likelihood scientists will someday spot a blue and white planet with liquid water and a breathable atmosphere.

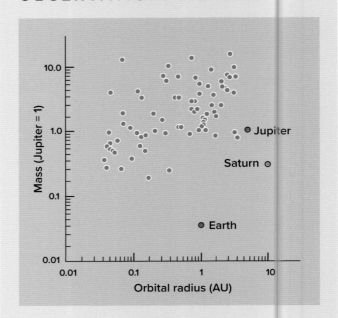

OBSERVATIONAL LIMITS

This chart shows the mass and orbital distance of some of the planets discovered orbiting other stars. Jupiter, Saturn, and Earth are shown for comparison. Due to the limited ability of human technology, planets discovered so far are large and often orbit close to their parent star. This does not mean Earth-like planets do not exist, only that larger, more complex space-based instruments will be needed to find them.

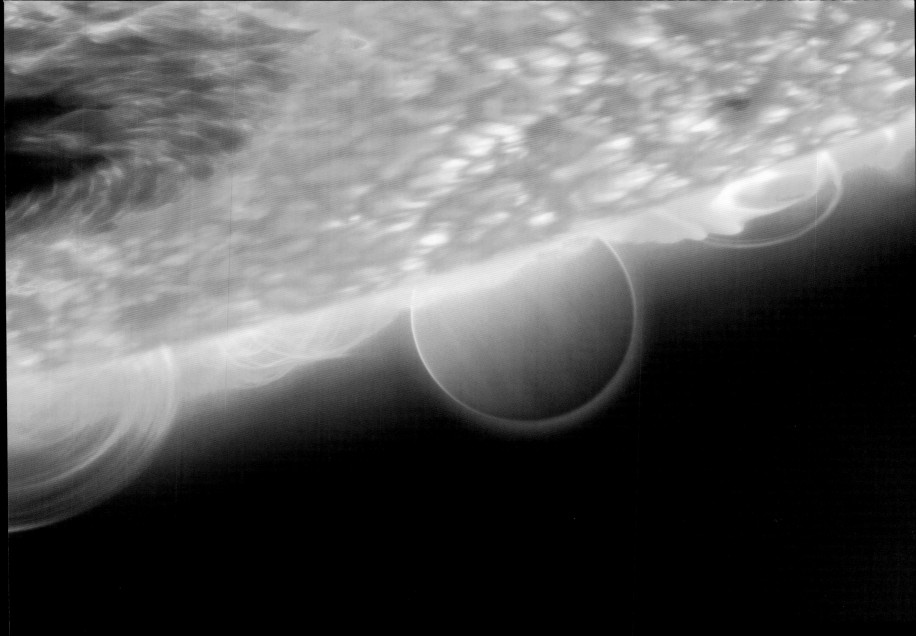

ABOVE Discovered in 2009 by the Hubble Space Telescope (HST), this Jupiter-sized planet, designated HD 189733b or 51 Pegasi b, has organic compounds aplenty but is too hot for life as we understand it. These observations, however, demonstrated that the basic chemistry for life can be measured on planets orbiting other stars.

LEFT The Kepler spacecraft undertook NASA's first planet-hunting mission.

OGLE-2014-BLG-0124L

Microlensing exoplanets

Our solar system

One of the most distant planets known is a gas giant about 13,000 light-years from Earth, OGLE-2014-BLG-0124L. Using the microlensing technique of indirect observation (see pages 30 and 84), the planets detected in this way are shown in yellow. The planets lie in a Milky Way star system 25,000 light-years from Earth.

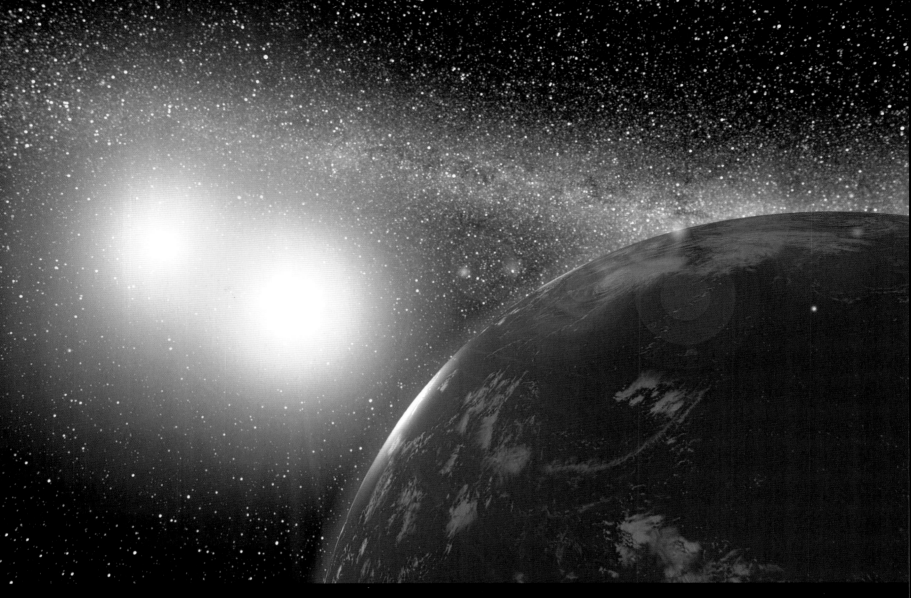

ABOVE In a 2017 study in the journal *Nature Communications*, researchers investigating the climates of exoplanets determined that this hypothetical planet, covered in water and located around the binary star system of Kepler-35A and B, could be habitable, depending on its distance from the two stars.

OVERLEAF A comparison of our solar system with three other systems containing exoplanets suggests that we may find Earth-like planets in the next few years.

"By March 1, 2024, 5,640 exoplanets had been confirmed by two or more separate sets of observations."

SUN
Mass: 1.989×10^{30} kg, about 333,000 times the mass of the Earth
Radius: 696,340 km

OUR INNER SOLAR SYSTEM

MERCURY
Planet mass: 3.3×10^{23} kg
Planet radius: 2,439.7 km

VENUS
Planet mass: 0.87×10^{24} kg
Planet radius: 6,051.8 km

EARTH
Planet mass: 5.972×10^{24} kg
Planet radius: 6,371 km

MARS
Planet mass: 0.42×10^{23} kg
Planet radius: 3,389.5 km

KEPLER-22
Sun-like hydrogen-fusing dwarf of the spectral type G5V.
Mass: 1.929×10^{30} kg
Radius: 681,090 km

KEPLER-22 SYSTEM
635 light-years from Earth

KEPLER-22 B
Super Earth
Planet mass: 9.1 Earths
Planet radius: 2.1 × Earth

KEPLER-186 B
Super Earth
Planet mass: 1.24 Earths
Planet radius: 1.07 × Earth

KEPLER-186 C
Super Earth
Planet mass: 2.1 Earths
Planet radius: 1.25 × Earth

KEPLER-186 D
Super Earth
Planet mass: 2.54 Earths
Planet radius: 1.4 × Earth

KEPLER-186 E
Super Earth
Planet mass: 2.15 Earths
Planet radius: 1.27 × Earth

KEPLER-186
M-type red dwarf.
Mass: 1.082×10^{30} kg
Radius: 363,850 km

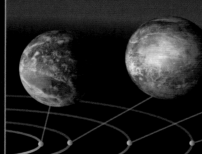

KEPLER-186 SYSTEM
579 light-years from Earth—discovered in 2014

TRAPPIST-1 B
Super Earth
Planet mass: 1.374 Earths
Planet radius: 1.116 × Earth

TRAPPIST-1 C
Super Earth
Planet mass: 1.308 Earths
Planet radius: 1.097 × Earth

TRAPPIST-1 D
Terrestrial
Planet mass: 0.388 Earths
Planet radius: 0.788 × Earth

TRAPPIST-1 E
Terrestrial
Planet mass: 0.692 Earths
Planet radius: 0.92 × Earth

TRAPPIST-1 F
Super Earth
Planet mass: 1.039 Earths
Planet radius: 1.045 × Earth

TRAPPIST-1
Ultra-cool red dwarf star, also called an M dwarf.
Mass: 1.77×10^{29} kg
Radius: 84,180 km

TRAPPIST-1 SYSTEM
41 light-years from Earth—discovered in 2016–17

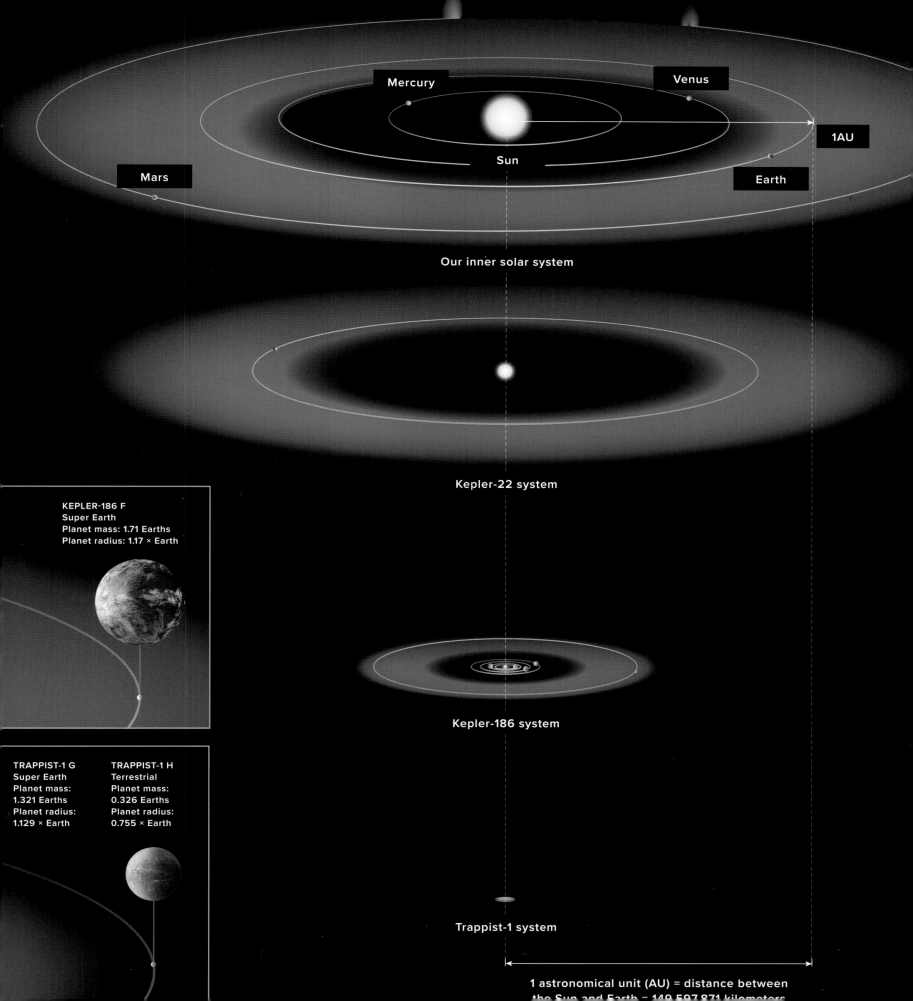

Though this artist's impression of exoplanet systems emphasizes how common planets might be around stars in the Milky Way, the artist took considerable license with this illustration; the planets, their orbits, and their host stars are all vastly magnified compared to reality.

GALAXIES AND STAR SYSTEMS

THE SEARCH FOR EXTRATERRESTRIAL INTELLIGENCE

Jill Tarter, US astrobiologist and former director of the Search for Extraterrestrial Intelligence (SETI) Institute in California, famously observed, "The existence of life beyond Earth is an ancient human concern. Over the years, however, attempts to understand humanity's place in the cosmos through science often got hijacked by wishful thinking or fabricated tales." Her statement points to two truths of the possibility of life in the cosmos: humans want to believe it is out there, and our imaginations sometimes outpace our knowledge.

Scientists have long sought to determine if life exists beyond Earth. No one knows how many habitable planets exist in our stellar neighborhood, but learning that is the first task. After finding those planets, a core question is what percentage of them might have evolved life forms with which we might communicate? Some scientists believe that this type of life exists everywhere; others believe that it is remarkably rare. No one knows for sure.

A program to search for extraterrestrial intelligence has been underway since the early 1970s. Any intelligent life that uses technology should be quite noisy, perhaps broadcasting radio and television waves in the same way that humans have been doing for more than a century. In 1960, US astrophysicist Frank Drake trained the National Radio Astronomy Observatory's 80 foot- (24 meter-) wide radio telescope at Epsilon Eridani, a sunlike star some ten light-years away. Unfortunately, he only received an Earth-based transmission, but others have followed Drake's example. During the 1970s, NASA supported some of this research, but in 1993 the US Congress terminated all tax-supported funding for SETI, deeming the project too fantastic to warrant tax-funded support. SETI advocates continued the search using private funding.

For each observation of a solitary star, signal-detection computers examine tens of millions of channels within a 10 MHz bandwidth. The computers filter out signals from ground-based sources on Earth and satellites in Earth orbit. They compare signals to the universe's natural background noise, and any strange or unfamiliar signal triggers a Follow-Up Detection Device. Two separate radio telescopes, hundreds of miles apart, track the signal. No artificial signal has been confirmed as yet. One could come tomorrow; it may never come at all.

The search for extraterrestrial life continues to the present.

THE VERY LARGE ARRAY

The Very Large Array (VLA) radio telescope array located near Socorro, New Mexico, is operated by the National Radio Astronomy Observatory and managed by Associated Universities, Inc., under a cooperative agreement with National Science Foundation (NSF). Built in the 1970s, and upgraded periodically thereafter, this array serves many purposes in radio astronomy, including for research associated with the search for extraterrestrial intelligence. The array was also featured in the movie *Contact* (1997), where it played a key role in providing the central character, played by Jodie Foster, contact with alien intelligence.

ABOVE SETI scientist Seth Shostak explains to an audience at NASA Ames Research Center in 2008 that SETI is not looking for "little green men." It is, however, asking the question: "When will we discover the extraterrestrials?"

TOP Jill Tarter, on whom Jodie Foster's character in *Contact* (1997) is based, pictured at her SETI office in 1988. Completing her PhD in astrophysics at the University of California at Berkeley in 1975, Tarter worked on NASA's High Resolution Microwave Survey (HRMS) and other projects. She is best known for her work on SETI and served as director of the Center for SETI Research, eventually moving on to the Bernard M. Oliver Chair for SETI at the SETI Institute.

ABOVE Frank Drake working through his "Drake Equation," which predicts that there are any number of possible civilizations in the universe.

TOP The SETI multichannel spectrum analyzer (MCSA) from Stanford University was used in the first SETI sky survey in 1984. A spectrum analyzer measures the magnitude of an input signal versus frequency, in this case over several channels. To the average viewer it looks like an oscilloscope; it displays frequency on the horizontal axis and amplitude on the vertical axis. It is a critical technology in seeking out radio signals from beyond Earth.

3 THE OUTER SOLAR SYSTEM

Eris, formerly known as Xena, was one of the new discoveries of small planetary bodies in the solar system that led to the establishment of the dwarf planet designation.

At its simplest, the solar system may be divided into three zones. The first zone—the inner solar system, closest to the Sun—contains the rocky planets Mercury, Venus, Earth, and Mars. Known as terrestrial planets because they have compact, rocky surfaces, these planets occupy a habitable area sometimes called the "Goldilocks zone"—the region around a star that has conditions supporting the possibility of liquid water, the necessary building block of life as we understand it. Fundamentally, this means that the region has at least some planets with temperatures high enough to maintain liquid water.

Together, the second and third zones comprise what is also known as the outer solar system—the region beyond the orbit of Mars of which very little was known until the Space Age—which will be our focus in this chapter. Even in the twenty-first century, it remains a mysterious place.

The second zone contains the Asteroid Belt between Mars and Jupiter—consisting of thousands of rocky and metallic bodies—and the four gas giant planets: Jupiter, Saturn, Uranus, and Neptune. This zone, and in particular these Jovian planets, have enamored astronomers from the time that Galileo turned the first telescope on them in 1610. The term Jovian is derived from Jupiter, the largest of the outer planets, and refers to the region where water, ammonia, and methane exist insofar as we know only in a frozen state. Little wonder that as soon as the opportunity permitted, spacecraft began to visit these giants.

The third zone includes the Kuiper Belt, of which Pluto is the most famous (but not the largest) body, and the Oort Cloud of distant long-period comets and other icy objects at the outer limits of the Sun. This is perhaps the most enigmatic part of the solar system as it has only been explored by one spacecraft, New Horizons (see page 166). The icy dwarf planets represent a fascinating puzzle, and efforts to explore this farthest zone of the solar system have recently begun.

While we have visited every planet of the solar system at least once, exploring the outer planets requires technologies, scientific inquiries, and timescales far more complex than those demanded by the closer, more Earth-like terrestrial planets. Some of these worlds may well hold life of some type; it's doubtful it will be a type with which we might communicate, but microbial forms of life may indeed be plentiful. Exploring these bodies—from gas giants, through tiny meteors and asteroids, to the farthest reaches of the solar system—has revolutionized our understanding of the region in which we dwell. This search for knowledge has also allowed humans to appreciate the complexity of the universe as never before and ponder in new ways our place in the cosmos.

Beginning with the Oort Cloud, heliosphere, and the outer Kuiper Belt, this chapter will reveal some of the most engaging mysteries uncovered in the farthest realms of our planetary system, but will also point to some of the great unsolved questions looming there.

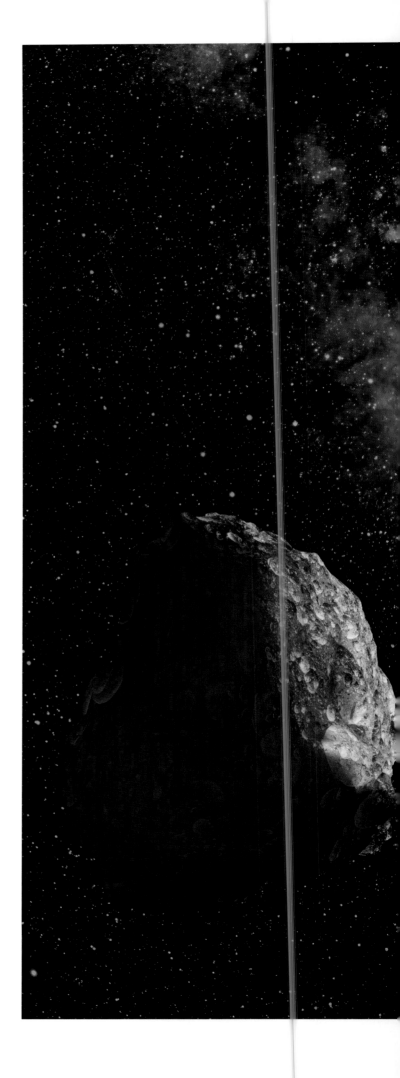

A Kuiper Belt Object (KBO) at the outer edge of the solar system, some 4 billion miles (6.5 billion kilometers) from the Sun. Residing so far away, KBOs receive little heat and light from the Sun, meaning they offer pristine, frozen samples of the solar system's makeup near the time of its birth some 4.6 billion years ago.

THE OUTER SOLAR SYSTEM

THE FARTHEST REACHES OF THE SOLAR SYSTEM

The outer edge of our solar system remains a mysterious place, though we know it to be made up of three discrete elements. At the furthest reaches is the Oort Cloud, which contains icy planetesimals, comets, and asteroids. Moving inwards, we encounter the heliosphere, where the solar system meets interstellar space, and then the Kuiper Belt, containing massive amounts of small bodies locked in orbit beyond the planets in the outer part of the solar system.

In the first half of the twentieth century, astronomers searched unsuccessfully for what they called Planet X. Gravitational measurements suggested that a large mass had to be at the outer edge of the solar system, and in 1930 American astronomer Clyde Tombaugh (1906–97) discovered Pluto. It was immediately christened the ninth planet, but something was amiss—Pluto's mass was insufficient to account for the gravitational pull from the outer solar system. So what could it be that was out there?

In 1950, Dutch astronomer Jan Oort came up with a theory based on observations of the comets and meteors that seemed to travel toward Earth from the outer solar system. The hypothesis now named for him posited that instead of a single Planet X, a vast cloud encapsulating the solar system made up of comets, asteroids, and other small, icy objects collectively asserted the observed gravitational pull. Oort's theory set in motion a search for more complex explanations, in which small outer solar system objects played a profound role in solar system evolution. The Oort Cloud might be the remnants of the original solar nebular that contracted, condensed, and created the planets we know. Current estimates of its size range between 2,000 and 200,000 astronomical units (AU: a measure of distance between the Sun and Earth), taking it out as far as one-tenth of the distance to the nearest star system, Alpha Centauri 3, which lies 4.2 light-years, or 267,000 AU, away. To make this distance a little more understandable, if a spacecraft went there at a speed equaled by Voyager 1 (51 AU from Earth over its first sixteen years), the trip would take 83,764.7 years to complete.

The Oort Cloud lies just outside the Sun's heliosphere—a vast bubble-like region of space formed by the solar wind, a constant flow of charged particles sent out by the Sun. The heliosphere shields the solar system from significant amounts of cosmic energy and radiation, some of which are captured there and some repelled by the gravitational field. At its theoretical boundary, the heliopause, particles from the solar system meet

JAN HENDRIK OORT (1900–92)

This noted Dutch astronomer made significant discoveries through a long career from his base at Leiden University in the Netherlands. A pioneer in radio astronomy, Oort famously discovered that the Milky Way, far from the proposed static grouping of star systems, rotated in a gravity-locked process around a dense center. He demonstrated that the Milky Way had a mass 100 billion times that of our Sun and, contrary to earlier conceptions, he also realized that our Sun was far removed from the center and resided in a gravitationally-bound arm circling it. Oort likewise studied dark matter, suggesting that as much as 84.5 percent of the universe might be made of this matter that could not be observed through any conventional means. Finally, he theorized in 1950 that the majority of comets came from the outer solar system, where small bodies were gravitationally bound. Evidence for this has grown over time and scientists have determined that the objects in the Oort Cloud, named for its discoverer, are easily affected by the gravitational pull of stars, the Milky Way, and bodies in the solar system.

ABOVE The Near-Earth Object Wide-Field Infrared Survey Explorer (NEOWISE) space telescope has been operating since 2009. On February 25, 2019, it captured Comet C/2018 Y1 Iwamoto in multiple exposures in infrared light, about 56 million miles (90 million kilometers) from Earth. Originating from the Oort Cloud, C/2018 Y1 Iwamoto's orbit brought it closer to the Sun than it has been in more than a thousand years. The comet appears as a string of red dots across the star field beyond.

RIGHT Scientific data from several spacecraft allowed the creation of this drawing of the solar system's heliosphere as it meets interstellar space. A solar wind, shown in blue, flows outward from the Sun until its movement is slowed and ultimately stopped by cosmic forces beyond. This creates a "bubble," with the heat and energy in various parts of this bubble depicted here in different colors, red being the warmest. The boundary between the "bubble" and interstellar space is known as the heliosphere, which is also constantly moving and interacting with other particles.

THE OUTER SOLAR SYSTEM

interstellar space. Here, the heliosphere encounters cosmic disturbances only presently being studied.

Moving inwards, the third element to be found at the edge of our solar system is the Kuiper Belt, a disk-shaped region of icy debris about 2.8 to 4.6 billion miles (4.5 to 7.5 billion kilometers), or 30 to 50 AU from the Sun. The Kuiper Belt is often referred to as our "final frontier," because of its location beyond the eight planets making up our solar system. Named for astrophysicist Gerard Kuiper, who theorized that the outer solar system was home to thousands of captured icy bodies, it is the major source of comets coming toward Earth.

Only in 1992 did observations clarify the existence of the Kuiper Belt, in particular through the detection of a 150-mile (241-kilometer) wide body designated 1992 QB1, later named Albion. This, the first trans-Neptunian object (any object which orbits the Sun at a greater average distance than Neptune) discovered after Pluto and its moon Charon, was small—less than 70 miles (113 kilometers) in diameter—but significant because it sparked a race to discover other bodies in this region. By the first part of the twenty-first century, nearly 2,000 Kuiper Belt Objects (KBOs) had been found.

Many KBOs are heavily endowed with organic (carbon-bearing) molecules and water ice. Sometimes they journey into the inner solar system, and one, Comet Halley, is on a cycle, returning every seventy-six years.

GERARD P. KUIPER (1905–73)

Dutch-born astronomer Gerard P. Kuiper dedicated himself to solar system observation. Alongside his theorization of the Kuiper Belt, named in his honor, he built a major planetary science organization at the University of Arizona. Just as NASA was setting up, Kuiper stepped forward to obtain considerable support to conduct planetary studies. He embraced the lunar exploration program of the 1960s—which many other space scientists thought was too expensive, believing that the best space science could be conducted using robotic probes—and worked to form questions about the Moon, develop instruments for answering those questions, and identify landing sites.

There are many known trans-Neptunian objects. KBOs are shown in blue tints, while objects in the more distant region are in red. The relative size of bodies is reflected in the size of the circles. Colored horizontal lines indicate the minimum and maximum distance of an orbit. Objects in 3:2 resonance orbits, including Pluto, revolve around the Sun three times for every two orbits of Neptune. Sedna moves beyond the horizontal access scale, reaching a maximum distance of about 975 AU.

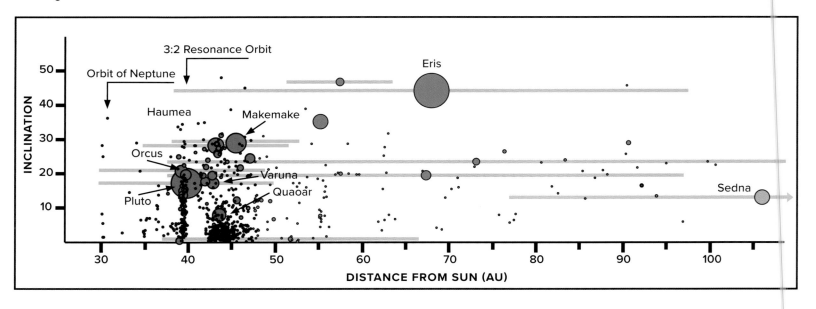

RIGHT The Kuiper Belt and the individual orbits of the four largest objects beyond Neptune are shown here. The scattered disk contains KBOs that were "scattered" into eccentric and inclined orbits by gravitational interaction with Neptune and the other outer planets, which play a central role in determining the distribution of KBOs. Most bodies within about 40 AU, or forty times the Sun–Earth distance, are linked to the movements of Neptune. Beyond this distance, most objects do not interact with Neptune and therefore have more complex orbits.

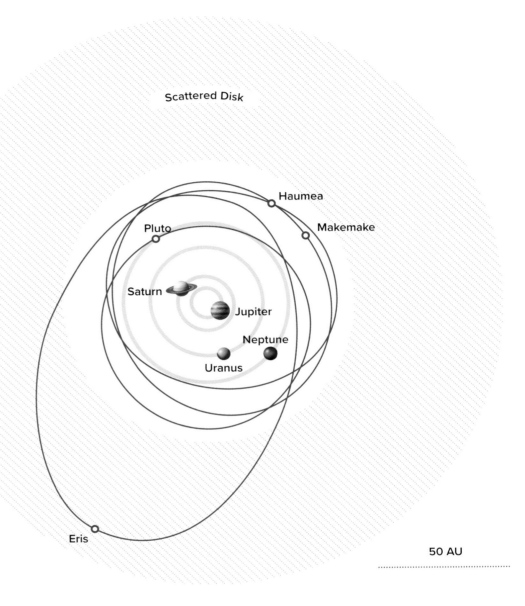

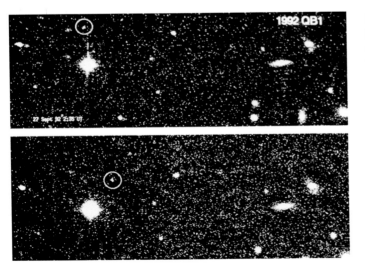

LEFT The first known KBO, 1992 QB1 (or Albion, circled), was discovered by astronomers David Jewitt and Janet Luu in 1992.

THE OUTER SOLAR SYSTEM

"Named for astrophysicist Gerard Kuiper, who theorized that the outer solar system was home to thousands of captured icy bodies, the Kuiper Belt is the major source of comets coming toward Earth."

The KBO 2003 UB313 (initially nicknamed Xena and later changed to Eris) and its satellite Gabrielle are located at the outer edge of the solar system. In the early twenty-first century, ground-based astronomers detected Eris and measured it at about thirty percent larger than the diameter of Pluto. The Hubble Space Telescope (HST) then trained its Advanced Camera for Surveys on the object, taking images on December 9 and 10, 2005, which found Eris to have a diameter of 1,490 miles (2,398 kilometers), with an uncertainty of 60 miles (97 kilometers). Pluto, famed since its discovery in 1930, was actually smaller, at only 1,422 miles (2,288 kilometers) in diameter. Eris may be seen in this illustration as the large object at the bottom, a portion of which is lit by the Sun. Located in the upper left corner of the image is Gabrielle, orbiting Eris.

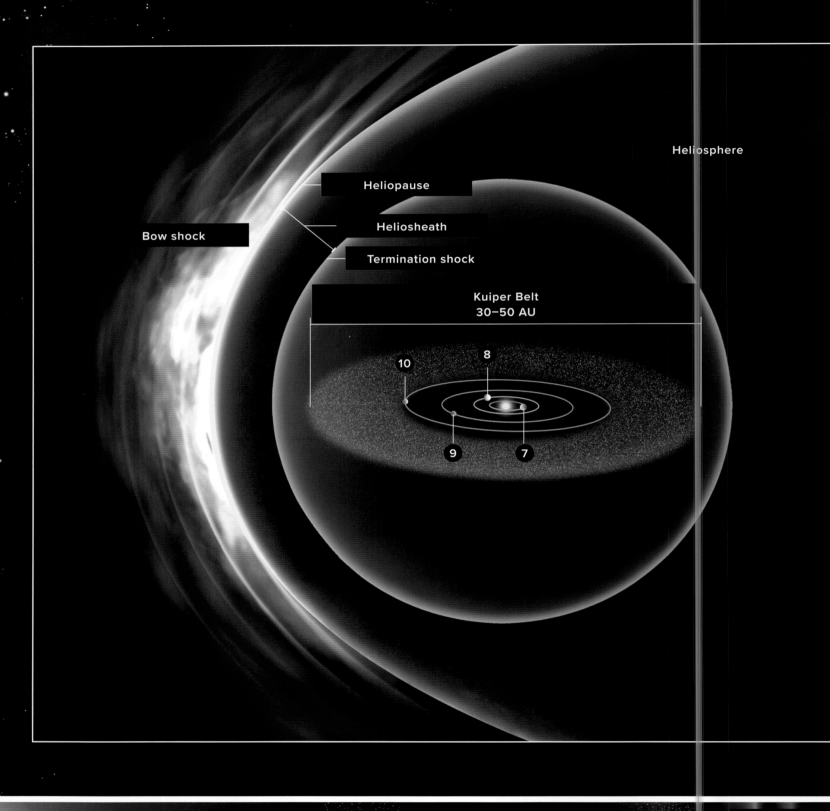
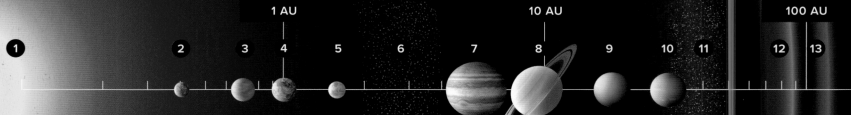

The heliosphere encloses our solar system and extends past the orbit of Pluto. The area at the edge of the heliosphere, where the solar wind slows down and begins to interact with the interstellar medium is called the heliosheath. As the solar system moves through space, it encounters cosmic energy from interstellar space, depicted here at the right of this illustration, and the bow shock (see page 106) between the two causes an elongation on the trailing edge. At the point the solar system encounters the interstellar medium, a compressed and turbulent heliopause serves as the boundary between them, where they are in equilibrium. The termination shock is at the innermost part of the boundary between the solar system and interstellar space. The scale at the bottom of this illustration depicts the size of the solar system in relation to other cosmic objects.

1. Sun
2. Mercury
3. Venus
4. Earth
5. Mars
6. Asteroid Belt 2–5 AU
7. Jupiter
8. Saturn
9. Uranus
10. Neptune
11. Kuiper Belt 30–50 AU
12. Termination shock 70–90 AU
13. Heliosphere 123 AU
14. Oort Cloud 1,000–100,000 AU

1,000 AU 10,000 AU 100,000 AU

LOGARITHMIC SCALE

THE PROBLEMATIC PLANET, PLUTO

In 1930, after years of searching for a mythical Planet X, Clyde Tombaugh discovered Pluto. It was immediately accepted as the ninth planet in our solar system, but when similarly sized objects were found in the 1990s, efforts to change Pluto's status began.

Astronomers debating Pluto's planetary status soon reached a crescendo. The 2003 discovery of the dwarf planet 2003 UB313 (Eris), larger than Pluto, sealed the deal. The nine-planet solar system as we knew it needed to change.

At the International Astronomical Union (IAU) meeting in 2006, scientists redesignated Pluto as a "dwarf planet," of which there are now officially five: Ceres, Pluto, Haumea, Makemake, and Eris. Scientists based this redesignation on three clear criteria for planetary status: (a) it is in orbit around the Sun; (b) it has sufficient mass for its gravity to make it nearly round; (c) it has cleared the neighborhood of other bodies around its orbit. In Pluto's case, while it is in orbit around the Sun and is round, it failed to have sufficient gravity to clear bodies around it. Indeed, Pluto and its moons—Charon, Styx, Nix, Kerberos, and Hydra—represent a system that also has other smaller bodies circling nearby.

Some refused to accept the demotion of Pluto to dwarf planet status, but the IAU decision made sense. It acknowledged how the scientific method worked to further understanding, and the ways in which new discoveries lead to necessary modification of what we think we know about the universe.

CLYDE TOMBAUGH (1906–97)

Clyde Tombaugh worked as an astronomer at the Lowell Observatory in Flagstaff, Arizona, and gained international fame for the discovery of Pluto. He continued to work on outer solar system astronomy thereafter and also discovered many asteroids.

In this image, Tombaugh poses with a blink comparator, used to check images of the night sky taken at the same time a few nights apart. Through this process an observer could switch back and forth between two images to note the similarities and differences.

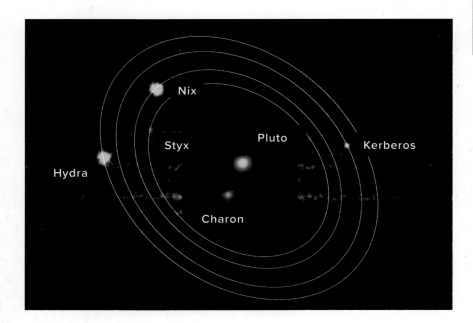

LEFT In July 2012 scientists working with imagery from the Hubble Space Telescope (HST) discovered Pluto's four small moons: Nix, Hydra, Styx, and Kerberos. This is a composite of two images of the Pluto system taken by the HST. The blue areas were generated by a long exposure which captured the tiny outer moons but greatly oversaturated Pluto and Charon. The dark central vertical band is from a shorter exposure, designed to show Pluto and Charon more clearly.

The New Horizons spacecraft (see page 166) approached the dwarf planet Pluto in late 2014. This image was captured on July 14, 2015, at a range of approximately 21,100 miles (33,900 kilometers) from Pluto. New Horizons made its closest approach about 45 minutes later.

PLUTO FAST FACTS

MEAN DISTANCE FROM SUN 3,670,050,000 miles (5,906,380,000 kilometers) or 39.48 astronomical units (AU)
DIAMETER 1,485.08 miles (2,390 kilometers)
DENSITY 1.1 grams/cubic centimeters
SURFACE GRAVITY 0.066 (Earth = 1)
ROTATION PERIOD (LENGTH OF DAY) 6.39 Earth days (spins backward compared to other planets)

REVOLUTION PERIOD (LENGTH OF YEAR) 248 Earth years
MEAN SURFACE TEMPERATURE -355.63 degrees Fahrenheit (-215.35 degrees Celcius)
NATURAL SATELLITES Charon, Styx, Nix, Kerberos, Hydra
DISCOVERER Astronomer Clyde Tombaugh, February 18, 1930

PLUTO AND THE NEW HORIZONS PROBE

Even as scientists debated Pluto's status, NASA undertook a mission there. After its launch in January 2006, New Horizons made its closest approach to Pluto on July 14, 2015. The spacecraft contained scientific instruments to map the geology and composition of Pluto, investigate Pluto's atmosphere, measure the solar wind, and assess interplanetary dust and other particles. New Horizons proved a boon for outer planetary exploration. Its flyby of Pluto, according to Principal Investigator Alan Stern of the Southwest Research Institute in Boulder, Colorado, yielded this top six list of discoveries:

1. The complexity of Pluto and its satellites is far beyond what we expected.
2. The degree of current activity and change on Pluto's surface is simply astounding.
3. Charon's enormous equatorial extensional tectonic belt hints at the freezing of a former water-ice ocean inside Charon in the distant past. Other evidence found by New Horizons indicates Pluto could have an internal water-ice ocean today.
4. Pluto's vast 620-mile (1,000-kilometer) wide heart-shaped nitrogen glacier (informally called Sputnik Planum), which New Horizons discovered, is the largest known glacier in the solar system.
5. Pluto shows evidence of vast changes in atmospheric pressure and, possibly, past presence of running or standing liquid volatiles on its surface—something only seen on Earth, Mars, and Saturn's moon Titan in our solar system.
6. Pluto's atmosphere is blue.

After passing Pluto, controllers flew New Horizons by other Kuiper Belt Objects (KBOs), continuing its mission.

NEW HORIZONS SPECIFICATIONS

LENGTH 8.9 feet (2.7 meters)
WIDTH 7.2 feet (2.2 meters)
HEIGHT 6.9 feet (2.1 meters)
WEIGHT 1,054 pounds (478 kilograms)
POWER SOURCE Radioisotope thermoelectric generator
LAUNCH VEHICLE Atlas V 551
LAUNCH DATE January 19, 2006
PLUTO CLOSEST APPROACH June 14, 2015; distance 7,800 miles (12,500 kilometers)
END OF MISSION Currently scheduled for October 1, 2024, but could be extended

ALAN STERN (1957–)

After completing his PhD in astrophysics and planetary science from the University of Colorado, Boulder, Alan Stern played key roles in the Rosetta mission to orbit a comet and the Lunar Reconnaissance Orbiter, which confirmed the presence of ice at the Moon's poles. Most importantly, he steered the development of the New Horizons mission in the first part of the twenty-first century. Thereafter, he served as chief scientist on the Moon express mission and worked as NASA's Associate Administrator for the Science Mission Directorate in 2007 and 2008.

LEFT The New Horizons spacecraft in the vicinity of Pluto.

BELOW New Horizons being prepared for launch at the Kennedy Space Center, Florida, in 2006.

THE OUTER SOLAR SYSTEM

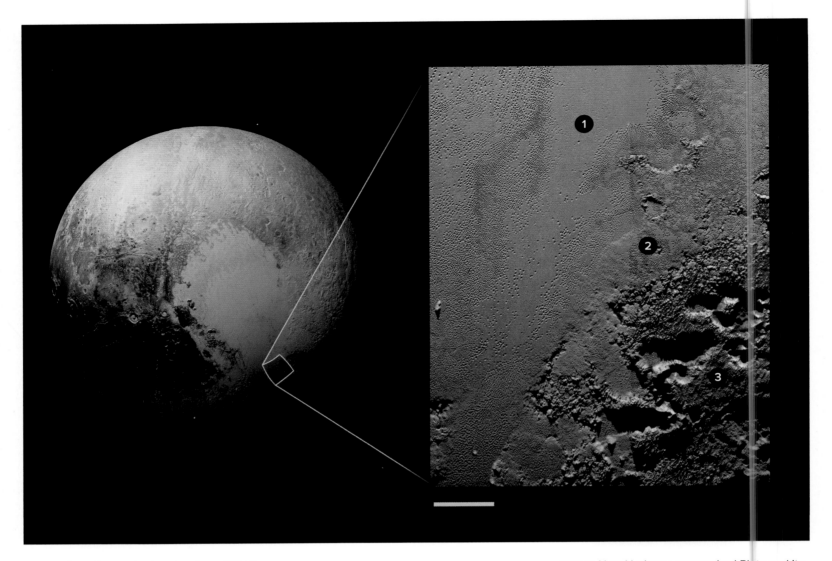

ABOVE An enhanced color view from NASA's New Horizons spacecraft, taken on June 9, 2016, zooms in on the southeastern portion of Pluto's great ice plains. At the lower right of the image the plains border rugged, dark highlands informally named Krun Macula, a dark feature on a planetary surface named for Krun, the lord of the underworld in the Mandaean religion. This macula rises 1.5 miles (2.5 kilometers) above the surrounding plains and shows scars of connected, circular pits that typically reach between 5 and 8 miles (8 and 13 kilometers) across, and up to 1.5 miles (2.5 kilometers) deep.

1. Flat plains
2. Hummocky marginal plains
3. Rugged highlands

RIGHT New Horizons approached Pluto and its largest moon, Charon, in July 2015. The craft's miniature cameras, radio science experiment, ultraviolet and infrared spectrometers, and space plasma experiments added significant knowledge to what was already known about this dwarf planet. It mapped the global geology and geomorphology of Pluto and Charon, their surface compositions and temperatures, and examined Pluto's atmosphere; yes, there is an atmosphere as well as water on Pluto. The spacecraft's most prominent design feature was its nearly 7-foot (2.1-meter) dish antenna, which allowed the spacecraft to communicate with Earth from up to 4.7 billion miles (7.5 billion kilometers) away.

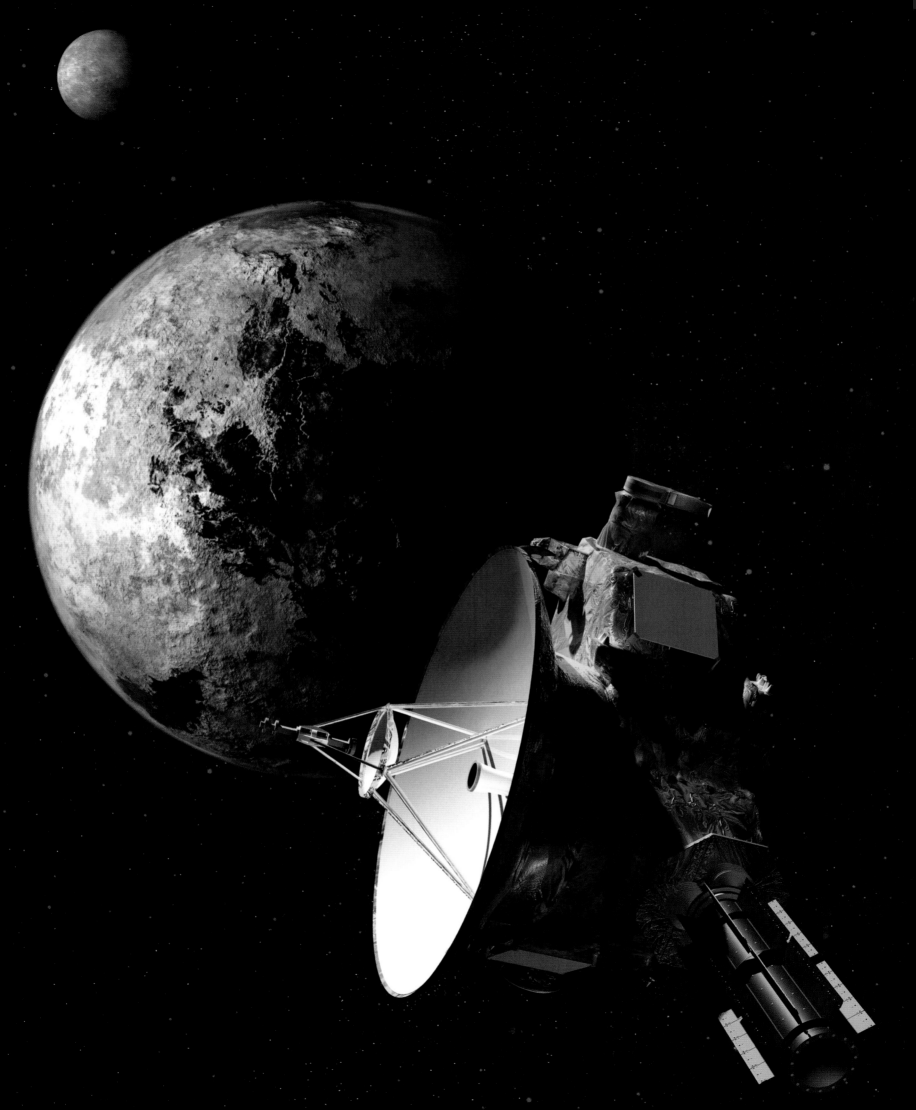

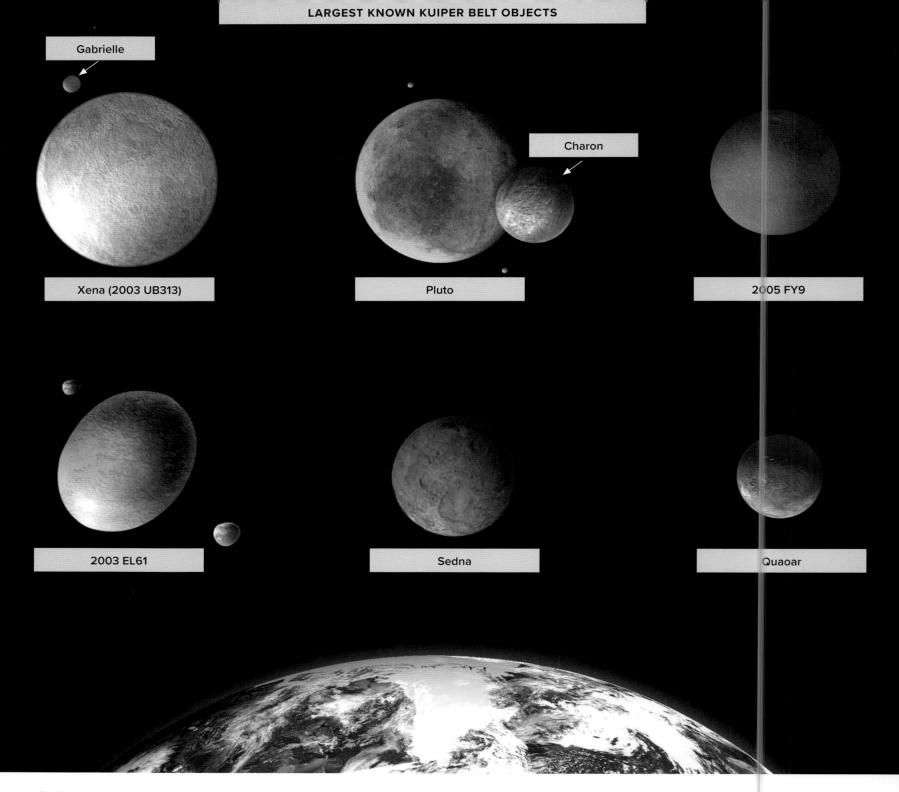

Bodies found beyond Neptune's orbit include Pluto, KBOs, and Oort Cloud objects. Pictured here relative in size to Earth are: (*Top row, left to right*): Eris and its moon, Dysnomia (formerly called Xena and Gabrielle); Pluto, Charon, and two of Pluto's much smaller four moons; and Makemake (formerly known as 2006 FY9). (*Bottom row, left to right*): Haumea and its moons (formerly known as 2003 EL61 [*top*] and Vesta [*bottom*]); Sedna; and Quaoar.

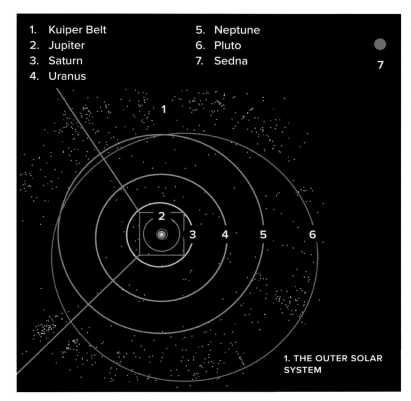

1. Kuiper Belt
2. Jupiter
3. Saturn
4. Uranus
5. Neptune
6. Pluto
7. Sedna

1. THE OUTER SOLAR SYSTEM

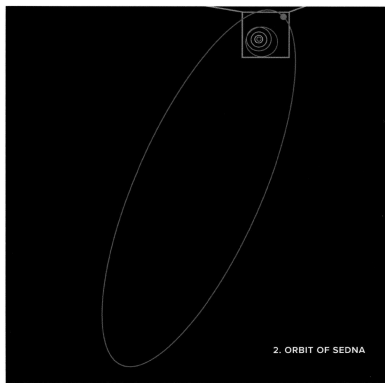

2. ORBIT OF SEDNA

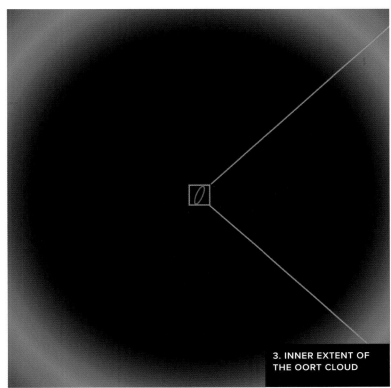

3. INNER EXTENT OF THE OORT CLOUD

The trans-Neptunian object 90377 Sedna lies in the farthest reaches of the solar system. Here, each panel zooms farther out to place Sedna in context:

1. The orbit of Sedna in relation to the orbits of Neptune and other KBOs.
2. Sedna's full orbit, illustrated with the object's location in 2004, nearing its closest approach to the Sun. Note the highly elliptical orbit.
3. Even this large orbit falls well inside the spherical Oort Cloud.

THE OUTER SOLAR SYSTEM

TAKING A GRAND TOUR, AND MORE

Five spacecraft are on course to leave the solar system. Pioneer 10, Pioneer 11, Voyager 1, Voyager 2, and New Horizons were all designed for outer planetary missions. All five spacecraft were accelerated to solar escape velocity and, having collected data and images of the gas giants, are moving outward beyond the heliosphere and into the cosmos.

During the 1960s, NASA scientists realized that it was possible to send spacecraft to all of the Jovian planets—Jupiter, Saturn, Uranus, and Neptune—when, once every 176 years, the planets gather on one side of the Sun for about a decade before their orbits take them farther apart. In what has become known as the Grand Tour, starting from the 1970s five spacecraft have made their way to interstellar space, with some still communicating with human controllers on Earth.

In 1964 NASA conceived Pioneer 10 and 11 as outer solar system probes. Although severe budgetary constraints forced a less ambitious effort than originally intended, NASA launched Pioneer 10 on March 3, 1972; it flew past Jupiter and Saturn and continued on its way out of the solar system. NASA received Pioneer 10's last, very weak signal on January 22, 2003. In 1973 NASA launched Pioneer 11, also encountering Jupiter and Saturn before officially departing the solar system. Pioneer 11 ended its mission on September 30, 1995, when the last transmission from the spacecraft reached Earth. Both Pioneer 10 and 11 were remarkable space probes, stretching from a thirty-month design life cycle into a mission of more than twenty years.

Meanwhile, NASA technicians prepared to launch twin probes that became known as Voyagers 1 and 2. More ambitious than the Pioneers, these probes were intended to explore all four Jovian planets. While NASA never received the funding its leaders believed necessary to complete this mission, its engineers designed magnificent exploring machines with sufficient longevity to fly past each of the gas giants and continue into interstellar space. NASA launched the probes from the Kennedy Space Center, Florida: Voyager 2 lifted off on August 20, 1977, while Voyager 1 entered space on a faster, shorter trajectory, launched on September 5, 1977.

As the mission progressed and the Voyagers succeeded admirably in studying Jupiter and Saturn, NASA sent Voyager 1 toward interstellar space. It became the first spacecraft to reach the termination shock in 2004. In June 2012, Voyager 1 detected an increase of cosmic rays at 119 astronomical units (AU), indicating that it had reached the interstellar medium and had

PIONEER 10 AND 11 PLAQUE

As a means of communicating with an alien civilization, this plaque was carried by the Pioneer 10 and 11 spacecraft leaving the solar system. Illustrations of a human male and female were drawn, with the spacecraft behind them for scale. The solar system (not to scale!) appears along the lower edge, and each planet (plus Pluto) is listed with its average relative distance from the Sun. Distances are listed in binary numbers in units of one-tenth the Mercury distance. The diagram uses numerical figures to explain locations and other information. The diagram in the upper left shows a hydrogen atom, by far the most abundant element in the universe, undergoing a shift in its electron energy level. Converging lines on the left show the position of the Sun relative to fourteen pulsars in the Milky Way and the center of the galaxy. The frequency of each pulsar is listed in binary numerals relative to the frequency of hydrogen emission.

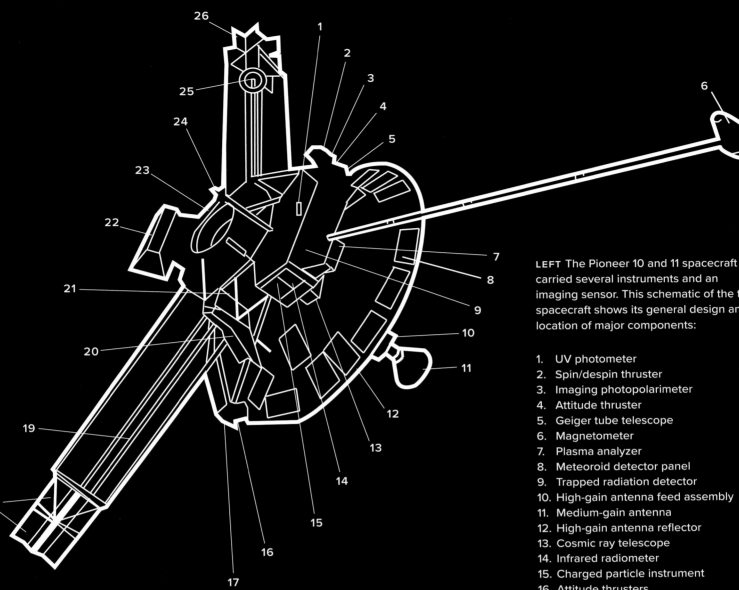

LEFT The Pioneer 10 and 11 spacecraft carried several instruments and an imaging sensor. This schematic of the twin spacecraft shows its general design and the location of major components:

1. UV photometer
2. Spin/despin thruster
3. Imaging photopolarimeter
4. Attitude thruster
5. Geiger tube telescope
6. Magnetometer
7. Plasma analyzer
8. Meteoroid detector panel
9. Trapped radiation detector
10. High-gain antenna feed assembly
11. Medium-gain antenna
12. High-gain antenna reflector
13. Cosmic ray telescope
14. Infrared radiometer
15. Charged particle instrument
16. Attitude thrusters
17. Sun sensor
18. Radioisotope thermoelectric generators (RTGs)
19. RTG power cable
20. Stellar reference assembly light shield
21. Thermal control louvers
22. Asteroid-meteoroid detector sensor
23. Separation ring
24. Low-gain antenna
25. RTG deployment damping cable
26. RTG

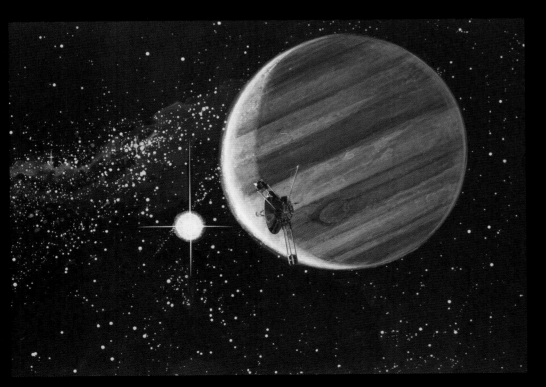

LEFT The Pioneer 10 spacecraft passed by the gas giant Jupiter. This 1973 illustration was one of several NASA depictions of what the mission might be like as it got underway.

departed the regions where the Sun's effects reigned supreme. It finally exited the heliosphere on August 25, 2012, when Voyager 1 became the first, but far from the last, human-made object to reach interstellar space. At that time, Voyager 1 was at a distance of about 122 AU, or about 11 billion miles (18 billion kilometers) from the Sun.

Meanwhile, NASA revectored the Voyager 2 probe to undertake close flybys of Uranus and Neptune. Thereafter, it journeyed beyond the heliosphere as well, passing beyond it on November 5, 2018. The Voyagers continue to provide important scientific data about the heliosphere and heliopause (the boundary between the Sun's influence and interstellar space), where the flow of the solar wind eventually stops as it ploughs into the particles and atoms that are embedded in the magnetic field of our galaxy.

Collectively, the two spacecraft provided information that revolutionized planetary science, helping to resolve some key questions while raising intriguing new ones about the origin and evolution of the solar system's planets. The two Voyagers took well over 100,000 images of the outer planets, rings, and satellites, as well as millions of magnetic, chemical spectra, and radiation measurements that characterized the nature of the outer solar system. The last imaging sequence was Voyager 1's portrait of most of the solar system, showing Earth and six other planets as sparks in a dark sky lit by a single bright star, the Sun.

A NASA assessment in 2023 announced that the Voyagers have enough electrical power and thruster fuel to return science data to Earth—though without imaging capability—until at least 2025. NASA estimates that by that time Voyager 1 will be about 13.8 billion miles (22.2 billion kilometers) from the Sun and Voyager 2 will be 11.4 billion miles (18.3 billion kilometers) away. Thereafter they will drift through the cosmos absent of any power and, in about 40,000 years, Voyager 1 will drift into the constellation Camelopardalis about 1.6 light-years away. Also about 40,000 years in the future Voyager 2 will pass 1.7 light-years from the star Ross 248, and in about 296,000 years it will pass 4.3 light-years from Sirius, the brightest star in the Earth's nighttime sky.

VOYAGES TO INTERSTELLAR SPACE

Voyager 1, now in interstellar space, was the subject of this NASA illustration showing the path out of the solar system. The magnetic field lines (yellow arcs) appear to lie in the same general direction as the magnetic field lines emanating from the Sun. In the outer region of the heliopause, labeled here the "slow-down region," the magnetic field lines generated by the Sun are piling up and intensifying.

1. Termination shock
2. Slow down region
3. Stagnation region
4. Heliosheath
5. Heliopause
6. Interstellar space

"The two Voyagers took well over 100,000 images of the outer planets, rings, and satellites, as well as millions of magnetic, chemical spectra, and radiation measurements that characterized the nature of the outer solar system."

RIGHT NASA's Voyager 1 journeyed into interstellar space beyond the Sun's gravitational field. Interstellar space is dominated by the plasma, or ionized gas, which was ejected by the death of nearby giant stars millions of years ago. The environment inside our solar bubble is dominated by the plasma exhausted by our Sun, known as the solar wind.

LEFT The two Voyager spacecraft continue to send data on magnetic fields and energetic particles as they enter interstellar space, though the imaging instruments on the scan platform, located at the top of this diagram, are no longer operating.

1. Ultraviolet spectrometer
2. Infrared spectrometer and radiometer
3. Photolarimeter
4. Low-energy charged particle detector
5. Hydrazine thrusters (x16)
6. Optical calibration target and radiator
7. Planetary radio astronomy and plasma wave antenna (x2)
8. Radioisotope thermoelectric generator (x3)
9. Low-field magnetometer (x2)
10. High-field magnetometer (x2)
11. High-gain antenna (3.7 m diameter)
12. "Bus" housing electronics
13. Cosmic ray
14. Wide angle camera
15. Narrow angle camera

THE OUTER SOLAR SYSTEM

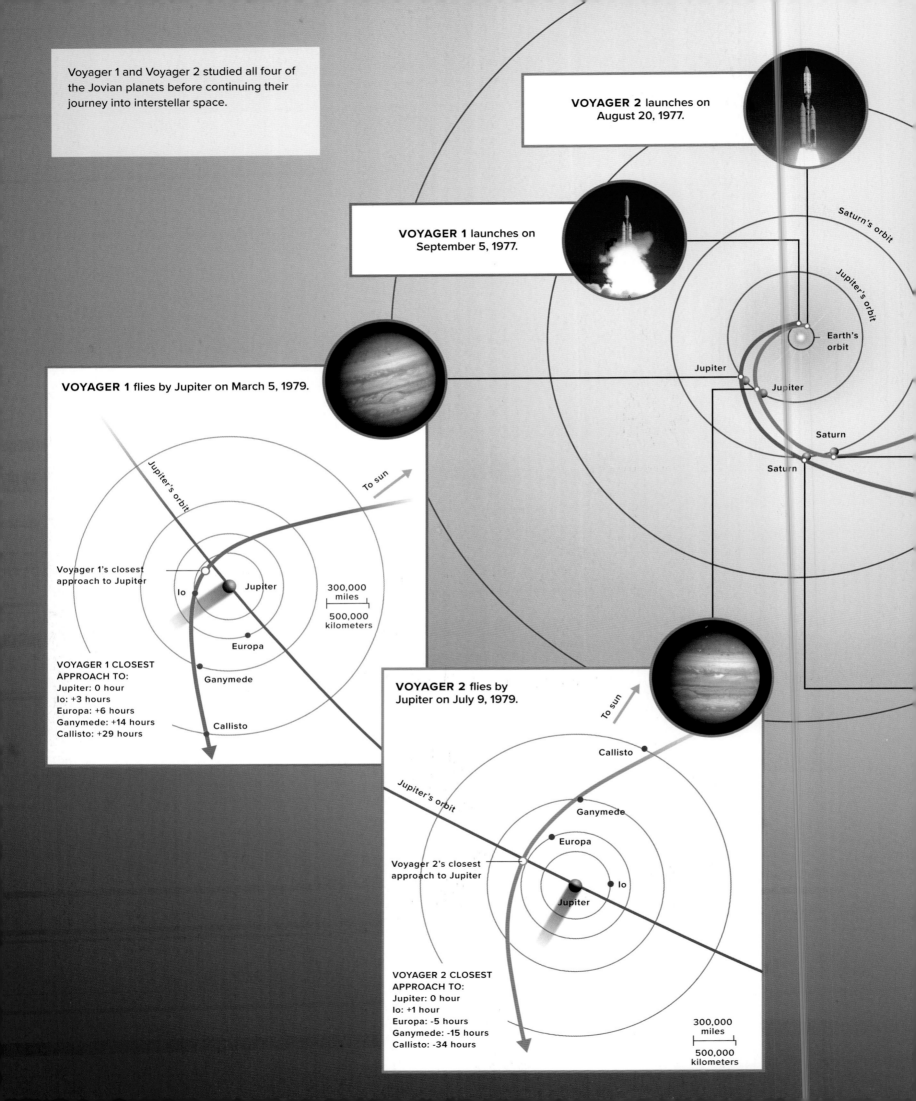

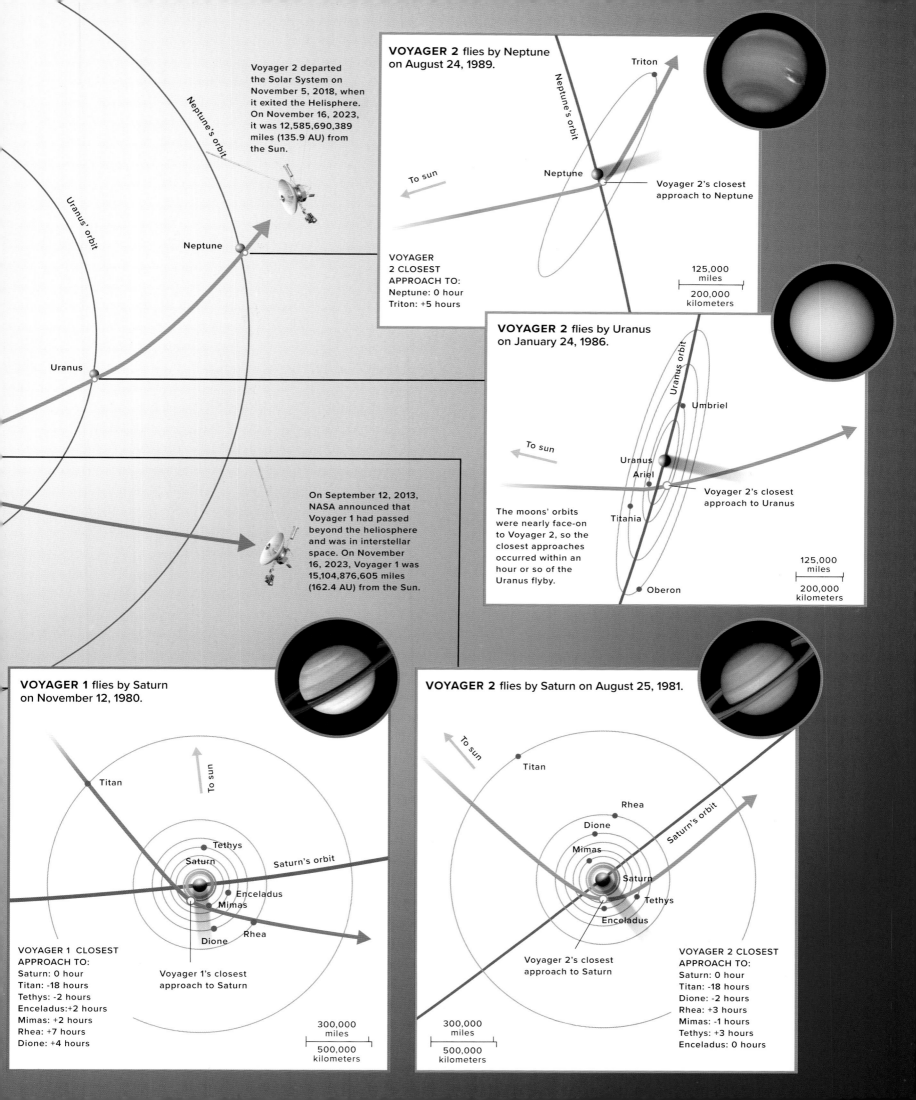

BELOW On February 14, 1990, Voyager 1 captured all the planets of the solar system. At the time, Voyager 1 was located about 4 billion miles (6.5 billion kilometers) from the Sun. Voyager 1 left the solar system at about 32 degrees above the ecliptic plane, making it possible to view all the planets from its point of view. The mosaic contains more than sixty individual frames. Several planets are shown magnified in the insets—these narrow-angle images were acquired as the spacecraft built the wide-angle mosaic. Venus and Earth were smaller than an image pixel, but their relative brightness made them visible. Uranus and Neptune appear "smeared" because Voyager moved during those fifteen-second exposure times, while Mars and Mercury were too small to be seen.

1. Jupiter
2. Earth
3. Venus
4. Saturn
5. Uranus
6. Neptune

RIGHT This montage of images taken by the two Voyager spacecraft shows the Jovian planets, left to right—Neptune, Uranus, Saturn, and Jupiter—visited by Voyager 2.

178 SMITHSONIAN ATLAS OF SPACE

THE OUTER SOLAR SYSTEM

THE FARTHEST OF THE JOVIAN PLANETS: NEPTUNE AND URANUS

Neptune and Uranus are difficult worlds to reach, and have only been closely approached once each, by Voyager 2 in the late 1980s.

Voyager 2 made its closest approach to Neptune, the furthest planet from the Sun, on August 25, 1989. Although Galileo had seen Neptune in 1612, he did not realize its planetary status. Only after French mathematician Urbain Joseph Le Verrier (1811–77) calculated the orbital path of Uranus—confirmed by German astronomer Johann Gottfried Galle and his student Heinrich Louis d'Arrest (1822–75), as well as others in 1846—did Neptune enter the pantheon of planets. During its flyby, Voyager 2 skimmed the north pole of Neptune by a mere 3,000 miles (4,800 kilometers) and determined the basic characteristics of Neptune and its largest moon, Triton. Unexpectedly, scientists found geysers of gaseous nitrogen on Triton. Those geysers suggested that Triton was geologically active, probably with a molten core that churned because of gravitational pulls from the Sun, Neptune, and other bodies in the outer solar system. Such a situation made it possible that some form of life might exist there in relation to this energy on the moon. Voyager 2 also discovered six new Neptunian moons and three new rings. The path of Voyager 2 past Neptune sent the spacecraft diving below the horizontal ecliptic plane of the planet in relation to the Sun, where it sped out of the heliopause without encountering other bodies in the solar system.

The seventh planet from the Sun and the third largest in the solar system, Uranus, was discovered through a telescope by the German-British astronomer and composer Sir William Herschel (1738–1822) on March 13, 1781. Over 200 years later, Voyager 2 made its closest approach on January 24, 1986, within 50,600 miles (81,500 kilometers) of Uranus's cloud tops. This mission changed everything. Beforehand, Uranus was a ball of gas seen through a telescope without any distinct features or understanding of its characteristics. Now, we could see that the gas giant had twenty-seven moons, a ring system like Saturn's that was faint but omnipresent, and a complex magnetosphere not unlike the one that protects Earth from cosmic radiation. Most important, unlike other planets of the solar system, Uranus had a near-horizontal tilt of its planetary axis, at 97.77 degrees, meaning it rotated North to South rather than West to East like Earth. This unique rotation gave Uranus a corkscrew magnetotail: magnetic fields are typically in alignment with a planet's rotation, but Uranus's magnetic field is tipped over and offset from the center of the planet by one-third of the planet's radius.

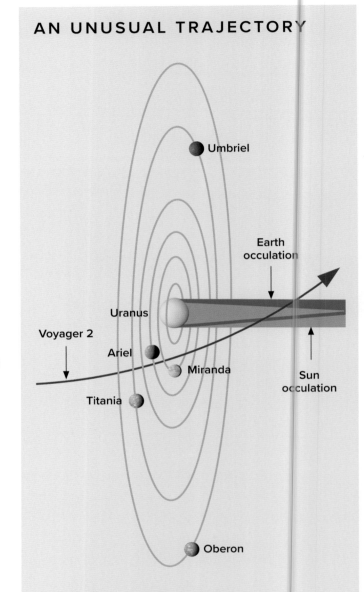

AN UNUSUAL TRAJECTORY

The Voyager 2 mission, visiting Neptune and Uranus, required an unusual trajectory. Uranus and its satellites have a unique configuration in the solar system. The axis of rotation of Uranus is tilted more than 90 degrees from the ecliptic, meaning that the poles of Uranus and its satellites point toward the Sun. The spacecraft was targeted for a flyby of the planet near the inner satellite Miranda. The other satellites were all viewed but from greater distances.

NEPTUNE FAST FACTS

MEAN DISTANCE FROM SUN 2.8 billion miles (4.5 billion kilometers) or 30.1 astronomical units
DIAMETER 31,000 miles (49.5 kilometers)
DENSITY 1,638 grams/cubic centimeter
SURFACE GRAVITY 11.27 meters/second squared (the speed at which objects drop toward Neptune will accelerate toward the planet; anything on Neptune would weigh 1.14 times more than that experienced on Earth)
ROTATION PERIOD (LENGTH OF DAY) 16 hours
REVOLUTION PERIOD (LENGTH OF YEAR) 165 Earth years
MEAN SURFACE TEMPERATURE 166 degrees Fahrenheit (-110 degrees Celcius)
NATURAL SATELLITES Four
DISCOVERER Johann Gottfried Galle and Heinrich Louis d'Arrest, September 23–24, 1846

Voyager 2's last whole-planet images of Neptune were taken through the green and orange filters on the spacecraft's narrow-angle camera in 1989. The images were captured 4.4 million miles (7 million kilometers) from the planet, four days and twenty hours before its closest approach. The Great Dark Spot and its companion bright smudge, the most noticeable feature in Neptune's atmosphere, are visible.

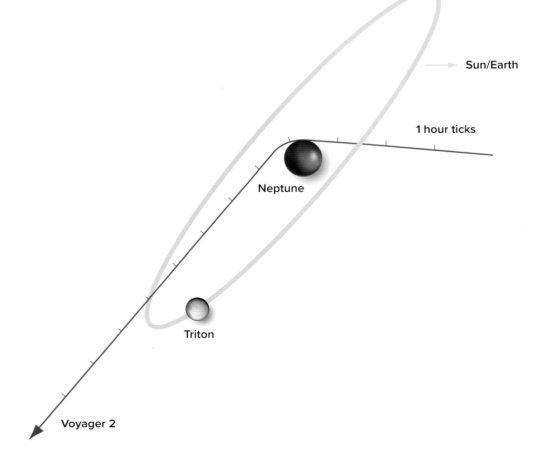

ABOVE A view of Neptune from its largest moon, Triton, emphasizes the reality of geysers of liquid methane erupting from Triton's surface, as discovered by the Voyager 2 mission.

TOP LEFT The volcanic plains of Neptune's moon Triton, produced using topographic maps derived from images acquired by Voyager 2.

MID-LEFT Voyager 2's encounter with Neptune in August 1989 yielded this image of the planet's outermost ring, 39,000 miles (63,000 kilometers) out, which clumps into two arcs.

LEFT The 1989 Voyager 2 flyby of Neptune was planned to provide a close encounter with Triton after its closest approach to Neptune, within 3,000 miles (5,000 kilometers) of Neptune's north pole. The path of Voyager 2 is tracked here as it encountered Neptune, used the planet's gravity-assist to put it on a different trajectory, and then flew past Triton. Voyager 2 came closer than any other previous planetary flyby.

182 SMITHSONIAN ATLAS OF SPACE

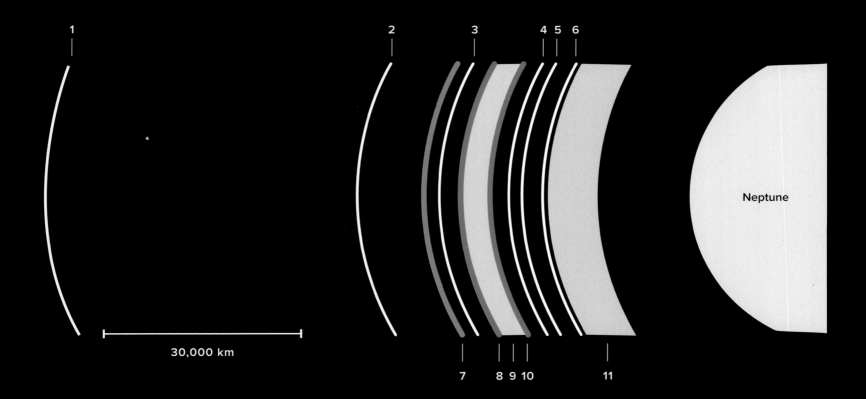

The rings of Neptune circle the planet (*right*) within the orbits of the small inner satellites. Like the rings of Uranus, the material is darker than at Saturn. Notable are the Lassell ring, which extends between the Arago and Leverrier rings, and the Adams ring, which consists of five arc sections instead of forming a complete disk.

Satellites:
1. Proteus
2. Larissa
3. Galatea
4. Despina
5. Thalassa
6. Naiad

Rings:
7. Adams
8. Arago
9. Lassell
10. Leverrier
11. Galle

"The two Voyagers took well over 100,000 images of the outer planets, rings, and satellites, as well as millions of magnetic, chemical spectra, and radiation measurements that characterized the nature of the outer solar system."

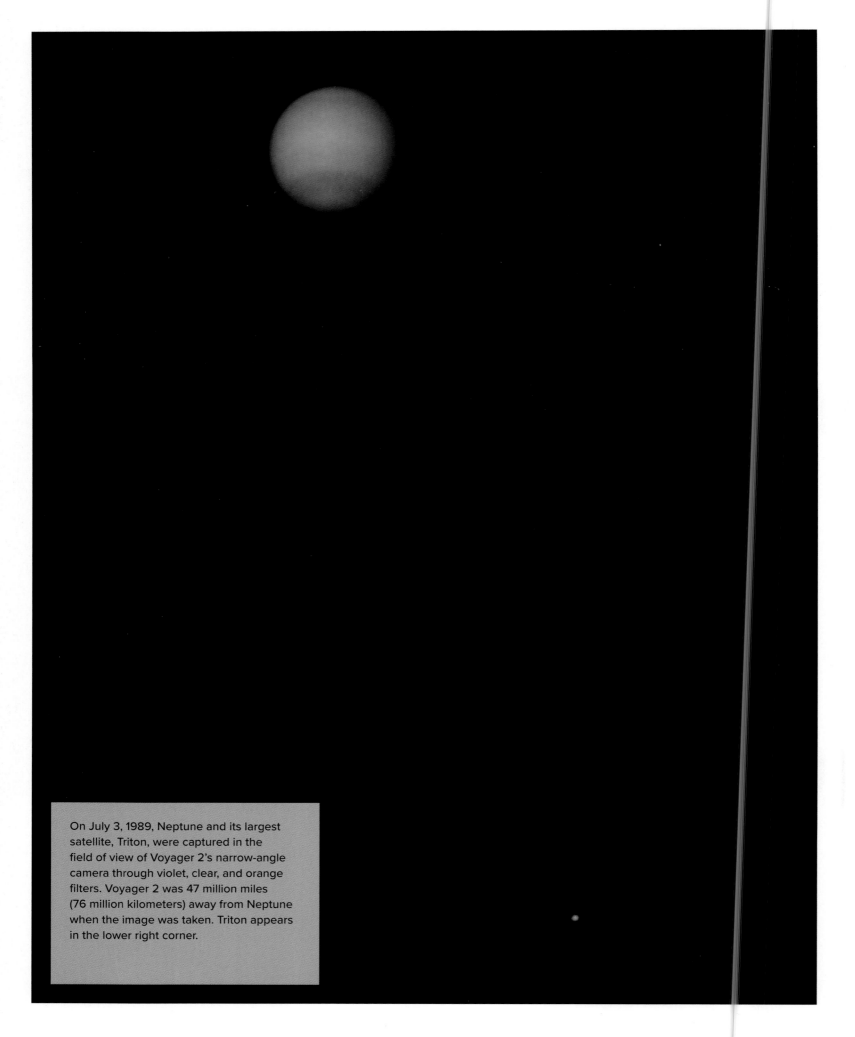

On July 3, 1989, Neptune and its largest satellite, Triton, were captured in the field of view of Voyager 2's narrow-angle camera through violet, clear, and orange filters. Voyager 2 was 47 million miles (76 million kilometers) away from Neptune when the image was taken. Triton appears in the lower right corner.

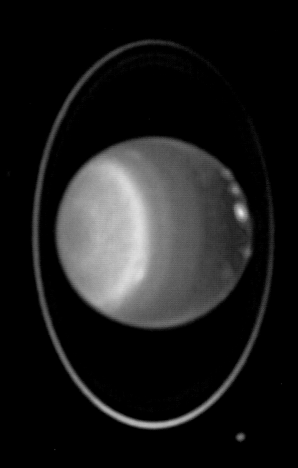

URANUS FAST FACTS

MEAN DISTANCE FROM SUN 1.8 billion miles (2.9 billion kilometers) or 19.8 astronomical units (AU)
DIAMETER 31,518.4 miles (50,723.9 kilometers)
DENSITY 1.27 grams/cubic centimeter
SURFACE GRAVITY 8.69 meters/second squared (the speed at which objects drop toward Uranus will accelerate toward the planet; anything on Uranus would weigh 0.89 times that experienced on Earth)
ROTATION PERIOD (LENGTH OF DAY)
17 hours 14 minutes
REVOLUTION PERIOD (LENGTH OF YEAR)
84 Earth years
MEAN SURFACE TEMPERATURE -320 degrees Fahrenheit (-195 degrees Celcius)
NATURAL SATELLITES Twenty-seven
DISCOVERER Sir William Herschel, March 13, 1781

Furthering the discoveries of Voyager 2, the Hubble Space Telescope (HST) captured Uranus surrounded by its four major rings and by ten of its twenty-seven known satellites. University of Arizona planetary scientist Erich Karkoschka created this false-color image using data taken on August 8, 1998, with the HST's Near-Infrared Camera and Multi-Object Spectrometer. The HST also found about twenty clouds—the spots on the image—as many as ever seen on Uranus.

LEFT Uranus's rings, as seen by the Voyager 2 spacecraft at the time of its encounter on August 24, 1989.

LEFT Voyager 2 provided visual proof of three newly discovered satellites of Uranus, shown here in an image taken on January 18, 1986, when the spacecraft was 4.8 million miles (7.7 million kilometers) from the planet. All three satellites lie outside the orbits of Uranus's nine known rings, the outermost of which, the epsilon ring, is seen at upper right. The largest of the three moons viewed here, 1986U1, was discovered on January 3, 1986. It is an estimated 55 miles (90 kilometers) across and orbits Uranus once every 12 hours 19 minutes at a distance of 41,040 miles (66,090 kilometers) from the planet's center. The other two moons, 1986U3 and 1986U4, are slightly smaller. 1986U3 orbits once every 11 hours 6 minutes at 38,350 miles (61,750 kilometers), while 1986U4 orbits every 13 hours 24 minutes at 43,420 miles (69,920 kilometers).

LEFT Voyager 2 captured Uranus's rings while in the planet's shadow, about 3.5 hours after the spacecraft's closest approach on August 24, 1989. The wide-angle exposure took 96 seconds, causing the short streaks, which are background stars. The rings are made up of micrometer-size particles and are very dark.

RIGHT Using imagery from Voyager 2, scientists were able to chart a grid planet on Uranus. The latitude–longitude grid superimposed on this Voyager 2 false-color image demonstrates the pattern of movement of Uranus's atmosphere, which circulates in the same direction as the planet rotates.

BELOW Computer enhanced to bring out atmospheric details, an image from Voyager 2 emphasizes the high-level haze in Uranus's upper atmosphere.

MAJOR MOONS OF URANUS

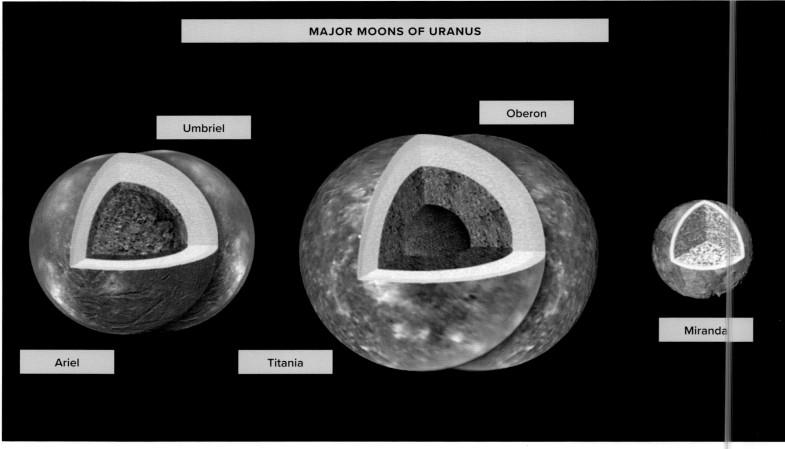

Ice/rock mixture Ice Ocean/brine Hydrated rock Dry rock

LEFT When Voyager 2 encountered Uranus, it revealed a world strikingly different from what astronomers had observed from Earth. The image on the left is a true color exposure from Voyager 2. While the resolution is better than that seen from Earth, it is largely lacking in detail. When processed in false color, using different hues to show changes in the planet's atmosphere, however, it tells a very different and compelling story. Returned on January 17, 1986, using the spacecraft's narrow-angle camera from 5.7 million miles (9.1 million kilometers) away from the planet's surface, the image on the left shows Uranus as human eyes would perceive it. It reveals a dark polar hood surrounded by progressively lighter concentric bands. Astronomers theorize that this is caused by a brownish haze concentrated over the pole.

RIGHT The ring particles in orbit around Uranus are ice and dust, but unlike the rings of Saturn (see page 194) they are much darker and not visible in reflected sunlight. The first nine rings were detected by measuring the light of a star passing behind the rings. Voyager 2 detected two others. Two outer rings, corresponding to the orbits of the satellites Portia and Mab, were later found using data from the HST.

LEFT Scientists believe there could be an ocean under ice on four of Uranus's five major moons: Ariel, Umbriel, Titania, and Oberon. Modeling, informed by a re-analysis of data from NASA's Voyager spacecraft, suggests that Titania is the likeliest moon to retain internal heat and a liquid water ocean under ice caps.

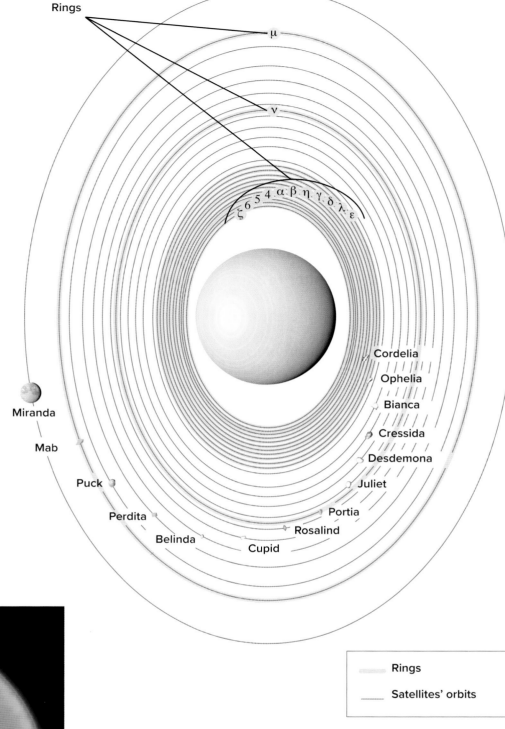

LEFT Another Uranus image, this time taken in 1997 by the HST, shows details of the cloud cover of Uranus reminiscent of those taken by Voyager 2. The HST used visible light to show the concentric clouds emanating from the northern hemisphere of the planet.

THE OUTER SOLAR SYSTEM

EXPLORING SATURN AND JUPITER

The second largest planet in the solar system, Saturn, with its striking rings, has been visited five times: by Pioneers 10 and 11, Voyagers 1 and 2, and an extended mission by Cassini. Gas giant Jupiter, located beyond Mars and the Asteroid Belt, has been visited seven times by spacecraft—Pioneers 10 and 11, Voyagers 1 and 2, an extensive orbital mission by Galileo, a flyby by New Horizons, and another orbiter to Jupiter, Juno—since the 1970s.

The exploration of these gas giants began with Pioneer 10 passing by Jupiter on December 4, 1973, followed by Pioneer 11 in November and December 1974, which came within 26,600 miles (42,800 kilometers) of Jupiter. Pioneer 11 then went on to Saturn, coming within 13,000 miles (21,000 kilometers) of the planet, where it discovered two new moons and a new ring, as well as charting Saturn's magnetic field, its climate and temperatures, and the general structure of its interior.

Voyagers 1 and 2 undertook successful flybys of Jupiter then, using the giant planet for gravity assistance, began lengthy journeys to Saturn. Between them, the two Voyagers took well over 100,000 images of the outer planets, rings, and satellites, as well as millions of magnetic, chemical spectra, and radiation measurements. The two spacecraft returned information to Earth that revolutionized solar system science, helping to resolve some key questions while raising intriguing new ones about the origin and evolution of the planets.

VOYAGERS 1 AND 2: SATURN

Voyager 1 arrived at Saturn in November 1980 and Voyager 2 followed in August 1981. In Saturn's rings, they discovered shepherding satellites (moons that orbit near the edge of a planetary ring and stabilize its ring's particles through gravitational pull). A special target for the missions was one of Saturn's many moons, Titan, which looked to have features that might harbor some form of life. Voyager 1's encounter with this inviting moon revealed a thick atmosphere, dense clouds, and water ice. The spacecraft also found that Titan's atmosphere was composed of 90 percent nitrogen, and that the pressure and temperature at the surface was 1.6 atmospheres and -292 degrees Fahrenheit (-180 degrees Celcius). This made it a place that scientists wanted to learn more about, playing into the desire to return for extended exploration, which came early in the twenty-first century.

LOVELY SATURN

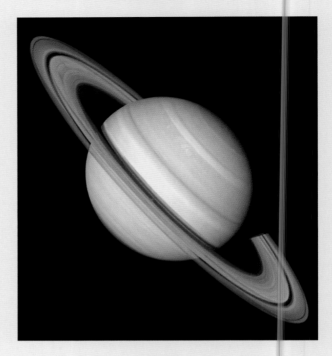

During the Voyager 2 encounter with Saturn in 1981, the spacecraft came within 63,000 miles (101,000 kilometers) of the gas giant. Voyager 2 noticed changes in Saturn's atmosphere since the Voyager 1 encounter and took more detailed images of the planet's rings. The Voyagers revealed a striking world with much more than just its ring system. The spacecraft provided more detailed images of the ring "spokes," and determined that Saturn's A-ring was perhaps only about 980 feet (300 meters) thick. During this flyby, Voyager 2 was hit by thousands of micron-sized dust grains that created "puff" plasma as they were vaporized. During this encounter, Voyager 2 photographed the Saturn moons Hyperion, Enceladus, Tethys, and Phoebe, as well as the more recently discovered Helene, Telesto, and Calypso.

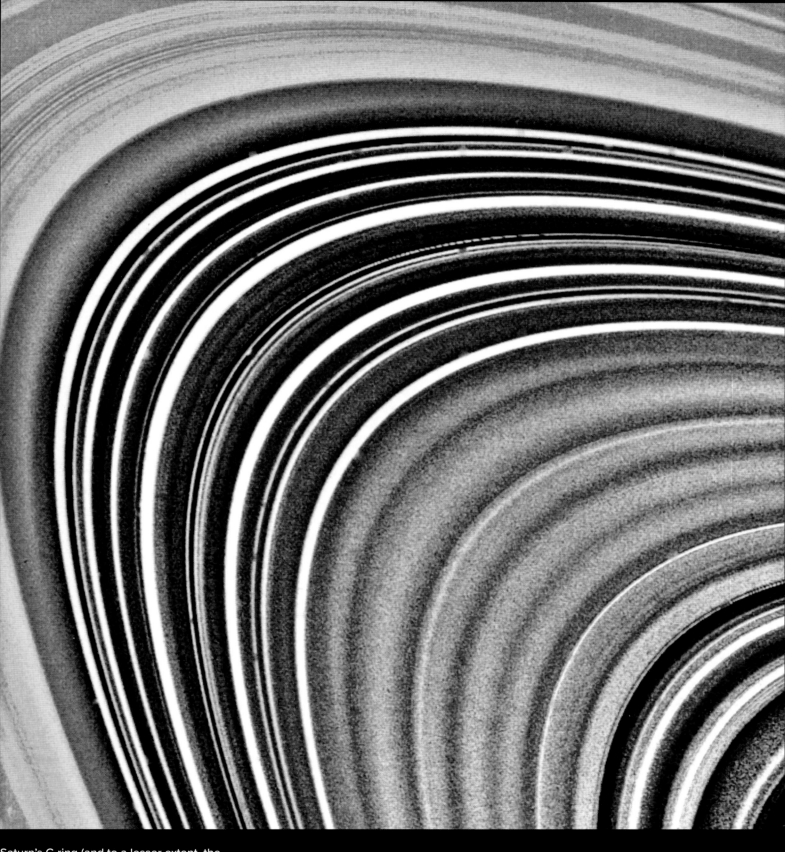

Saturn's C-ring (and to a lesser extent, the B-ring at top and left) was captured on August 23, 1981, by Voyager 2. The unique colors emerged by compiling three images taken through ultraviolet, clear, and green filters. At the time, Voyager 2 was 1.7 million miles

At Saturn, the Voyagers discovered that the gas giant's atmosphere is almost entirely hydrogen, leading scientists to conclude that Saturn is the only planet less dense than water. Near its equator, the Voyagers measured wind velocities as high as 1,100 miles per hour (1,800 kilometers per hour), blowing mostly in an easterly direction. Both Voyagers measured the rotation of Saturn (the length of a day) at 10 hours, 39 minutes, 24 seconds.

CASSINI-HUYGENS: SATURN

Demonstrating the international character of many planetary missions, the Cassini-Huygens probe to Saturn was conducted by a collaboration of NASA, the European Space Agency (ESA), and the Italian Space Agency. Launched in 1997, this spacecraft had an orbiter built by NASA (Cassini) and a lander (Huygens) built by European entities. Flying together, it separated upon arrival at Saturn and began orbiting the planet on July 1, 2004. It also sent the probe (Huygens) to the surface of Saturn's moon Titan on January 15, 2005. Huygens was ESA's first outer planetary mission.

At Saturn, Cassini discovered three new moons (Methone, Pallene, and Polydeuces); observed water ice geysers erupting from the south pole of the moon Enceladus; obtained images appearing to show lakes of liquid hydrocarbon (such as methane and ethane) in Titan's northern latitudes; and discovered a storm at the south pole of Saturn with a distinct eye wall (concentric cycles of turbulence like those seen in Earth's most intense cyclones). Cassini, like Galileo at Jupiter (see page 198), has demonstrated that icy moons orbiting giant gas planets are potential refuges of life and attractive destinations for a new era of robotic planetary exploration. In addition, on April 3, 2014, NASA reported that Cassini had found evidence of a large subterranean water ocean on Enceladus. It was yet another instance of an abode of life in the solar system.

"At Saturn, the Voyagers discovered that the gas giant's atmosphere is almost entirely hydrogen, leading scientists to conclude that Saturn is the only planet less dense than water."

SATURN FAST FACTS

MEAN DISTANCE FROM SUN 886 million miles (1.4 billion kilometers) or 9.5 astronomical units
DIAMETER 74,500 miles (120,000 kilometers)
DENSITY 1.326 grams/cubic centimeter
SURFACE GRAVITY 1.07 meters/second squared (the speed at which objects dropped toward Saturn will accelerate toward the planet; anything on Saturn would weigh 107 percent that experienced on Earth)
ROTATION PERIOD (LENGTH OF DAY) 10.7 hours
REVOLUTION PERIOD (LENGTH OF YEAR) 29 Earth years
MEAN SURFACE TEMPERATURE -59 degrees Fahrenheit (-15 degrees Celcius)
NATURAL SATELLITES 145
DISCOVERER Christiaan Huygens, 1645

TOP RIGHT Cassini's initial orbit around Saturn was very elliptical. Flybys of satellites were performed while lowering the orbit to within the distance of Lapetus. For clarity, this diagram shows only half of the orbits around Saturn (pink) during the initial phase of the mission. The four labeled orbits are the most important for getting Cassini into a sustainable orbit around Saturn for an extended encounter. The rest of the tracks are much more routine.

1. Arrival trajectory
2. Initial orbit
3. Lapetus orbit
4. Titan orbit

RIGHT Cassini performed two flybys of Venus and one of Earth to obtain the velocity needed to leave the inner solar system. It then flew by Jupiter before finally arriving at Saturn in July 2004, more than six years after launch. Cassini's route is tracked in red, and planetary orbits are in brown.

1. Launch from Earth, October 15, 1997
2. Venus swingby, April 26, 1998
3. Deep space maneuver, December 3, 1998
4. Venus swingby, June 24, 1998
5. Earth swingby, August 18, 1999
6. Jupiter swingby, December 30, 2000
7. Saturn arrival, July 1, 2004

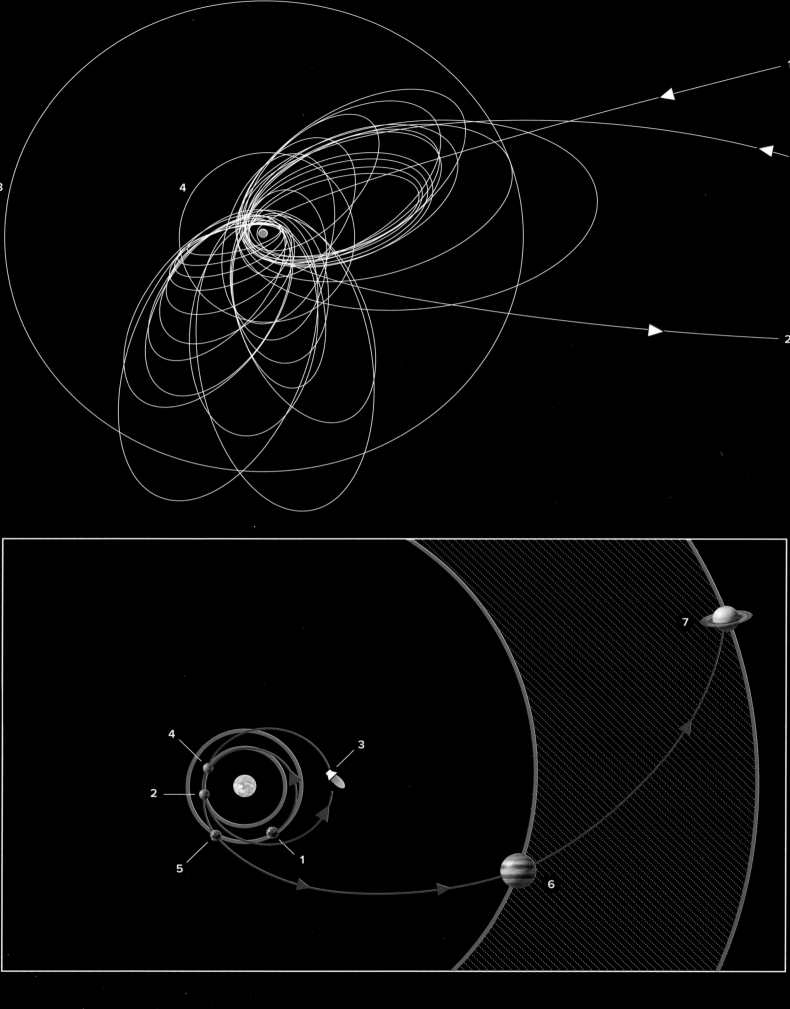

THE OUTER SOLAR SYSTEM

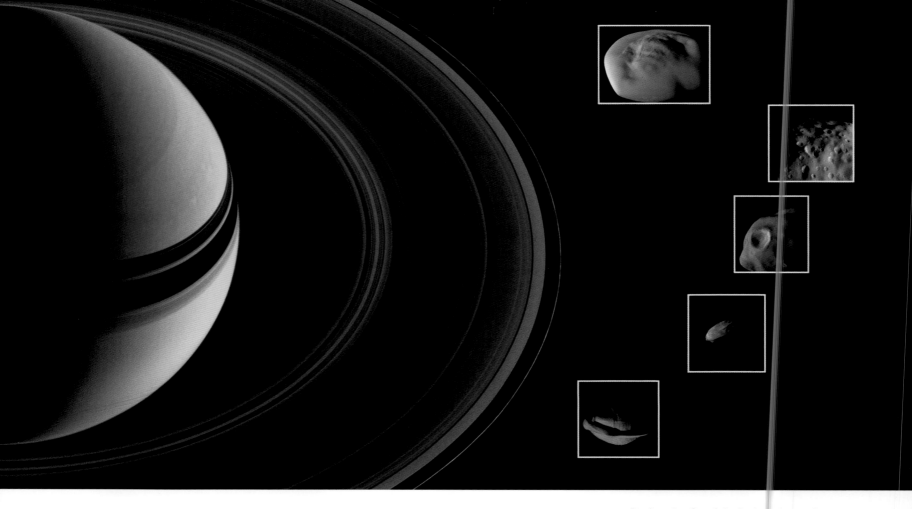

ABOVE During the Cassini mission, the probe made close flybys of Saturn's rings and investigated the moons (shown top to bottom) of Pan and Daphnis in the A ring; Atlas at the edge of the A ring; Pandora at the edge of the F ring; and Epimetheus. The moons' diameter ranges from 5 miles (8 kilometers) for Daphnis to 72 miles (116 kilometers) for Epimetheus. This composite image depicts the rings and the moons (which are not to scale) of Saturn.

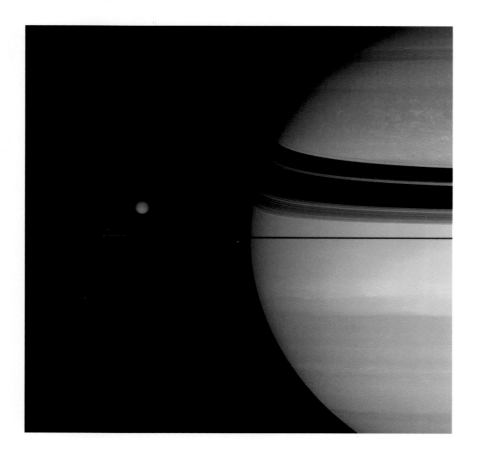

LEFT Titan (3,200 miles/5,150 kilometers across) is seen on the left side of this image, above Saturn's distinctive rings. The image was taken by Cassini's wide-angle camera on October 26, 2007, at a distance of approximately 920,000 miles (1.5 million kilometers) from Saturn.

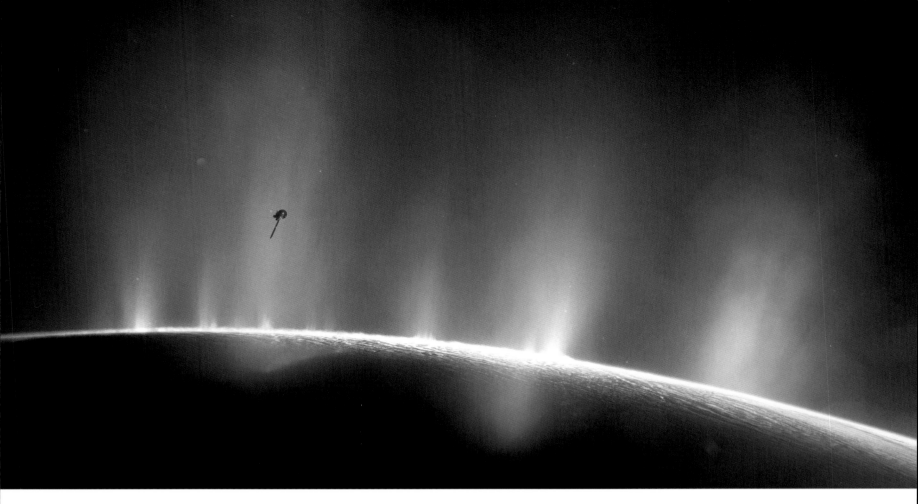

ABOVE The Cassini spacecraft at Saturn imaged the icy moon Enceladus spraying a "huge plume" of watery vapor far into space in October 2015.

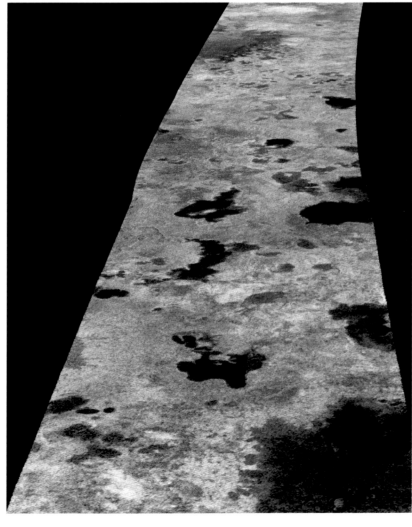

RIGHT The Huygens probe that flew with Cassini to Saturn specifically investigated the moon Titan, theorized since the Voyager missions as a world rich in organic compounds. Cassini-Huygens confirmed the existence of oceans or lakes of liquid methane on Titan, shown in this image from the Cassini flyby of July 22, 2006.

THE OUTER SOLAR SYSTEM

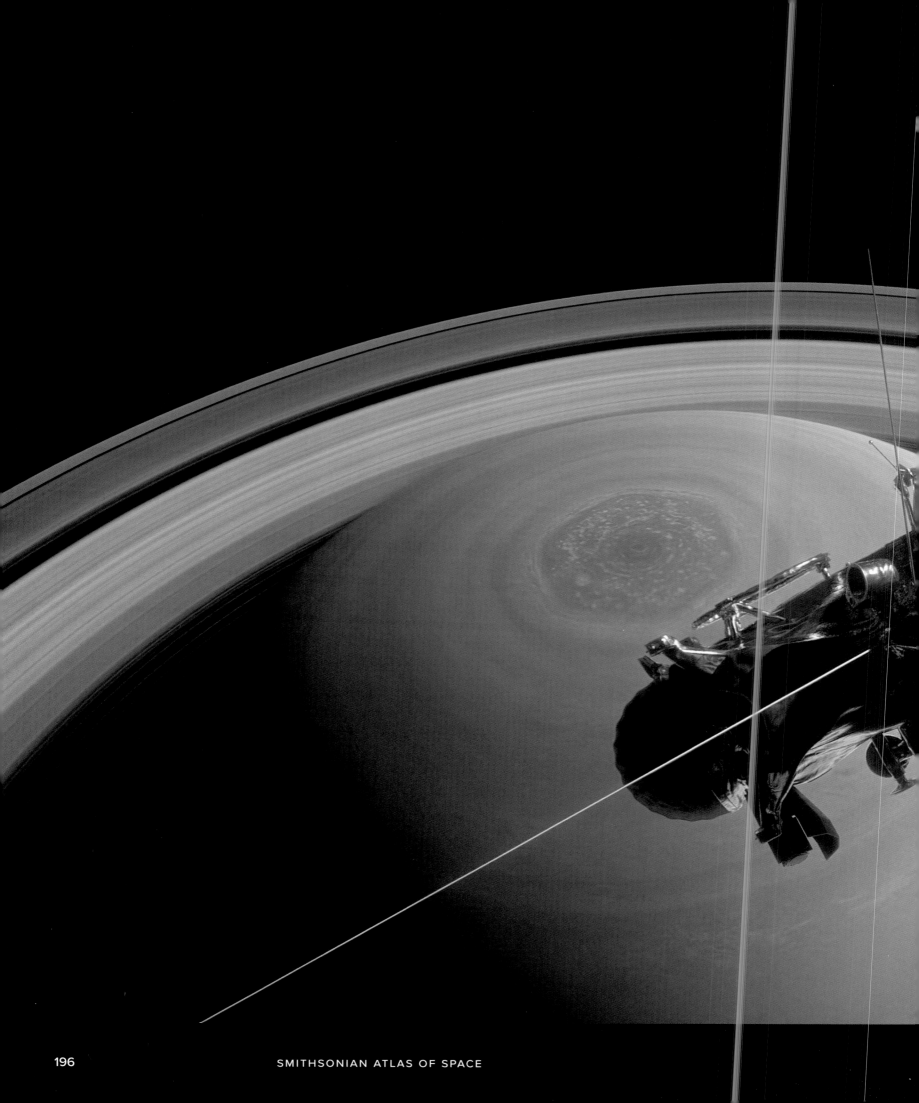

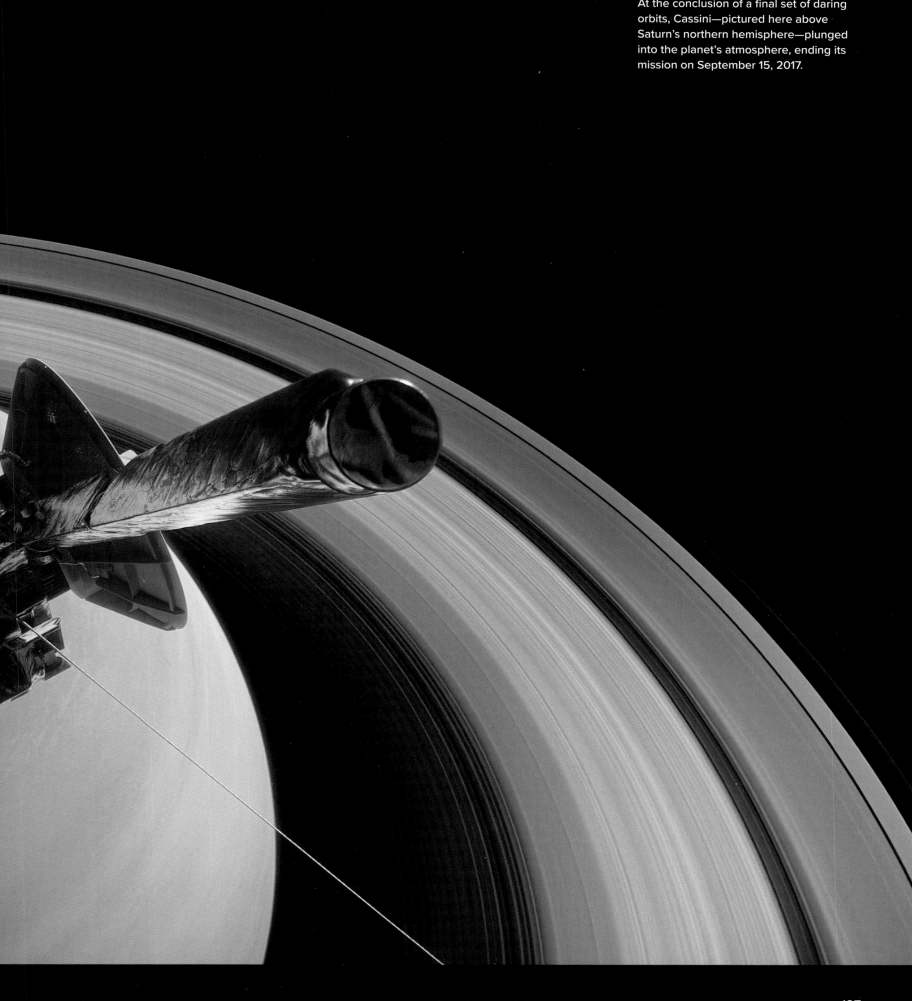

At the conclusion of a final set of daring orbits, Cassini—pictured here above Saturn's northern hemisphere—plunged into the planet's atmosphere, ending its mission on September 15, 2017.

ABOVE On June 11, 1974, Pioneer 10 approached the gas giant Jupiter, giving humanity its first close-up look at the largest planet of the solar system.

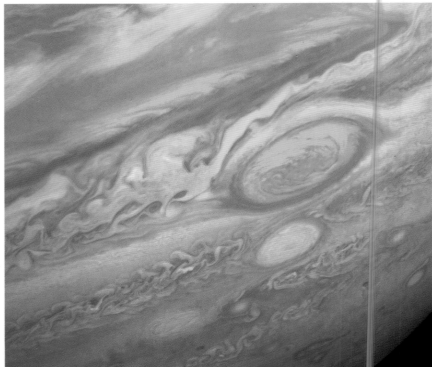

ABOVE A white oval, different from the one observed in a similar position at the time of the Voyager 1 encounter, is situated south of the Great Red Spot on Jupiter. Voyager 2 took this picture of the region extending from the equator to the southern polar latitudes in the neighborhood of the Great Red Spot on July 3, 1981, from a distance of 3.72 million miles (5.99 million kilometers).

VOYAGERS 1 AND 2: JUPITER

Voyager 1's closest approach to Jupiter occurred on March 5, 1979, when it discovered a thin ring around the Jovian planet, and two new moons, Thebe and Metis. The rings suggested that Jupiter had more in common with Saturn than previously thought. Voyager 2 followed and flew within 350,000 miles (560,000 kilometers) of Jupiter's cloud tops on July 9, 1979. Over the next four months, it returned 17,000 photographs and a treasure trove of scientific data about Jupiter and many of its moons, including the presence of volcanoes on Io (Jupiter's rocky moon).

GALILEO TO JUPITER

Following the Voyager missions, sustained exploration of Jupiter commenced on October 18, 1989, when NASA deployed the Galileo spacecraft from Space Shuttle *Atlantis* (STS-34) and set it on a gravity-assisted journey to Jupiter, arriving in December 1995. The first spacecraft to orbit the giant planet, Galileo conducted a multiyear encounter, sending scientific data about the density and chemical makeup of the giant planet's cloud cover back to Earth.

Galileo captured imagery of Comet Shoemaker-Levy 9's collision with Jupiter in July 1994, discovered a turbulent Jovian atmosphere—complete with lightning and thunderstorms a thousand times the size of those on Earth—and conducted close-

RIGHT Known for its Great Red Spot, Jupiter's atmosphere also captures charged particles like the auroras on Earth. Using the Hubble Space Telescope (HST)'s ultraviolet imaging capabilities, this 2016 image captures the glow of high-energy particles entering Jupiter's atmosphere near its magnetic poles and then colliding with atoms of gas.

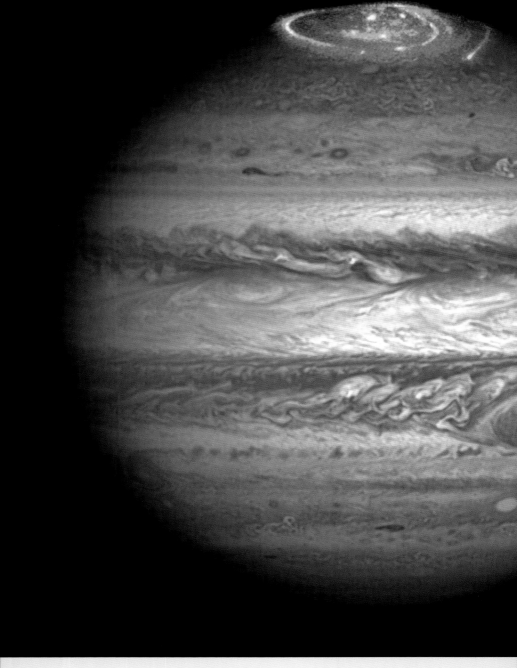

JUPITER FAST FACTS

MEAN DISTANCE FROM SUN 484 million miles (778 million kilometers) or 5.2 astronomical units
DIAMETER 43,440.7 miles (69,911 kilometers)
DENSITY 1,270 grams/cubic centimeter
SURFACE GRAVITY 24.79 meters/second squared (the speed at which objects dropped toward Jupiter will accelerate toward the planet; an object on Jupiter would weigh 240 percent that experienced on Earth)
ROTATION PERIOD (LENGTH OF DAY) 9.8 hours
REVOLUTION PERIOD (LENGTH OF YEAR) 11.9 Earth years
MEAN SURFACE TEMPERATURE -234 degrees Fahrenheit (-145 degrees Centigrade)
NATURAL SATELLITES 80
DISCOVERER Galileo Galilei, 1610

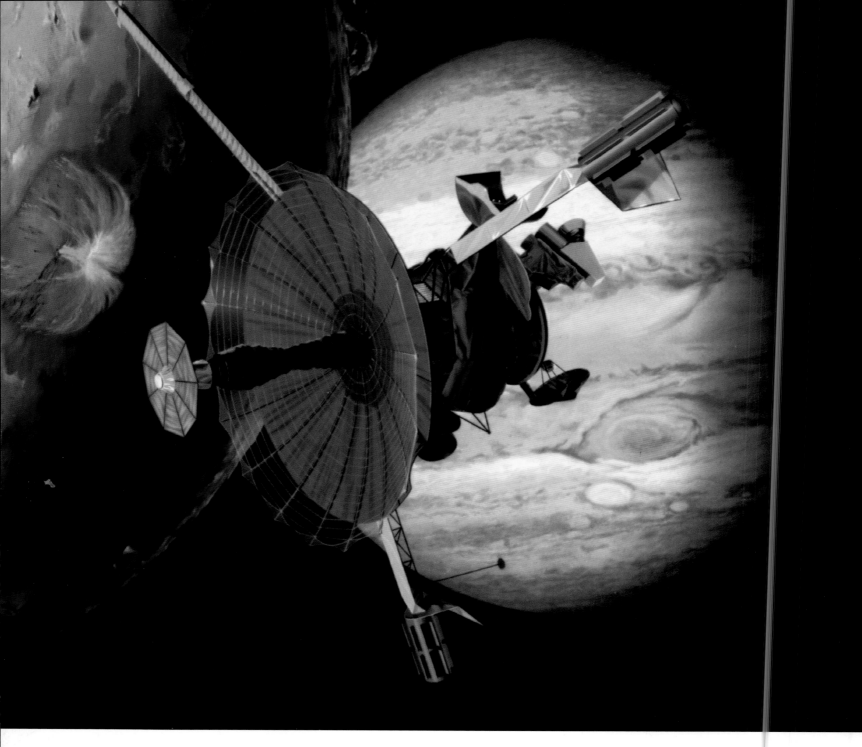

NASA's Galileo spacecraft made multiple close approaches to Jupiter's volcanically active moon, including a first pass in December 1995, during its arrival in the Jupiter system.

up inspections of the Jovian moons Ganymede, Callisto, and Io. While passing by the latter, Galileo observed eruptions of Io's Loki volcano, the largest and most powerful in the solar system. Galileo also sent a probe into Jupiter's atmosphere on December 7, 1995, its instruments relaying data before the pressure of the planet destroyed it after about forty-five minutes.

In 1996 data from Galileo revealed that Jupiter's moon Europa may harbor "warm ice" or even liquid water, an environment in which life as we understand it could potentially exist. This proved to be one of the most astounding scientific discoveries of the 1990s and prompted scientists to advocate sending a lander to explore Europa.

The flight team for Galileo ceased operations and plummeted the spacecraft into Jupiter's atmosphere on September 21, 2003, thereby ending a remarkable mission.

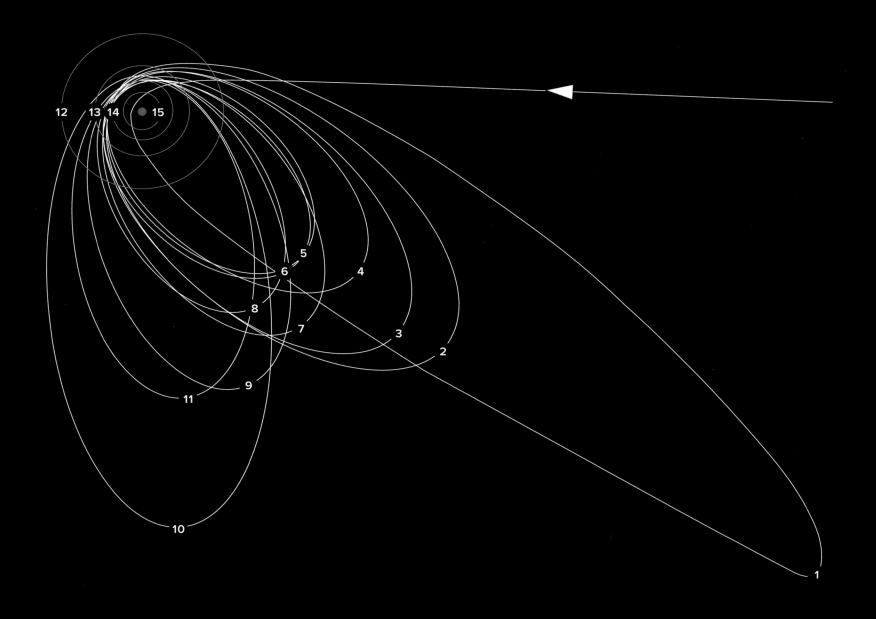

After being captured by Jupiter's gravity in 1995, Galileo looped around the planet, used its thruster to perform a maneuver, then entered orbit. On each subsequent orbit, a close flyby of a different satellite was planned. This diagram shows the initial eleven orbits after arrival at Jupiter (red). Galileo eventually completed thirty-two orbits before being deliberately targeted for entry into Jupiter's atmosphere.

Orbits:
Numbers 1–11

Satellites:
12. Callisto
13. Ganymede
14. Europa
15. Io

"In 1996 data from Galileo revealed that Jupiter's moon Europa may harbor 'warm ice' or even liquid water, an environment in which life as we understand it could exist."

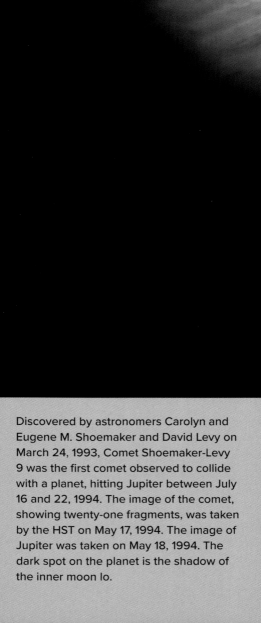

Discovered by astronomers Carolyn and Eugene M. Shoemaker and David Levy on March 24, 1993, Comet Shoemaker-Levy 9 was the first comet observed to collide with a planet, hitting Jupiter between July 16 and 22, 1994. The image of the comet, showing twenty-one fragments, was taken by the HST on May 17, 1994. The image of Jupiter was taken on May 18, 1994. The dark spot on the planet is the shadow of the inner moon Io.

RIGHT One of the discoveries made possible by visiting Jupiter was the understanding that the giant planet had a complex system of rings. While far from as distinctive as Saturn's rings, those of Jupiter are no less fascinating. This map depicts their placement in the gravitational field around the planet.

BELOW The Juno spacecraft is the most recent visitor to Jupiter, launched in 2011, and it has been exploring the solar system's largest planet since 2016. This image shows cloud tops from the JunoCam instrument during a very close approach to Jupiter in March 2022. Citizen scientist Thomas Thomopoulos created this enhanced-color image using raw data from the JunoCam. At the time the raw image was taken, the Juno spacecraft was about 44,000 miles (71,000 kilometers) above Jupiter's cloud tops, at a latitude of about 55 degrees south, and fifteen times closer than Ganymede, which orbits about 666,000 miles (1.1 million kilometers) away from Jupiter.

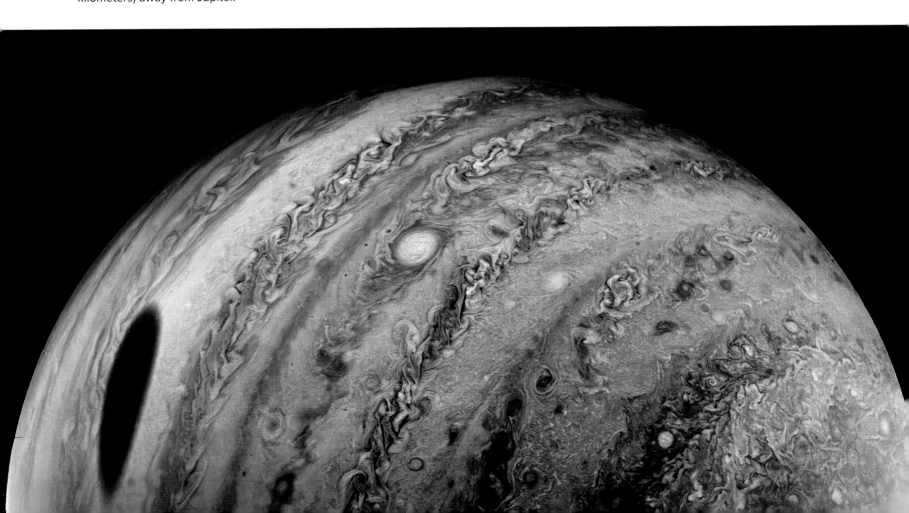

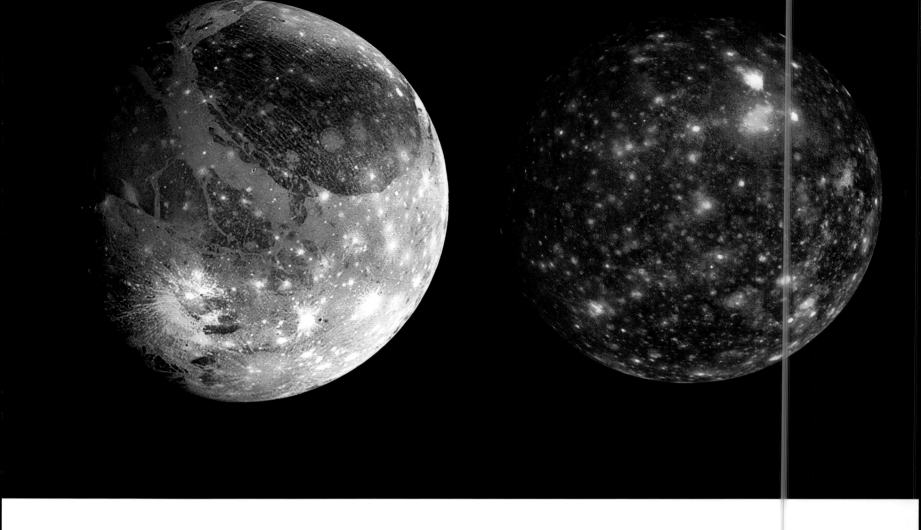

EDWARD C. STONE (1936–)

Appointed as NASA's chief scientist for the Voyager mission in 1972, Edward C. Stone led the science effort for the program for more than twenty years. His efforts helped to usher in the age of outer planetary exploration in the 1970s. He served between 1991 and 2001 as director of the Jet Propulsion Laboratory, but that did not end his work on Voyager. He oversaw the Voyager interstellar mission in the first part of this century and still remains a key planetary scientist.

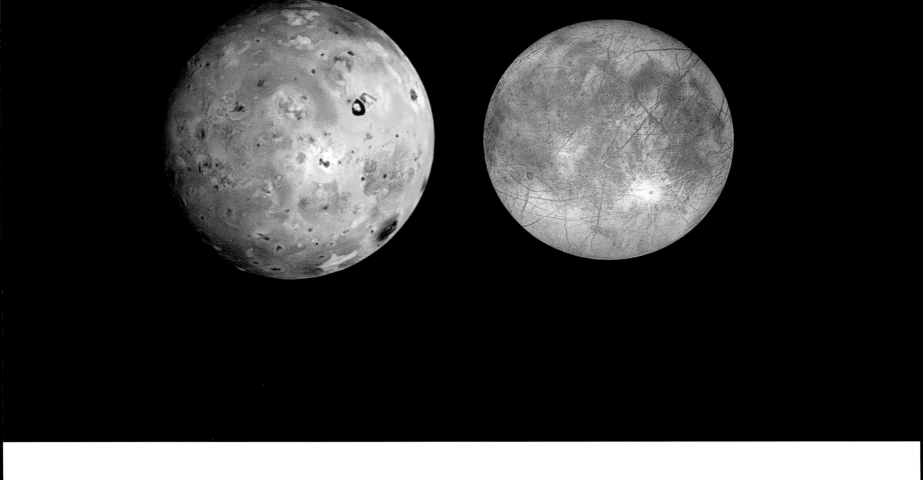

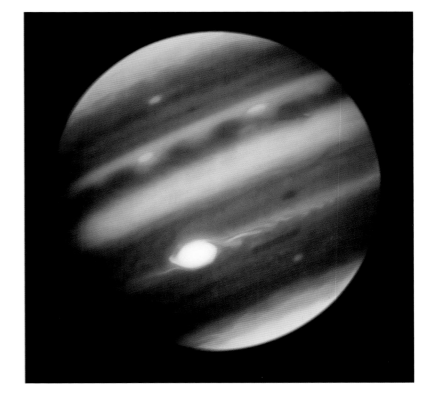

ABOVE The four largest moons of Jupiter, at their relative sizes. From left to right: Callisto, Ganymede, Io, and Europa.

RIGHT This composite, false-color infrared image of Jupiter reveals haze particles over a range of altitudes, as seen in reflected sunlight. It was taken using the Gemini North Telescope Near-Infrared Imager on May 18, 2017, in collaboration with the investigation of Jupiter by NASA's Juno mission.

Since the Galileo and Cassini missions to Jupiter and Saturn, scientists have continued to learn much about the two planets. The James Webb Space Telescope (JWST) has revealed details about how Saturn's moon Enceladus feeds a water supply to the entire system of Saturn and its rings, through gravitational movement of particles from body to body in the Saturn system. Shown here with Saturn, Enceladus is highlighted in the box to the left along with indications of water. Most striking is the light-bluish plume of water vapor showing below Enceladus. The presence of water toruses (a revolving circle of material around an axis, not unlike water circling a drain) is significant—it could be an indicator of the possible existence of life in the Saturn system.

1. Enceladus water torus
2. Enceladus
3. Enceladus
4. Enceladus gravity field
5. Water vapor

The spectral analysis below contains data collected over wavelength, depicting the water vapor recorded by the JWST's instruments.

Interstellar particle stream

The Stardust mission was one of the most remarkable of the first part of this century. The probe flew through the tail of Comet Wild 2 and returned samples to Earth for analysis. The return capsule is now on display at the Smithsonian's National Air and Space Museum. This map depicts the trajectory of Stardust as it journeyed outward to its encounter with this comet. Earth's orbit is shown in grey, and the orbit of Comet-Wild 2 is shown in blue.

1. Launch from Earth, February 6, 1999
2. Deep space maneuver, March 2000
3. Interstellar particle collection, March–May 2000
4. Earth gravity assist, January 15, 2001
5. Deep space maneuver, November 2001
6. Interstellar particle collection, July–December 2002
7. Deep space maneuver, July 2003
8. Comet Wild-2 encounter, January 2, 2004
9. Return to Earth, January 15, 2006

— Heliocentric loop 1
— Heliocentric loop 2
— Heliocentric loop 3

 Deep space maneuvers

 Interstellar particle collection

DISCOVERING ASTEROIDS

The largest object to ever be identified as an asteroid in the solar system is Ceres. Approaching 587 miles (945 kilometers) in diameter, Ceres is now considered a dwarf planet. The next largest are Vesta, Pallas, and Hygiea, which are between 248 miles (400 kilometers) and 326 miles (525 kilometers) in diameter. All other known asteroids are less than 211 miles (340 kilometers) across. Regardless, thousands of these objects have been discovered, and there are millions more. These cold, icy bodies of the solar system are most abundant in the Asteroid Belt and Kuiper Belt. A small number end up on collision courses with Earth, but most burn up in Earth's atmosphere.

There have been some eighty asteroids larger than 100 miles (162 kilometers) in diameter identified, mostly in the Asteroid Belt. While most of these pose Earth no danger, it is important to track these objects and an international effort to do so is underway.

Most recently, NASA undertook an unusual test of technologies to deflect possible killer asteroids and comets heading for Earth. Its Double Asteroid Redirection Test (DART) engaged the asteroid Dimorphos on September 22, 2022, impacting it and modestly changing its trajectory. While Dimorphos was not heading for Earth at the time, this flight demonstrated that such a deflection was possible. Dimorphos was not large, only 530 feet (160 meters) in diameter. It orbits a larger, 2,560-foot (780-meter) body called Didymos, which itself orbits the Sun at a distance of 1.0–2.3 AU once every 770 days.

THE OUTER SOLAR SYSTEM

MISSIONS TO ASTEROIDS

Galileo This spacecraft encountered two asteroids on its way to Jupiter: 951 Gaspra, at a distance of 1,000 miles (1,600 kilometers) in 1991; and 243 Ida, identifying it as the first known example of an asteroid with a moon of its own. Subsequently named Dactyl, it measures about 1 mile (1.5 kilometers) in diameter and orbited about 62 miles (100 kilometers) from Ida's center.

Near-Earth Asteroid Rendezvous Shoemaker (also known as NEAR Shoemaker) Launched by NASA in 1996, this spacecraft flew within 753 miles (1,212 kilometers) of Asteroid Mathilde in June 1997. It rendezvoused with and landed on Asteroid Eros on February 12, 2001.

Deep Space 1 Launched in 1998, Deep Space 1 flew past Asteroid 9969 Braille in July 1999. During a flyby at a range of only 16 miles (26 kilometers), its instruments found intriguing similarities in the geology and surface features of Braille and Asteroid Vesta, one of the largest asteroids in the solar system.

Stardust Built for a comet rendezvous and sample return, Stardust also encountered Asteroid Annefrank in 2002, passing within 2,050 miles (3,300 kilometers), finding it irregularly shaped, cratered, and about 5 miles (8 kilometers) in diameter. It then encountered Comet Wild 2, captured cometary particles, and returned them to Earth.

Hayabusa Launched on May 9, 2003, by the Japan Aerospace Exploration Agency (JAXA), Hayabusa was a sample return probe sent to the Asteroid Itokawa. On November 25, 2005, it successfully landed on Itokawa. In April 2007, Hayabusa started its return to Earth, arriving on June 13, 2010. Mission controllers attempted a parachute landing in the South Australian outback, but the spacecraft broke up on reentry and was incinerated before reaching the ground.

Rosetta The ESA probe launched in 2004, which flew by 2867 Šteins in 2008 and 21 Lutetia in 2010.

Dawn Launched in 2007, Dawn began an eight-year, 3 billion-mile (4.9 billion-kilometer) mission. In August 2011 Dawn encountered the Asteroid Vesta and in 2015 the dwarf planet Ceres, two of the largest objects that lie within the Asteroid Belt.

Chang'e Launched by China National Space Administration on December 13, 2012, this probe flew within 2 miles (3.2 kilometers) of Asteroid 4179 Toutatis on an extended mission.

Hayabusa 2 JAXA launched this probe in December 2014, and returned samples from asteroid 162173 Ryugu on December 5, 2020, before continuing its mission until 2032.

STARDUST'S FINDINGS

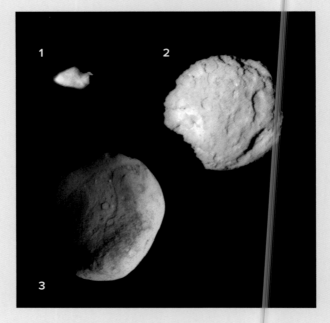

1 Annefrank
2 Wild 2
3 Tempel 1

Asteroid Annefrank is one of several objects visited by the Stardust mission. Annefrank is modest in size; seen here as an irregularly shaped, cratered body in this image taken by NASA's Stardust spacecraft during a November 2, 2003, flyby of the asteroid. Stardust flew within about 2,050 miles (3,300 kilometers) of the asteroid as a rehearsal for the spacecraft's encounter with its primary target, comet Wild 2, in January 2004, and then Tempel 1. The camera's resolution was sufficient to show that Annefrank is about 5 miles (8 kilometers) in length, twice the predicted size from Earth-based observations. The surface reflects about 0.1 to 0.2 percent of sunlight, slightly less than anticipated. A few craters that are hundreds of meters across can be seen. The straight edge in the right side of the image may be an artifact of processing.

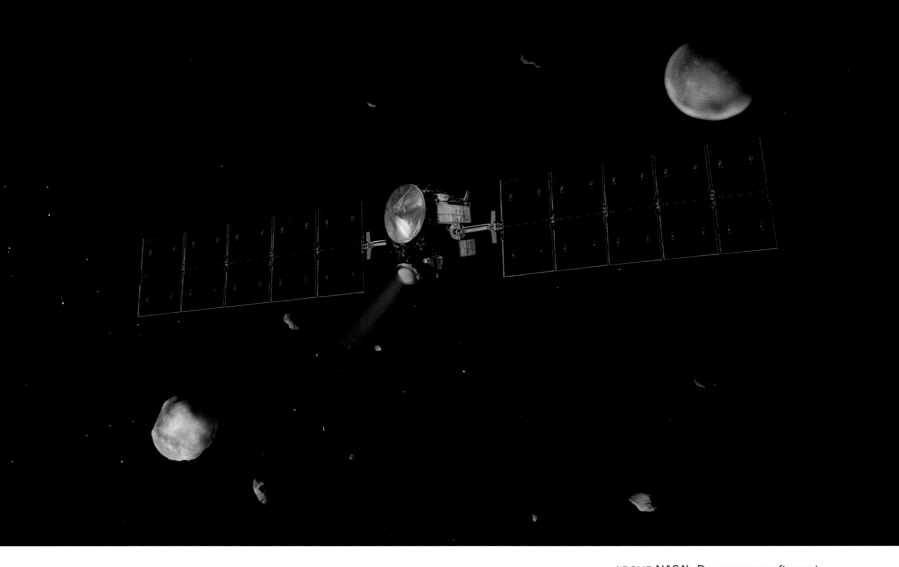

ABOVE NASA's Dawn spacecraft spent fourteen months orbiting Vesta from 2011 to 2012, before journeying on to Ceres. The Dawn mission was dynamic in that it was the first spacecraft to go into orbit around two destinations in our solar system beyond Earth.

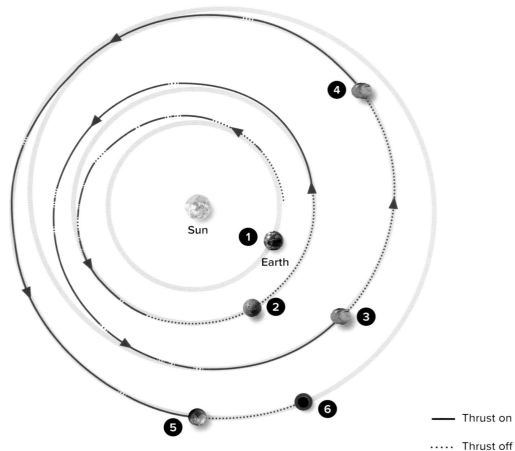

LEFT The Dawn probe used small thrusters to achieve the trajectory needed to visit the two objects, Ceres and Vesta, in the Asteroid Belt between Mars and Jupiter. This map depicts the trajectory of Dawn as it journeyed outward to its encounters in the Asteroid Belt. The use of thrusters is also depicted, and orbits are shown in grey.

1. Launch, September 27, 2007
2. Mars gravity assist, February 2009
3. Vesta arrival, August 2011
4. Vesta departure, May 2012
5. Ceres arrival, February 2015
6. End of mission, July 2015

—— Thrust on
····· Thrust off

THE OUTER SOLAR SYSTEM

OSIRIS-REx Launched by NASA on September 8, 2016, the probe is part of a sample return mission to asteroid 101955 Bennu. On October 20, 2020, it descended to the asteroid and "pogo-sticked off" it while successfully collecting a sample, which it returned to Earth on September 24, 2023.

Double Asteroid Redirect Test (DART) and LICIACube Launched in 2021, DART evaluated the kinetic impact on the asteroid Didymos. It also carried a 6U CubeSat provided by the Italian Space Agency to Didymos, which was released on September 11, 2022, before the DART impact into the asteroid.

Lucy Launched in 2021, Lucy was designed to make flyby observations of eight Trojan asteroids—one main belt asteroid and seven asteroids—orbiting ahead of or behind Jupiter beginning in late 2023.

Near-Earth Asteroid Scout (NEA Scout) This mission, launched in November 2022, employed a 6U CubeSat and a solar sail to fly by and return images of the Near-Earth Asteroid, Asteroid 2020 GE, estimated to be about 13–59 feet (4–18 meters) across. Controllers never obtained contact with the spacecraft after launch.

Psyche (Discovery 14) Launched on October 13, 2023, this NASA mission is heading to asteroid 16 Psyche where it will orbit the body and explore the origin of planetary cores beginning in 2026.

RIGHT The complex journey of NEAR Shoemaker from Earth to Eros is depicted in this map of its trajectory (red).

1. Launch, February 17, 1999
2. Flyby of Asteroid Mathilde, June 27, 1997
3. Deep space maneuver, July 3, 1997
4. Earth gravity assist, January 23, 1998
5. Flyby of Asteroid Eros, December 23, 1998
6. Deep space maneuver, January 3, 1999
7. Eros arrival, February 12, 2001
8. Earth orbit
9. Eros orbit

BOTTOM LEFT The OSIRIS-REx sample return mission to Asteroid Bennu relayed these three images from the asteroid's northern hemisphere. A wide-angle photograph (*left*), shows a 590-foot (180-meter) wide boulder-strewn area as well as a relatively flat area in the upper right. The two boxed areas were also imaged by a different camera on OSIRIS-REx. The resulting images (*right*) show a 50-foot (15 meter) boulder (*top*) and a relative flat area nearby (*bottom*).

BELOW OSIRIS-REx's sample return capsule landed by parachute at the Utah Test and Training Range operated by the US Department of Defense on September 24, 2023. It contained a sample from Asteroid Bennu, collected in October 2020.

SMITHSONIAN ATLAS OF SPACE

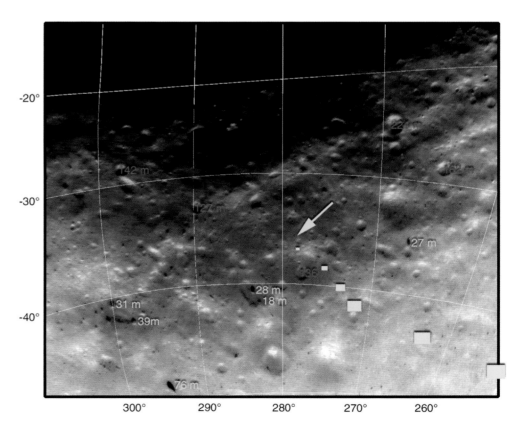

RIGHT The NEAR Shoemaker mission was a sparkling success story. This map of NEAR Shoemaker on Eros depicts the planned landing site. Diameters of craters are shown in red, and diameters of boulders are shown in yellow, both measured in meters. The six yellow "footprint" boxes show the descent of NEAR Shoemaker as it approaches the surface at 3,000, 2,500, 2,000, 1,500, 1,000, and 500 meters, and the yellow arrow marks the estimated touchdown site. Coordinates along the left side of the map are degrees south latitude and coordinates along the bottom are degrees west longitude.

THE OUTER SOLAR SYSTEM

NASA's Double Asteroid Redirection Test (DART) spacecraft prior to impact with asteroid Didymos. DART was designed to test the possible impact of deliberately crashing a spacecraft into an asteroid to change its course.

"There have been some eighty asteroids larger than 100 miles (162 kilometers) in diameter identified, mostly in the Asteroid Belt. While most of these pose Earth no danger, it is important to track these objects and an international effort to do so is underway."

ABOVE Launched in 2014, Hayabusa 2 is a JAXA asteroid sample-return mission that rendezvoused with the near-Earth asteroid 1999 JU3, also called Ryugu, in 2018. Hayabusa 2 landed a probe carrying three tiny rovers on the surface and returned samples to Earth in December 2020.

BELOW Observed from NASA's 230-foot (70-meter) antenna at the Goldstone Deep Space Communications Complex in California and the National Science Foundation (NSF)'s 330-foot (100-meter) Green Bank Telescope in West Virginia, these three radar images of near-Earth asteroid 2003 SD220 were obtained on December 15–17, 2018. From left to right: (1) December 15, asteroid 2003 SD220 at 2.8 million miles (4.5 million kilometers) from Earth; (2) December 16, the asteroid gets closer, at 2.5 million miles (4.0 million kilometers); and (3) the asteroid at 2.2 million miles (3.5 million kilometers) from Earth on December 17. The asteroid safely passed Earth on Saturday, December 22, 2018, at about 1.8 million miles (2.9 million kilometers). It was the asteroid's closest approach in more than four hundred years.

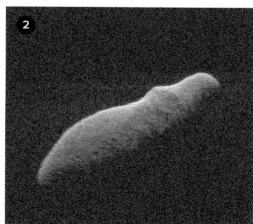
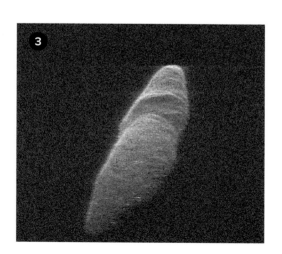

THE OUTER SOLAR SYSTEM

Inaugurated by NASA as a small-scale science mission on January 4, 2017, the Psyche probe is presently en route to the metallic asteroid 16 Psyche, where it will accumulate data on the asteroid's composition using a multispectral imager, a magnetometer, and a gamma-ray spectrometer. Launched on a SpaceX Falcon Heavy rocket on October 13, 2023, it will take a lengthy path—including a Mars gravity-assist—to reach 16 Psyche by 2029. Once there, Psyche will seek to offer insights into the asteroid's geology, shape, composition, magnetic field, and mass, shedding light on planetary formation. Made largely of metals, 16 Psyche offers new opportunities to understand the formation of terrestrial planets, including Earth.

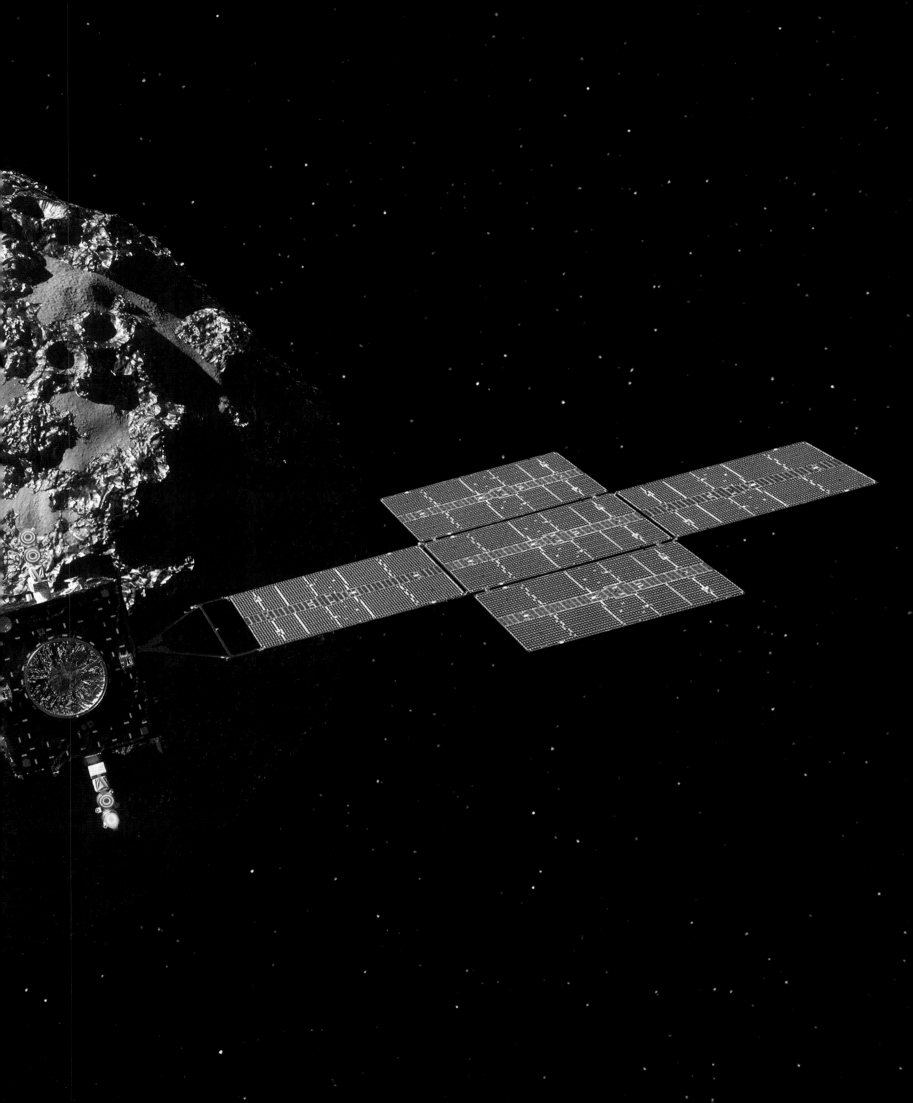

4 OUR NEARBY WORLDS

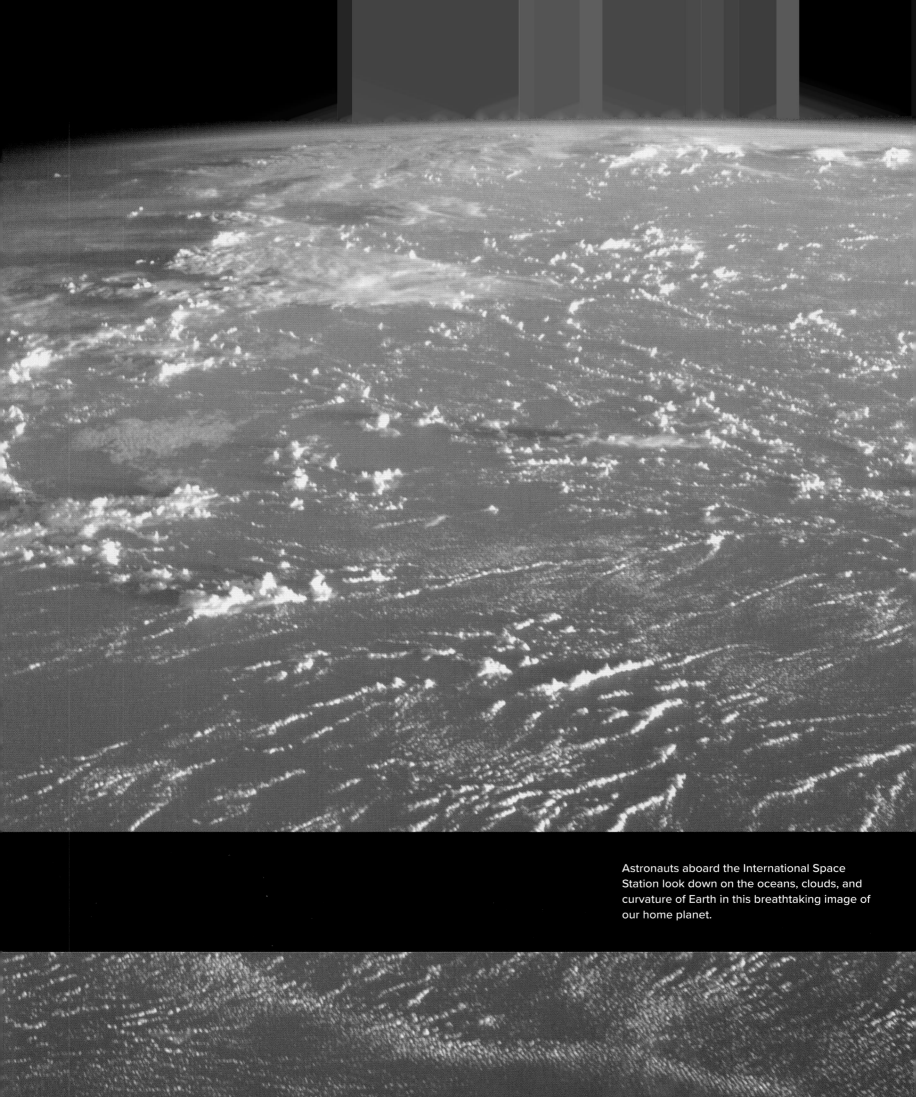

Astronauts aboard the International Space Station look down on the oceans, clouds, and curvature of Earth in this breathtaking image of our home planet.

Humans have long observed from afar the planets Mars, Venus, and Mercury, and over the centuries mythologies, ideals, and explanations for the planets' characteristics have evolved. Each one of these planets was just enough like Earth to raise expectation of the possibility of life, as humans understood it, to evolve there. And every one of them has been visited several times by space probes sent from Earth since the beginning of the Space Age in the 1950s. What we have learned through this process has been both wondrous and disappointing, especially since we have yet to discover life beyond our planet.

The region of the solar system from Mars to Mercury, containing the terrestrial planets in our system, is dominated by small rocky planets, some of which are located in a perceived habitable zone. Earth, of course, is teeming with life, but many have long believed that Mars was once a watery planet which may have harbored life for at least some of its existence. Before the middle part of the twentieth century, folklore suggested that Venus might also have life, usually thought of as existing in a Precambrian-like environment in which dinosaurs might exist. Even Mercury, closest to the Sun, while long thought to be too hot and extreme for life as we understand it to exist on the surface, might hold underground forms of life.

Indeed, the search for life beyond Earth has shaded every aspect of terrestrial planetary exploration. While geology, climate, atmospheres, and other sciences dominate every aspect of space exploration, biology and the promise of life has been a persistent ingredient in the exploration of Mars and Venus, and, at some level, even Mercury.

Before the twentieth century, the possibility of visiting these rocky, terrestrial planets in the inner part of the solar system was remote. The advent of the telescope in the seventeenth century enabled the viewing of Mars, Venus, Mercury, and other nearby bodies with greater clarity than ever before, but knowledge of them was still very much in its infancy. The Space Age offered the opportunity for the first time in human history to travel to terrestrial planets of the solar system and to explore them in depth. Humanity's long-held beliefs about Earth's nearest neighbors have been altered, and in some cases dashed, by the sustained investigation that has taken place since the beginning of this remarkable age of exploration.

This chapter will narrate the history of exploration of the terrestrial planets, beginning with Mars. Earth and its Moon, also an important subject of study from space, follows; with Venus and Mercury completing the discussion. The investigation is ongoing, and exciting at every turn.

IMAGING MARS

Fabled as the Red Planet because of its pronounced reddish hue, Mars has enticed humans for centuries. In 2016, controllers on the ground trained the Hubble Space Telescope's (HST's) superb camera on the planet during its opposition (closest approach to Earth), at 50 million miles away. It is the best single photograph of Mars taken from a telescope located near Earth, achieving a spatial scale of 5 miles, or 8 kilometers per pixel. The lighter and darker colorations of features on the ground—in reality highlands and lowlands on the planet's surface—were often thought of in earlier generations as evidence of features on the planet built by intelligent life there.

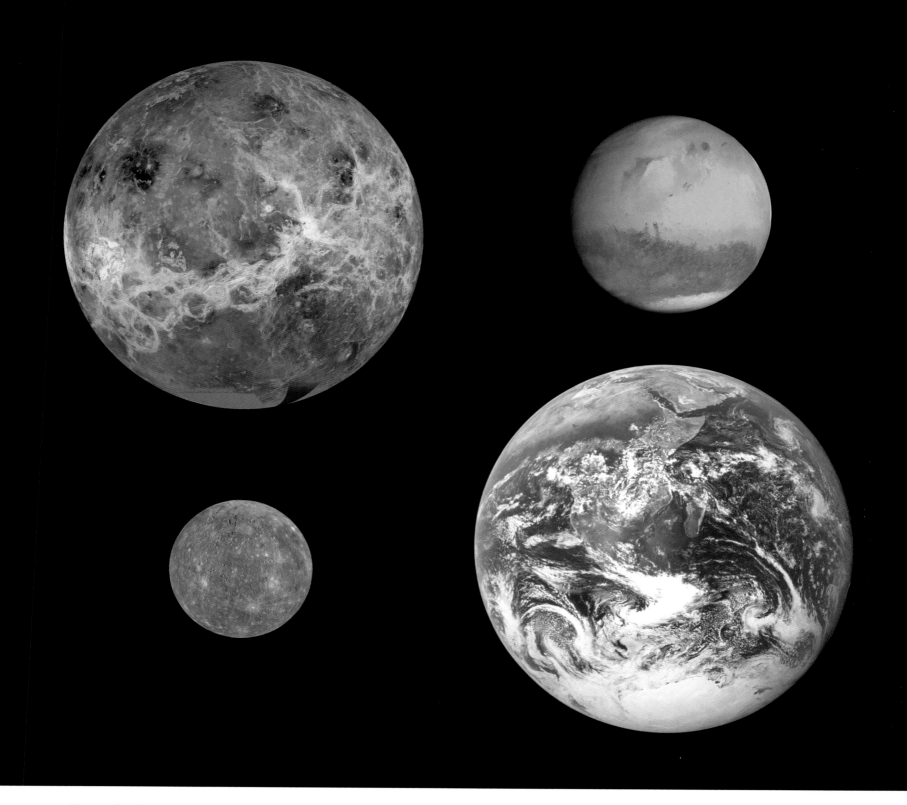

The relative sizes of (*clockwise from top left*) Venus, Mars, Earth, and the Moon. Venus, although shrouded in clouds that have been stripped away in this radar image made by the Magellan spacecraft in the early 1990s, is nearly the same size as Earth. Mars is much smaller in size.

ENTICING MARS

For centuries Mars has enticed humans, in no small measure because it might harbor life as we understand it. In the Space Age, Mars is one of the great fascinations in a solar system of many attractions.

Desires have long dominated ideas about Mars. The ancients personified the planet: the Babylonians called it Nergal—the great hero, the king of conflicts; the Egyptians referred to it as Har Decher, the Red One. It signified combat and war. So too with the ancient Greeks and Romans, who named it for their god of war.

In the twentieth century many embraced the idea of life on Mars, since it orbits in the habitable zone of the solar system, a place where liquid water might exist. This idea has dominated science fiction about Mars, framing the eleven-volume science-fiction *Martian Series* (1911–43) by Edgar Rice Burroughs, and *The Martian Chronicles* (1950) by Ray Bradbury, for example. These science-fiction potboilers have remained popular, prompting movie adaptations such as *The Martian Chronicles* miniseries in 1980 and the Disney big-screen epic *John Carter* (2012).

Not until the first spacecraft reached Mars in the 1960s did these ideas about finding life on Mars begin to change in popular culture. Finding a craterlike landscape there signaled the reality that preconceptions about Mars being an Earthlike planet required revision. Nonetheless, the desire to find evidence of life on Mars remains and has dominated many scientific investigations of the Red Planet, so named because it appears with a reddish hue through telescopic observation from Earth.

MARS FAST FACTS

MEAN DISTANCE FROM SUN 142 million miles (229 million kilometers) or 1.5 astronomical units (AU)
DIAMETER 4,220 miles (6,791 kilometers)
DENSITY 3.933 grams/cubic centimeter
SURFACE GRAVITY 3.72076 meters/second squared (about 38 percent of Earth's gravity)
ROTATION PERIOD (LENGTH OF DAY) 24 hours, 39 minutes, 35 seconds
REVOLUTION PERIOD (LENGTH OF YEAR) 687 Earth days
MEAN SURFACE TEMPERATURE -80 degrees Fahrenheit (-62 degrees Centigrade)
NATURAL SATELLITES Two
DISCOVERER No single person is credited with the discovery of Mars; it has been observed from Earth for centuries. It was first observed by telescope by Galileo Galilei in 1610.

LEFT The cargo ship and glider designed by German-American aerospace engineer Wernher von Braun (1912–77) as part of his proposal for a human mission to Mars.

RIGHT Created by stitching together more than a thousand images of Mars taken by the Viking spacecraft that visited the Red Planet in 1976, this global color image is at a resolution of 0.62 miles (1 kilometer) per pixel. The most notable features are the polar ice cap and the so-called Mars Gash, the long line located just below the equator of the planet. Formally named Valles Marineris, it is a system of canyons that runs along the Martian equatorial plain for more than 2,500 miles (4,000 kilometers). It is about 120 miles (200 kilometers) wide and up to 23,000 feet (7 kilometers) deep. Valles Marineris is the largest known canyon in the solar system.

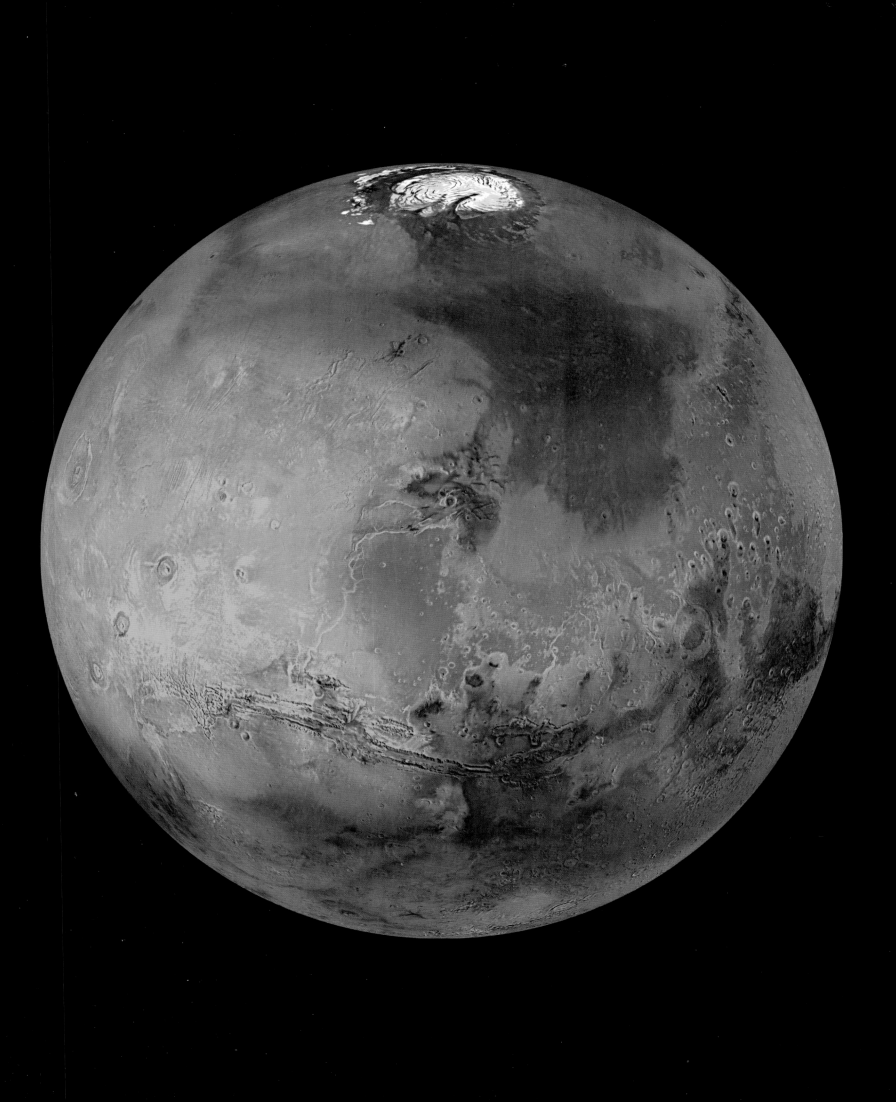

MARTIAN CANALS?

Beyond science fiction, many Mars observers accepted the reports of such astronomers as Giovanni Schiaparelli (1835–1910) about *canali* (channels) on Mars, leading to all manner of speculations about complex technological civilizations on the Red Planet. This led French author Camille Flammarion to speculate in *Uranie* (1889) on what life on Mars might be like: "They have straightened and enlarged the watercourses and made them like canals, and have constructed a network of immense canals all over the continents."

American gentleman astronomer Percival Lowell (1855–1916) pushed the idea of canals on Mars built by a complex dying civilization. Using personal funds, he built the Lowell Observatory near Flagstaff, Arizona, to facilitate studying the planet and argued until his death that life had evolved on Mars.

Magazine illustrations commonly portrayed the planet as a network of canals. Editors at *Life* magazine informed readers in 1944 that the canals served to irrigate patches of vegetation "that change from green to brown in seasonal cycles." German-American science writer Willy Ley assured readers in a 1952 issue of *Collier's* magazine that "lichens and algae" most assuredly existed on Mars. The idea of complex life on Mars stayed in the popular imagination, and we still want to believe that life might once have existed there in some form.

RIGHT Including six orthographic projections of Mars, this map from 1967 shows the most detailed information about the surface of the planet available at the time. Even then, the features could still be interpreted as canals. The areas named here represent geographical regions that astronomers started using to identify locations on the planet. Many were versions of ancient classical names. The most extensive geographical nomenclature for Mars resulted from the work of Italian astronomer Giovanni Schiaparelli.

BOTTOM RIGHT Created between 1877 and 1888, Schiaparelli's drawing of the two hemispheres of Mars gave rise to the belief that intelligent beings had built canals to bring water from the poles to an arid equatorial region. He wrongly assumed this to be due to seasonal changes in vegetation; the gullies are, in fact, made by powerful dust storms.

NINETEENTH-CENTURY MAPS OF MARS AND THEIR CANALS

Both Giovanni Schiaparelli and Percival Lowell prepared maps of the Martian surface that fueled speculation about life on Mars. Schiaparelli made the first detailed map of the Red Planet, naming its "seas" and "continents." It clearly showed what some took to be canals and gave credence to misconceptions that it was more Earthlike than was actually the case.

Lowell wrote three books on this subject—*Mars* (1895), *Mars and its Canals* (1906), and *Mars as the Abode of Life* (1908)—insisting that Mars was a dying planet whose inhabitants had constructed a vast system of canals to distribute water from the polar regions to population centers elsewhere. This map is from *Mars as the Abode of Life* and shows the canals Lowell thought existed on the Martian surface.

Although popular, few astronomers accepted Lowell's arguments. Italian astronomer Vincenzo Cerulli (1859–1927) concluded that these channels were nothing more than optical illusions. However, no one could convince Lowell that what he saw on Mars was not the product of a complex civilization, and these misconceptions did not end until spacecraft arrived there in the 1960s.

OUR NEARBY WORLDS

EARLY MARS MISSIONS

As part of a desperate Cold War struggle, both the Americans and Soviets made Mars an early target of their space programs, sending probes there throughout the 1960s. They learned—as both countries faced many failures in their efforts—that successfully accomplishing those missions would be fraught with difficulties.

The Soviet Union sent the first spacecraft to Mars in the 1960s. Six missions—four flybys, one lander, and one impactor—were launched between October 1960 and November 1964, but not a single one of them was successful. In 1971 the Soviet Union finally reached Mars with its Mars 2 and Mars 3 Orbiters. Although not entirely successful, since the landers failed to reach the Red Planet, these spacecraft sent back a total of sixty images of Mars.

The United States also had a poor record of accomplishment or success with robotic missions to Mars during the first decade of the Space Age, losing two of six probes before they reached Mars. Eventually, Mariner 4 arrived at Mars on July 15, 1965, flying within 6,118 miles (9,846 kilometers) of the planet and taking twenty-one close-up pictures. These photographs depicted a planet without structures and canals, nothing that even remotely resembled a pattern that intelligent life might produce.

Based on this information, the weekly magazine *US News & World Report* announced definitively in its August 9, 1965, issue that "Mars is dead." Even President Lyndon B. Johnson pronounced that "life as we know it with its humanity is more unique than many have thought."

Mariners 6 and 7, launched in 1969, also imaged the Red Planet, but it was Mariner 9 that entered Martian orbit and provided significant data in 1971 and 1972. Scientists at NASA's Jet Propulsion Laboratory (JPL), Pasadena, California, processed Mariner 9's imagery into a globe that showed the subtle details revealed by the spacecraft, such as the relics of ancient riverbeds and gullies in the desolate landscape (see page 230). Completed in September 1973, these globes showed better than anything else the large-scale geological features of the planet and aided in Mars mission-planning thereafter.

NASA's Mariner 4 spacecraft was superimposed on an illustration of Mars to advertise the 1965 mission.

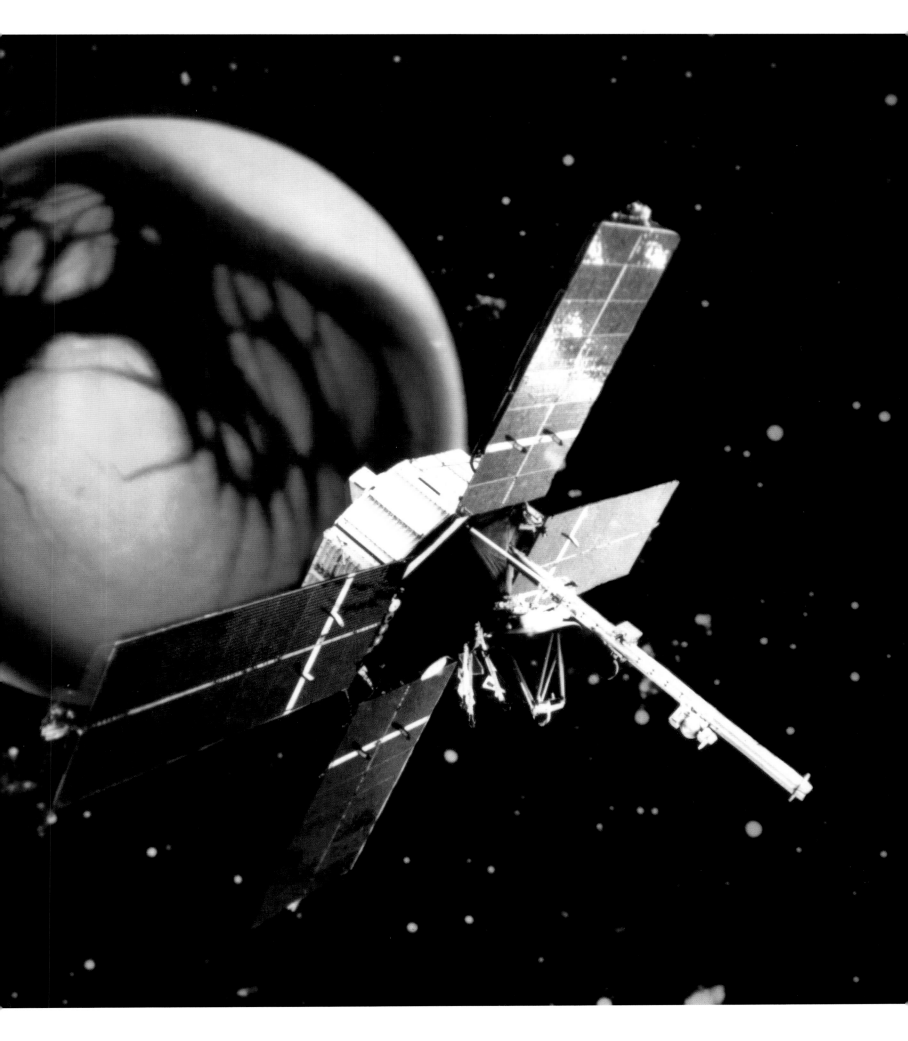

OUR NEARBY WORLDS

ABOVE A real-time data translator machine converted Mariner 4 digital image data into numbers printed on strips of paper. Engineers from NASA's JPL then placed the strips side by side on a display panel and hand-colored the numbers like a paint-by-numbers picture, making both a work of art and the first digital image from space. JPL technicians framed the resulting image and presented it to director William Pickering.

ABOVE A simple tape storage device like this was used on Mariner 4 to record imagery of the Red Planet, which was then transmitted back to Earth through the communications system.

ABOVE An enhanced contrast version of the first Mars photograph released by Mariner 4 on July 15, 1965. This first close-up photograph of another planet was transmitted digitally from the spacecraft to Earth using data stored on an onboard tape recorder for later transmission.

ABOVE This picture from Mariner 4 clearly shows craters on Mars, making it look more like a Moonscape than anything else. It did more than any other image to quash the notion that Mars might be habitable.

ABOVE A view of the entire planet of Mars, photographed by Mariner 7 from 200,000 miles (300,000 kilometers) away in 1969. The image shows NIX Olympia (the circular feature in the upper-center quadrant of the image), later identified as the giant shield volcano Olympus Mons, and polar caps.

RIGHT A 4-foot (1-meter) Mariner 9 photomosaic globe of Mars on display at the Smithsonian National Air and Space Museum, Washington, DC, represents not only the first photomosaic globe of Mars ever made, but also the first made of any planetary body. Over 1,500 photos were used to produce the original. Each image had to be computer processed to produce consistent shading and to give it the proper geometry for its placement on the globe, and then cut by hand so it could be mosaicked with other overlapping images without interfering with important surface features. The overlap of various images as they were pieced together on this remarkable globe can be seen.

OUR NEARBY WORLDS

LANDERS, ROVERS, AND FLYERS

Successes with the Mariner flybys and orbiters at Mars steeled NASA's efforts to land there. Beginning with the Viking landers in 1976, several additional missions have reached the surface of Mars, some roving the landscape collecting data, while one helicopter has even flown in the thin Martian atmosphere.

Some observers have characterized the 1970s as the golden age of planetary exploration because of the probes sent to the outer planets, and especially because of the Viking Mars landers. Although the golden age might be overblown, certainly the twin orbiters and landers, Vikings 1 and 2, were spectacularly successful. Launched by NASA in 1975, both landed during the bicentennial celebration of the United States in the summer of 1976, and promptly mesmerized the world. The landers, rovers, and flyers sent to Mars showed humanity that the planet was both inviting and different from Earth.

Project Viking's two identical spacecraft, each consisting of a lander and an orbiter, sent transmissions to Earth until November 11, 1982. One of the most important scientific activities of this project involved an attempt to determine whether there was life on Mars. While early readings showed evidence of biological material, mission biologists were determined that it was a "false positive" based on the incorrect calibration of instruments. In the end, it was reluctantly announced that the possibility of finding life on Mars had been overhyped.

Viking, while successful overall, was a disappointment in this regard. It found no evidence of life on the surface of Mars, or even life that might live at the depths that the lander could dig to from the Martian surface. As it turns out, this should not have been surprising. Surface dwellers are rare—on Earth, most of the biomass lives below the planetary surface in the soil or oceans.

After Viking, NASA did not send any spacecraft to Mars for almost twenty years. When it did, its Mars Observer failed enroute in 1993. Intended to provide the most detailed data yet available about Mars, the mission went smoothly until controllers lost contact with it on August 21, 1993, three days before the spacecraft's capture in orbit around Mars. The loss of Mars Observer came as a result of an explosion in the fuel lines of the spacecraft. One wit offered an alternative explanation, suggesting that after the landing by the Vikings in 1976 the Martians had developed a planetary defense system that was now knocking out everything sent to the Red Planet.

During planning for the mission, and while the landers operated on the surface of Mars, scientists and engineers used this test article for the Viking landers to model how the landers would respond to various radio commands.

OUR NEARBY WORLDS

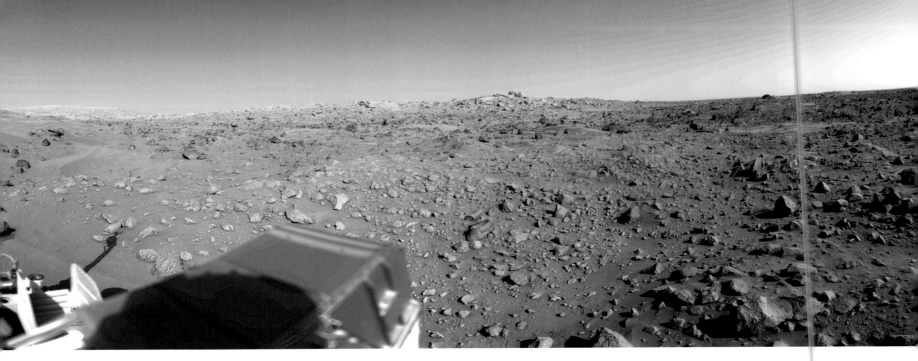

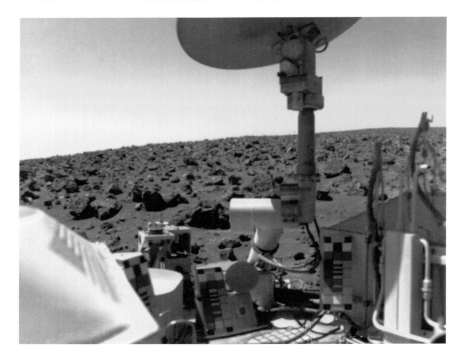

ABOVE This is the first panoramic view taken by Viking 1 from the surface of Mars. The out of focus spacecraft component toward left center (in shadow) is the housing for the Viking sample arm, which is not yet deployed. On the horizon to the left is a plateau-like prominence much brighter than the foreground material between the rocks. The horizon features are 1.8 miles (3 kilometers) away. At left is a collection of fine-grained material reminiscent of sand dunes.

LEFT Big Joe, a large boulder (about 6.6 feet [2 meters] long) with reddish fine-grained silt that spills down its sides lies about 26 feet (8 meters) from the Viking 1 Lander. Some of the other blocks of the field can be seen to the left, extending out toward the horizon.

BOTTOM LEFT This boulder-strewn field of red rocks stretches to the horizon, 2 miles (3 kilometers) from Viking 2's position on Mars's Utopia plain.

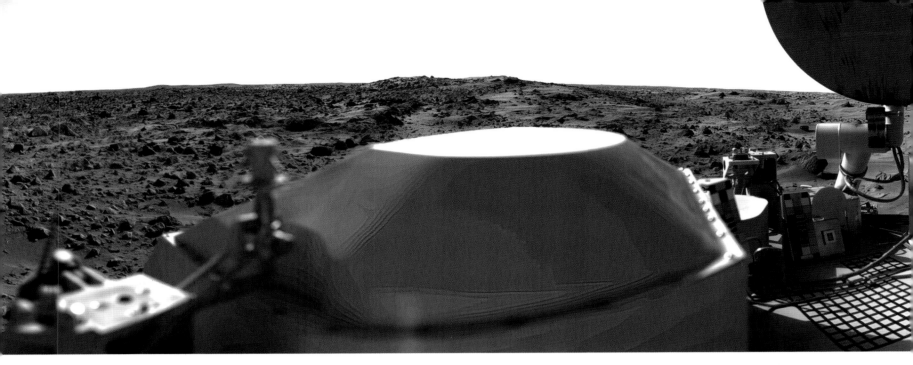

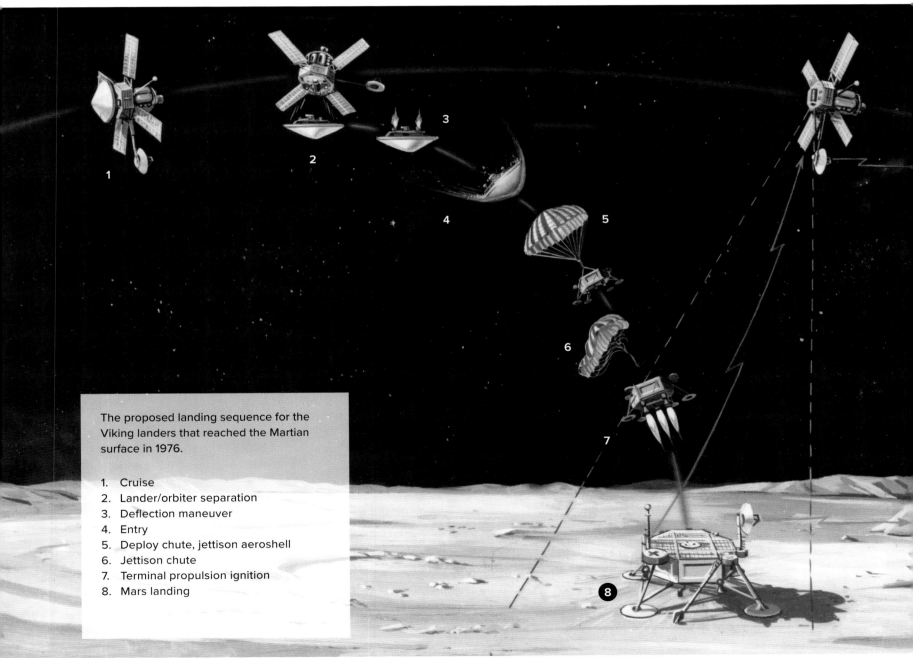

The proposed landing sequence for the Viking landers that reached the Martian surface in 1976.

1. Cruise
2. Lander/orbiter separation
3. Deflection maneuver
4. Entry
5. Deploy chute, jettison aeroshell
6. Jettison chute
7. Terminal propulsion ignition
8. Mars landing

OUR NEARBY WORLDS

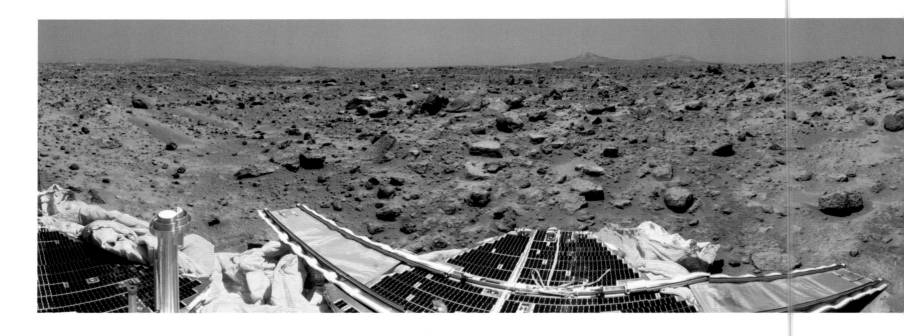

THE LITTLE ROVER THAT COULD

The exploration of Mars received another boost on July 4, 1997, when Mars Pathfinder landed successfully, marking the first return to the Red Planet since 1976. Upon landing, its small, 23-pound (10.4-kilogram) robotic rover, named Sojourner, departed the main lander and began to record weather patterns, atmospheric opacity, and the chemical composition of rocks washed down into the Ares Vallis floodplain, an ancient outflow channel in the northern hemisphere of Mars. This vehicle completed its projected milestone thirty-day mission on August 3, 1997, capturing far more data on the atmosphere, weather, and geology of Mars than scientists had expected. In all, the Pathfinder mission returned more than 1.2 gigabits (1.2 billion bits) of data and over 10,000 tantalizing pictures of the Martian landscape.

The results from Pathfinder proved exceptional. It showed that the Martian environment had changed over the eons and that it had once been a watery planet. The rocks and soil of the landing site showed unmistakable signs of rushing water eroding the surface and moving geological materials, just as seen on Earth during floods. These results reinvigorated the exploration of Mars at the beginning of the twenty-first century.

ABOVE Pathfinder landed in Ares Vallis, a floodplain covered with rock, boulders, and rounded pebbles swept down and deposited by floods occurring early in Martian history. Soon after Mars Pathfinder landed in 1997, shown here with air bags deflated, the site was formally named the Carl Sagan Memorial Station in honor of the pioneering planetary scientist. The rover, still in its carrier before deployment to the surface of Mars, was christened for American civil rights crusader Sojourner Truth. The excitement surrounding the revelation that Mars may once have been a watery planet energized future efforts to understand it.

RIGHT This unique image of Mars Pathfinder from above is a product of three sets of data: 1) a color mosaic image of the panorama; 2) an image that indicates the distance to the nearest object at each pixel location, referred to as a range image; and 3) a digital image of a full-scale museum model of the Mars Pathfinder Lander. It gives the impression of viewing the lander on the Martian surface from above. The Pathfinder Rover, Sojourner, is shown near a rock nicknamed Moe.

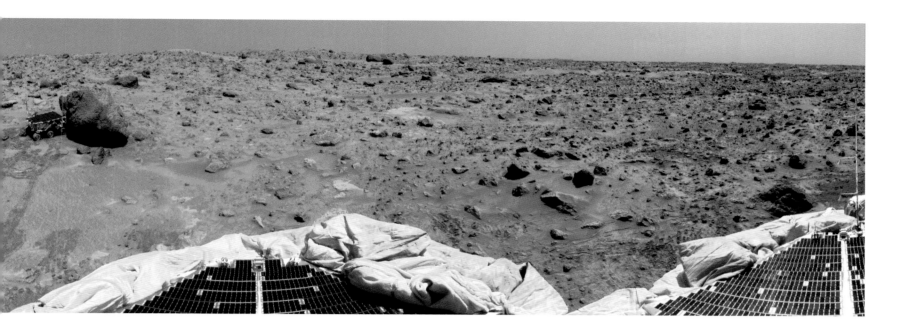
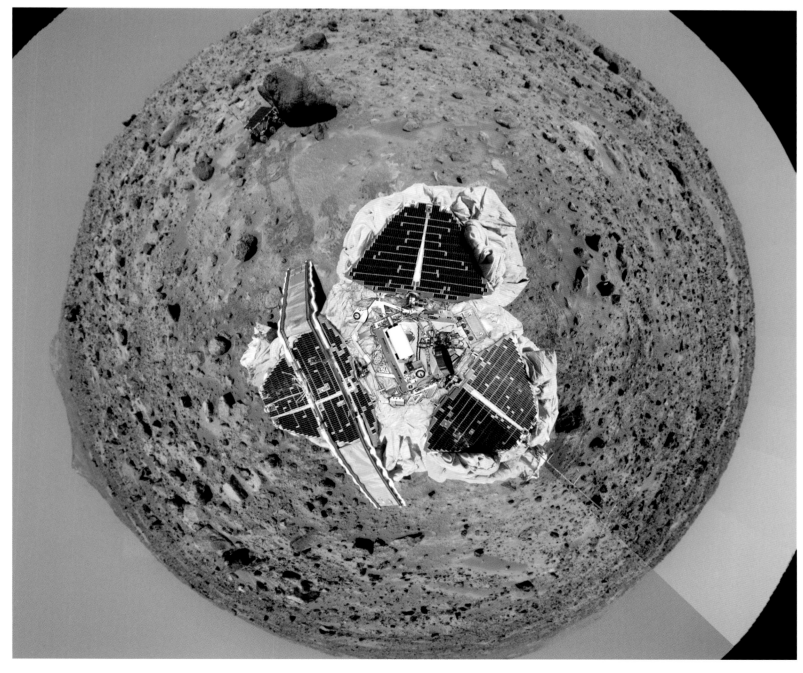

AN ARMADA OF ROVERS

In 2004 the twin Mars Exploration Rovers, Spirit and Opportunity, captured the public's attention around the world. Each weighing around 396 pounds (180 kilograms), they had a suite of five scientific instruments, as well as a rock abrasion tool for grinding weathered rock surfaces and a dexterous robotic arm to manipulate rock samples. They landed far apart on the surface: Spirit touched down in Gusev crater on January 4, 2004; while Opportunity landed on the other side of the planet in Meridiani Planum three weeks later.

Designed to last for only ninety days on the Martian surface, both rovers far outperformed their service life. Over the course of their operations, they drove more than seven times farther than originally planned. Spirit had covered 4.8 miles (7.7 kilometers) by the time it ceased communicating with Earth on March 22, 2010, with controllers ending its mission on June 8, 2011. Opportunity lasted much longer, ceasing operations on February 13, 2019, after having traveled 28.06 miles (45.16 kilometers). Along the way, both contended with hills and craters, sand traps, and technical problems.

Another successful rover, Curiosity, landed on Mars on August 6, 2012. On Earth, an impromptu gathering at New York's Times Square watched the landing on a big screen, chanting "Sci-ence, sci-ence, sci-ence!" Due to its size, NASA engineers employed an innovative "sky crane" system to lower Curiosity onto the surface. About three minutes prior to touchdown, it deployed a parachute but switched to retrorockets before, in the final phase of the descent, lowering the rover down to the surface in the Gale crater from the descent platform on a tether.

In 2021 NASA's Perseverance Rover, based on the Curiosity design, also reached the Red Planet. It carried with it the Ingenuity Mars Helicopter. First flying on April 19, 2021, through January 18, 2024, Ingenuity completed a total of seventy-two flights totaling 128.8 flying minutes, covering 11 miles (17 kilometers) and reaching altitudes as high as 79 feet (24 meters).

The Chinese rover Zhurong also landed on Mars on May 14, 2021, touching down in the southern region of Utopia Planitia. It then traveled on the Martian surface for 6,302 feet (1,921 meters) through to May 20, 2022. Altogether, the landers, rovers, and flyers have made some stunning discoveries. Mars, for example, has been found to be more hospitable than thought after the first Mariners went there in the 1960s. Measuring the radiation levels on the Martian surface suggested that they were not much higher than those that astronauts encounter aboard the International Space Station. This enhances the possibility that human missions to Mars might be feasible. Additionally, these probes found evidence of ancient streambeds where water once flowed and, while drilling into the soil, Curiosity spotted some of the key chemical ingredients for life, especially carbon.

THE PLANETARY SOCIETY

To emphasize serious science related to Mars and other planets, lobby for increased funding, and combat misinformation, the individuals pictured here helped to found the Planetary Society, beginning in the 1970s. Seated with a Mars globe and models of the Viking Orbiter and lander in the foreground are Bruce Murray, director of the Jet Propulsion Laboratory (*left*), and Cornell University astrophysicist Carl Sagan (*right*). Standing are Louis Friedman (*left*), who led the Planetary Society for many years in the early 2000s, and Harry Ashmore (*right*), an advisor, Pulitzer Prize winning journalist, and Civil Rights movement leader in the 1960s.

RIGHT The solar panels of Spirit were so dusty that the rover almost blends into the background in this image assembled from frames taken by the Panoramic Camera during the period between October 26 and 29, 2007. Dust on the solar panels reduced the amount of electrical power the rover could generate from sunlight each day.

BELOW This map shows the path that NASA's Spirit Rover took during its last two years of operation on Mars (February 4, 2009 to December 15, 2010). The distances are marked in sols, the Martian day, which lasts 24 hours, 39 minutes, and 35.244 seconds.

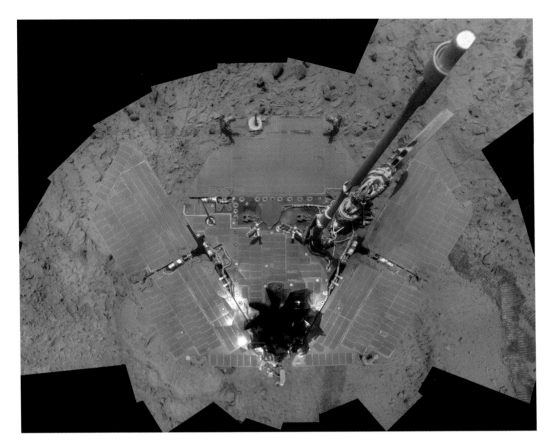

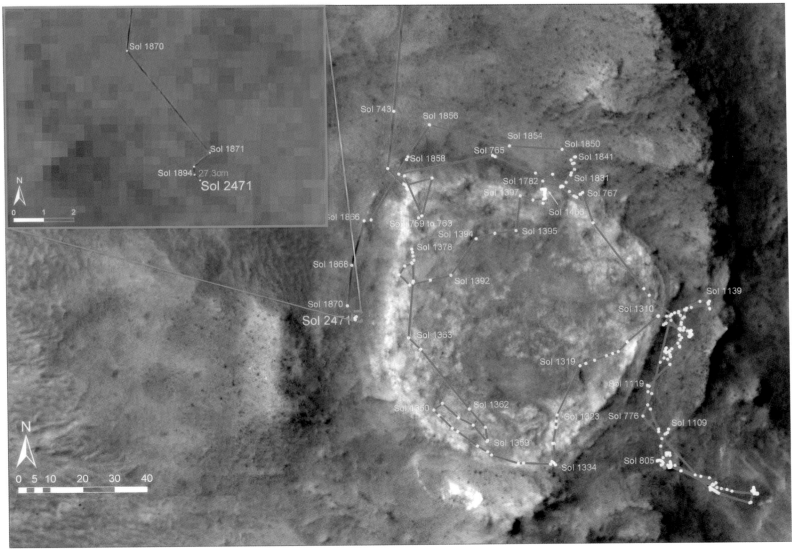

OUR NEARBY WORLDS

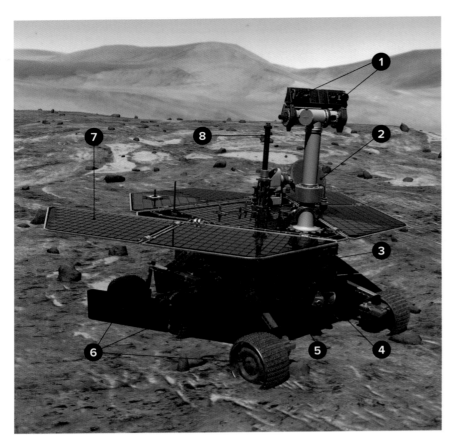

ABOVE Key features of NASA's Mars Exploration Rovers Spirit and Opportunity include:

1. Cameras
2. High gain antenna
3. Front hazard cameras
4. Instruments
5. Arm (folded)
6. Wheels
7. Solar arrays
8. Low gain antenna

TOP RIGHT Opportunity made this curving 52-foot (15.8-meter) drive during its 1,160th Martian day, or sol. It was testing a navigational capability called Field D-star, which enabled the rover to plan optimal long-range drives around any obstacles, thereby traveling the most direct safe route to the designated destination. Field D-Star and several other upgrades were part of the new onboard software update sent to the rovers from Earth in 2006.

RIGHT This striking image of NASA's Opportunity Rover's silhouette was taken by its rear hazard avoidance camera late in the evening on Mars, on March 20, 2014, more than a decade after the beginning of the rover's mission.

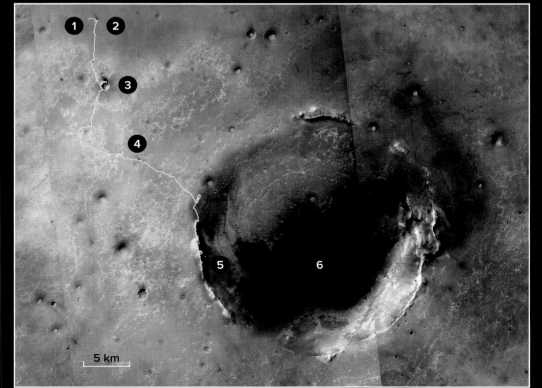

LEFT This map shows the path that NASA's Opportunity Rover took during its Mars mission. Beginning at Opportunity's landing site, Eagle crater, it ranged 28.06 miles (45.16 kilometers) to its final resting spot on the rim of Endeavour crater. The rover was descending down into the crater in Perseverance Valley when a dust storm ended its mission.

1. Eagle crater
2. Endurance crater
3. Victoria crater
4. Santa Maria crater
5. Perseverance Valley (final resting spot)
6. Endeavour crater

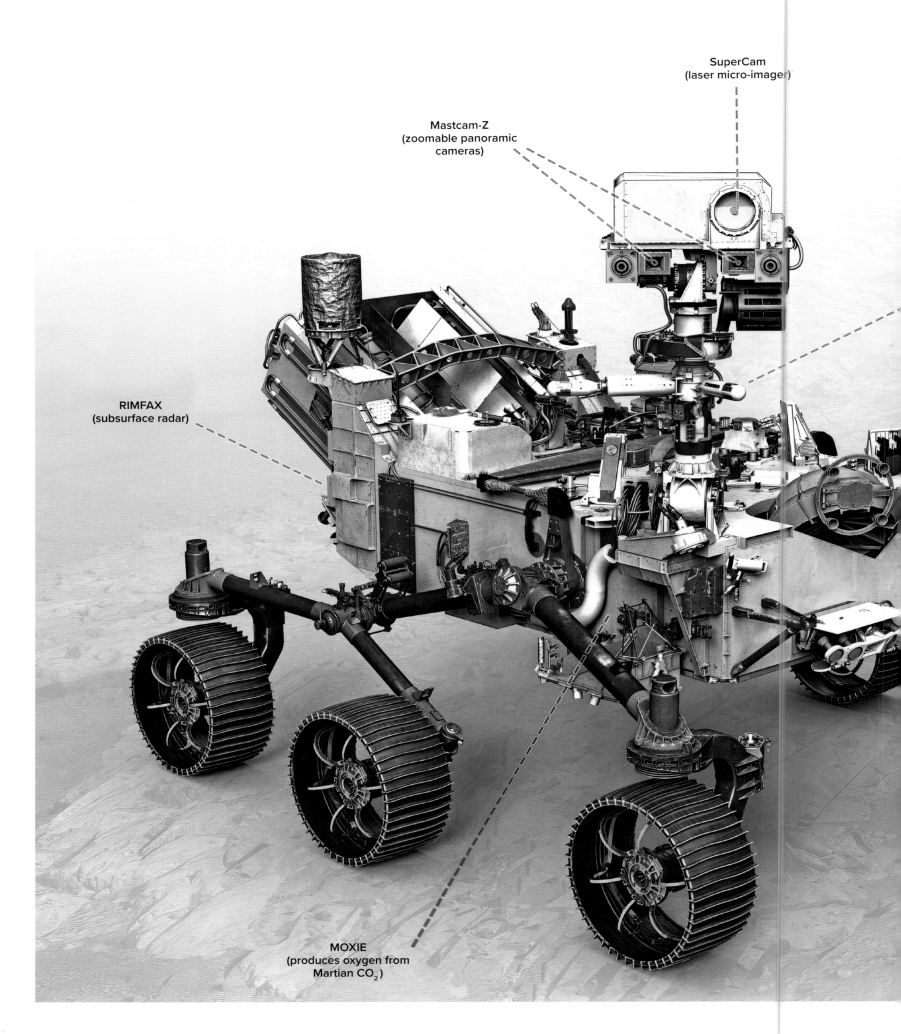

The Curiosity and Perseverance Rovers are based on the same design. Both are car-sized, about 10 feet long (not including the arm), 9 feet wide, and 7 feet tall (3 meters long, 2.7 meters wide, and 2.2 meters tall). Here is Perseverance, with callouts of its instruments.

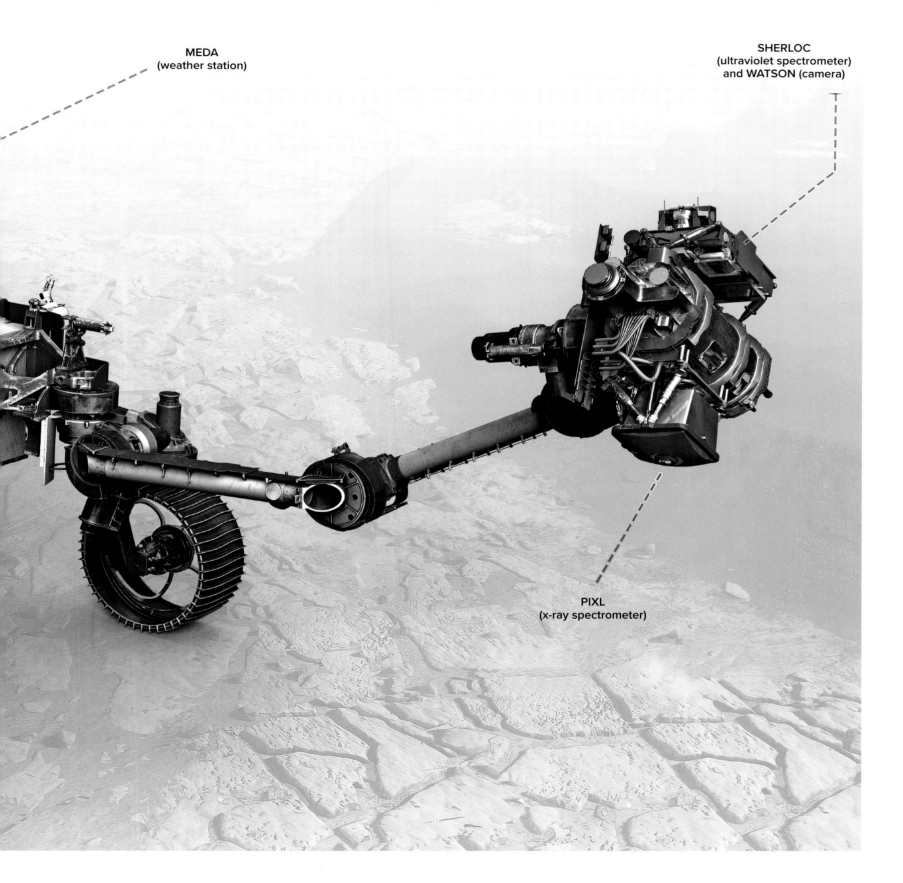

MEDA
(weather station)

SHERLOC
(ultraviolet spectrometer)
and WATSON (camera)

PIXL
(x-ray spectrometer)

OUR NEARBY WORLDS

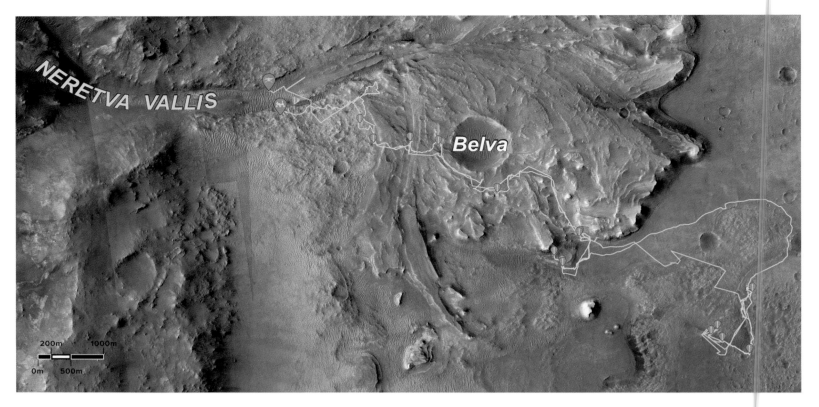

ABOVE A traverse map showing the path of NASA's Perseverance Mars Rover and its Ingenuity Mars Helicopter. It shows the landing point for Perseverance in the lower right of the map, and the motion of the rover on a white line. The red notations on the track show points at which the rover collected data on the soil and rock composition. The yellow line shows the flights of the helicopter Ingenuity, with the dots depicting each landing location. The current resting places for both Perseverance and Ingenuity are shown at the end points of their track lines, in the upper left of the map.

TOP RIGHT On September 23, 2019, the Mars Reconnaissance Orbiter (MRO) took an exquisite image of the Elysium Planitia landing area for the InSight Lander and its Curiosity Rover. Operating above the planet's surface at 169 miles (272 kilometers), MRO snapped the best sight yet of InSight, looking like a dark spot in the center of the main image. Blown up in the inset at lower right, the MRO image shows the two circular solar panels deployed on the lander, giving the craft a span of 20 feet (6 meters).

RIGHT This map of the entire surface of Mars shows successful probe landing sites. Most of these landings were scattered through the equatorial region of Mars, and although some look relatively close together, in reality they are separated by thousands of miles.

1. Phoenix
2. Viking 1
3. Pathfinder
4. Opportunity
5. Perseverance
6. Viking 2
7. InSight
8. Curiosity
9. Spirit

OUR NEARBY WORLDS

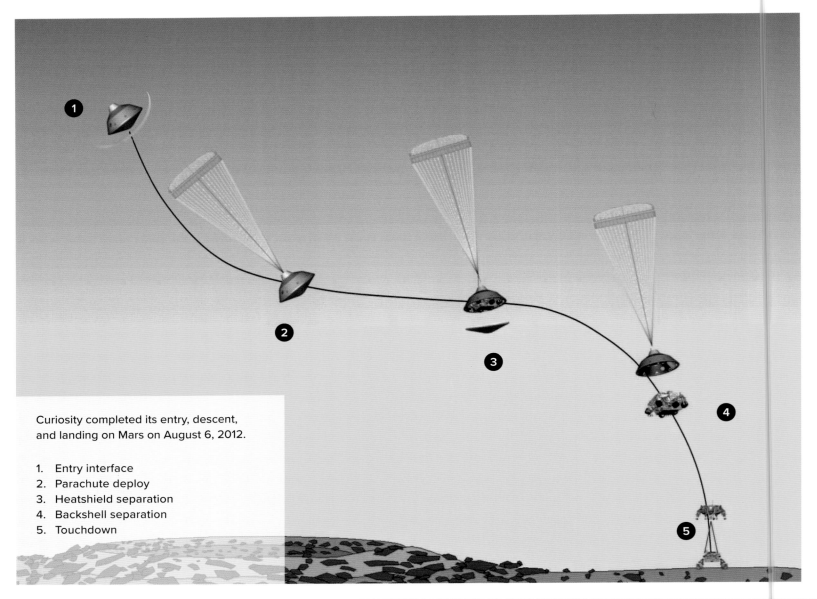

Curiosity completed its entry, descent, and landing on Mars on August 6, 2012.

1. Entry interface
2. Parachute deploy
3. Heatshield separation
4. Backshell separation
5. Touchdown

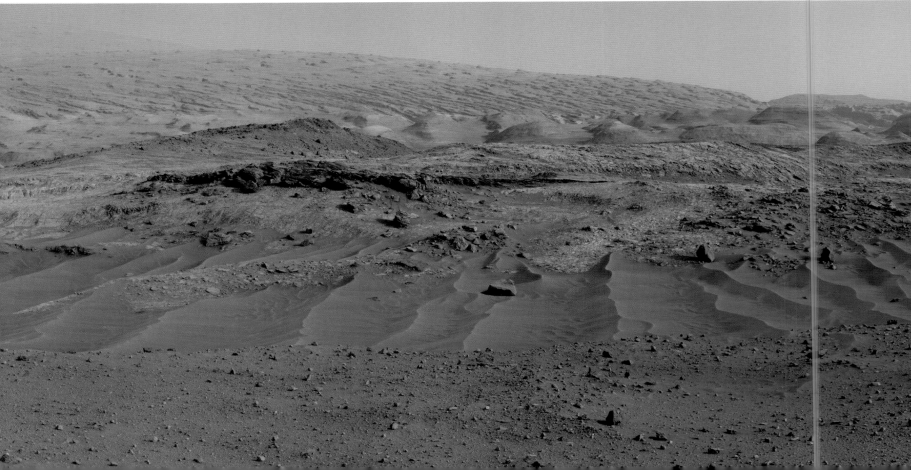

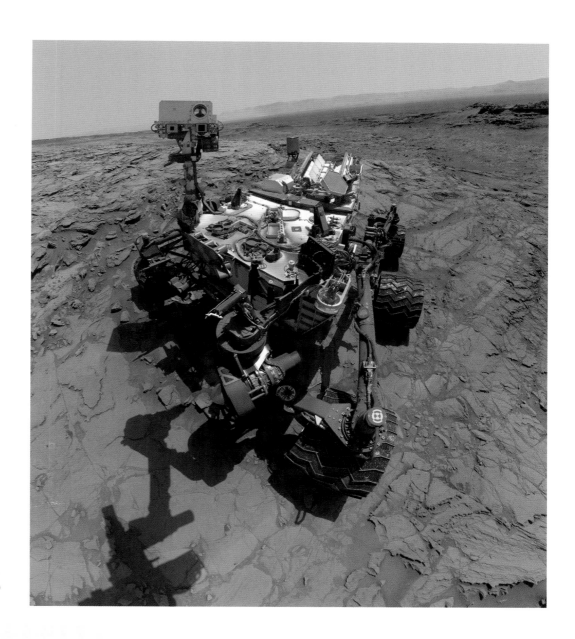

RIGHT This Curiosity self-portrait was taken at the Big Sky Drilling Site in Gale crater, Mars, October 6, 2015. Clearly seen in the foreground is the camera mount extending above the front of the rover. At the back is a white cylindrical component with what looks like paddlewheels surrounding it. This is the radioisotope thermoelectric generator, which powers the rover using as a heat source nuclear material attached to a thermocouple to create electrical power.

BELOW Curiosity's view of an alluring Martian panorama looking south toward Mount Sharp (*center left*).

FOLLOW THE WATER: EXPECTATIONS OF LIFE ON MARS

Following the 1990s discovery that Mars had once been a watery oasis in the solar system's habitable zone, NASA devised a strategy to search for evidence of H2O. "Follow the water" became the watchwords of every Mars mission thereafter.

The hopes of finding life on Mars took a new turn in 1996. In August, a team of scientists from NASA and Stanford University announced that a Mars meteorite found in the Allan Hills of Antarctica contained evidence of ancient Martian life. Scientists hypothesized that the 4.2-pound (1.9-kilogram) potato-sized rock, to which they gave the less-than-catchy name ALH84001, formed as an igneous rock about 4.5 billion years ago, when Mars was a much warmer place. Then about 15 million years ago, a large asteroid hit the Red Planet and jettisoned the rock into space, where it remained until crashing into Antarctica in around 11,000 BCE. According to some experts, ALH84001 appeared to contain fossil-like remains of Martian microorganisms 3.6 billion years old.

In the summer of 1996, scientists announced evidence of organic molecules in this Martian meteorite, which suggested that primitive life may have existed on early Mars. This discovery stimulated enthusiasm for a new exploration mission. Prior to the meteorite study, NASA had already initiated a program in which it planned to send two spacecraft, an orbiter and a lander, to Mars roughly every two years over the course of a decade. Making the search for life a central goal for future Mars exploration efforts, NASA formed a multidisciplinary group to develop strategies leading to the discovery of signs of life.

As it turned out, when other scientists examined the findings of the NASA-funded team most rejected its conclusion that ALH84001 provided evidence of past life. Even without a scientific consensus on the significance of these findings, they nevertheless led to a renewed interest in Mars exploration.

NASA'S MARS GLOBAL SURVEYOR AND MARS RECONNAISSANCE ORBITER

After the Mars Pathfinder mission in 1997, NASA shifted the focus of its Mars exploration efforts toward seeking evidence of water. In 1998 the Mars Global Surveyor (MGS) entered Martian orbit with the primary goal of mapping the planet's surface. This was completed in January 2001, with more than 98 percent of the surface mapped, and so the MGS turned to pursuing "follow the water" efforts to reimage in greater detail areas that showed evidence of ancient flooding. Using its images, planetary scientists identified more than 150 geographic features that were created by fast-flowing water.

ALLAN HILLS METEORITE (ALH84001)

It may not look impressive, but this 4.5 billion-year-old rock, labeled meteorite ALH84001, astounded both the scientific community and the general public in 1996. It is one of ten meteorites from Mars in which researchers found organic carbon compounds that originated on Mars.

Even more than the meteorite itself, this high-resolution image from an electron microscope shows an unusual carbonite tube-like structure less than one-hundredth the width of a human hair found in ALH84001, a meteorite of Martian origin. Called worms in popular accounts, this image suggested to the general public that life existed on Mars. Scientists are more skeptical, but many long for the day that they might discover undisputed life there.

The findings of Mars Pathfinder set in motion the idea that Mars had once been a watery planet more Earthlike than not. Oceans are believed to have existed there at least 3 billion years ago. The surface environment of ancient Mars was different to that of today, and with plentiful water may have allowed life forms to develop.

RIGHT Taken on June 15, 1998, by the MGS, this image of the surface of Mars shows an area 15.6 x 19.5 miles (25.1 x 31.3 kilometers) in size. The photograph excited both scientists and the public, as it shows groundwater seepage and surface runoff. It was one of the first and most dramatic images suggesting that the "follow the water" strategy represented a rewarding way to pursue Mars exploration.

FAR RIGHT A portion of the wall and floor of an ancient impact crater in the southern cratered terrain of Noachis Terra, captured by the MGS in 2000. Many think the smooth, dark surface on the crater floor may be the remains of a pond or lake.

OUR NEARBY WORLDS

Launched in August 2005, with a more sophisticated instrument package than its predecessor, the Mars Reconnaissance Orbiter (MRO) started operations on Mars on March 10, 2006. It joined several other probes exploring the planet, either in orbit or on the surface. These included MGS, the European Space Agency's Mars Express, 2001 Mars Odyssey, and two Mars Exploration rovers, Spirit and Opportunity. At the time, this set a record for the most operational spacecraft on Mars. Images from MRO, alongside additional images from MGS, showed further evidence of dry riverbeds, floodplains, and gullies on Martian cliffs and crater walls that suggested the presence of water flowing on the surface at some point in the history of Mars. MRO remains operational, continuing to "follow the water."

But the most intriguing possibility came with the realization that life-forms might still be living on Mars today, beneath polar caps or in subterranean hot springs warmed by vents from the core. Discoveries from many spacecraft and the evidence signifying that water once freely flowed suggested that Martian equivalents of single-celled microbes that dwell in Earth's bedrock might be found in underground caverns. Scientists were quick to add, however, that these theories were unproven.

RIGHT NASA's MGS in orbit.

BELOW Scientific instruments monitor the water cycle in the Mars atmosphere and the associated deposition and sublimation of water ice on the surface, while probing the subsurface to see how deep the water-ice reservoir extends. To the far left, the MRO's radar antenna beams down and "sees" into the first few hundred feet (up to 1 kilometer) of Mars's crust. Just to the right, the next beam highlights the data received from the imaging spectrometer, which identifies minerals on the surface. The next beam represents the high-resolution camera, which can zoom in on local targets, providing the highest-resolution orbital images yet of features such as craters, gullies, and rocks. The beam that shines horizontally is that of the Mars Climate Sounder instrument. The electromagnetic spectrum is represented on the top right, and individual instruments are placed where their capability lies. The blue arrows provide estimations of the water cycle found on Mars.

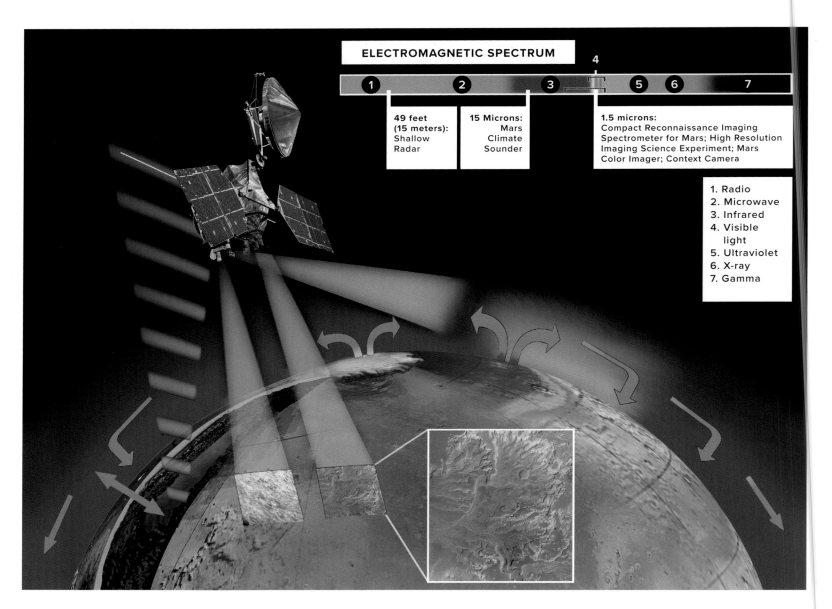

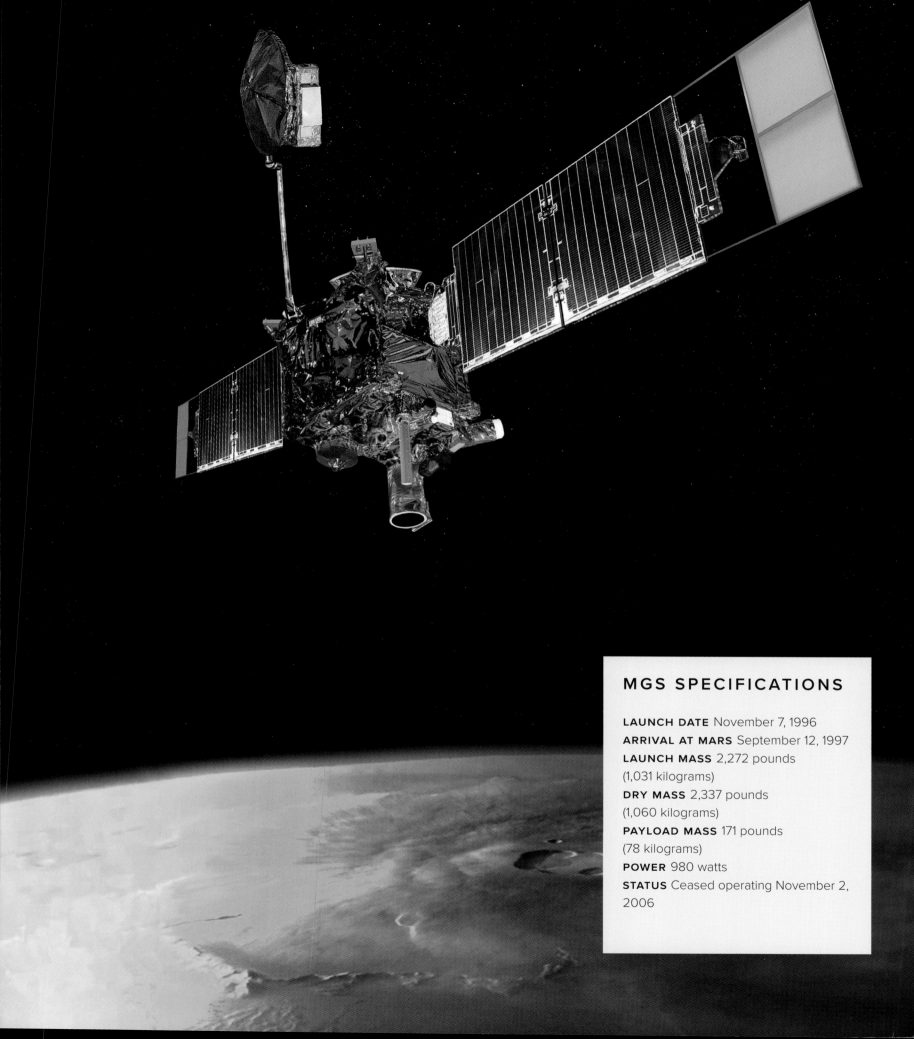

MGS SPECIFICATIONS

LAUNCH DATE November 7, 1996
ARRIVAL AT MARS September 12, 1997
LAUNCH MASS 2,272 pounds
(1,031 kilograms)
DRY MASS 2,337 pounds
(1,060 kilograms)
PAYLOAD MASS 171 pounds
(78 kilograms)
POWER 980 watts
STATUS Ceased operating November 2, 2006

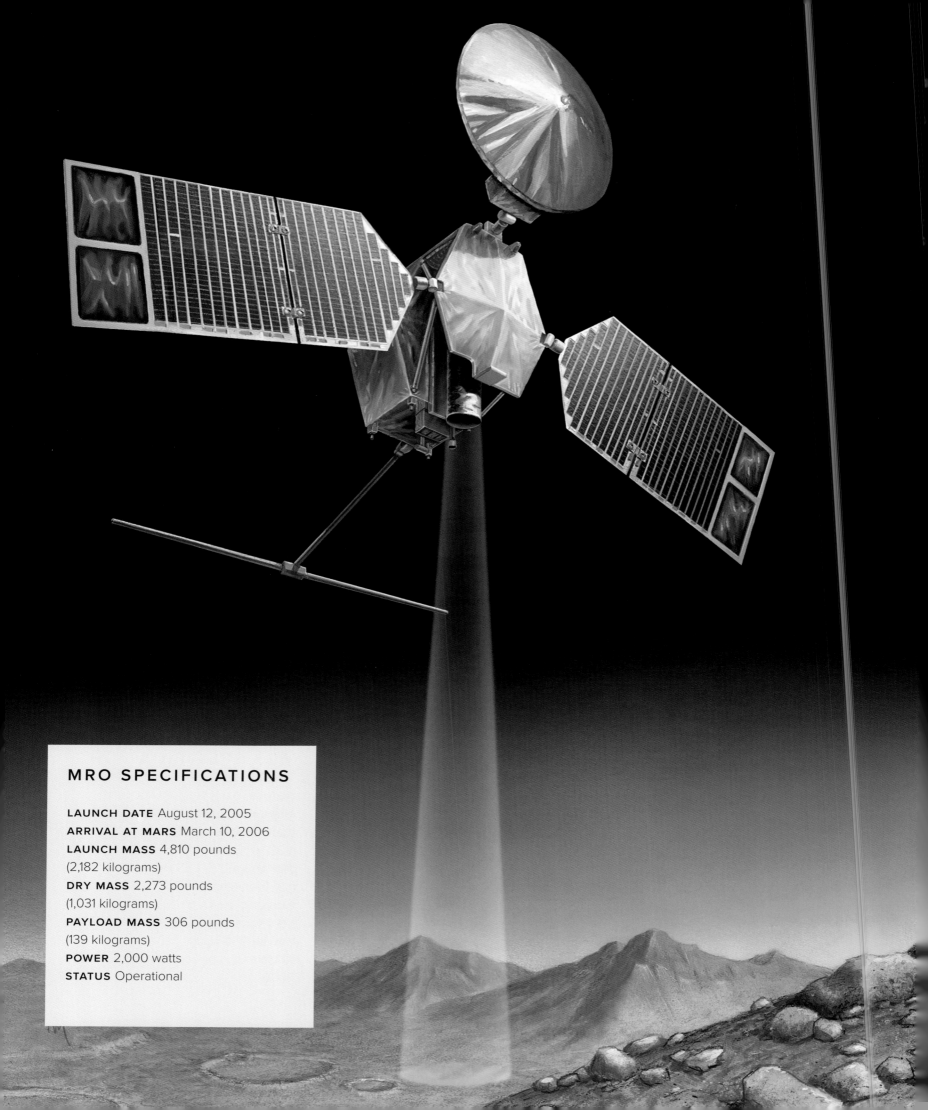

MRO SPECIFICATIONS

LAUNCH DATE August 12, 2005
ARRIVAL AT MARS March 10, 2006
LAUNCH MASS 4,810 pounds
(2,182 kilograms)
DRY MASS 2,273 pounds
(1,031 kilograms)
PAYLOAD MASS 306 pounds
(139 kilograms)
POWER 2,000 watts
STATUS Operational

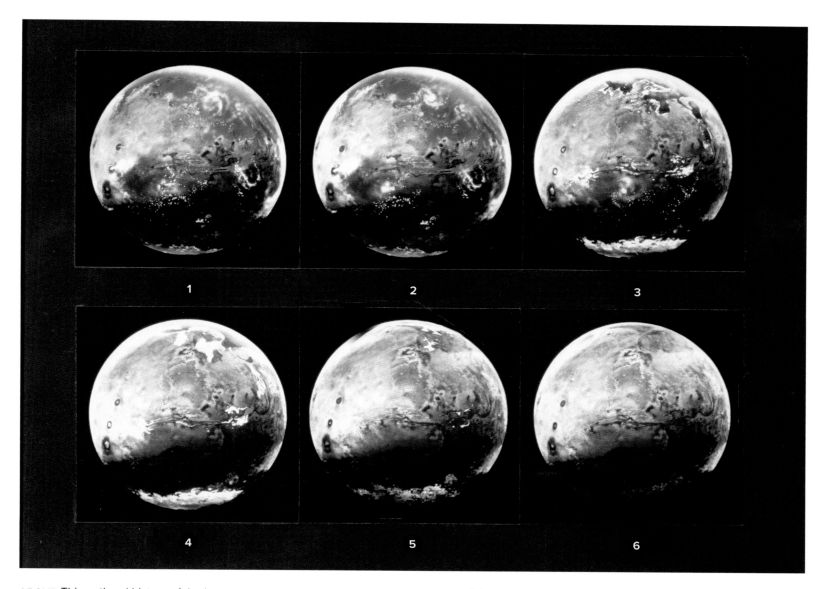

ABOVE This notional history of the loss of water on Mars was created by Ames Research Center scientist Chris McKay, based on observations about the planet. It depicts the water loss from 4 billion years ago to the present.

1. 4 billion years ago
2. 3.8 billion years ago
3. 3.5 billion years ago
4. 2 billion years ago
5. 1 billion years ago
6. Now

LEFT MRO examining the planet's surface.

RIGHT By using the "follow the water" strategy, humanity may someday find sand-laden jets shooting into the polar sky.

OUR NEARBY WORLDS

THE MAN FROM MARS

NASA's Viking 1 Orbiter photographed a cropping of mountains in Mars's northern latitudes on July 25, 1976 (top). The top center mountain resembles a human face wearing a helmet, sparking a controversy that has extended to the present. Is it artificial?

A later spacecraft, MGS, in orbit around Mars at the end of the twentieth century, took an image (bottom) of the so-called "face on Mars" on April 8, 2001, the first opportunity since the arrival of MGS in April 1998 to image the site. The resolution for this image was much greater than Viking, about 6.6 feet (2 meters) per pixel. As demonstrated here, the "face" was an optical illusion of light and shadow.

BELOW In one interpretation of the origin of some deposits in the Eridania basin of southern Mars, seafloor hydrothermal activity from more than 3 billion years ago is credited.

1. Ice cover
2. Max sea level (3,600 feet/1,100 meters)
3. Lower sea level (2,300 feet/700 meters)
4. Evaporation
5. Chloride deposition
6. Ground water
7. Hydrothermal and volcanic activity
8. Subsurface alteration
9. Magmatism

OVERLEAF Four images of Mars taken from orbit suggest the stark differences seen on the Red Planet. (*Top left*) The Aram Chaos, a 174-mile (280-kilometer) diameter crater on Mars, shows volcanic rock formations eroded by intense water flows in the planet's distant past. (*Top right*) This image of the Savich crater on Mars, a 117-mile (188-kilometer) wide depression near the northeastern edge of the much larger Hellas impact basin, shows all the signs we see elsewhere, both on Mars and Earth, of a concentrated flow of water eroding the crater's walls. (*Bottom left*) In another instance evidencing water flow on ancient Mars, this image shows the Harmakhis Vallis, an approximately 497-mile (800-kilometer) long outflow channel located in eastern Hellas. (*Bottom right*) The northern plains of Arabia Terra on Mars feature craters that contain curious formations, possibly the result of ice flows.

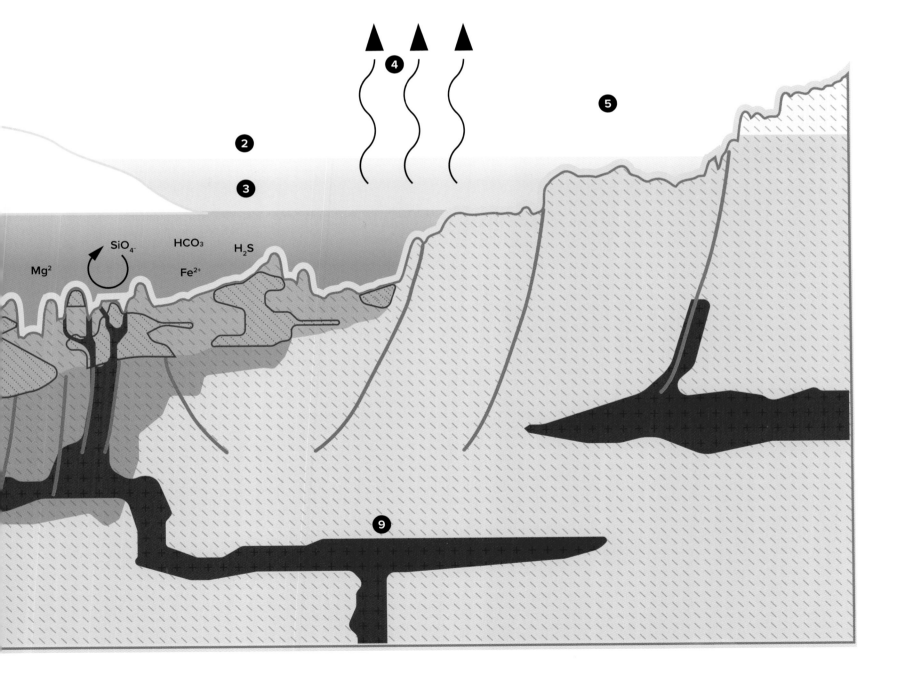

OUR NEARBY WORLDS

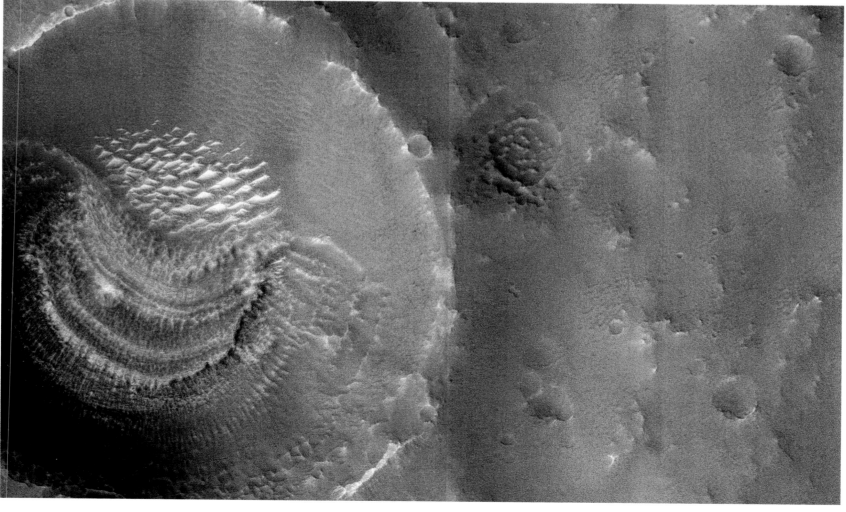

WHY IS MARS SO HARD?

As the three maps on the following pages illustrate, of the fifty-one missions to Mars over the course of the Space Age, only slightly more than half—twenty-six in total—can be considered fully successful. While this statistic has improved with time—missions to Mars have fared better than this 50 percent success rate since the 1990s—even in the years since 1992, eight of twenty-six missions have failed or partially failed.

So what makes Mars exploration so difficult? It is a complex question, but the distance from Earth and the state of human technology have much to do with this issue. Mars remains hard to reach, and difficult to navigate and investigate on arrival.

The history of missions to Mars offers a reality check for anyone who believes that we might easily send humans to the planet in the near term. Thus far, only nation state actors have undertaken missions to Mars. That may change in the future if sufficient profit motive for undertaking these missions is found. For most of the Space Age, Mars missions were undertaken only by the United States and the Soviet Union. That has changed in the last few decades. Six of the twenty-six missions since the end of the Cold War are by entities other than the USA or Russia. A broadening of actors will continue into the future.

The various types of robotic missions thus far undertaken to Mars range from flybys to orbiters to landers to rovers to, most recently, atmospheric flyers (see page 238). We will see an increasing number of landers, rovers, and flyers in the future.

SAMPLES FROM MARS

Returning samples to Earth has been a longstanding objective of Mars exploration. The logic of such a mission is obvious—it would allow scientists on Earth to study Mars samples using the resources of the best laboratories on the planet. NASA has considered several sample return options over a long period of time, but as yet none have achieved formal development status.

New technologies to land on Mars, roam and recover samples, and then to return to Earth will be required. Nine successful landers have reached Mars, though no sample return flights have taken place. This may change by 2035—NASA, the ESA, and the national space agencies of China, Russia, and Japan have developed proposals to do so.

In this ambitious proposal for a sample return mission, a landing would take place near Jezero crater, where Perseverance (*far left*) is located. NASA would then land a Sample Retrieval Lander (*far right*) carrying a Mars Ascent Vehicle, shown here launching a sample return capsule into Mars orbit, where it would rendezvous with an Earth return vehicle.

LEFT Launched on May 5, 2018, the Mars InSight Lander is one of the most sophisticated probes to reach the Red Planet. Its mission was to measure interior, formation, and seismic activity such as meteor impacts. InSight deployed an active seismic monitoring station (the circular object which may be seen connected by cable to the lander), the first such instrument sent beyond Earth. It monitored several "marsquakes" on the planet. This is one of the last images taken by NASA's InSight Mars Lander, just a few days before the mission ended on December 11, 2022.

RIGHT The Ranger spacecraft of the 1960s was designed to take high-quality pictures before crashing into the Moon. This schematic of the Block III version, which proved successful after several failures, shows the major components of the probe.

1. Solar panel
2. Attitude control
3. Directional high-gain antenna
4. Sun shield
5. Omni antenna
6. Radio Corporation of America TV subsystem
7. Communications & Control System and command
8. Power
9. Attitude control roll jet
10. Attitude control yaw jet
11. Attitude control pitch jet
12. Primary sun sensor pad (4)
13. Backup timer
14. Battery (2)
15. A/C gas storage bottle

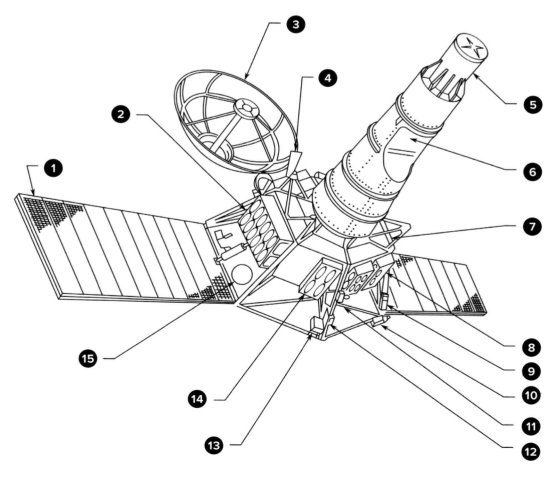

OUR NEARBY WORLDS

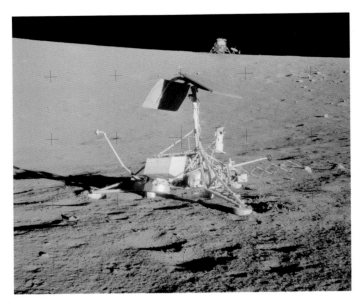
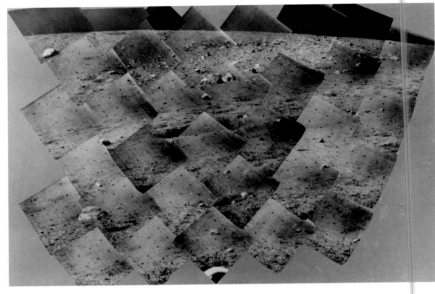
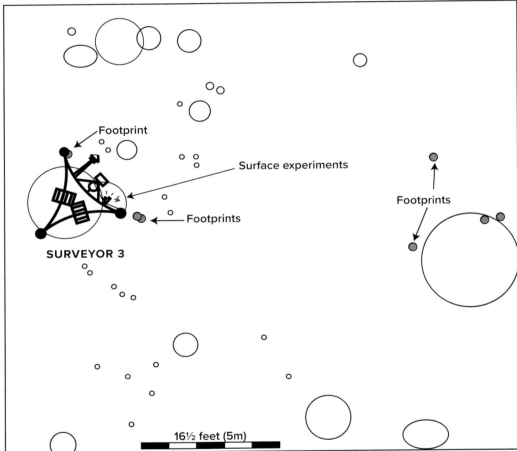

ABOVE This mosaic of Surveyor 3 pictures taken in 1967 shows Block crater, just below the rim of Surveyor crater, pictured right of center.

TOP LEFT Apollo 12 astronaut Alan Bean captured the Surveyor 3 spacecraft on his second extravehicular activity, or spacewalk, on November 20, 1969. Surveyor 3 landed on the Moon inside the edge of a small crater on April 19, 1967, where it imaged the surface and performed soil mechanics experiments. The arm of the soil mechanics sampler is seen extended out to the right. The panels on top of the center mast are the solar arrays. The camera is the white cylinder just to the right of the mast. The arm extending upward to the left is the omnidirectional antenna. The spacecraft is just over 10 feet (3 meters) high. This view is looking to the north, toward the lunar module (LM) of Apollo 12 in the distance.

LEFT As shown by the footprints here, the Surveyor 3 spacecraft bounced twice on landing before coming to rest almost 33 feet (10 meters) from the original point of touchdown. The other black circles are small craters on the landing site.

RIGHT Lunokhod 1—the first successful robotic lunar rover—was carried to the Moon by the Luna 17 spacecraft before undertaking its journey across the surface.

Although Surveyor 4 failed, by the time of the program's completion in 1968 the remaining three Surveyor missions had yielded significant scientific data both for Apollo missions and for the broader lunar science community.

Meantime, the Soviet Union also visited the Moon numerous times with spacecraft. Its Luna program, sometimes called Lunik, sent fifteen successful spacecraft to the Moon between 1959 and 1976, many of which represented firsts in the Space Race. While the Soviets had many failures, not publicly acknowledged at the time, it did successfully send two rovers to the surface and returned samples in three other missions.

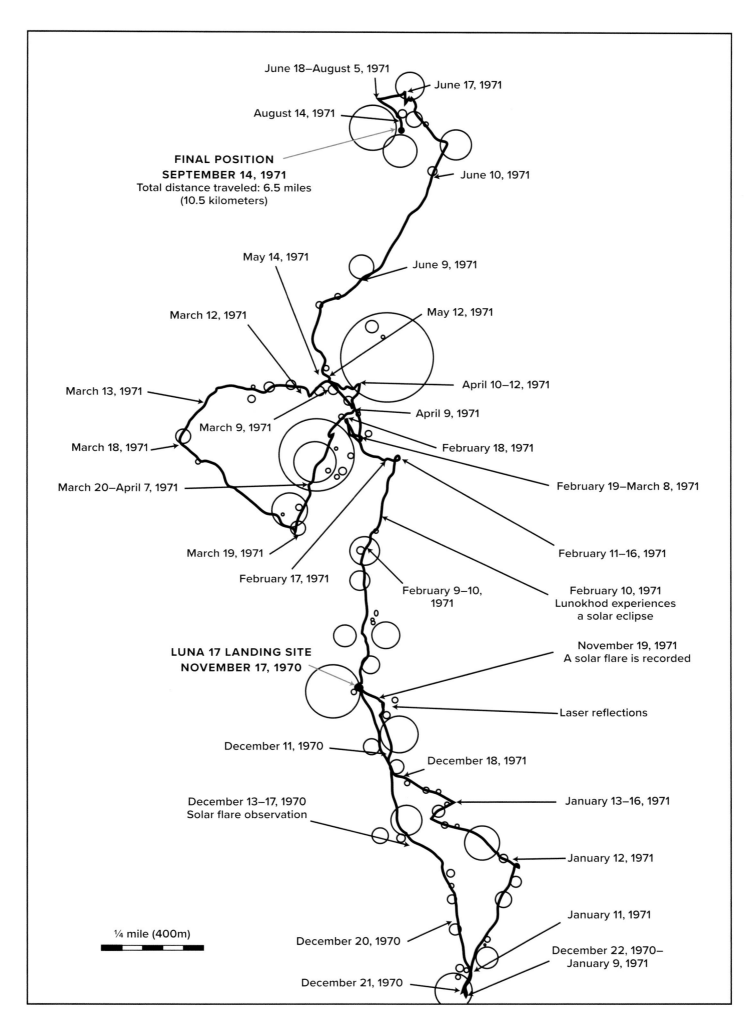

"Both the United States and the Soviet Union, locked in Cold War competition carried out on a broad front, sought to best the other by sending probes to the Moon. The resulting Space Race transformed human knowledge of Earth's nearest neighbor."

RIGHT Lunokhod 1 was one of the Soviet Union's great successes. It was the first remote-controlled vehicle to land on another solar system body. Launched on the Luna 17 spacecraft on November 10, 1970, it reached the surface of the Moon on November 17. It drove around the surface in short bursts until September 14, 1971, when contact was lost. It traveled a total of more than 6 miles (10 kilometers; see page 265) and returned more than 20,000 images and twenty-five soil analysis investigations.

BELOW The movement of the Lunokhod 2 Rover, carried to the Moon by the Luna 21 spacecraft, is tracked in this traverse map. The red dots and arrows in the bottom left corner indicate the journey of the rover from the February 13–14, 1973, location to the March 13, 1973, location before backtracking to the earlier spot. It then returned once again, as controllers found something interesting and went back to see what else they could learn, before moving on to the March 14 and later sites. The "Magnetometer traverse" stop on the right of this map was the result of controllers sending the rover west for additional readings.

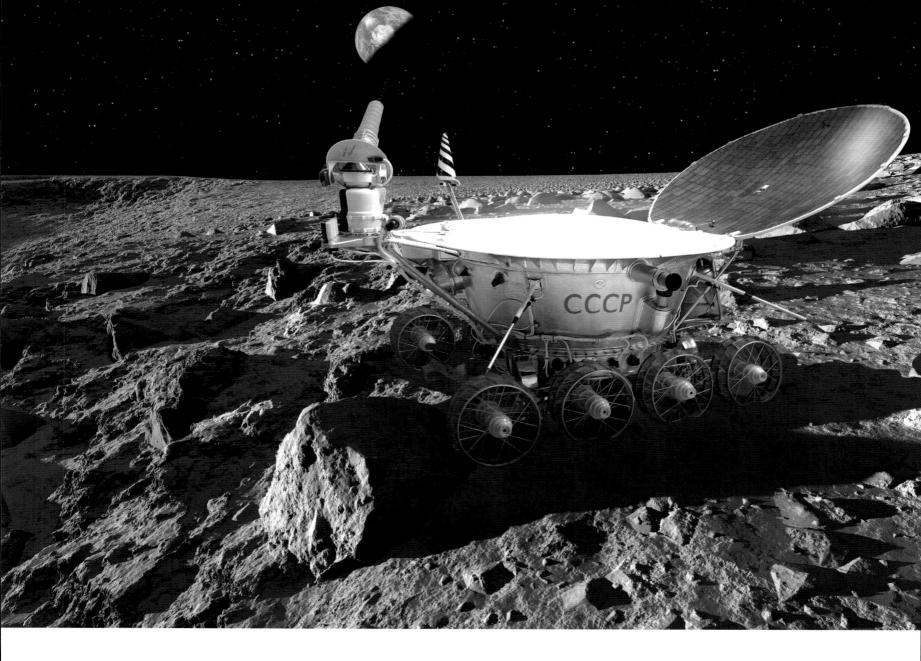
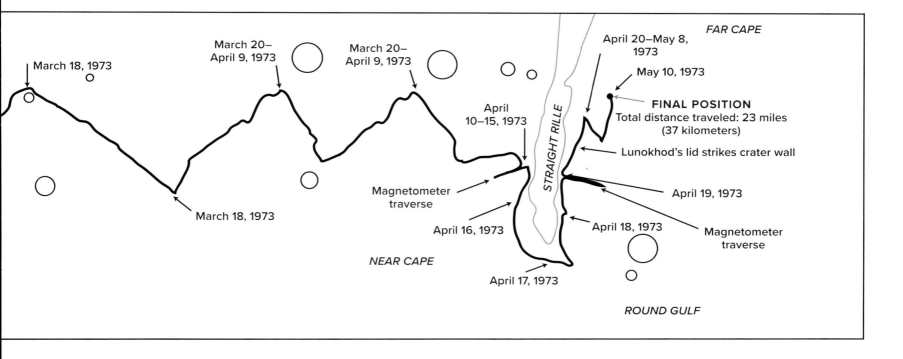

Since those missions in the 1960s and 1970s, several other spacecraft have returned to the Moon. In 1994 the Clementine spacecraft, a joint robotic mission flown by the Department of Defense's Strategic Defense Initiative Organization and NASA, mapped more than 90 percent of the lunar surface. It found that ice existed from an asteroid crash at the Moon's Shackleton crater at the South Pole, reenergizing lunar science.

The Lunar Prospector probe, a small, spin-stabilized craft that would "prospect" the lunar crust and atmosphere for minerals, water-ice, and certain gases, followed. Launched in 1998, it confirmed that something approaching 300 million tons of water-ice was scattered inside the craters on both lunar poles.

China, Japan, and India have all also sent probes to the Moon. The Japanese Space Exploration Agency's Kaguya mission, comprising an orbiter at 62 miles (100 kilometers) altitude and two small satellites (Relay Satellite and VRAD Satellite) in polar orbit, launched on September 14, 2007, with a mission to explore the evolution of the Moon. Scientific instruments will undertake a global map of the lunar surface, magnetic field measurements, and gravity field measurements. Also of note is Chang'e-4, sent by China to the Moon. It deployed the Yutu-2 Rover on the far side on January 3, 2019, the first such vehicle to operate there.

The many uses of water mean that mining it could potentially sustain a lunar colony. From ice, humans could create water, oxygen, and hydrogen. The latter could be used to produce rocket fuel and generate electricity. This has created something of a "gold rush" mentality for the Moon, with numerous parties seeking to return there and harvest the resources available.

RIGHT During its 1994 flight, the Clementine spacecraft returned images of Earth and the Moon. This colorized image shows the full Earth over the lunar North Pole as Clementine completed mapping orbit 102 on March 13, 1994. It is a sunny day over Africa and the Arabian Peninsula. The large crater at the bottom of the image is named Plaskett.

BELOW A topographic map of the Moon, showing both near and far side, was compiled from more than 5,000 images taken during the Clementine mission in 1994. It shows laser altimetry measured in kilometers (red = high; purple = low); while the far side (right) is high and mountainous, the near side (left) is low. Note also the large 1,500-mile (2,500-kilometer) diameter South Pole-Aitken basin that can be readily seen on the far side of the Moon, in the purple area at the bottom of this image.

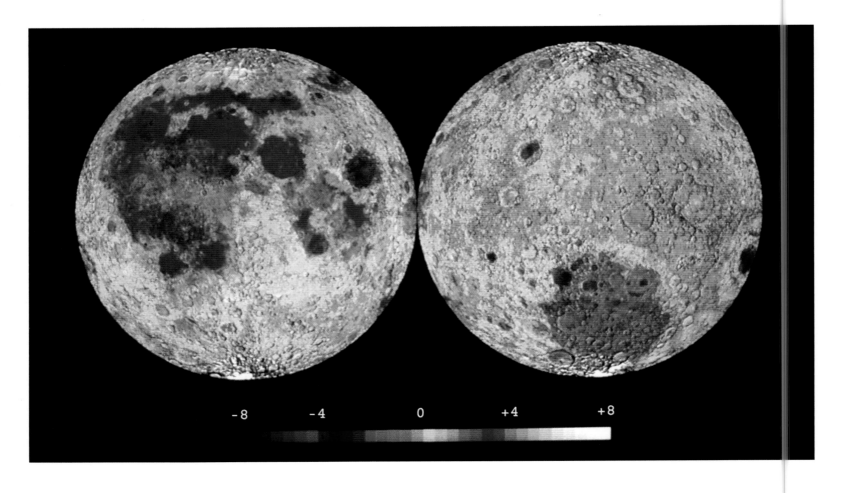

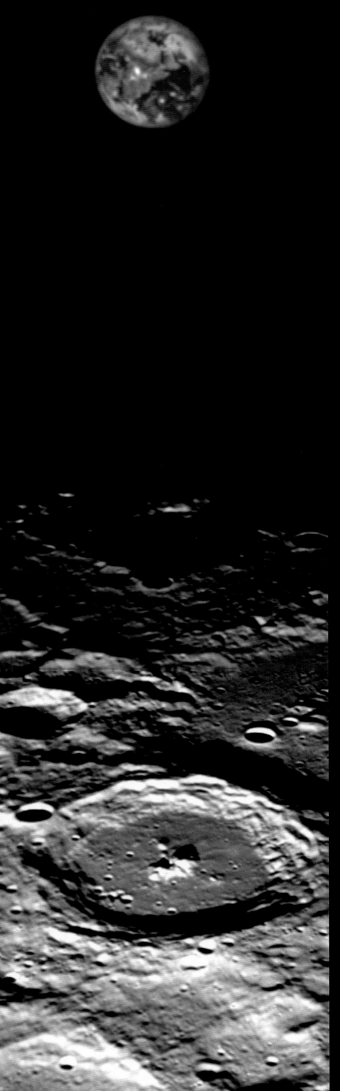

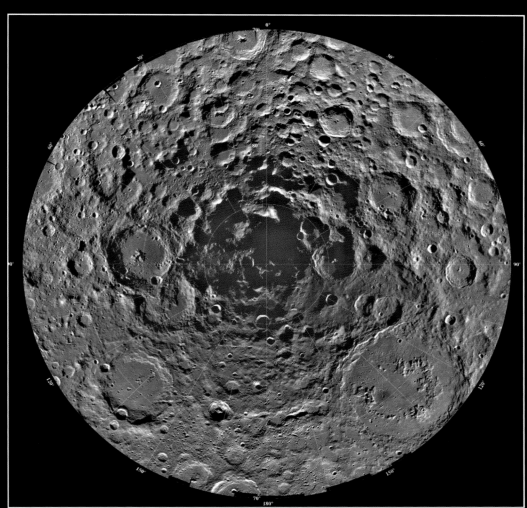

ABOVE A total of 1,500 Clementine images make up this mosaic of the south polar region of the Moon in 1994. A sizable portion of the dark area near the pole may be in permanent shadow, and sufficiently cold to retain ice.

"The Clementine spacecraft, a joint robotic mission flown by the Department of Defense's Strategic Defense Initiative Organization and NASA, mapped more than 90 percent of the lunar surface."

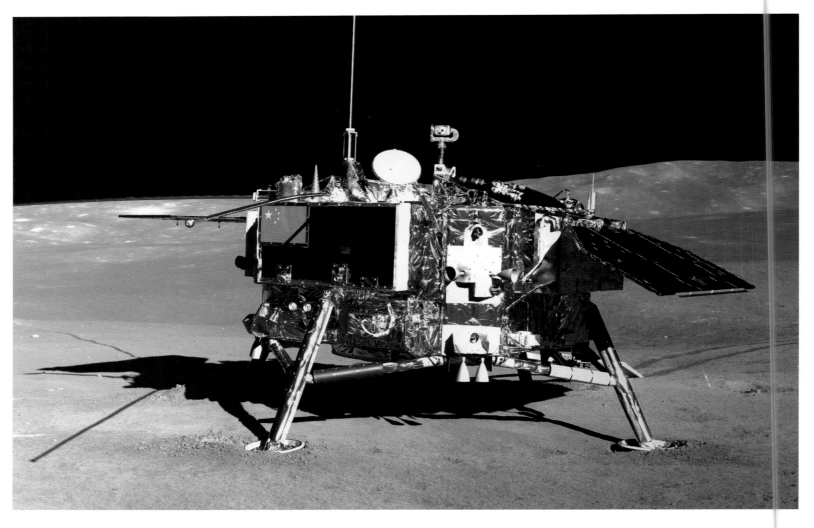

ABOVE China has been engaged in several robotic missions to the Moon. The results of the Chang'e landers and the Yutu-2 Rover on the back side have been spectacular. The lander of the Chang'e-4 probe was captured here by the rover Yutu-2 (Jade Rabbit-2) on January 11, 2019.

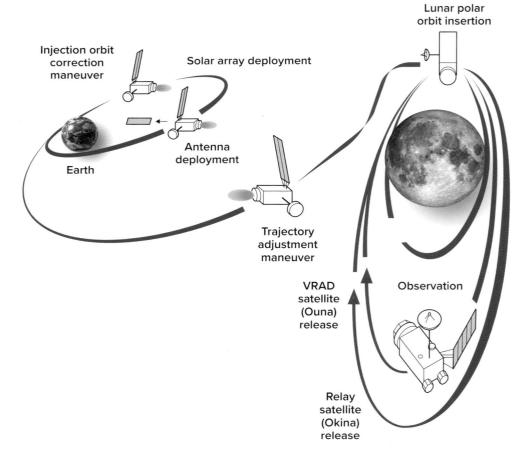

LEFT Data from the Japanese Kaguya mission allowed the creation of the most detailed topographical model of the Moon to date. The mission's profile, including the release of two small satellites, Okina and Ouna, is mapped here. JAXA called Kaguya "the largest lunar mission since the Apollo program."

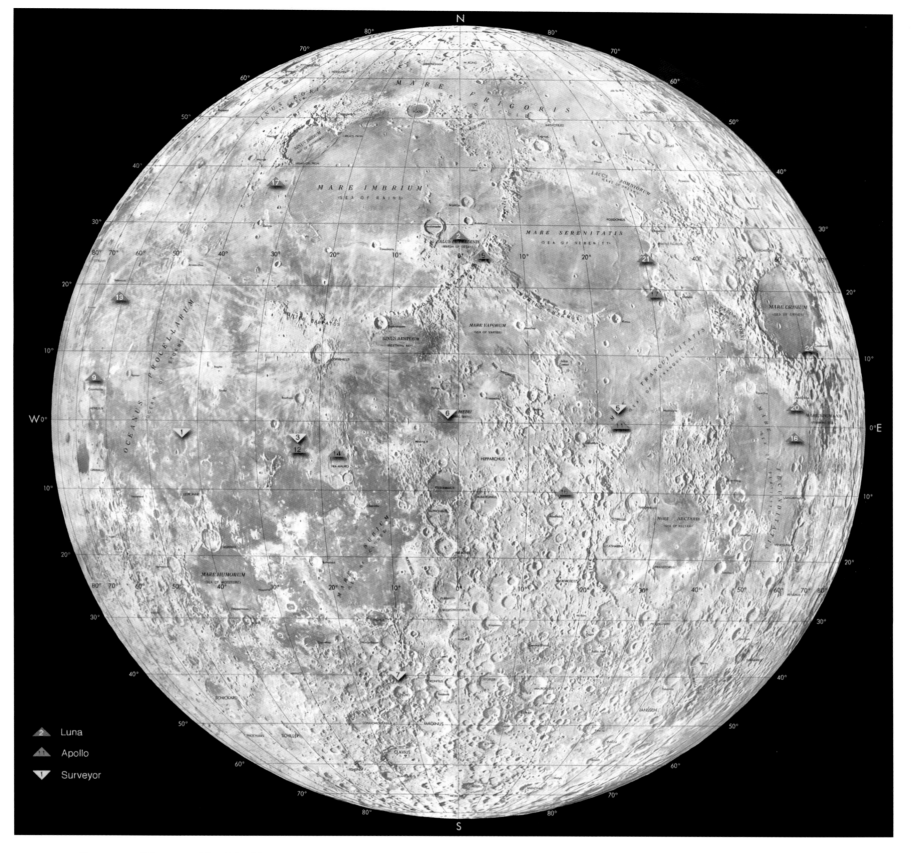

On a map of the near side of the Moon, the Surveyor landers are shown in yellow, the Soviet Luna spacecraft in red, and the Apollo landing missions in green.

OUR NEARBY WORLDS

APOLLO AND THE LUNAR LANDINGS

The human landings on the Moon represented the grandest adventure of the twentieth century. A result of the Cold War struggle between the United States and the Soviet Union, the Apollo program sent six crews to the surface of the Moon between 1969 and 1972.

When US President John F. Kennedy announced on May 25, 1961, the decision to land an American on the Moon and return him safely "before this decade is out," it necessitated an aggressive effort to achieve this objective. It became the overarching agenda for the first decade of NASA. The project had originated as an effort to deal with an unsatisfactory situation: the global perception of Soviet leadership in science and technology. But beyond these immediate political objectives, Project Apollo took on a life of its own, and left an important legacy to both the nation and the proponents of space exploration.

The first Apollo mission of public significance was the flight of Apollo 8—a historic mission to orbit the Moon. Two more Apollo missions occurred before the climax of the program: the lunar landing in 1969. That landing came during the flight of Apollo 11, which lifted off on July 16, 1969, and—after confirmation that the hardware was working well—began the three-day trip to the Moon. Then, at 4:18 p.m. eastern US time on July 20, 1969, the lunar module (LM)—with astronauts Neil Armstrong and Buzz Aldrin aboard—landed on the lunar surface, while Michael Collins orbited overhead in the Apollo command module. Later, Armstrong set foot on the surface, telling millions on Earth that it was "one small step for man—one giant leap for mankind."

This stunning flight set the stage for later Apollo landing missions, with five more taking place through December 1972. Each of them increased the time spent on the Moon and the complexity of the experiments conducted there. The scientific experiments on the Moon and on the lunar soil samples returned have provided grist for scientists' investigations ever since. Notably, scientists reached a consensus on the origin of the Moon—billions of years ago a body potentially the size of Mars crashed into Earth, comingling materials from both bodies into the present-day Moon. Additionally, we learned of unique resources on the Moon, especially Helium-3, that might be mined and used as an energy source. The scientific return was significant, especially for the last three Apollo missions, which used a lunar roving vehicle to travel in the vicinity of the landing site.

HOW DID THE MOON ORIGINATE?

The Apollo 11 crew—(*left to right*) Neil Armstrong, commander; Michael Collins, command module pilot; and Buzz Aldrin, LM pilot—checking out the crew compartment of their spacecraft on June 10, 1969, before their mission. This crew sensed the significance of their mission, but only in retrospect do we appreciate the contribution to knowledge about the Moon's origins that came with NASA's Apollo program.

The six landing missions on the Moon made by the Apollo astronauts between 1969 and 1972, as well as the samples returned by the Soviet Union's robotic probes, enabled an exhaustive analysis by scientists of materials returned from the lunar surface. It made possible the answer to this series of questions: "How old is the Moon, how was it formed, and what is its composition?"

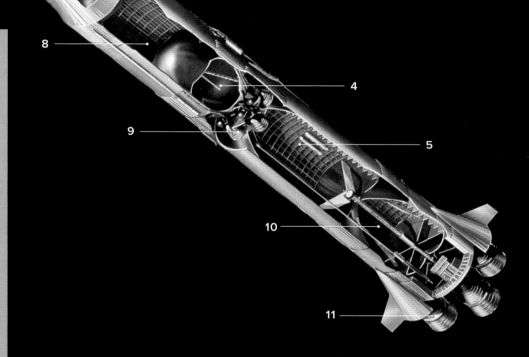

The core technology necessary to send humans to the Moon was the mighty Saturn V rocket, which generated 7.5 million pounds (3.4 million kilograms) of thrust at launch. The major components of the rocket included:

1. Apollo capsule
2. Lunar module
3. Liquid oxygen (LOX) tank
4. LOX tank
5. LOX tank
6. Fuel tank
7. 1x J-2 engine
8. Fuel tank
9. 5x J-2 engines
10. Fuel tank
11. 5x F-1 engines

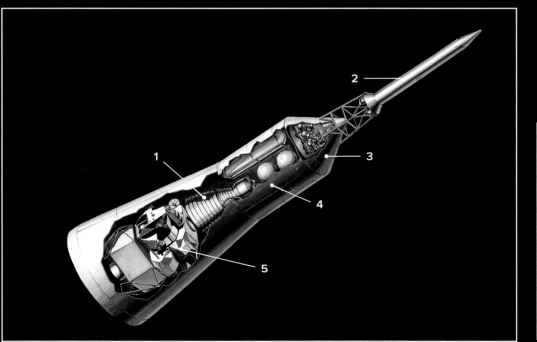

The second core component of the technology needed for the lunar landing was the Apollo spacecraft. This cutaway shows its major components:

1. Engine
2. Launch escape system
3. Command module
4. Service module
5. Lunar module

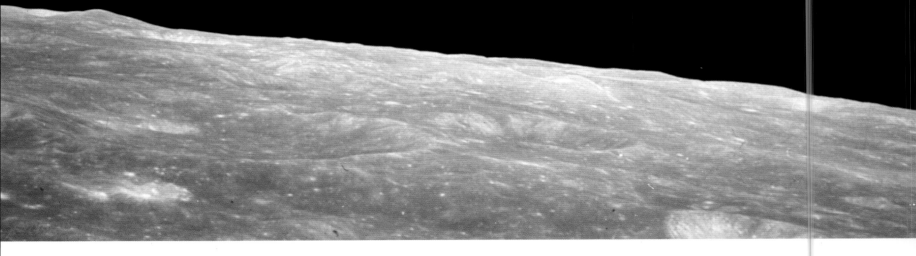

"The first Apollo mission of public significance was the flight of Apollo 8 —a historic mission to orbit the Moon."

ABOVE "Earthrise," one of the most iconic images from the Apollo program, was taken in December 1968 during the Apollo 8 mission. This view of the rising Earth greeted the Apollo 8 astronauts as they came from behind the Moon after the first lunar orbit. Used as a symbol of the planet's fragility, it juxtaposes the gray, lifeless Moon in the foreground with the blue and white Earth teeming with life, hanging in the blackness of space.

RIGHT The Apollo 9 LM was photographed in a lunar landing configuration from the command/service module on the fifth day of the Apollo 9 Earth-orbital test flight in March 1969. The landing gear on Apollo 9 LM, nicknamed the "Spider," was deployed.

BELOW Before the first missions to the Moon took place, NASA and its corporate partners sought to promote the program through visualization of the effort. Here, the ascent engine fires as the Apollo 11 LM launches from the surface of the Moon. The descent stage served as a launch base and remained on the lunar surface. Rocketdyne, a division of the North American Rockwell Corporation, was the subcontractor for the ascent engine. Grumman Aircraft Engineering Corporation, Bethpage, New York, was the prime contractor.

OUR NEARBY WORLDS

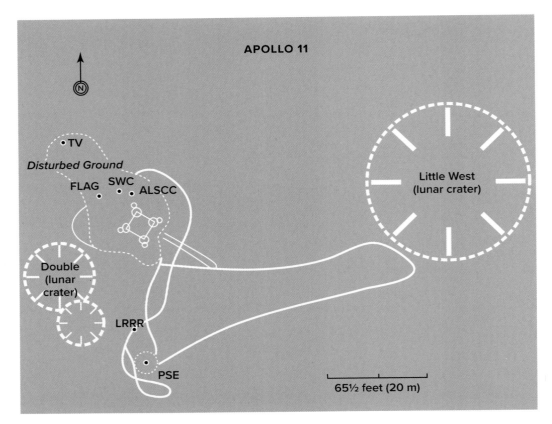

LEFT This traverse map depicts the locations of objects at the Apollo 11 landing site as well as the tracks of the astronauts as they worked during the more than two hours they spent outside the spacecraft. The circular objects are craters at the landing site; the solid lines are astronaut tracks; the dotted line enclosure highlights an area of intense human disturbed ground. Several objects were deployed around the landing site: a television camera (TV), US flag, SWC (Solar Wind Composition Experiment), ALSCC (Apollo Lunar Surface Closeup Camera), LRRR (Laser Ranging Retroreflector) experiment; and PSE (Passive Seismic Experiment).

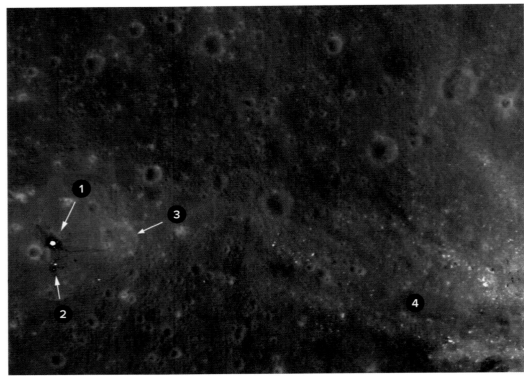

LEFT The landing site of Apollo 11 on July 20, 1969, captured by the Lunar Reconnaissance Orbiter in 2010. The bright object at left is the descent stage of the LM, and hardware and trails created by astronaut footsteps are visible, as well as the trek to the crater at the right of the landing site. The astronauts talked about how every step kicked up lunar dust, an exceptionally powdery film over the strata below, and left a trail on the surface. The image also shows the location of the Early Apollo Scientific Experiments Package (EASEP). The ejecta label (4) is lunar dust from the landing sent flying more than 130 feet (40 meters) from the touchdown site.

1. Apollo 11 LM descent stage
2. EASEP
3. Little West crater
4. Ejecta

RIGHT One of the most iconic images of the twentieth century was a ceremonial moment at the landing of Apollo 11 on the Moon. Here, Buzz Aldrin has just planted a US flag on the lunar surface, July 20, 1969. The flag proved a powerful trope of American exceptionalism.

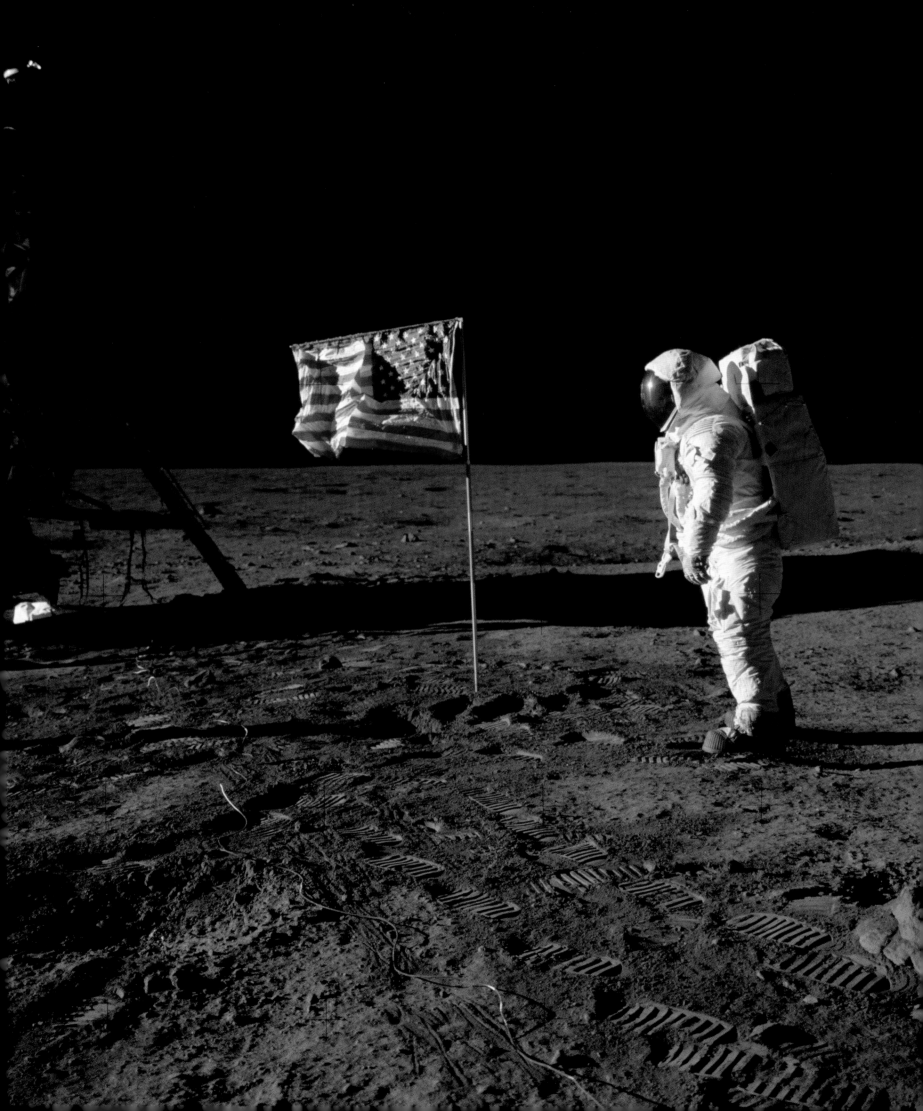

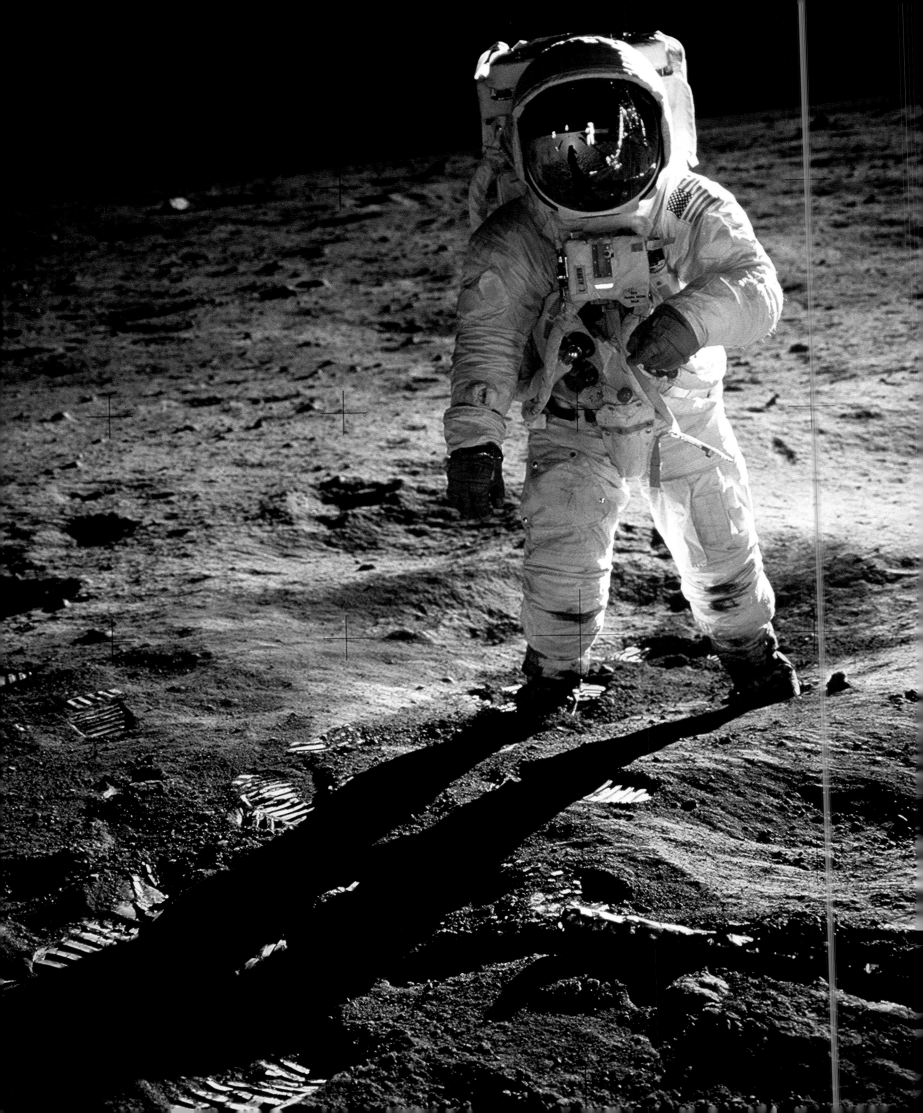

"At 4:18 p.m. eastern US time on July 20, 1969, the Lunar Module—with astronauts Neil Armstrong and Buzz Aldrin aboard—landed on the lunar surface, while Michael Collins orbited overhead in the Apollo command module. Later, Armstrong set foot on the surface, telling millions who saw and heard him on Earth that it was 'one small step for man—one giant leap for mankind.'"

Buzz Aldrin on the lunar surface during the July 20, 1969, surface operations of the Apollo 11 mission. This image has been reproduced in many forms and for divergent purposes around the world. Seen in the foreground is the leg of the LM Eagle during the Apollo 11 extravehicular activity. Neil Armstrong took this photograph—his image is reflected in the visor of Aldrin's spacesuit.

OUR NEARBY WORLDS

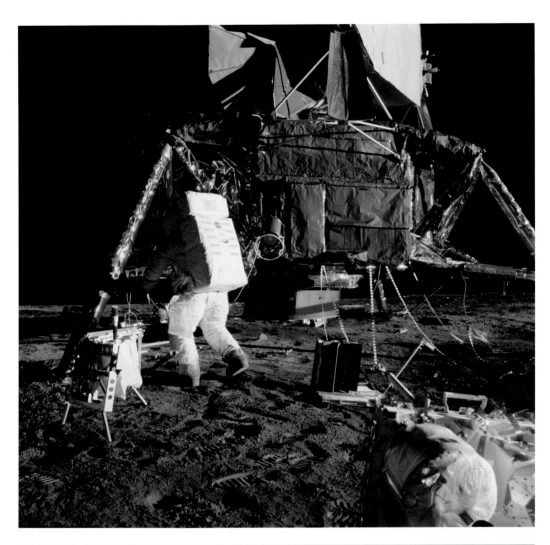

LEFT Each of the six landing missions deployed an Apollo Lunar Surface Experiments Package. Here, Apollo 12 astronaut Alan Bean deploys the experiments at the landing site during the second lunar landing in the fall of 1969. The landing areas were very much work sites as the astronauts sought to use their limited time on the surface to accomplish as much as possible.

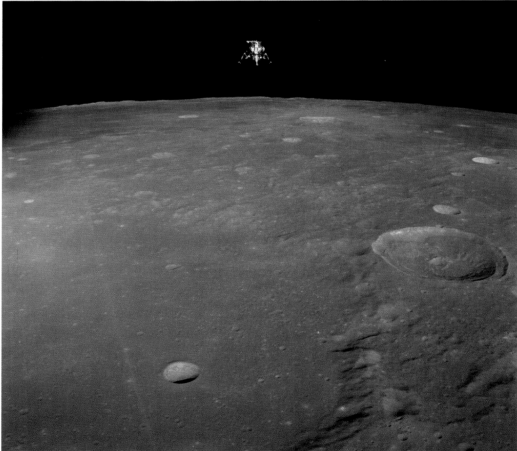

LEFT The Apollo 12 LM was photographed on November 19, 1969, in a lunar landing configuration.

RIGHT The US Geological Survey prepared these maps of the landing sites for Apollos 11, 12, and 14. As well as the landing sites and traverse paths, the map shows key activities undertaken on the surface.

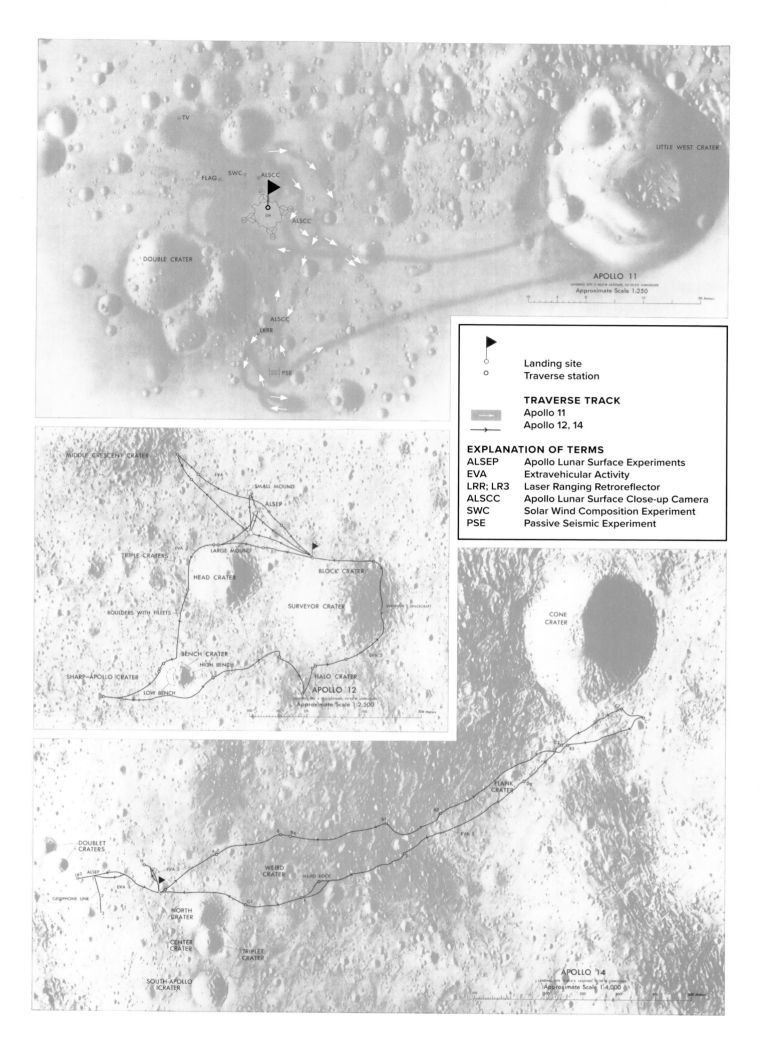

OUR NEARBY WORLDS

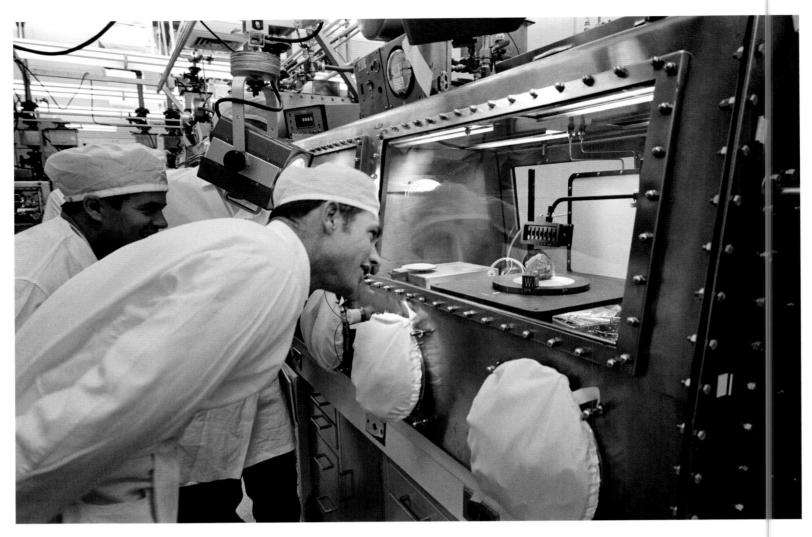

ABOVE Astronaut David R. Scott, commander of the Apollo 15 mission, gets a close look at the Genesis Rock at the Lunar Receiving Laboratory of the Manned Spacecraft Center, Houston, Texas, on August 12, 1971. This rock helped to piece together the geological history of the Moon.

LEFT A traverse map of the Apollo 15 mission demonstrates the expanding sweep of lunar exploration. The thick lines indicate paths taken by the astronauts during their three trips around the landing site—called EVA 1, EVA 2, and EVA 3—using a lunar roving vehicle (LRV). This enabled the astronauts to travel much farther and collect far more diverse geological samples. Each stop during these explorations, LRV 1 through to LRV 11, is labeled.

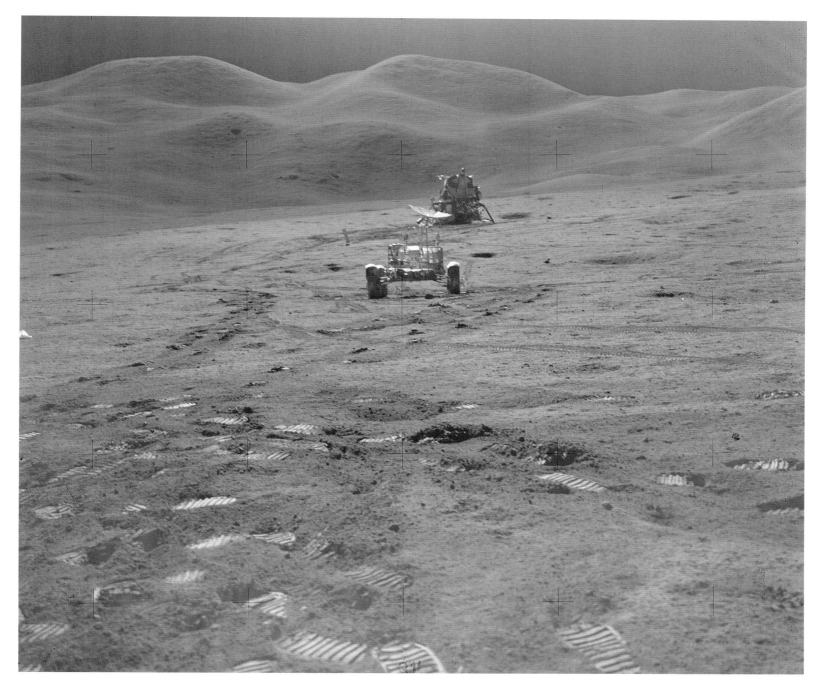

ABOVE Taken by Apollo 15 astronaut James Irwin during the crew's second extravehicular activity, this photograph shows the rover, the LM, and the Swann mountain range in the background.

RIGHT A view of the Apollo 15 command/service modules in lunar orbit, photographed from the LM just after rendezvous in 1971. The lunar nearside is in the background. This view is looking southeast into the Sea of Fertility, a relatively flat area on the lunar surface.

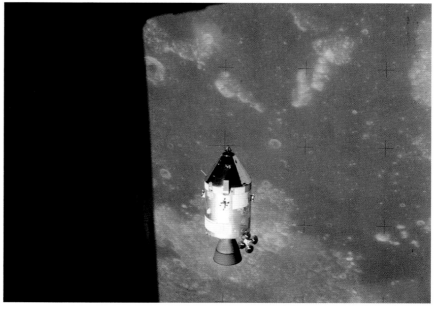

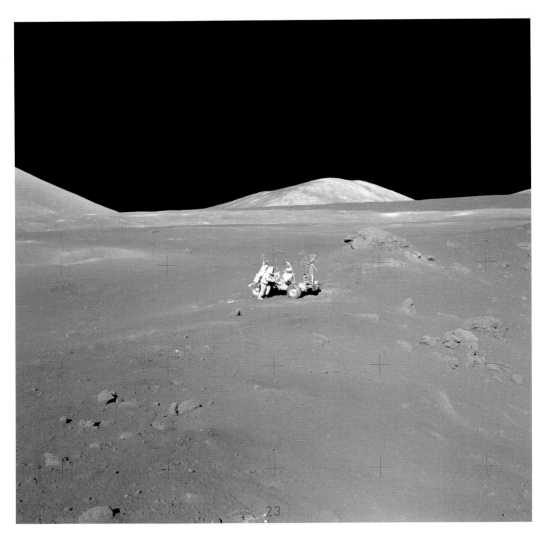

LEFT This extraordinary lunar panorama shows Apollo 17 astronaut geologist Harrison (Jack) Schmitt at Station 4 (Shorty crater) with the LRV during the crew's second extravehicular activity at the Taurus-Littrow landing site. Shorty crater is to the right. More so than any other image of astronauts on the lunar surface, this image suggests the "magnificent desolation," to use Buzz Aldrin's phrase, of what was found there.

BELOW The Apollo 16 and 17 missions extended the depth and breadth of lunar exploration at the end of the program in the early 1970s. The thick lines on these traverse maps indicate paths taken by the astronauts on each mission during their three extravehicular activities using the lunar rovers. Each track is labeled EVA 1, 2, or 3. Numbers show each stop made by the astronauts. The circular areas are craters, some of which are named, and the dotted lines and hash marks depict other geographical features encountered by the astronauts. Each of these missions lasted progressively longer and collectively reaped a scientific harvest of astonishing significance.

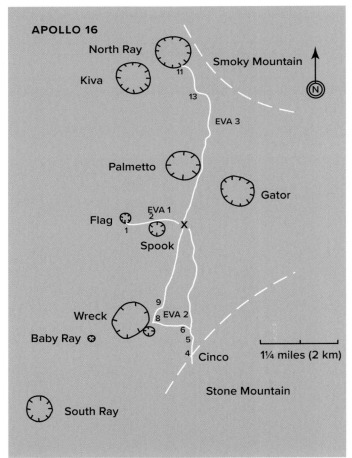

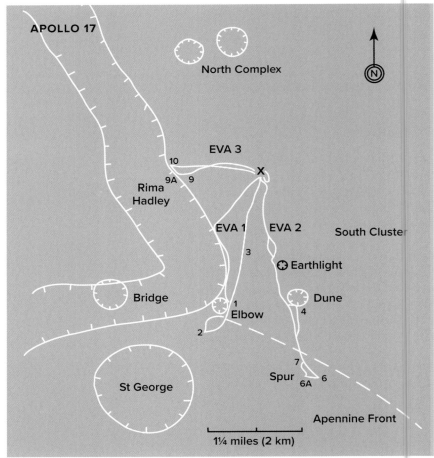

Apollo 17 astronaut Eugene Cernan driving the LRV during extravehicular activity, with the LM in the background.

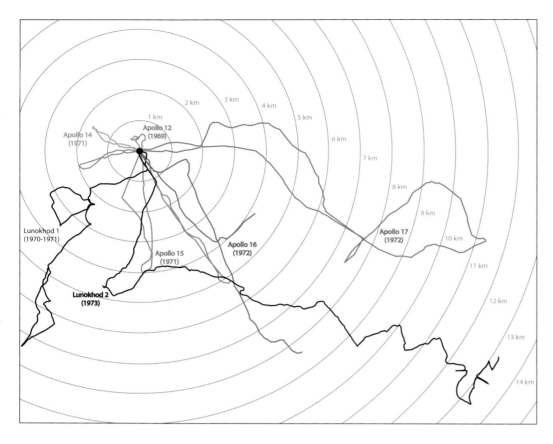

LEFT This map superimposes the various traverses of the Apollo program with those of Lunokhod, showing various distances and directions. In reality, neither human-made rovers nor the Apollo astronauts have traveled far on the lunar surface. Apollo 17, the last of the human landing missions, journeyed only about 2 miles (3 kilometers) from the landing site. The Chinese Yutu-2 Rover, operating on the back side of the Moon since 2019, has only traveled about 3,300 feet (1,000 meters) in its more than three years on the surface.

BELOW Based on images from NASA's Lunar Reconnaissance Orbiter, photometrically normalized and released on October 9, 2017, this color composite mosaic shows most of the Moon's surface.

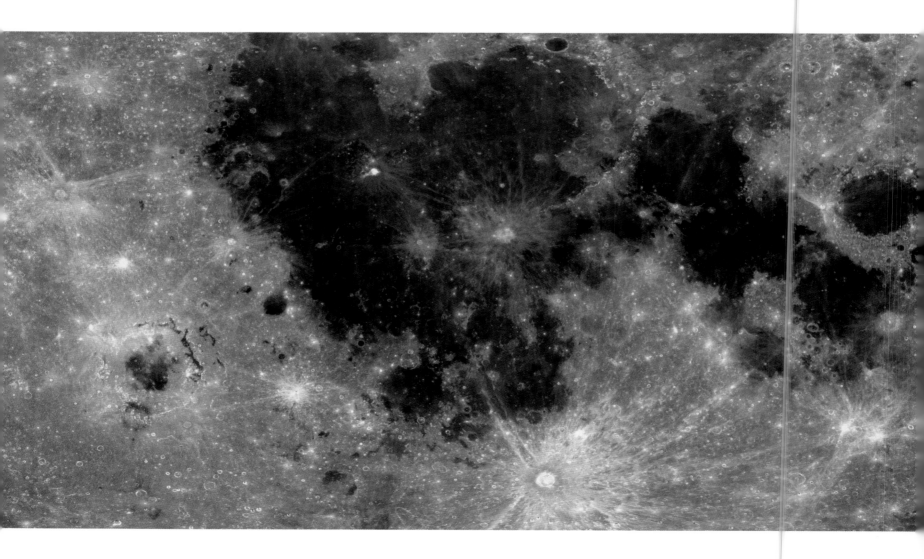

BELOW Due to its spectacular high-reflectance rays, Aristarchus crater has been a popular landform since telescopes were first pointed toward the Moon. In this stunning picture from August 6, 2018, NASA's Lunar Reconnaissance Orbiter spacecraft slewed 62 degrees (west to east), looking across the crater.

"Notably, scientists reached a consensus on the origin of the Moon—billions of years ago a body potentially the size of Mars crashed into Earth, comingling materials from both bodies into the present-day Moon."

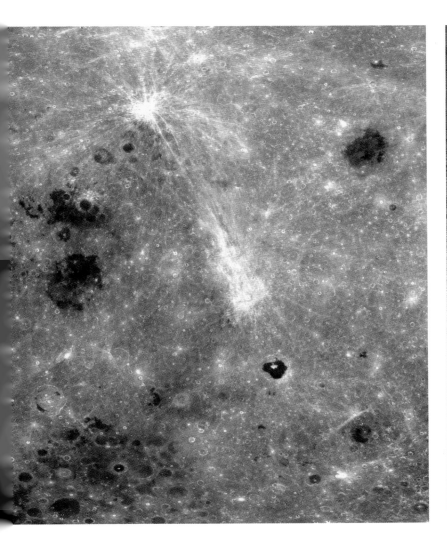

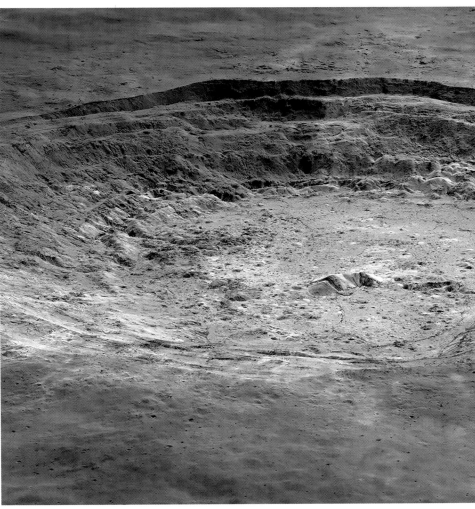

OUR NEARBY WORLDS

MOON MISSION FLYBYS AND ORBITERS

Spacecraft/Launch Vehicle	Date	Operator/Nation	Type	Status
Pioneer 0 (Able I)/Thor DM-18 Able I	Aug 17, 1958	USAF (USA)	Orbiter	Launch failure
Pioneer 1 (Able II)/Thor DM-18 Able I	Oct 11, 1958	NASA (USA)	Orbiter	Launch failure
Pioneer 2 (Able III)/Thor DM-18 Able I	Nov 8, 1958	NASA (USA)	Orbiter	Launch failure
Pioneer 3/Juno II	Dec 6, 1958	NASA (USA)	Flyby	Launch failure
Pioneer 4/Juno II	Mar 3, 1959	NASA (USA)	Flyby	Partial failure
Luna 3 (E-2A No. 1)/Luna	Mar 4, 1959	OKB-1 (USSR)	Flyby	Success
Pioneer P-3 (Able IVB)/Atlas-D Able	Nov 26, 1959	NASA (USA)	Orbiter	Launch failure
Luna E-3 No.1/Luna	Apr 15, 1960	OKB-1 (USSR)	Flyby	Launch failure
Luna E-3 No.2/Luna	Apr 16, 1960	OKB-1 (USSR)	Flyby	Launch failure
Pioneer P-30 (Able VA)/Atlas-D Able	Sep 25, 1960	NASA (USA)	Orbiter	Lauch failure
Pioneer P-31 (Able VB)/Atlas-D Able	Dec 15, 1960	NASA (USA)	Orbiter	Lauch failure
Zond 3 (3MV-4 No.3)/Molniya	Jul 18, 1965	Lavochin (USSR)	Flyby	Success
Explorer 33 (AIMP-D)/Delta E1	Jul 1, 1966	NASA (USA)	Orbiter	Lauch failure
Lunar Orbiter 1/Atlas SLV-3 Agena-D	Aug 10, 1966	NASA (USA)	Orbiter	Partial failure
Luna 11 (E-6LF No. 101)/Molniya-M	Aug 21, 1966	Lavochkin (USSR)	Orbiter	Partial failure
Luna 12 (E-6LF No. 102)/Molniya-M	Oct 22, 1966	Lavochkin (USSR)	Orbiter	Success
Luna 13 (E-6M No. 205)/Molniya-M	Dec 21, 1966	Lavochkin (USSR)	Orbiter	Success
Lunar Orbiter 3/Atlas SLV-3 Agena-D	Feb 5, 1967	NASA (USA)	Orbiter	Success
Lunar Orbiter 4/Atlas SLV-3 Agena-D	May 4, 1967	NASA (USA)	Orbiter	Sucess
Explorer 35 (AIMP-E)/Delta E1	Jul 19, 1967	NASA (USA)	Orbiter	Success
Lunar Orbiter 5/Atlas SLV-3 Agena-D	Aug 1, 1967	NASA (USA)	Orbiter	Success
Soyuz 7K-L1 No.4L/Proton-K/D	Sep 27, 1967	Lavochkin (USSR)	Flyby	Spacecraft failure
Soyuz 7K-L1 No.5L/Proton-K/D	Nov 22, 1967	Lavochkin (USSR)	Flyby	Launch failure
Luna E-6LS No. 112/Molniya-M	Feb 7, 1968	Lavochkin (USSR)	Orbiter	Launch failure
Luna 14 (E-6LS No. 113)/Molniya-M	Apr 7, 1968	Lavochkin (USSR)	Orbiter	Success
Soyuz 7K-L1 No. 7L/Proton-K/D	Apr 22, 1968	Lavochkin (USSR)	Flyby	Launch failure
Zond 5/Proton-K/D	Sep 14, 1968	Lavochkin (USSR)	Flyby	Success
Zond 6/Proton-K/D	Nov 10, 1968	Lavochkin (USSR)	Flyby	Success
Apollo 8/Saturn V	Dec 21, 1968	NASA (USA)	Crewed Orbiter	Success
Soyuz 7K-L1 No. 13L/Proton-K/D	Jan 20, 1969	Lavochkin (USSR)	Flyby	Launch failure
Soyuz 7K-L1S No. 3/N-1	Feb 21, 1969	Lavochkin (USSR)	Orbiter	Launch failure
Apollo 10/Saturn V	May 18, 1969	NASA (USA)	Orbiter	Success
Zond 7/Proton-K/D	Jun 14, 1969	Lavochkin (USSR)	Flyby	Success
Soyuz 7K-L1S No. 5/N1	Jul 3, 1969	OKB-1 (USSR)	Orbiter	Lauch failure
Apollo 11/Saturn V	Jul 16, 1969	NASA (USA)	Orbiter/Lander	Success
Apollo 12/Saturn V	Nov 14, 1969	NASA (USA)	Orbiter/Lander	Success
Apollo 13/Saturn V	Apr 11, 1970	NASA (USA)	Orbiter/Lander	Partial failure
Zond 8 (7K-L1 No. 14L)/Proton-K/D	Oct 20, 1970	Lavochkin (USSR)	Flyby	Success
Apollo 14/Saturn V	Jan 31, 1971	NASA (USA)	Orbiter/Lander	Success
Apollo 15/Saturn V	Feb 14, 1971	NASA (USA)	Orbiter/Lander	Success
Luna 19/Proton-K/D	Sep 28, 1971	Lavochkin (USSR)	Orbiter	Success
Apollo 16/Saturn V	Apr 16, 1972	NASA (USA)	Orbiter/Lander	Success
Soyuz 7K-LOK No. 1/N1	Jul 3, 1972	OKB-1 (USSR)	Orbiter	Spacecraft failure
Apollo 17/Saturn V	Dec 7, 1972	NASA (USA)	Orbiter/Lander	Success
Explorer 49 (RAE-B)/Delta 1913	Jun 10, 1973	NASA (USA)	Orbiter	Success
Mariner 10/Atlas SLV-3D Centaur-D1A	Nov 3, 1973	NASA (USA)	Flyby	Success
Luna 22/Proton-K/D	May 29, 1974	Lavochkin (USSR)	Orbiter	Success
ISEE-3/Delta 2914	Aug 12, 1978	NASA (USA)	Flyby	Success
Geotail/Delta II 6925	Jul 24, 1992	ISAS (Japan)/NASA (USA)	Flyby	Success
Clementine (DSPES)/Titan II (23)G Star-37FM	Jan 24, 1994	USAF/NASA (USA)	Orbiter	Success
WIND/Delta II 7925-10	Nov 1, 1994	NASA (USA)	Flyby	Success
HGS-1/Proton-K/DM3	Dec 24, 1997	Hughes (USA)	Flyby	Success

Spacecraft/Launch Vehicle	Date	Operator/Nation	Type	Status
Lunar Prospector (Discovery 3)/Athena II	Jan 7, 1998	NASA (USA)	Orbiter	Success
Nozomi/M-V	Jul 3, 1998	ISAS (Japan)	Flyby	Success
WMAP/Delta 7425-10	Jun 30, 2001	NASA (USA)	Flyby	Success
SMART-1/Ariane 5G	Sep 27, 2003	ESA (EU)	Flyby	Success
STEREO A/STEREO B/Delta II 7925-10L	Oct 25, 2006	NASA (USA)	Flyby	Success
THEMIS (ARTEMIS P1/ARTEMIS P2)/Delta II 7925-10L	Feb 17, 2007	NASA (USA)	Orbiter	Success
SELENE (Kaguya/Okina/Ouna)/H-IIA 2002	Sep 14, 2007	JAXA (Japan)	Orbiter	Success
Chang'e-1/Long March 3A	Oct 24, 2007	CNSA (China)	Orbiter	Success
Chandrayaan-1/PSLV-XL C11	Oct 22, 2008	ISRO (India)	Orbiter/Impactor	Success
Lunar Recconnaissance Orbiter/LCROSS/Atlas V 401	Jun 18, 2009	NASA (USA)	Orbiter/Impactor	Success
Chang'e-2/Long March 3C	Oct 1, 2010	CNSA (China)	Orbiter	Success
GRAIL (Ebb (GRAIL-A) and (Flow (GRAIL-B)	Sep 10, 2011	NASA (USA)	Orbiter	Success
LADEE/Minotaur V	Sep 7, 2013	NASA (USA)	Orbiter	Success
Chang'e-5-T1/Long March 3C	Oct 23, 2014	CNSA (China)	Orbiter	Success
Manfred Memorial Moon Mission/Long March 3C	Oct 23, 2014	LuxSpace (Luxembourg)	Flyby/Impactor (Post Mission)	Success
TESS/Falcon 9 Full Thrust	Apr 18, 2018	NASA (USA)	Flyby	Success
Longjiang-1/Longjiang-2/Long March 4C	May 21, 2018	CNSA (China)	Orbiter	Success
Chandrayaan-2/LVM3	Jul 22, 2019	ISRO (India)	Orbiter/Lander/Rover	Partial failure
Chang'e 5/Long March 5	Nov 23, 2020	CNSA (China)	Orbiter/Lander/Asender/Sample return	Success
CAPSTONE/Electron	Jun 28, 2022	NASA (USA)	Orbiter	Success
Danuri (Korea Pathfinder Lunar Orbiter)/Electron	Aug 4, 2022	KARI (Republic of Korea)	Orbiter	Success
Artemis 1 Orion MPCV CM-002/Space Launch System (SLS) (Block 1)	Nov 16, 2022	NASA (USA)	Orbiter	Success
LunaH-Map/Lunar IceCube/Space Launch System (SLS) (Block 1)	Nov 16, 2022	NASA (USA)	Orbiter	Success
ArgoMoon/Space Launch System (SLS) (Block 1)	Nov 16, 2022	ASI (Italy)	Flyby	Success
LunIR/Space Launch System (SLS) (Block 1)	Nov 16, 2022	Lockheed Martin (USA)	Flyby	Success
Near-Earth Asteroid Scout/Space Launch System (SLS) (Block 1)	Nov 16, 2022	NASA (USA)	Flyby	Spacecraft failure
EQUULEUS/Space Launch System (SLS) (Block 1)	Nov 16, 2022	JAXA (Japan)	Flyby	Success
OMOTENASH/Space Launch System (SLS) (Block 1)	Nov 16, 2022	JAXA (Japan)	Oribter/Retrorocket/Surface Probe	Spacecraft failure
BioSentinel/Space Launch System (SLS) (Block 1)	Nov 16, 2022	NASA (USA)	Flyby	Success
CubeSat for Solar Particles/Space Launch System (SLS) (Block 1)	Nov 16, 2022	NASA (USA)	Flyby	Spacecraft failure
Team Miles/Space Launch System (SLS) (Block 1)	Nov 16, 2022	NASA (USA)	Flyby	Success
Lunar Flashlight/Falcon 9 Block 5	Dec 11, 2022	NASA (USA)	Flyby	Spacecraft failure
Jupiter Icy Moons Explorer/Ariane 5 ECA	Apr 14, 2023	NASA (USA)	Flyby	Success
Chandrayaan-3/Vikram lander/Pragyan rover/LVM3	Jul 14, 2023	ISRO (India)	Orbiter/Lander/Rover	Success
SLIM (LEV-1/LEV-2 (Sora-Q)/H-IIA	Sep 6, 2023	JAXA (Japan)/Tomy/Doshisha University	Flyby/Lander/Hopper/Rover	Success
Odysseus (IM-1)/Space X Falcon 9	Feb 23, 2024	NASA (USA)	Lander	Success

ABOVE AND OVERLEAF Flyby and orbiter missions to the Moon are listed in the table above. Missions intended to reach the Moon's surface are mapped on the following pages.

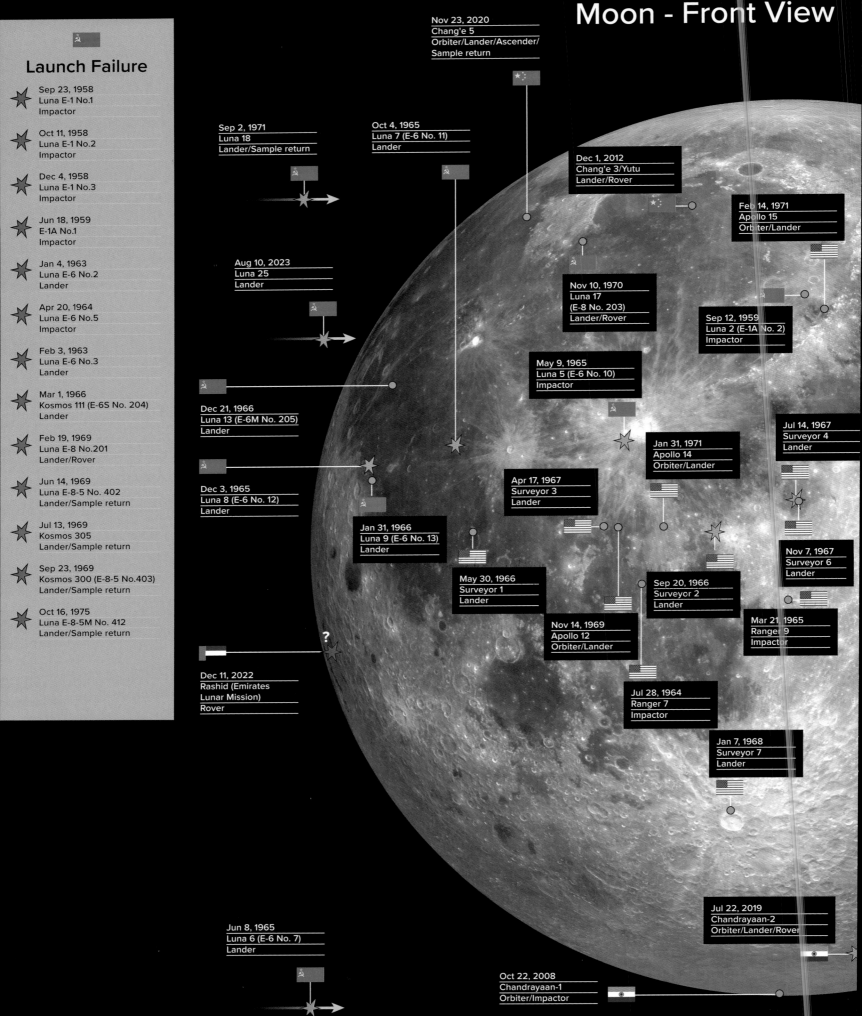

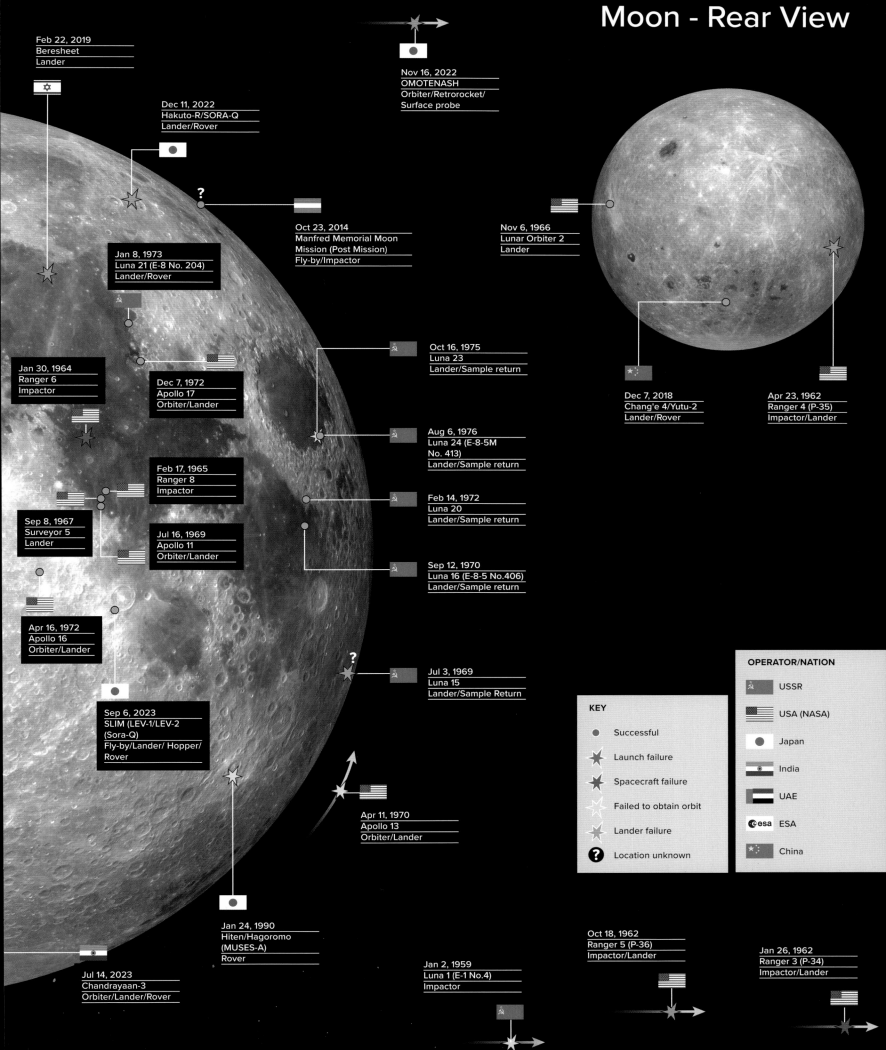

MISSION TO PLANET EARTH

Scientists have been studying Earth for centuries, but the rise of spaceflight in the twentieth century allowed them to observe and measure changes over time on a planetary scale, just as spacecraft sent to other planets in the solar system did. This capability has transformed human understanding of our home planet.

EARTH FAST FACTS

MEAN DISTANCE FROM SUN 93 million miles (150 million kilometers) or 1 astronomical unit (AU)
DIAMETER 7926.38 miles (12,756 kilometers)
DENSITY 5.513 grams/cubic centimeter
SURFACE GRAVITY 9.80 meters/second squared
ROTATION PERIOD (LENGTH OF DAY) 23 hours, 56 minutes, 4 seconds
REVOLUTION PERIOD (LENGTH OF YEAR) 365.242 days
MEAN SURFACE TEMPERATURE 59 degrees Fahrenheit (15 degrees Celsius)
NATURAL SATELLITES One
DISCOVERER No single person is credited with the discovery of Earth. The first picture of Earth from space was taken from a V-2 rocket launched from New Mexico on March 7, 1947

The perspective afforded by satellite imaging has been a great boon in understanding changes in Earth over time. It provided new levels of precision in weather forecasting and climate science, land uses, water temperatures and sea-level rise, as well as a host of other geophysical factors for this planet.

Scientific uses of satellites to understand Earth could be imagined before the Space Age, of course, but bringing them to fruition required considerable time and money. In the United States during the 1960s, a small collection of scientists (mostly located either at universities or in government laboratories) were interested in using satellites to monitor Earth, and worked with European and other allies to undertake global scientific measurements. Accordingly, in its first twenty years of existence NASA launched three satellites devoted to Earth observation: the weather satellite Tiros in 1960, the Earth resources monitoring satellite Landsat in 1972, and the oceanographic research satellite Seasat in 1978. These satellites proved remarkably successful.

When Mount Saint Helens erupted on May 18, 1980, for example, satellites tracked the tons of volcanic ash that spread eastward, allowing meteorologists both to warn of danger and to study the effects of the explosion on the world's climate. More spectacular, and more disconcerting, Nimbus 7, in orbit since 1978, revealed that ozone levels over the Antarctic had been dropping for years and had reached record lows by October 1991. This data, combined with that from other sources, led to the 1992 decision to enact global protocols to ban chemicals that depleted the ozone layer.

A new phase of undertaking Earth science from space began in the 1980s when NASA started a program named Mission to Planet Earth (MTPE) to systematize the study of this planet. As space robotics technologies matured, scientists already involved in environmental science refocused attention on developing a view of Earth as an integrated, interdependent system, using satellite observations to help create global climate models. In 1987 a NASA report written by former astronaut Sally Ride recommended embracing the MTPE concept as a priority for both the United States and the world. While there had to be rescoping of the program over time, this report served as the catalyst for an investment of more than $10 billion to build and operate a series of orbital spacecraft, and to analyze data from them for environmental purposes. The program's Earth Observing System

RIGHT A full view of Earth, taken by the Geostationary Operational Environmental Satellite (GOES-8). Operated by the National Oceanic and Atmospheric Administration (NOAA), the system is excellent for tracking storms of all types.

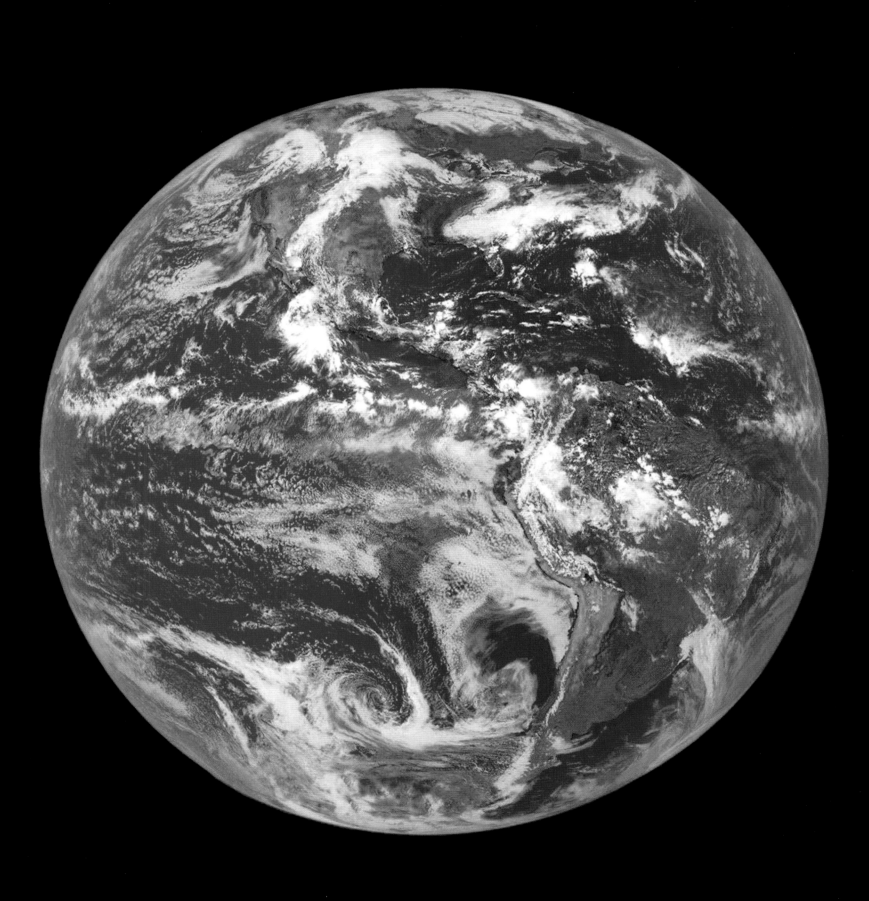

(EOS) satellites then collected data in a variety of ranges on air, land, and sea bodies on the planet.

These satellites demonstrated a profound value thereafter. The Galveston hurricane of 1900, for instance, came from nowhere and killed one-sixth of the local population when it hit. In contrast, satellite data warned Galveston residents of Hurricane Rita in September 2005 and gave them time for evacuation, so that only 113 deaths occured as a result of the storm in southern Texas. In addition, weather satellites detect and track forest fires, volcanoes, and severe storms, as well as document measures of rainfall and winds. Interestingly, it is the tracking of severe weather patterns and decision-making about evacuation that has benefited the most from geosynchronous weather satellites. NOAA has provided a compendium of economic statistics concerning weather disasters, noting that actions taken to overcome these efforts save in excess of $10 billion in the United States every year.

By 2000, Earth system science had matured, and a variety of Earth-observing spacecraft enabled scientists to obtain sophisticated data about our planet's physical characteristics. Among others, these spacecraft include the Tropical Rainfall Measuring Mission (TRMM), the Sea-viewing Wide Field-of-View Sensor (SeaWiFS) mission, the Quick Scatterometer (QuikSCAT) and TOPEX/Poseidon ocean studies missions, and the Active Cavity Radiometer Irradiance Monitor Satellite (ACRIMSAT) and Upper Atmosphere Research Satellite (UARS) missions. Instruments from these satellites are measuring atmospheric chemistry, biomass burning, and land-surface changes ranging from Greenland to the tropical Pacific Ocean. Collectively, these spacecraft have revolutionized our understanding of Earth and the global processes taking place here.

Tiros 1, the first weather satellite, was launched by the US on April 1, 1960. Its key features are called out here.

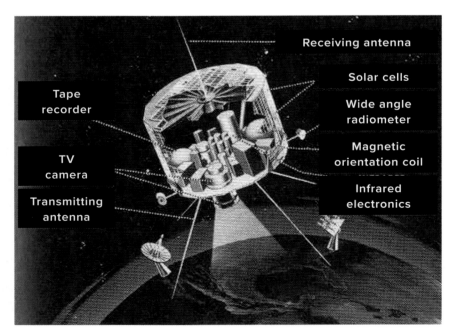

JAMES E. HANSEN AND THE ONGOING DEBATE OVER CLIMATE CHANGE

In the 1980s scientists warned of global climate change, sometimes referred to as "global warming," based on data from many sources but especially that from space-based observation. NASA scientist James E. Hansen (b. 1941) became a central participant in this effort. He had been involved in research about global warming for several years, and his organization, NASA's Goddard Institute for Space Studies, in Manhattan, had a long tradition of tracking the rising annual global temperatures over the decades since the Space Age began.

Hansen, as well as many other scientists, argued that evidence compels action to combat global warming, by reducing the level of carbon dioxide. Famously, in June 1988 he told a US Senate committee of the potential hazard of climatic changes. One sentence caught the public's attention: "It's time to stop waffling . . . and say that the greenhouse effect is here and is affecting our climate now." Such strident statements did not endear Hansen to political leaders, who faced opposition from business interests.

Hansen was far from the first to make this case, and the US Congress acted as early as 1978 to pass the National Climate Program Act, following it up with the Global Climate Change Research Act of 1990, making more funding available for climate science.

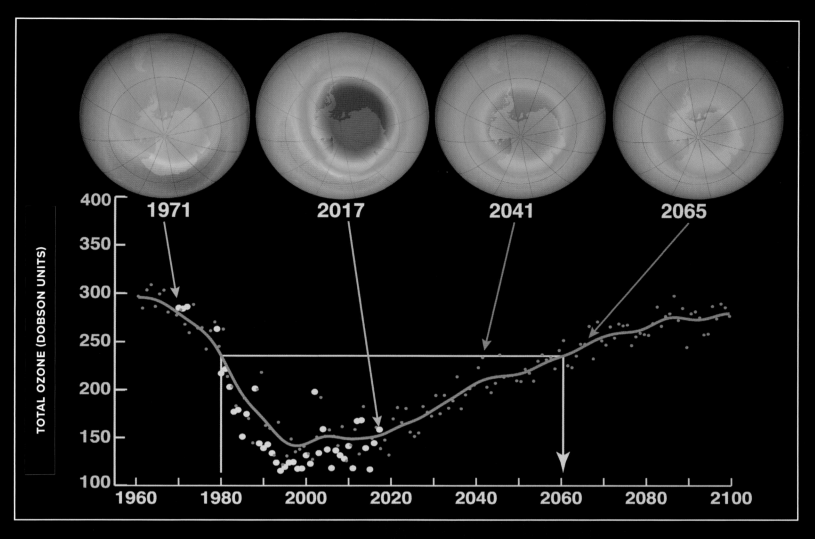

ABOVE Orbital satellites have recorded daily images of the ozone hole over Antarctica. Close monitoring of ozone depletion is necessary to foster the scientific understanding needed to secure international agreements instituting corrective measures. This graph shows each year's October average minimum ozone over Antarctica. The red curve is the trend line of ozone recovery. The four globes show the changes in the ozone layer over time—the bluer the image, the less ozone there is in the upper atmosphere. Once the Montreal Protocol was adopted, the ozone layer began to recover.

LEFT Data from remote sensing satellites can be used to track forest fires that endanger populated areas. In this image of southern California, collected by the MODIS sensor on Terra satellite in October 2003, at least five groups of fires, some of the largest ever in California, are seen burning. At least thirteen people lost their lives because of these fires, many of which appear to have been caused by carelessness or arson. Thousands were evacuated across the region and hundreds of homes were lost.

VIRGINIA T. NORWOOD (1927–2023)

Virginia T. Norwood, considered by many as the mother of Landsat, at the Storm Detector Radar Set at the Army Signal Corps Laboratories in New Jersey. She designed the Multispectral Scanner System (MSS), a revolutionary technology first used on Landsat 1 in 1972.

Trained as a mathematical physicist at MIT, Norwood showed talent as an accomplished engineer early on in her career. At age twenty-two, prior to her work on Landsat, she developed and patented a radar reflector that was able to uncover previously untraceable high-altitude winds. At thirty-nine, when Surveyor 1 made a soft landing on the Moon in 1966 and sent images of the lunar surface back to Earth, it used a transmitter designed by Norwood's team. She also oversaw the design of the system's antenna. Thanks to the communications equipment Norwood and her team had designed, Surveyor landed intact, paving the way for the Apollo landings that would begin two years later.

Within months of Surveyor's launch, she began work on a satellite designed to record detailed data of Earth's resources—her MSS. This pioneering technology yielded new insights into geology and mineral resources, pollution, forestry, and more. For this work, Norwood received the 1979 William T. Pecora award, acknowledging her significant contribution towards bettering our understanding of our home planet through remote sensing.

ABOVE An article of the Earth Resources Technology Satellite (which became Landsat 1 upon launch) in a space chamber test at General Electric's Space Division. This first satellite, launched in 1972, included multiple sensors that relayed masses of data to scientists. A succession of more capable satellites in the series have been operating ever since.

BELOW Landsat 1 mapped Earth's surface features over time. This image of Los Angeles, taken on June 25, 1974, is displayed with the visible green, the visible red, and an infrared channel coded as blue, green, and red, respectively. Downtown LA appears as a light blue patch in the lower right.

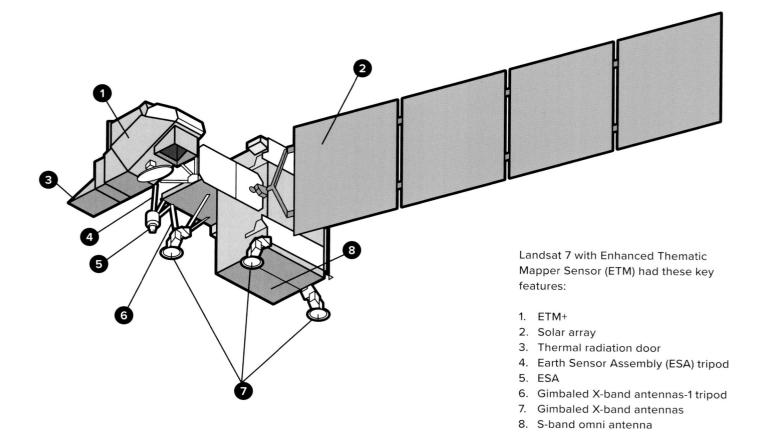

Landsat 7 with Enhanced Thematic Mapper Sensor (ETM) had these key features:

1. ETM+
2. Solar array
3. Thermal radiation door
4. Earth Sensor Assembly (ESA) tripod
5. ESA
6. Gimbaled X-band antennas-1 tripod
7. Gimbaled X-band antennas
8. S-band omni antenna

RIGHT Using a color mosaic of images from the Landsat 5 satellite and the Shuttle Radar Topography Mission aboard the Space Shuttle *Endeavour* in 2000, this image surveys from Lake Ontario and the St. Lawrence River (*bottom*) to Long Island (*top*), showing the varied topography of eastern New York State and parts of New England. The higher area in the left foreground is the Adirondack Mountains, a deeply eroded landscape that includes the oldest rocks in the eastern United States. On the right are the Catskills, a part of the Appalachian Mountain chain. Between these ranges, a wide valley holds the Mohawk River and the Erie Canal. To the northwest (*lower right*) of the Catskills are the Finger Lakes of central New York. The Hudson River extends from the left center to New York City at the upper right.

OUR NEARBY WORLDS

LEFT Using six Landsat 5 images collected in 2009 and 2011, the United States Geological Survey (USGS) team created this mosaic of Chesapeake Bay. The silvery purple line is the Washington, DC–Baltimore–Philadelphia–New York City corridor.

BELOW A schematic of Seasat, with key features called out.

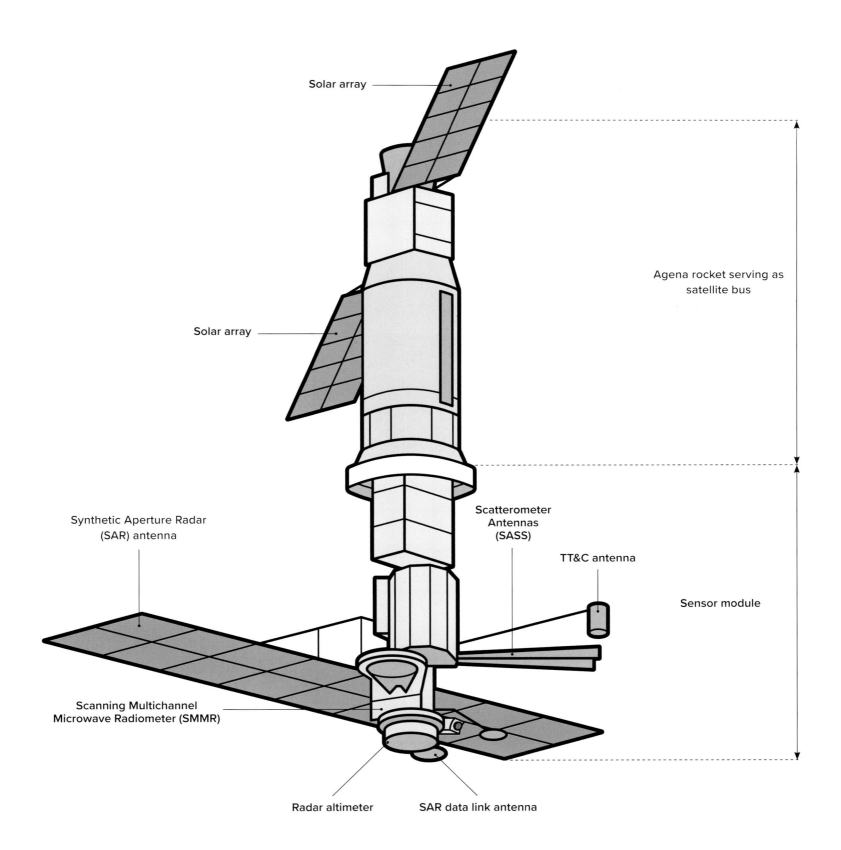

OUR NEARBY WORLDS

299

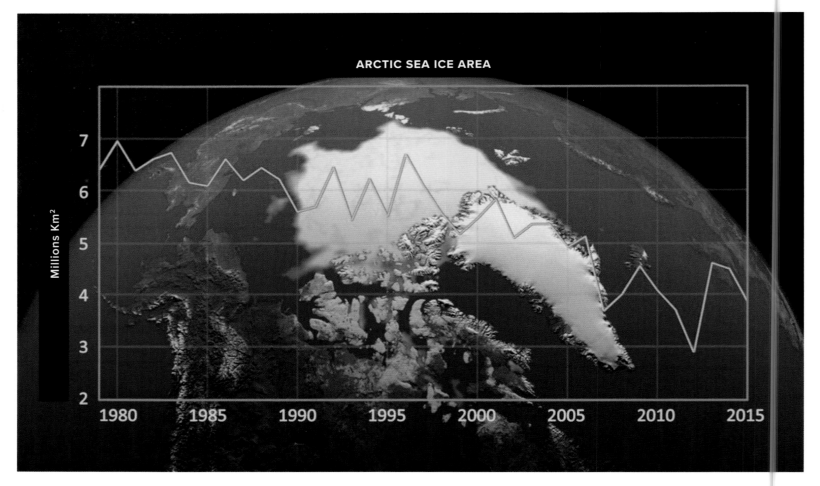

ARCTIC SEA ICE AREA

ABOVE AND LEFT Satellites have been studying sea ice from space since 1979. While the graph above shows that the level does go up and down depending on the year, the overall trend is downward, suggesting the effects of global climate change being seen in the Arctic. In 1979 (*top*) there were 6.4 million square kilometers (2.5 million square miles) of sea ice, but by 2015 (*bottom*) the Arctic minimum sea ice covered an area of only 3.885 million square kilometers (1.5 million square miles).

ABOVE Space imagery has greatly aided in analyses of Earth's environment. This image from August 3, 2023, shows the Barents Sea near Russia and Scandinavia where microscopic phytoplankton thrive in nutrient-rich waters, feeding invertebrates and small crustaceans that sustain fish, seabirds, and mammals. While individual phytoplankton are too small to be visible to the naked eye, the lighter-blue plume seen in the ocean in the center of the picture shows billions of these creatures and how they have altered the water over hundreds of miles.

RIGHT This map illustrates the 2011–21 average air temperature against the 1956–76 baseline air temperature, with a scale of change shown below. Surface air temperature changes to date have been most pronounced in northern latitudes and over land masses.

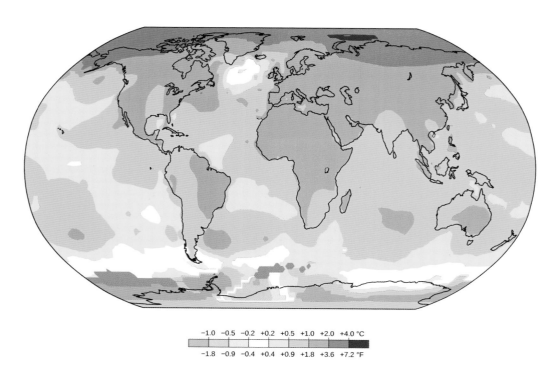

−1.0 −0.5 −0.2 +0.2 +0.5 +1.0 +2.0 +4.0 °C
−1.8 −0.9 −0.4 +0.4 +0.9 +1.8 +3.6 +7.2 °F

OUR NEARBY WORLDS

A stunning time-lapse image of the Milky Way was taken from the International Space Station (ISS) in 2015. A portion of the station is visible, as well as the limb of Earth (the edge of the atmosphere that appears almost as a halo). Astronaut Kjell Lindgren commented on social media on September 2, 2015, about this image: "Large lightning strike on Earth lights up our solar panels."

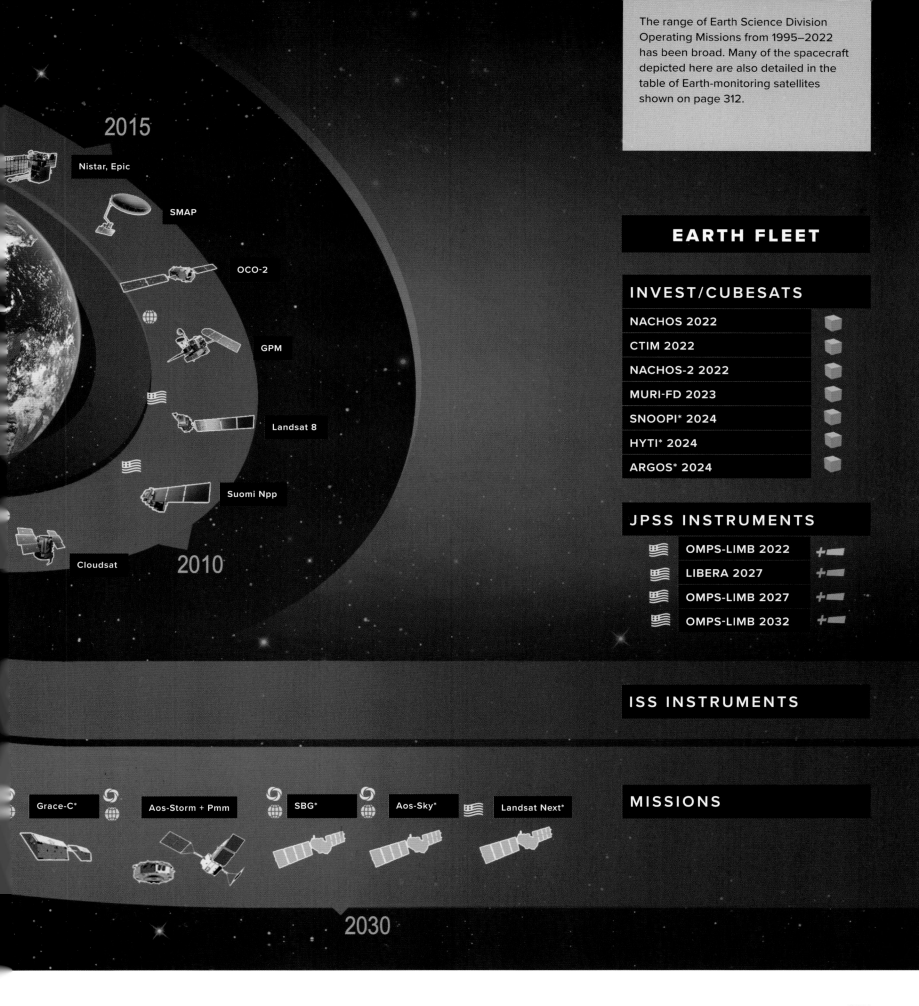

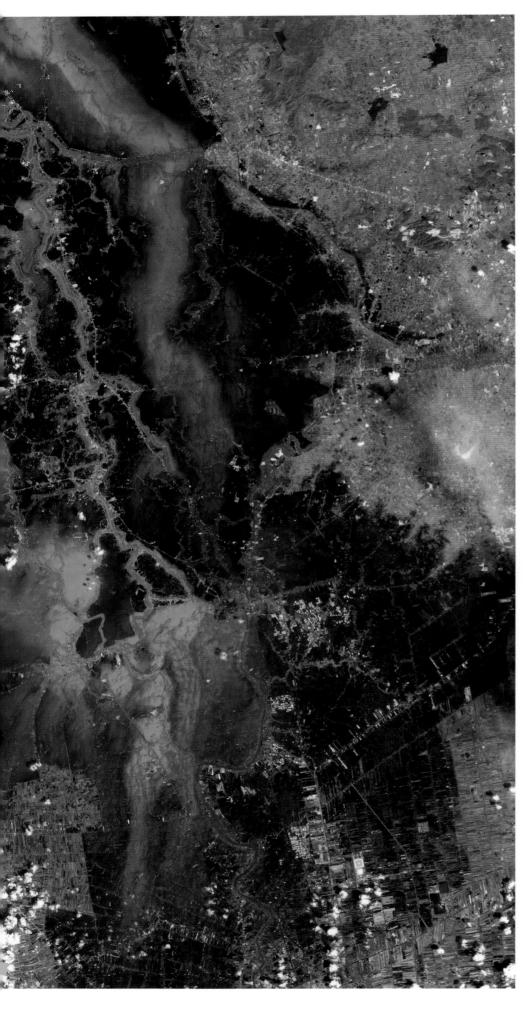

LEFT On October 23, 2011, NASA's Terra satellite captured this image of flood waters approaching the capital city of Bangkok as the Ayutthaya River overflowed its banks.

BELOW Workers at Vandenberg Air Force Base in California prepare NASA's Terra spacecraft for launch. Launched in 1999, Terra inaugurated a fundamental data record useful in charting changes in Earth's environment.

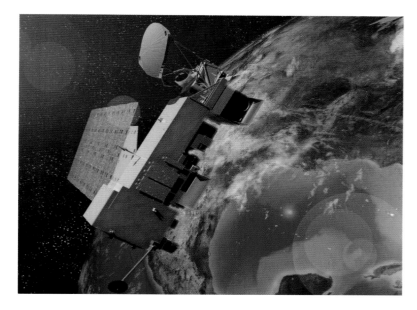

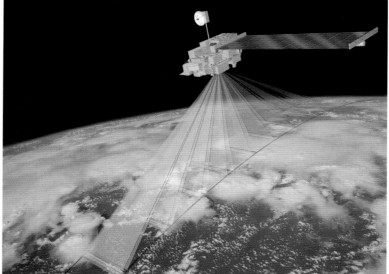

ABOVE The Terra satellite provided scientific data in high spatial detail. Its imagery is carefully calibrated to provide accurate measures of the brightness, contrast, and color of objects.

BELOW The Aquarius/SAC-D satellite observatory was the product of an agreement between the US and Argentina. After being launched from Vandenberg Air Force Base on June 10, 2011, it began monitoring ocean salinity.

ABOVE In the early 2000s, NASA began launching a new generation of research spacecraft specifically designed to study Earth. Aqua was one of these spacecraft, gathering congruent data with a suite of interrelated instruments, and since its launch in a polar orbit in 2002 it has provided valuable data on how Earth's air, water, and land masses interact as a system.

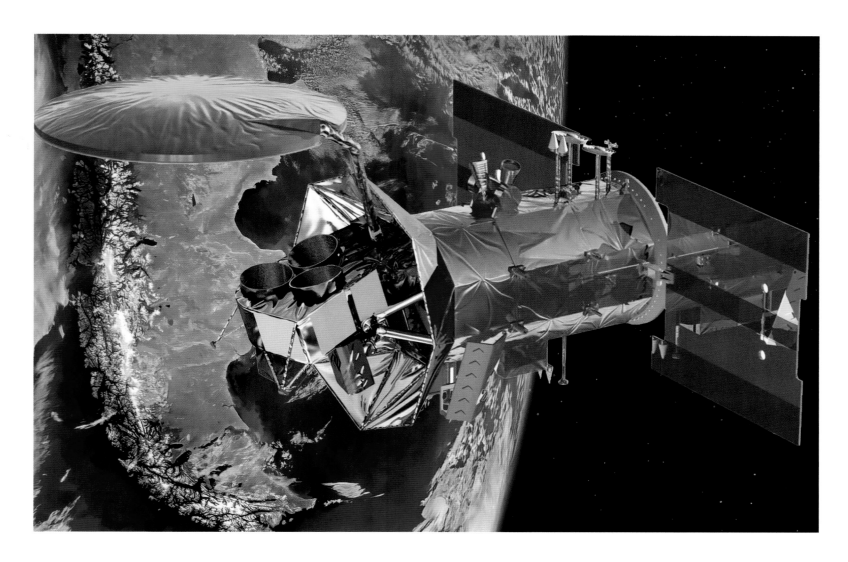

OUR NEARBY WORLDS

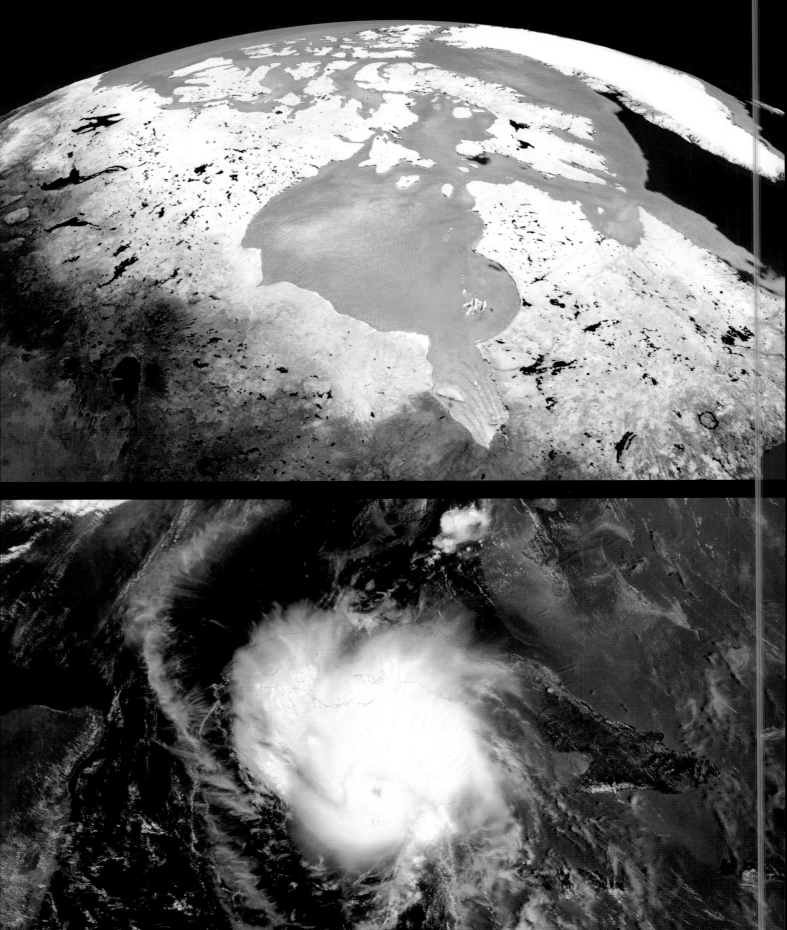

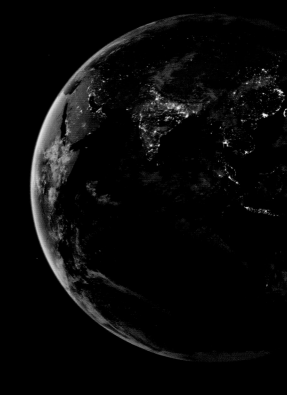

ABOVE AND RIGHT Since the 2011 launch of the NASA-NOAA Suomi National Polar-orbiting Partnership satellite, a research team led by Earth scientist Miguel Román of NASA's Goddard Space Flight Center has been analyzing nighttime light data and developing new software and algorithms to make imagery clearer, more accurate, and readily available. These three composite images—showing the Americas, Europe and Africa, and Asia—provide a view of Earth at night.

TOP LEFT Sea ice in Hudson Bay, northern Canada, captured by the Aqua satellite's Advanced Microwave Scanning Radiometer for the Earth Observing System.

LEFT Such spacecraft as GOES and Terra enable more effective extreme weather prediction than ever before. The MODIS instrument aboard NASA's Terra satellite captured this true-color image of Hurricane Charley on August 12, 2004, at 11:55 a.m. EDT. At the time this image was taken, Charley had maximum sustained winds near 90 miles per hour (145 kilometers per hour) with higher gusts and was moving toward the northwest at 17 miles per hour (23 kilometers per hour).

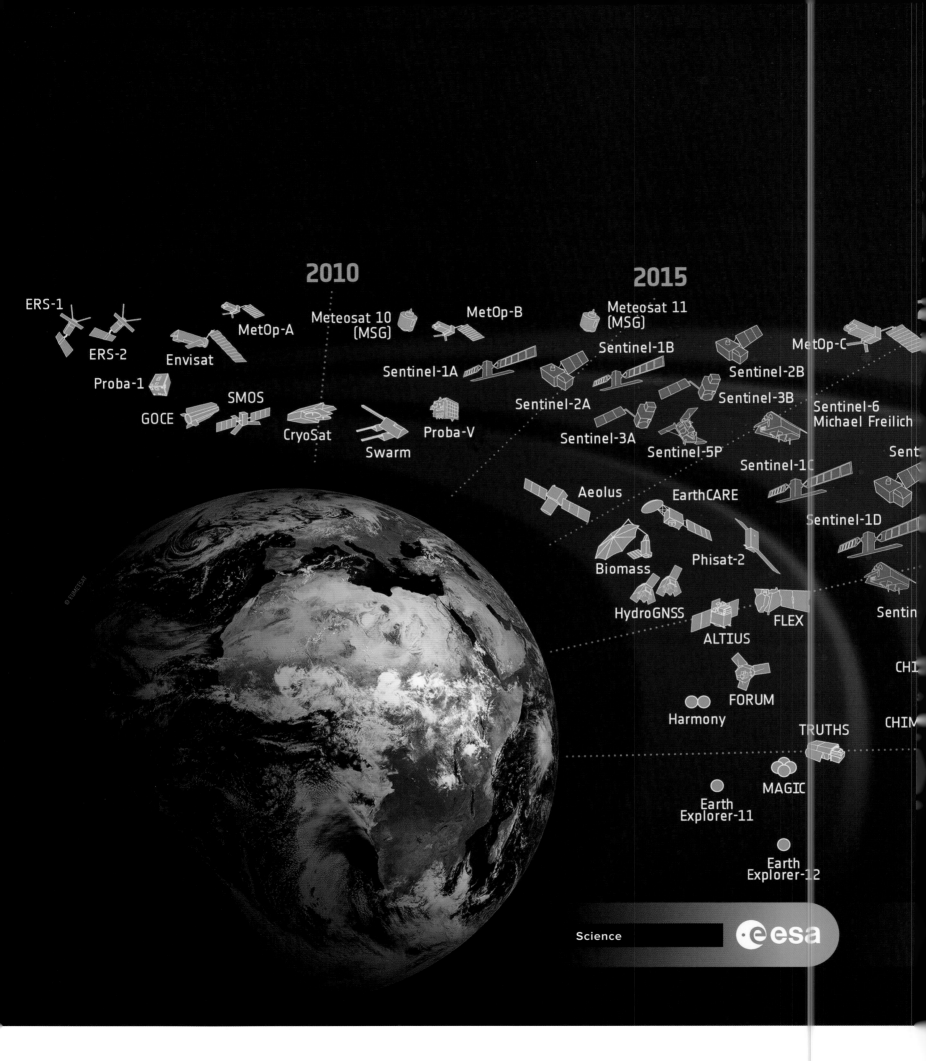

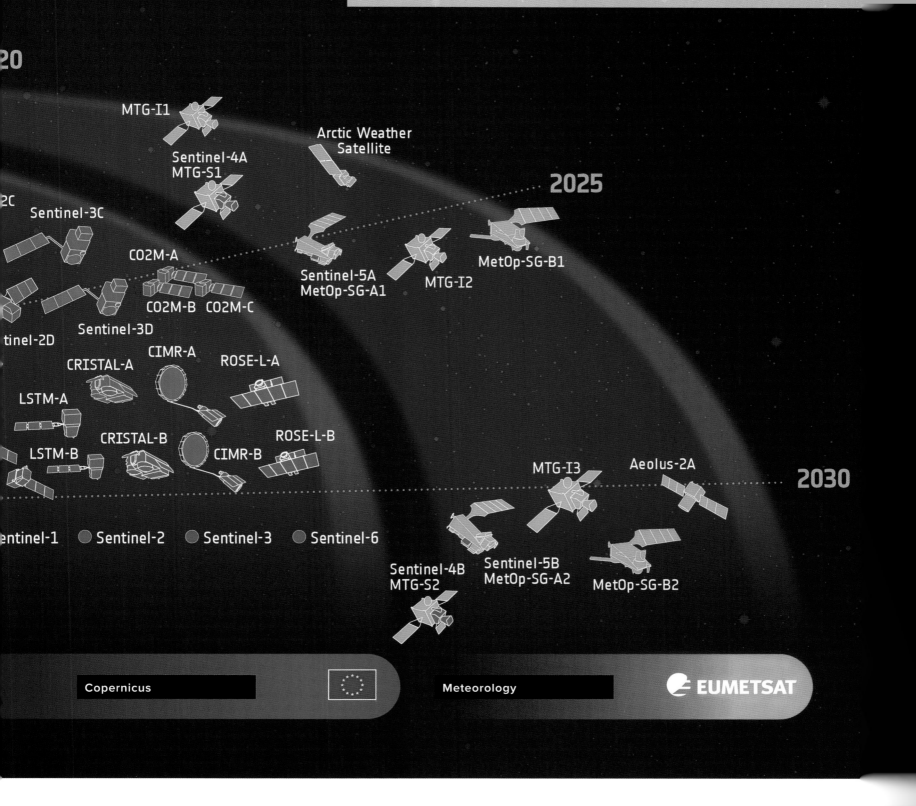

As with NASA, the European Space Agency (ESA)'s range of efforts to understand Earth has been broad. ESA-developed Earth observation missions are depicted here, many of which are also detailed in the table of Earth-monitoring satellites shown on page 312. The missions fall into three programs: the ESA's "Science" missions, Copernicus, the Earth observation component of the European Union's space program, and the European Organisation for the Exploitation of Meteorological Satellites (EUMETSAT). Across these programs, ESA's satellites are used to forecast the weather and answer important Earth science questions. They provide essential information for improving agricultural practices, maritime safety, and disaster relief efforts, among many other everyday applications.

OUR NEARBY WORLDS

THE BROAD RANGE OF EARTH OBSERVATION SATELLITES

Satellite	Date of Operation	Launch Site
ATS-3 (Advanced Technology Satellite)	Dec 7, 1966–Dec 1, 1978	Cape Canaveral
Landsat 1	Jul 23, 1972–Jan 6, 1978	Vandenberg
Landsat 2	Jan 22, 1975–Feb 25, 1982	Vandenberg
GOES-1 (Geostationary Operational Environmental Satellite)	Oct 16, 1975–Mar 7, 1985	Vandenberg
Landsat 3	Mar 5, 1978–Mar 31, 1983	Vandenberg
DE 1 and DE 2 (Dynamics Explorer)	Aug 3, 1981–Feb. 28, 1991 and Feb. 19, 1983	Vandenberg
Landsat 4	Jul 16, 1982–Dec. 19, 1993	Vandenberg
ERBS (Earth Radiation Budget Satellite)	Oct. 5, 1984–Oct. 14, 2005	Cape Canaveral
Landsat 5	Mar 1, 1984–Jun 5, 2013	Vandenberg
CRRES (Combined Release and Radiation Effects Satellite)	Jul 25, 1990–Oct 12, 1991	Cape Canaveral
ERS-1 (European Remote-Sensing Satellite)	Jul 17, 1991–Mar 2000	Kourou
ATLAS-1 (Atmospheric Laboratory for Applications and Science)	Mar 24, 1992–Apr 2, 1992	Cape Canaveral
Landsat 6	Oct 5, 1993–Oct 5, 1993	Vandenberg
ESSA (Environmental Science Services Administration) program	Feb 3 1966– Jun 12, 1968	Cape Canaveral
ADEOS I (Advanced Earth Observing Satellite)	Aug 17, 1996–Jun. 30, 1997	Cape Canaveral
SeaWiFS	Aug 1, 1997–Dec 11, 2010	Vandenberg
TRMM	Nov 27, 1997–Apr 9, 2015	Tanegashima
Landsat 7	Apr 15, 1999–Sep 27, 2021	Vandenberg
QuikSCAT	Jun 19, 1999–Nov 19, 2009	Vandenberg
Terra (EOS-AM)	Dec 18, 1999–	Vandenberg
ACRIMSAT	Dec 20, 1999–Jul 30, 2014	Vandenberg
CHAMP (New Millennium Program)/EO-1 (Earth Observing 1)	Jul 15, 2000–Sep 19, 2010	Plesetsk 132/1
NMP (New Millennium Program)/EO-1 (Earth Observing 1)	Nov 21, 2000–Mar 30, 2017	Vandenberg
Jason 1	Dec 7, 2001–Jul 1, 2013	Vandenberg
Meteor 3M-1/SAGE III (Stratospheric Aerosol and Gas Experiment)	Dec 10, 2001–Mar 6, 2006	Baikonur
GRACE (Gravity Recovery and Climate Experiment)	Mar 17, 2002–Oct 27, 2017	Plesetsk Cosmodrome
Aqua	May 4, 2002–	Vandenberg
ADEOS II (Midori II)	Dec 14, 2002–Oct 24, 2003	Tanegashima
ICESat (Ice, Cloud, and Land Elevation Satellite)	Jan 12, 2003–Aug 14, 2010	Vandenberg
SORCE (Solar Radiation and Climate Experiment)	Jan 25, 2003 – Feb 25, 2020	Cape Canaveral
Aura	Jul 15, 2004–	Vandenberg
CloudSat	Apr 28, 2006–	Vandenberg
CALIPSO (Cloud-Aerosol Lidar and Infrared Pathfinder Satellite Observations)	Apr 28, 2006–	Vandenberg
Aquarius	Jun 10, 2011–Jun 17, 2015	Vandenberg
Landsat 8	Feb 11, 2013–	Vandenberg
OCO-2 (Orbiting Carbon Observatory)	Jul 2, 2014–	Vandenberg
SMAP (Soil Moisture Active Passive)	Jan 31, 2015–	Vandenberg
ICESat-2	Sep 15, 2018–	Vandenberg
Landsat 9	Sep 27, 2021–	Vandenberg

Agency	Purpose
NASA	Weather observation
NASA/NOAA	Gather data on land use over time
NASA/NOAA	Gather data on land use over time
NOAA	Thirteen GOES satellites: weather monitoring and forecasting; scientific research to understand land, atmosphere, ocean, and climate dynamics
NASA/NOAA	Gather data on land use over time
NASA	Investigate interactions between plasmas of magnetosphere and ionosphere
NASA/NOAA	Gather data on land use over time
NASA	Study Earth's radiation budget and stratospheric aerosol and gases
NASA/NOAA	Gather data on land use over time
NASA	Investigate fields, plasmas, and energetic particles inside the magnetosphere
ESA	Measure wind speed and direction and ocean wave parameters
NASA	Flown aboard Space Shuttle *Atlantis* on mission STS-45 in spring 1992 to unravel human impact on the environment
NASA/NOAA	Gather data on land use over time
ESSA/NASA	Provide cloud-cover photography
NASA/NASDA	Joint USA/Japan satellite to study wind scattering and map the ozone layer
GeoEye/NASA	Provide quantitative data on global ocean bio-optical properties
NASA/JAXA	Monitor and study tropical rainfall
NASA/NOAA	Supply the world with global land surface images
NASA/JPL	Acquire global radar cross-sections and near-surface vector winds
NASA	Provide global data on the state of the atmosphere, land, and oceans
NASA	Study total solar irradiance (total amount of sunlight that falls on Earth)
GFZ (German Research Center for Geosciences)	Atmospheric and ionospheric research
NASA	Demonstrate new technologies and strategies for improved Earth observations
NASA/CNES	USA/France mission to provide information on ocean surface current velocity and heights
Roscosmos	Measure ozone, aerosols, water vapor, and other key parameters of Earth's atmosphere
NASA/DLR	Measure Earth's mean and time-variable gravity field
NASA	Collect water information in the Earth system
JAXA/NASA	Monitor the water and energy cycle as a part of the global climate system
NASA	Measure ice-sheet mass balance and related characteristics
NASA	Improve understanding of the Sun
NASA	Investigate questions about ozone trends, air-quality changes, and their linkage to climate change
NASA	Provide survey of vertical structure and overlap of cloud systems
NASA/CNES	USA/France mission to improve understanding of the role aerosols and clouds play in regulating Earth's climate
NASA/CONAE	USA/Argentina mission to map the spatial and temporal variations of sea-surface salinity
NASA/USGS	Supply the world with global land-surface images
NASA	Provide space-based global measurements of atmospheric carbon dioxide
NASA	Measure surface-soil moisture and freeze–thaw state
NASA	Measure ice-sheet mass balance
NASA / USGS	Provide global land-surface images, continuation of the Landsat program

OUR NEARBY WORLDS

VENUS: A CLOUD-COVERED INFERNO

Venus, a near twin of Earth in terms of size, has long been viewed as a potential home for life in the solar system. Those expectations dominated thinking about the planet as the Space Age began, and they were only fully dashed with sustained exploration that revealed the planet was an inferno—or were they?

Early in the Space Age, scientists around the world recognized the attraction of Venus as a near twin to Earth in terms of size, mass, and gravitation, and so speculated about the possibility of life existing there in some form. Charles Greeley Abbot (1872–1973), director of the Smithsonian Observatory, suggested in the 1920s that Venus "appears lacking in no essential to habitability." It turned out that he was completely wrong and that his conclusion was wishful thinking. The first space probes to Venus showed it to be a stark world, anathema to life as we understand it.

VENUS'S RUNAWAY "GREENHOUSE EFFECT"

Another theory, which proved true, suggested Venus was far from a world which might support life. Notably, Cornell University astrophysicist Carl Sagan demonstrated that Venus was a planet whose cloud cover fostered a runaway "greenhouse effect" where atmospheric pressures and temperatures were far above any on Earth. Sagan wrote in 1961: "At such high temperatures, and in the absence of liquid water, it appears very unlikely that there are indigenous surface organisms at the present time . . . However, since, as has been mentioned, there can have been no appreciable periods of time when Venus had both extensive bodies of water and surface temperatures below the boiling point of water, it is unlikely that life ever arose on Venus."

While honestly searching for life beyond Earth, Sagan and many other scientists came to this conclusion reluctantly and held out hope that spacecraft might prove them wrong. Such was not the case, however; the "greenhouse effect" was undeniable.

CARL SAGAN (1934–96)

During debates over global warming on Earth in the 1980s and 1990s, Carl Sagan pointed to Venus as an example of what could happen here if humans failed to grapple with CO_2 emissions and counteract the warming of the planet. Sagan told the US Senate in 1984 that "nature has arrayed for us a range of planets, some of which there is negligible greenhouse effect, others significant greenhouse effect and one a monster greenhouse effect, and it is very useful to take note of what nature has kindly provided for our edification."

He added, "in the case of Venus . . . the surface temperature . . . is something like 430 Centigrade, 900 Fahrenheit, hotter than the hottest household oven. The reason for that is, we now know from spacecraft exploration most recently the Pioneer/Venus series of spacecraft by the United States that it is due to a massive greenhouse effect in which carbon dioxide is the principal constituent." Most importantly, Sagan emphasized that what scientists see on Venus is "precisely the same greenhouse gas we're concerned with in this hearing."

"Early in the Space Age, scientists around the world recognized the attraction of Venus as a near twin to Earth in terms of size, mass, and gravitation."

VENUS FAST FACTS

MEAN DISTANCE FROM SUN 67 million miles (108 million kilometers) or 0.72 astronomical units (AU)

DIAMETER 7,518.59 miles (12,100 kilometers), about 95 percent of Earth's diameter

DENSITY 5.243 grams/cubic centimeter, slightly lower than Earth

SURFACE GRAVITY 8.87 meters/second squared (about 90 percent of Earth's gravity)

ROTATION PERIOD (LENGTH OF DAY) 243 Earth days

REVOLUTION PERIOD (LENGTH OF YEAR) 225 Earth days

MEAN SURFACE TEMPERATURE 867 degrees Fahrenheit (464 degrees Celsius)

NATURAL SATELLITES None

DISCOVERER No single person is credited with the discovery of Venus; it has been observed from Earth for centuries. It was first observed by telescope by Galileo Galilei in 1610.

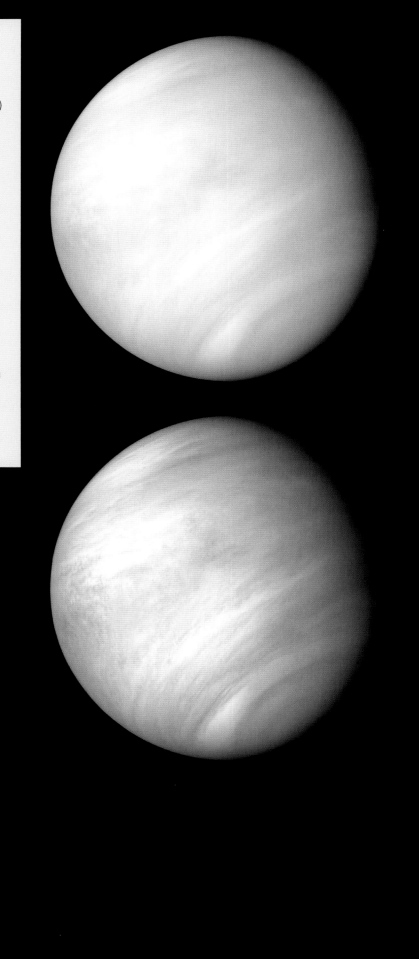

Venus, shrouded in clouds, has excited wonder and imagination for centuries. NASA's Mariner 10 spacecraft visited there in 1974 and captured this view of the planet (top), revealing very few features of Earth's nearest twin in terms of size. More recently, NASA reprocessed the image (bottom), enhancing contrast and emphasizing the clouds about 40 miles (65 kilometers) above the planet's surface. While mostly white, the red-tinted patches are a conundrum. They may be the result of sulfuric compounds or even biological materials, but a consensus has yet to be reached among scientists.

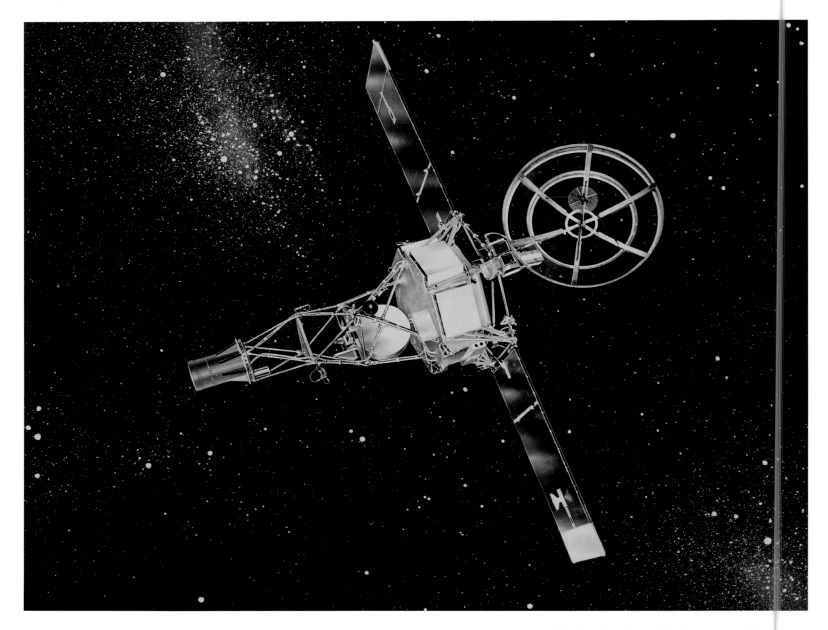

Mariner 2—the world's first successful interplanetary space probe—flew within 21,000 miles (34,000 kilometers) of Venus in December 1962, sending back the first data available about the planet's extremely hostile conditions.

PROBING VENUS

Both the United States and the Soviet Union sent probes to Venus early and often during the Space Age. In the summer of 1962, NASA launched Mariner 2 toward Venus, which in December arrived at the planet, probing the clouds, estimating planetary temperatures and pressures, measuring the charged particle environment, and looking for a magnetic field similar to Earth's magnetosphere (but finding none).

These efforts confirmed the harshest predictions about Venus. Scientists learned that the planet's atmosphere consists of approximately 97 percent carbon dioxide. And while it was very rocky, it had no water, with temperatures on the surface of more than 867 degrees Fahrenheit (464 degrees Celsius), regardless of whether it was night or day, summer or winter. Finally, the pressure on the surface of Venus is ninety times that which may be found on Earth.

Through the late 1960s, the Soviets also sent probes to Venus to obtain data from the inhospitable surface, but none succeeded until Venera 7 returned the first information from the surface in December 1970. For twenty-three minutes the lander reported

ABOVE The final preparations for the flight of Mariner 2 were completed in an assembly facility at the Atlantic Missile Range (AMR), Cape Canaveral, Florida. The spacecraft was designed and built by the Jet Propulsion Laboratory, then shipped to AMR, where the antenna and solar panels were assembled prior to testing and launch.

RIGHT Engineers at NASA's Jet Propulsion Laboratory review data sent by the Mariner 2 probe from Venus in 1962.

OUR NEARBY WORLDS

on conditions on the ground before succumbing to extreme heat and pressure. It was the first time that any lander had returned information from the surface of another planet.

Scientists learned much more about Venus in the early 1990s after the Magellan spacecraft mapped about 95 percent of the planet. Some surprises emerged, especially as plate tectonics and lava flows showed evidence of volcanic eruptions.

Since then, MESSENGER (Mercury Surface, Space Environment, Geochemistry, and Ranging) made two flybys of Venus enroute to Mercury. This mission, and subsequent ones operated by the European Space Agency (ESA), Japan, and the United States, have filled in some of the gaps in knowledge about Earth's twin, enabling us to learn that Venus is very much an "evil twin," uninviting for human habitation.

In all, more than forty spacecraft have been sent to Venus since 1962. One spacecraft—Japan's Akatsuki—is currently in orbit. Three new missions are intended to be launched in the next decade.

"Scientists learned that the planet's atmosphere consists of approximately 97 percent carbon dioxide. And while it was very rocky, it had no water, with temperatures on the surface of more than 867 degrees Fahrenheit (464 degrees Celsius), regardless of whether it was night or day, summer or winter."

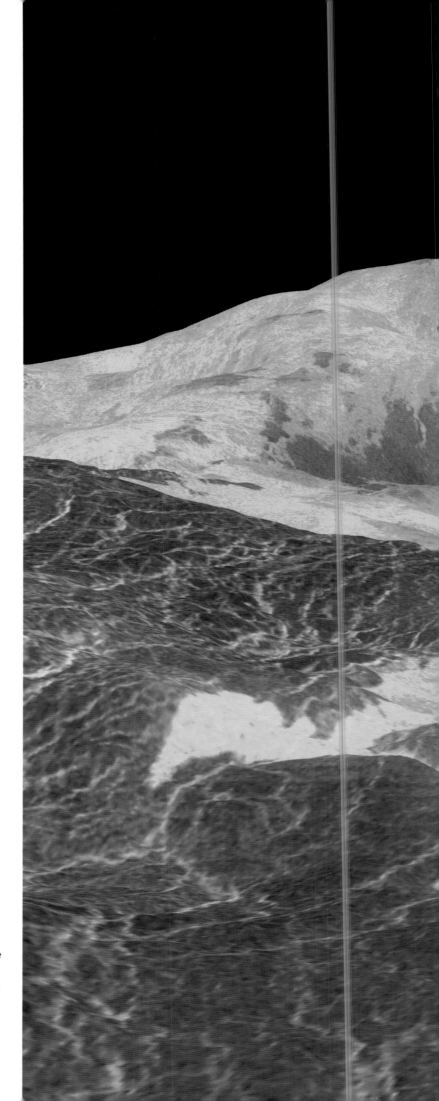

Using cloud-penetrating synthetic aperture radar imagery, NASA's Magellan spacecraft orbited Venus and undertook sophisticated exploration of the planet in the first part of the 1990s. Here, the Maat Mons mountain on Venus was captured from 347 miles (558 kilometers) north of Maat Mons at an elevation of 1 mile (1.6 kilometers) above the terrain. The superheated surface enhanced by the extreme greenhouse effect of the clouds covering the planet is shown here with lava flows extending for hundreds of miles across the fractured plains shown in the foreground.

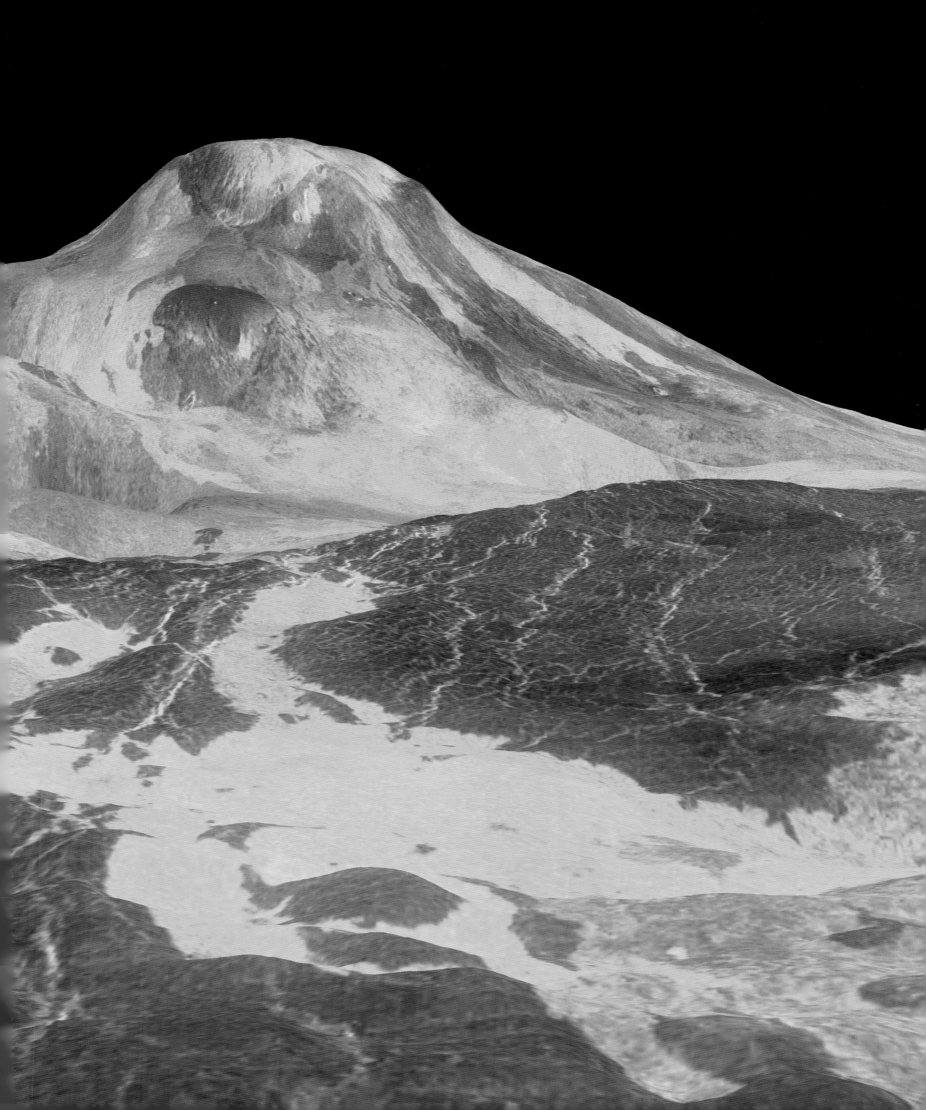

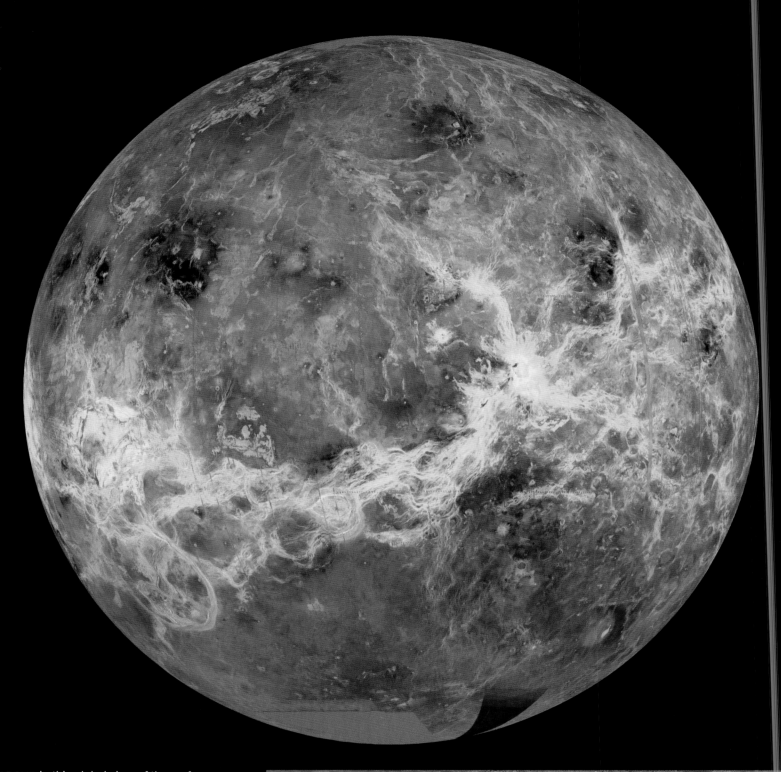

ABOVE In this global view of the surface of Venus from Magellan's synthetic aperture radar image, simulated color—based on color images obtained by the Venera 13 and 14 landing craft as well as other imagery—is used to enhance small-scale structures. The bright serpentine feature near the equator is Ovda Regio, a mountainous region in the western portion of what scientists named the Great Aphrodite Equatorial Highland. The dark areas scattered across the image are the remnants of large meteorite impacts.

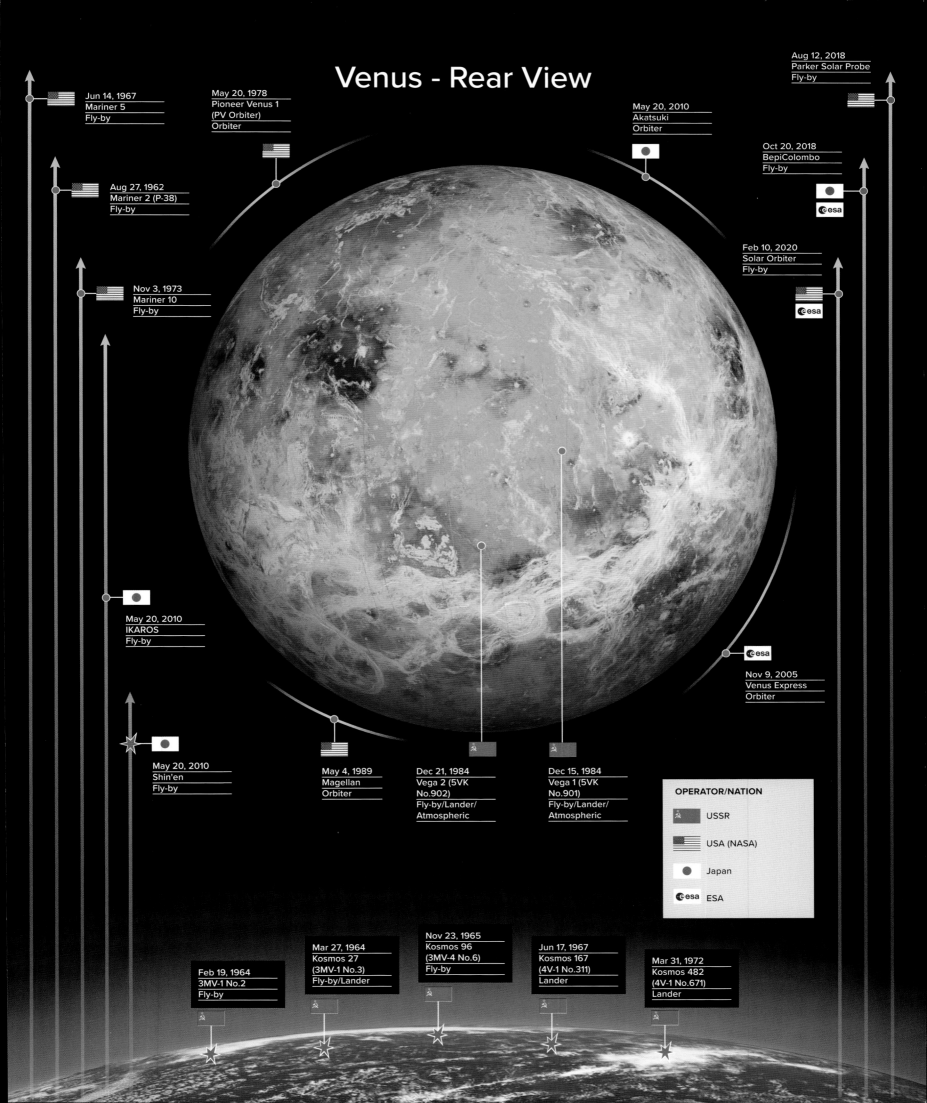

SCORCHING MERCURY

Mercury, the closest of all the planets to the Sun, has long been assessed as a scorching world. In science fiction it is often characterized as a place where anyone standing in direct sunlight would be instantly vaporized. An overstatement, no doubt, but it remains an uninviting world for life as we understand it.

Only four spacecraft have been sent to Mercury. The first, Mariner 10, launched on November 3, 1973, and reached Venus on February 5, 1974, after a flight of three months. In three flybys, Mariner 10 showed that Venus had at best a weak magnetic field, and the ionosphere interacted with the solar wind to form a bow shock (the shockwave created by the collision of a stellar wind with another medium). It also confirmed that Mercury had no atmosphere and a cratered surface.

NASA's MESSENGER (Mercury Surface, Space Environment, Geochemistry, and Ranging) explored Mercury with three flybys before orbiting the planet for four years, after which it crashed on the surface at the end of its mission in 2015. Launched in 2004, MESSENGER captured 100,000 images of the planet's sun-drenched surface. It revealed a large amount of water in Mercury's exosphere, discovered water-ice at the planet's poles, and located evidence of past volcanic activity on its surface.

In 2018 the European Space Agency (ESA) and the Japanese Space Exploration Agency (JAXA) launched a joint mission to Mercury, BepiColombo, containing two spacecraft, the Mercury Planetary Orbiter (MPO), and the Mercury Magnetospheric Orbiter (MMO). It first encountered Mercury during a flyby on October 1, 2021, and has continued a succession of flybys thereafter before entering a formal orbit of Mercury in late 2025 for extended investigation.

MERCURY FAST FACTS

MEAN DISTANCE FROM SUN 36 million miles (58 million kilometers) or 0.4 astronomical units (AU)
DIAMETER 3,030 miles (4,876 kilometers), about 38 percent of Earth's diameter
DENSITY 5.427 grams/cubic centimeter, only slightly less than Earth's density of 5.515 grams/cubic centimeter
SURFACE GRAVITY 3.7 meters/second squared (about 38 percent of Earth's gravity)
ROTATION PERIOD (LENGTH OF DAY) 176 Earth days
REVOLUTION PERIOD (LENGTH OF YEAR) 87.97 days (0.25 Earth years)
MEAN SURFACE TEMPERATURE 333 degrees Fahrenheit (167 degrees Celsius)
NATURAL SATELLITES None
DISCOVERER No single person is credited with the discovery of Mercury; it has been observed from Earth for centuries. It was first observed by telescope by Galileo Galilei in 1610.

Mercury, the closest planet to the Sun, has been visited only a few times by space probes, but the results have been spectacular. In the 2010s NASA's MESSENGER probe orbited Mercury and collected scientific data about the tidal-locked planet—one side always faces the Sun—and found that remarkably it was not completely the inferno previously thought. This image shows Mercury's north polar region, colored by the maximum biannual surface temperature, which ranges from >400 K (red) to 50 K (purple). Mercury's sunlit surface has the highest temperatures, but parts of the polar regions remain permanently shadowed, as seen in craters shown here in purple. In these regions even maximum temperatures can be extremely low. MESSENGER and Earth-based instruments demonstrated that water-ice deposits are present there. The craters nearest Mercury's poles have surface temperatures less than 100 K (-280°Fahrenheit/-173°Celcius), and water-ice is stable on the surface. What might exist in those regions?

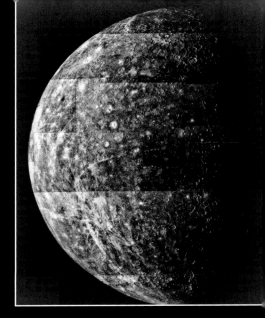

ABOVE The Mariner 10 spacecraft imaged Mercury's southern hemisphere during its initial flyby of the planet in 1974.

CENTER During its closest approach on July 8, 1974, Mariner 10 spacecraft captured these striking craters, making it clear that Mercury has been bombarded by meteorites for eons.

RIGHT A near global mosaic of Mercury comprising images captured by Mariner 10 in 1974.

BELOW The instruments aboard the Mariner 10 spacecraft sent to Venus and Mercury in 1973.

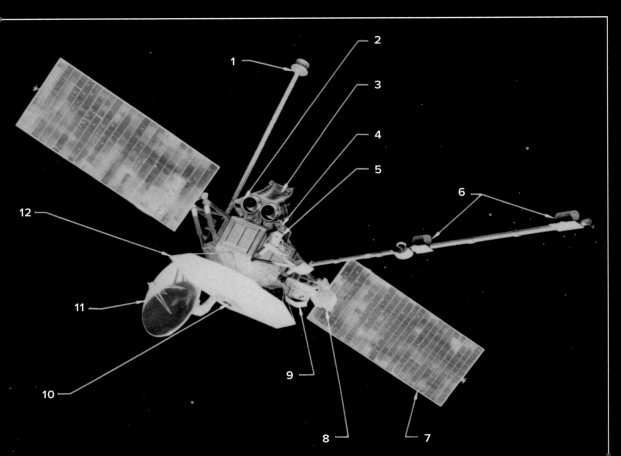

1. Low-gain antenna
2. Airglow ultraviolet spectrometer
3. TV cameras
4. Charged particle telescope
5. Occulation ultraviolet spectrometer
6. Magnetometers
7. Tiltable solar panel
8. Plasma science
9. Infrared radiometer
10. Rocket motor nozzle
11. Steerable high-gain antenna
12. Sun shade

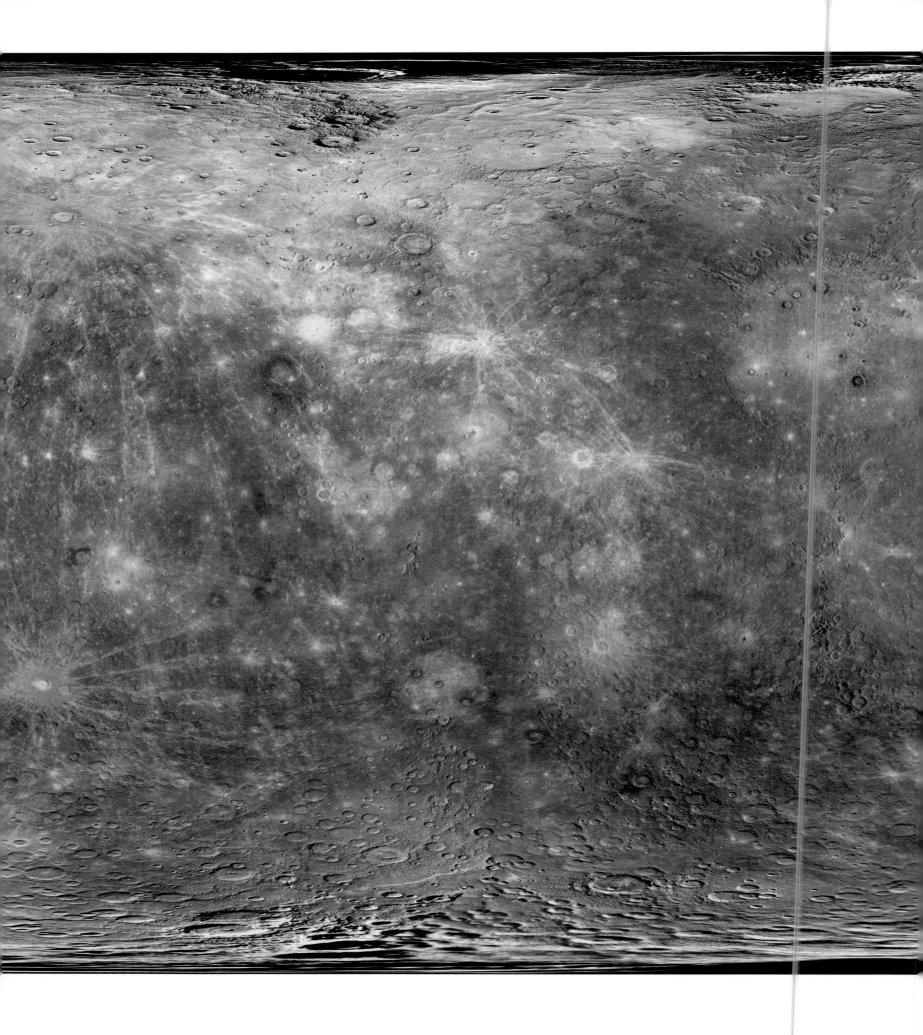

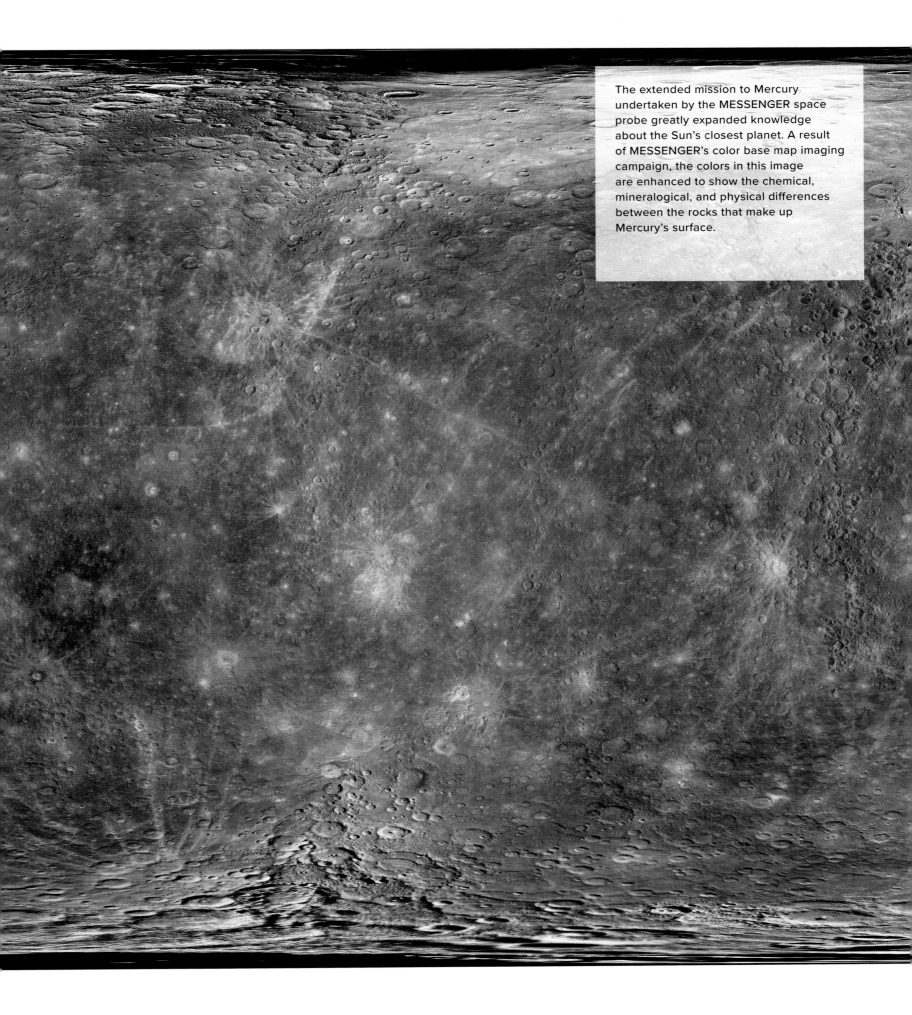

The extended mission to Mercury undertaken by the MESSENGER space probe greatly expanded knowledge about the Sun's closest planet. A result of MESSENGER's color base map imaging campaign, the colors in this image are enhanced to show the chemical, mineralogical, and physical differences between the rocks that make up Mercury's surface.

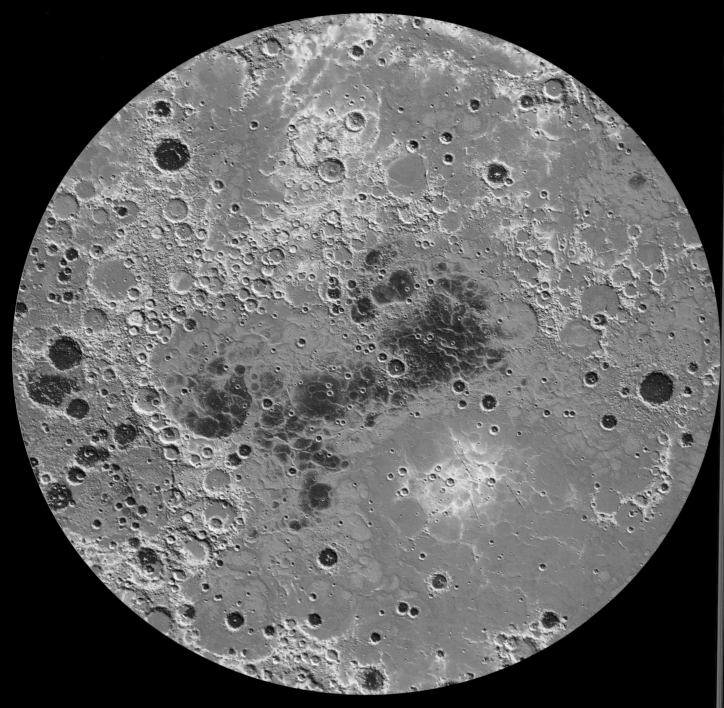

ABOVE In this photo mosaic of imagery taken by MESSENGER, the lowest regions of Mercury's topography are shown in purple, and the highest regions are in red. The dominant green areas are relatively flat plains at midpoints between the highlands and basins. The difference in elevation between the lowest and highest regions shown here is 6 miles (10 kilometers).

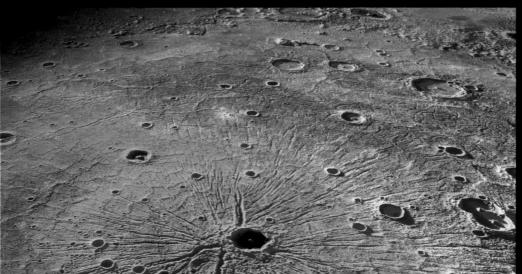

LEFT Looking northwest over the Caloris Basin, a depression of about 900 miles (1,500 kilometers) in diameter was formed several billion years ago by the impact of a large object onto Mercury's surface. In the foreground, we see the Pantheon Fossae, a set of tectonic troughs, radiating from the center of the basin outward.

LEFT The BepiColombo mission excited scientists, as well as the public, when it took this view of Mercury on October 1, 2021, within 1,502 miles (2,418 kilometers) of the planet's surface. The region shown is part of Mercury's northern hemisphere and shows evidence of considerable volcanic activity, with lava flows and eruptions.

BELOW The ESA-JAXA BepiColombo spacecraft was launched in October 2018. Taking a circuitous route, it should orbit Mercury beginning in 2025. Once there, its two spacecraft, the Mercury Planetary Orbiter and Mercury Magnetospheric Orbiter, will study Mercury's magnetic field, magnetosphere, and interior and surface structures.

OUR NEARBY WORLDS

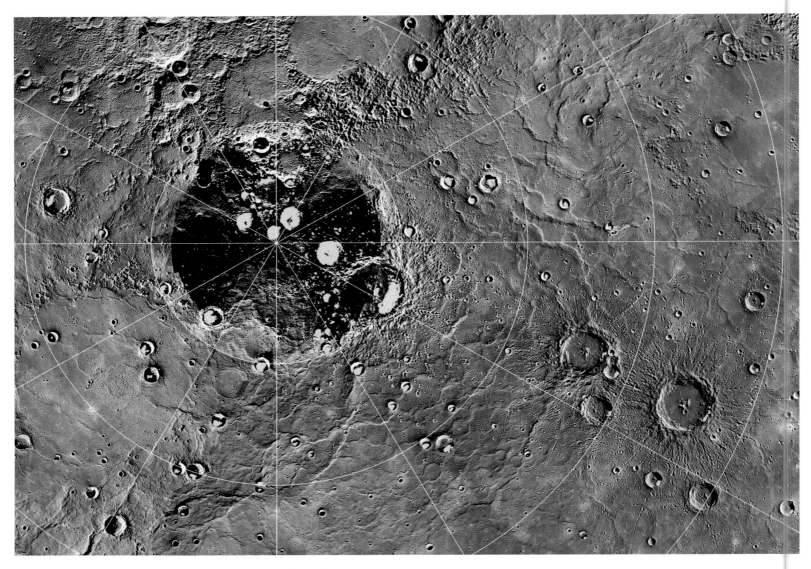

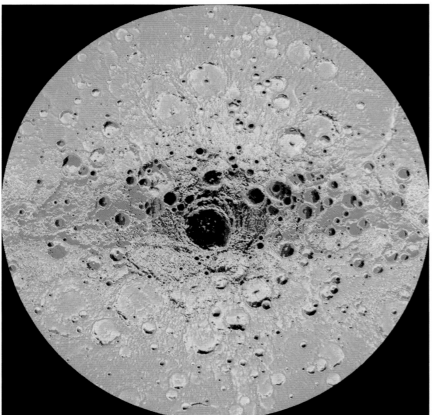

ABOVE The highest-resolution radar image of Mercury's north polar region was created by the Arecibo Observatory, overlaid here on a mosaic of MESSENGER orbital images. The yellow, radar-bright features are believed to contain water ice.

LEFT This illumination map of Mercury's south polar region was created from eighty-nine wide-angle camera images acquired by the Mercury Dual Imaging System (MDIS) over one complete Mercury solar day. The map is colored on the basis of the percentage of time that a given area is sunlit; areas appearing black are regions of permanent shadow, green indicates 25 percent illumination, and orange shows 45 percent.

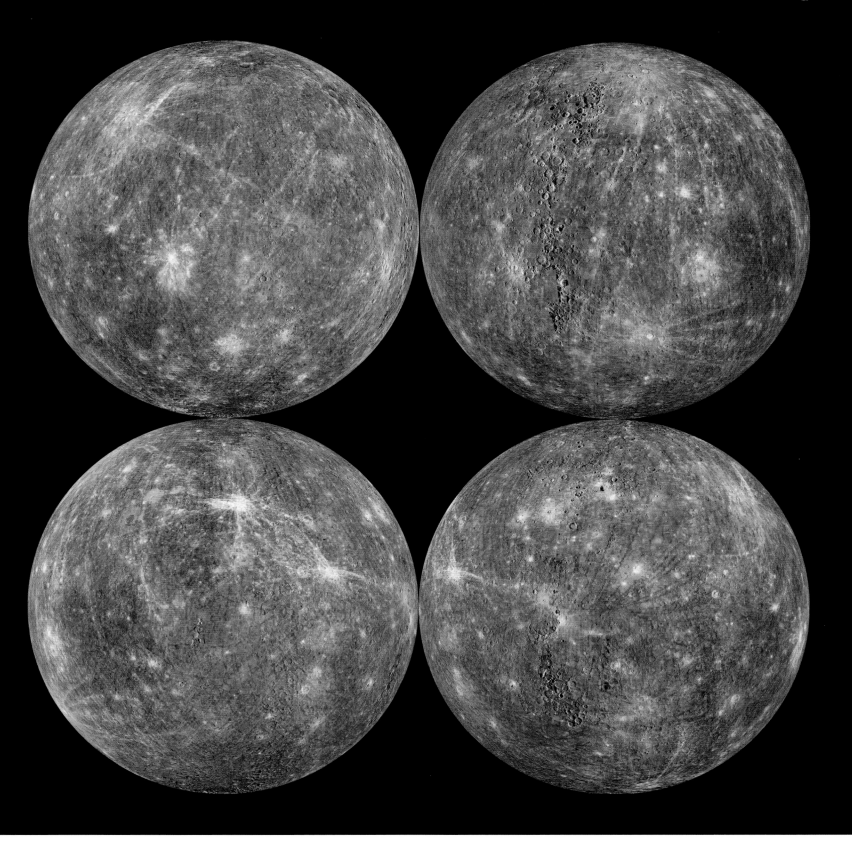

The Visual and Infrared Spectrometer (VIRS) onboard MESSENGER has been collecting surface measurements to learn more about the minerals and surface processes on Mercury. It has revealed both broad terrains and small, distinct features such as pyroclastic vents and fresh craters. The diversity of the surface can be seen here; colors represent composite wavelenghts measured by VIRS, with 575 nanometers (nm) as red, 415 nm/750 nm as green, and 310 nm/390 nm as blue.

Center latitude (*all globes*): 0°
Center longitude (*top left*): 270° E
Center longitude (*top right*): 0° E
Center longitude (*bottom left*): 90° E
Center longitude (*bottom right*): 180° E

OUR NEARBY WORLDS

THAT LUCKY OLD SUN

The Sun holds the solar system together with the force of its gravity and keeps Earth in its habitable zone, at least so far. Astronomers have sought to understand the Sun for centuries, using sophisticated ground-based observatories for all manner of research. Since the dawn of the Space Age, numerous spacecraft have also studied the Sun's mysteries and added to our understanding of the cosmos.

The famous 1949 song "That Lucky Old Sun, Just Rolls Around Heaven All Day," really says very little about the center of our solar system. The Sun's gravity holds this system in place, and its burning fuel provides heat, light, and energy, making life possible on Earth. Humans have been studying the Sun for centuries, and in the Space Age have deployed a range of missions to study everything from its atmosphere to its surface. While the Sun is not physically explorable with current technology, many solar observation probes have operated since 1958. Much of the data collected on the Sun has been about understanding cosmic rays, which periodically bombard Earth and disrupt communications and other electronics capabilities; coronal mass ejections (large expulsions of plasma and magnetic field from the Sun's corona); and what many space operations personnel refer to as "space weather"—solar phenomena that affect activities here on Earth and spacecraft in orbit. Sun-exploring spacecraft include: Parker Solar Probe, Solar Orbiter, Solar and Heliospheric Observatory (SOHO), Advanced Composition Explorer (ACE), Interface Region Imaging Spectrograph (IRIS), Wind, Hinode, Solar Dynamics Observatory (SDO), Deep Space Climate Observatory (DSCOVR), CubeSat for Solar Particles (CuSP), and Solar Terrestrial Relations Observatory (STEREO).

The Sun and its atmosphere consist of several zones, or layers, from the inner core to the outer corona. Solar activity leads to solar eruptions, which includes such phenomena as sunspots, flares, prominences, and coronal mass ejections that influence space weather, or near-Earth environmental conditions. Modern society depends heavily on a variety of technologies that are susceptible to space weather. The Sun's perturbations can cause geomagnetic storms, disrupting satellite communications and navigational equipment, and can even cause blackouts. The average coronal mass ejection (CME) colliding with Earth results in an additional 1,500 gigawatts of electricity being added to the atmosphere: this is equivalent to twice the power-generating capacity of the whole United States.

SUN FAST FACTS

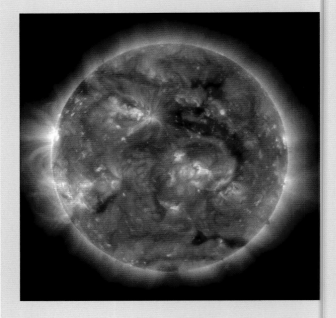

DIAMETER 864,600 miles (1,391,400 kilometers), about 109 times that of Earth
DENSITY 1.4 grams/cubic centimeter, slightly less than Earth's density of 5.515 grams/cubic centimeter
SURFACE GRAVITY 28.02 meters/second squared
ROTATION PERIOD (LENGTH OF DAY) 26.24 Earth days
REVOLUTION PERIOD (LENGTH OF YEAR) 230 million years to circle the Milky Way galaxy
MEAN SURFACE TEMPERATURE 10,000 degrees Fahrenheit (5,500 degrees Celsius)
NATURAL SATELLITES Eight planets
DISCOVERER No single person is credited with the discovery of the Sun; it has been observed from Earth for centuries

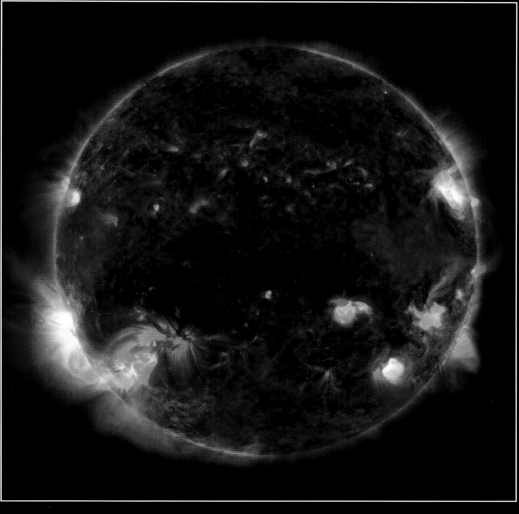

LEFT A composite image of the Sun, released on February 9, 2023, comprising high-energy x-ray data from NASA's Nuclear Spectroscopic Telescope Array (NuSTAR) shown in blue; lower energy x-ray data from the X-ray Telescope (XRT) on the Japanese Aerospace Exploration Agency's Hinode mission shown in green; and ultraviolet light detected by the Atmospheric Imaging Assembly (AIA) on NASA's Solar Dynamics Observatory (SDO) shown in red. Most interestingly, the imagery shows that the Sun's outer atmosphere, its corona, registers temperatures more than a million degrees—a hundred times hotter than temperatures further inside the Sun. Why? There is no clear explanation, and this question remains an important one for future investigation.

BELOW These images, all taken on October 27, 2017, show the Sun from its surface to its upper atmosphere. The first image shows the Sun in filtered white light; the other seven images were taken in different wavelengths of extreme ultraviolet light, each revealing different temperatures and features.

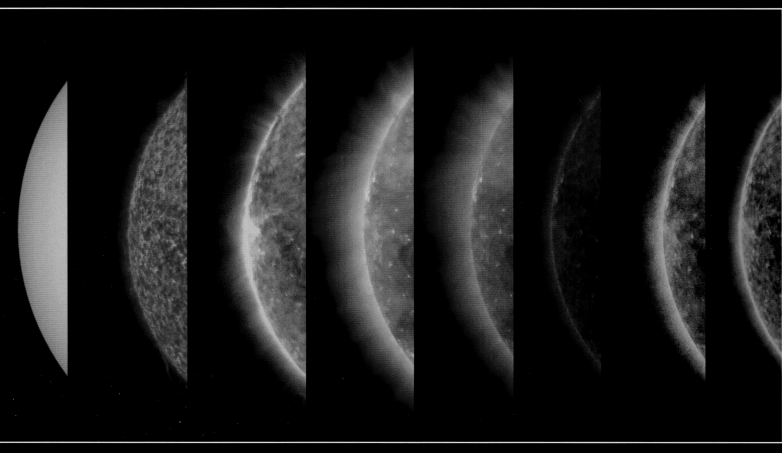

OUR NEARBY WORLDS

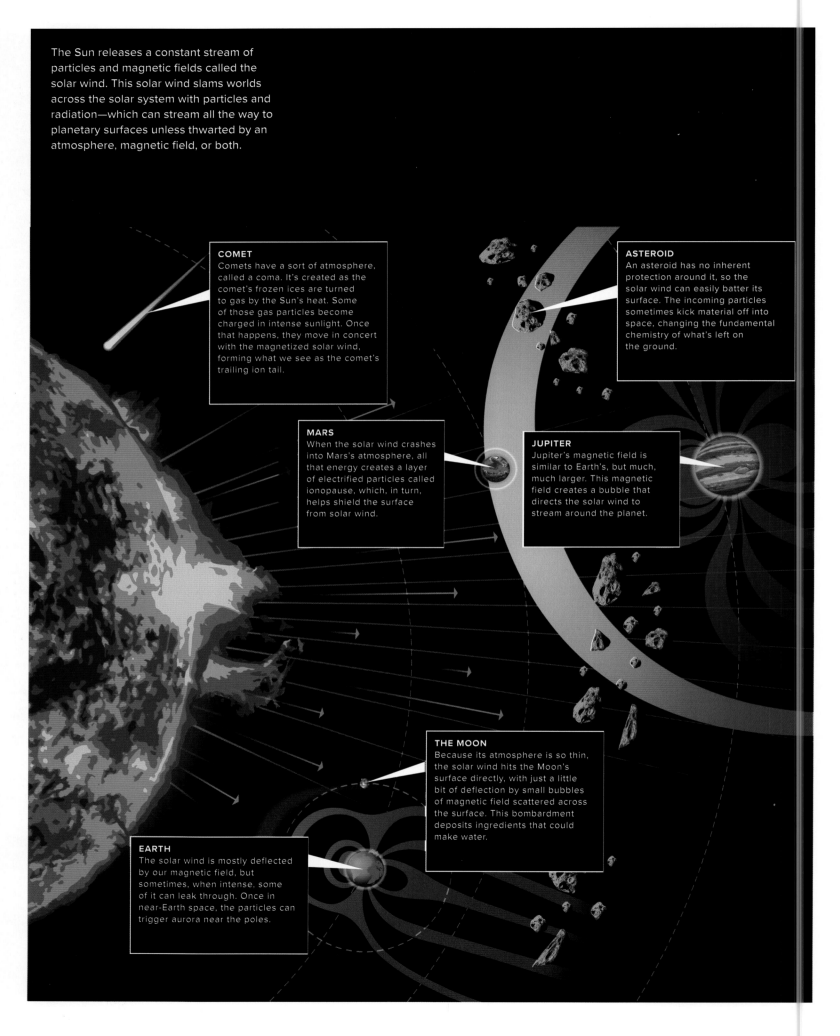

The Sun releases a constant stream of particles and magnetic fields called the solar wind. This solar wind slams worlds across the solar system with particles and radiation—which can stream all the way to planetary surfaces unless thwarted by an atmosphere, magnetic field, or both.

COMET
Comets have a sort of atmosphere, called a coma. It's created as the comet's frozen ices are turned to gas by the Sun's heat. Some of those gas particles become charged in intense sunlight. Once that happens, they move in concert with the magnetized solar wind, forming what we see as the comet's trailing ion tail.

ASTEROID
An asteroid has no inherent protection around it, so the solar wind can easily batter its surface. The incoming particles sometimes kick material off into space, changing the fundamental chemistry of what's left on the ground.

MARS
When the solar wind crashes into Mars's atmosphere, all that energy creates a layer of electrified particles called ionopause, which, in turn, helps shield the surface from solar wind.

JUPITER
Jupiter's magnetic field is similar to Earth's, but much, much larger. This magnetic field creates a bubble that directs the solar wind to stream around the planet.

THE MOON
Because its atmosphere is so thin, the solar wind hits the Moon's surface directly, with just a little bit of deflection by small bubbles of magnetic field scattered across the surface. This bombardment deposits ingredients that could make water.

EARTH
The solar wind is mostly deflected by our magnetic field, but sometimes, when intense, some of it can leak through. Once in near-Earth space, the particles can trigger aurora near the poles.

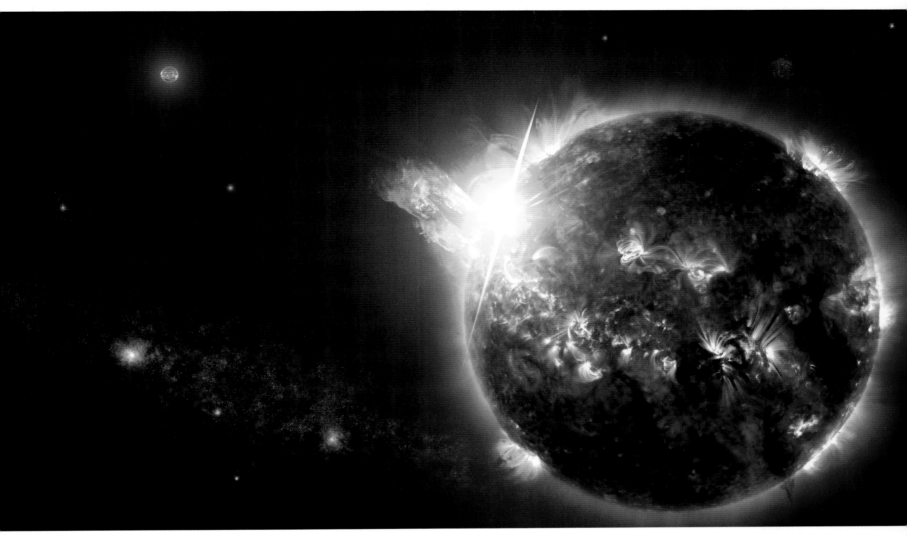

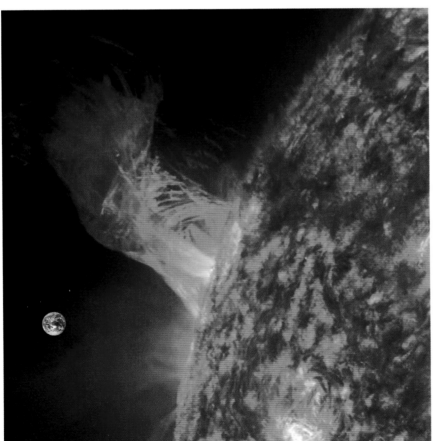

ABOVE On April 23, 2017, NASA's Swift satellite detected the strongest, hottest, and longest-lasting sequence of stellar flares ever seen from a nearby red dwarf star, recreated here in an artist's impression.

LEFT The length of this solar eruption extends about 160,000 miles (257,000 kilometers) out from the Sun. Earth, superimposed to give a sense of scale, is about 7,900 miles (12,700 kilometers) in diameter. This relatively minor solar eruption is about twenty times the diameter of our planet.

OVERLEAF Many specialized Sun-observing spacecraft have been launched by various agencies, with the aim of studying the Sun's surface and solar phenomena. Their orbits are mapped here. NASA's range of Pioneer missions throughout the 1960s are not included, as there is limited information available on their orbits.

OUR NEARBY WORLDS

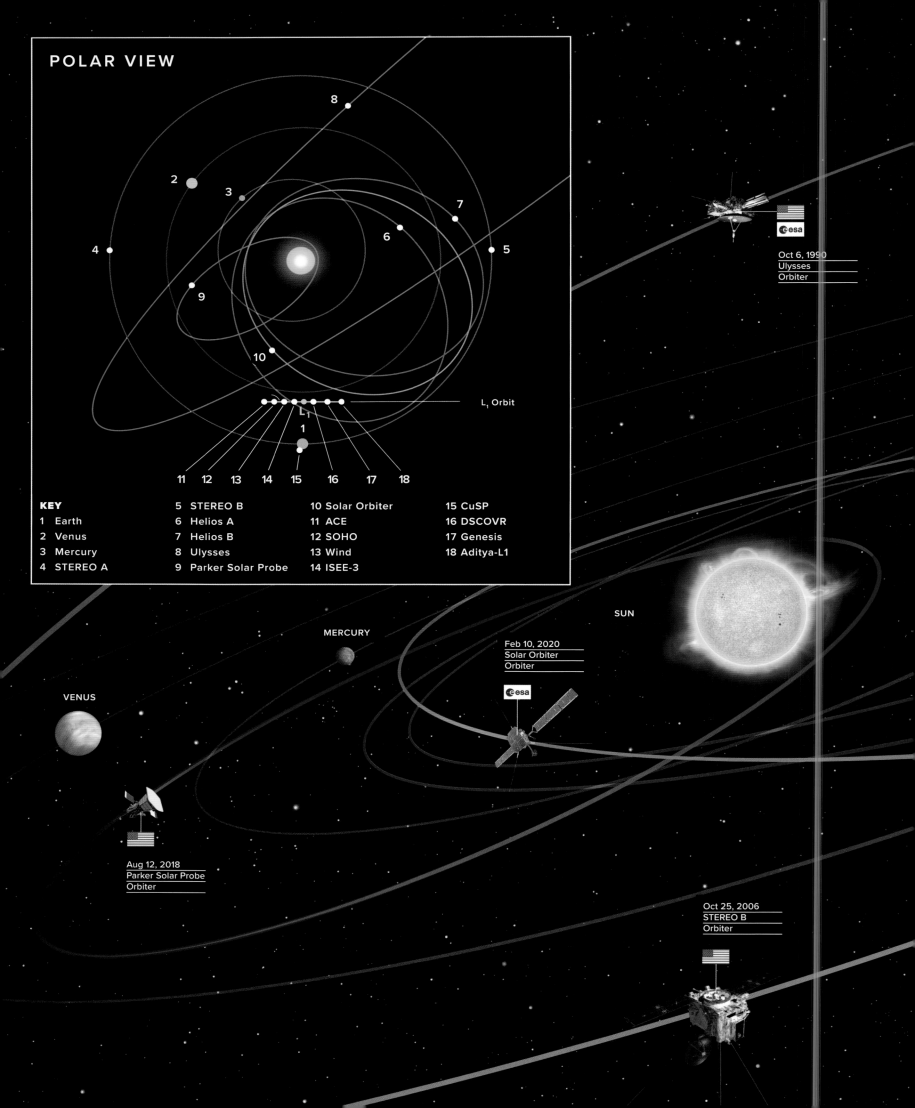

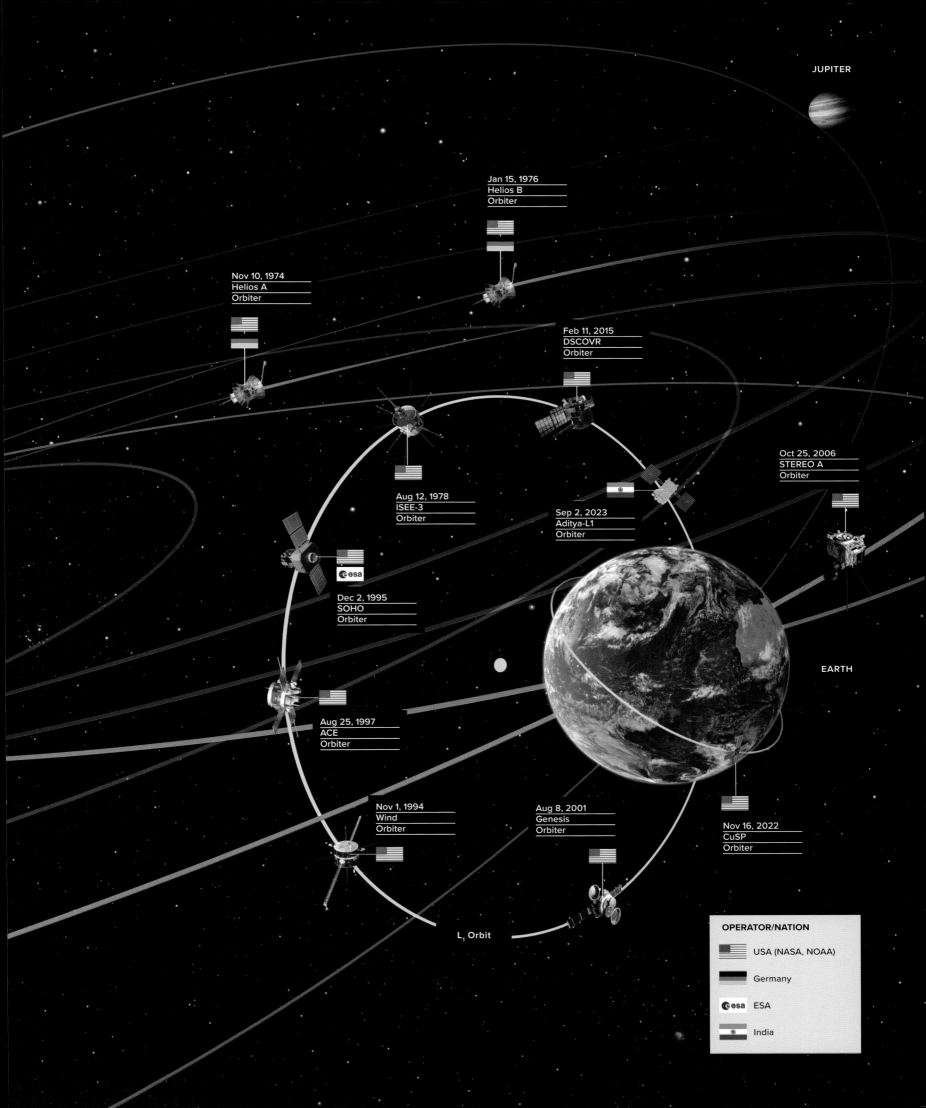

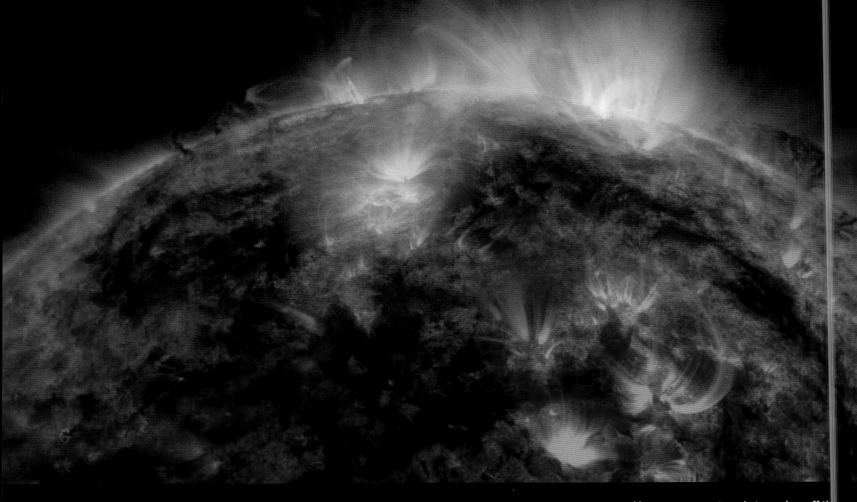

ABOVE X-rays were captured streaming off the Sun in the first image taken by NASA's Nuclear Spectroscopic Telescope Array (NuSTAR). The NuSTAR data, seen in green and blue, reveals solar high-energy emission (green shows energies between 2 and 3 kiloelectron volts, and blue shows energies between 3 and 5 kiloelectron volts), and is overlaid on a picture taken by NASA's Solar Dynamics Observatory.

LEFT Magnetic loops, or flux ropes, on the Sun's surface posess spiraling magnetic field lines. A vast amount of electric current runs through the core of each "rope," and they are believed to drive powerful coronal mass ejections. This image, captured by NASA's Solar Dynamics Observatory on July 18, 2012, has been processed to highlight the edges of each loop to make the structure clearer.

NASA's Solar Dynamics Observatory captured a significant solar flare, which peaked on September 10, 2014. This flare is classified as an X1.6 class flare. "X" denotes the most intense flares, while the number provides more information about its strength—an X2 is twice as intense as an X1, an X3 is three times as intense, and so on.

OUR NEARBY WORLDS

5 WHAT MIGHT THE FUTURE HOLD?

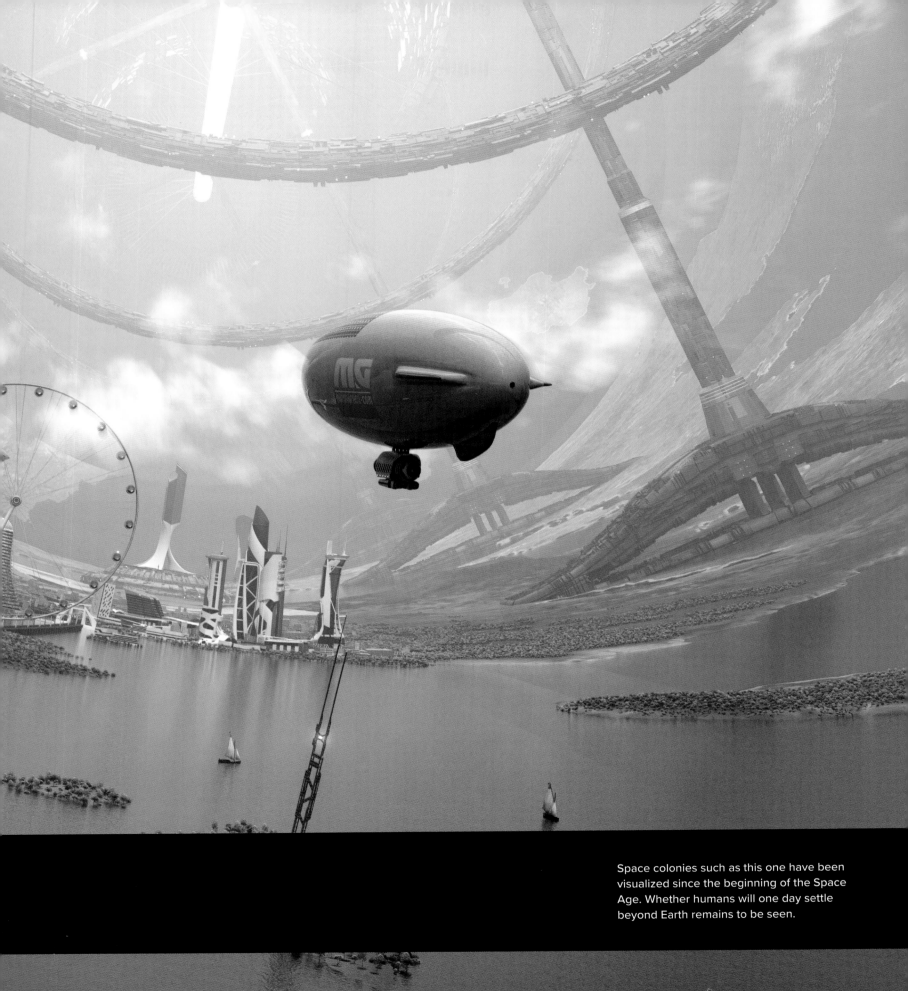

Space colonies such as this one have been visualized since the beginning of the Space Age. Whether humans will one day settle beyond Earth remains to be seen.

There is no question that space exploration provides a window on the universe from which fantastic new discoveries have been made, and this will no doubt continue into the future. Human experiences in space during the remainder of the twenty-first century will go far beyond the achievements of the twentieth century—the possibilities for space exploration are immeasurable.

Extending our presence throughout the solar system seems a very real possibility. No doubt humans will return to the Moon in the first half of this century—it is such a compelling target. The nations of the world, as well as several independent companies, see the potential for widespread commercial activities there. Accordingly, we are at an inflection point where renewed use of the Moon in the coming decades will likely spark lunar transit and orbiting vehicles, research stations, and commercial activities on the Moon, and perhaps the beginning of more permanent settlements.

We have come to this point as a culmination of three major phases of the Space Age, with a new phase of lunar operations just commencing:

1950s–80s: THE HEROIC ERA OF THE SPACE RACE

During this period, two rival nations, the United States and the Soviet Union, dominated the space agenda and used it as a theater in a global Cold War. In this era, humans learned to fly in space, but it was still very much a frontier.

1980s–2000s: EARTH ORBIT IS INCORPORATED INTO THE NORMAL REALM OF HUMAN ACTIVITIES

During this time, lengthy and diverse human flights in Earth's orbit advanced scientific understanding and practical application of the space environment for everyday use, turning orbital space into a place that was no longer a frontier. Communications, navigation, and other orbital capabilities reoriented the way in which humans lived their lives on Earth.

2000s–PRESENT: THE RISE OF COMMERCIAL/ENTREPRENEURIAL SPACE ACTORS

US President Bill Clinton's 1996 Presidential Space Directive "To stimulate private sector investment, ownership, and operation of space assets" succeeded. In the first decades of the twenty-first century, NASA—the world leader in space activities—has turned over much of its orbital activities to outside commercial firms, enabling it to focus attention on cis-lunar (from Latin, meaning "on this side of the Moon") and even trans-lunar (also from Latin, meaning "beyond the Moon") space exploration.

This activity has set the stage for broad activities, first at the Moon and then Mars, as well as the potential for space colonies and exploration of other intriguing places in the solar system.

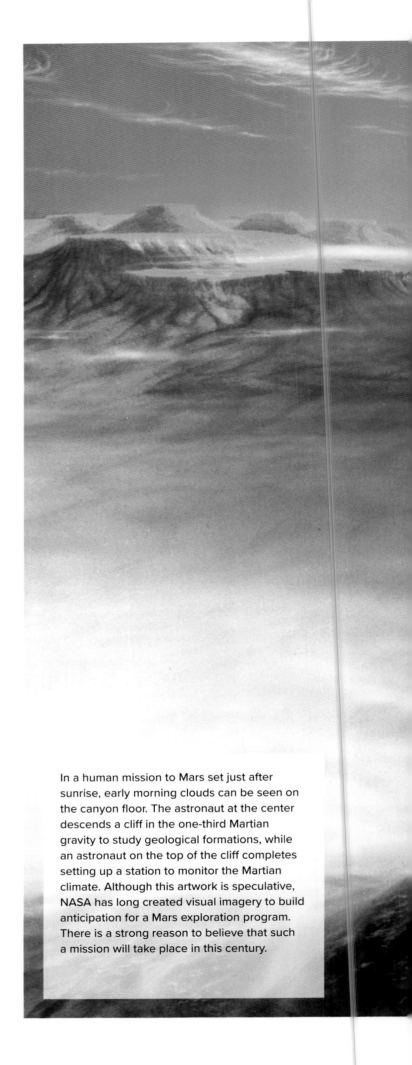

In a human mission to Mars set just after sunrise, early morning clouds can be seen on the canyon floor. The astronaut at the center descends a cliff in the one-third Martian gravity to study geological formations, while an astronaut on the top of the cliff completes setting up a station to monitor the Martian climate. Although this artwork is speculative, NASA has long created visual imagery to build anticipation for a Mars exploration program. There is a strong reason to believe that such a mission will take place in this century.

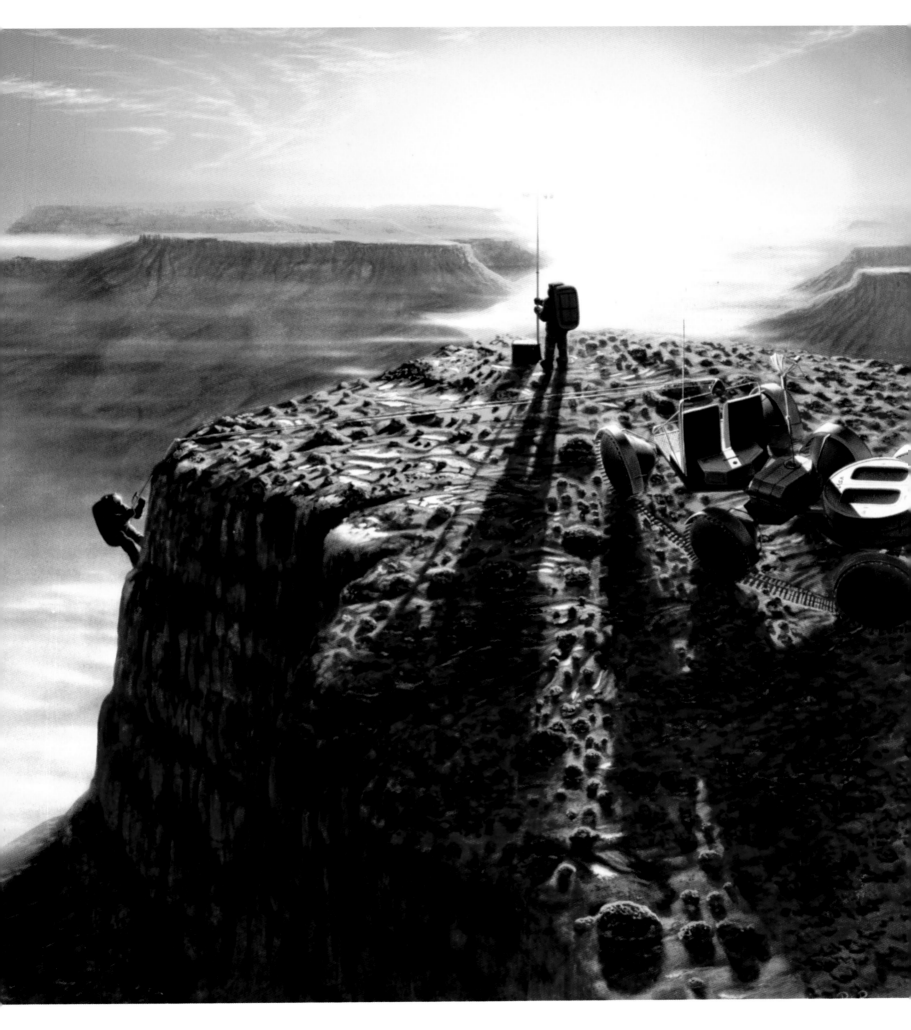

WHAT MIGHT THE FUTURE HOLD?

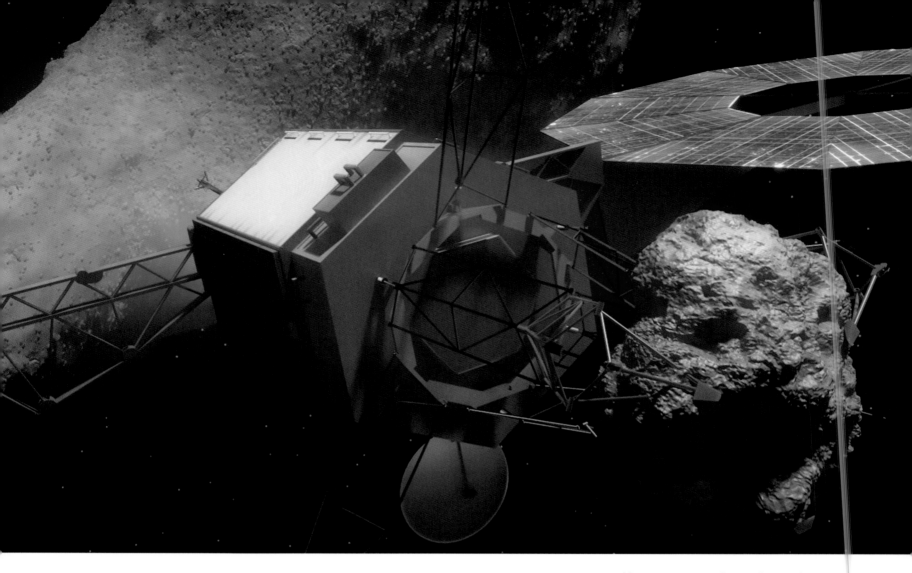

"Extending our presence throughout the solar system seems a very real possibility. No doubt humans will return to the Moon in the first half of this century—it is such a compelling target."

ABOVE Many space agencies, and more than a few commercial firms, envision a bounteous future in space based on resource extraction from asteroids and other bodies of the solar system. Technology like this Asteroid Redirect Mission (ARM) with robotic capture and positioning for potential mining purposes would be critical.

TOP RIGHT NASA's Artemis III mission intends to land humans on the surface of the Moon for the first time since the Apollo program ended more than fifty years ago. Here, an ascent vehicle separates from a descent vehicle and departs the lunar surface.

RIGHT Axiom Space have been selected to design and build NASA's new lunar EVA (Extravehicular Activity) suits for the Artemis III mission.

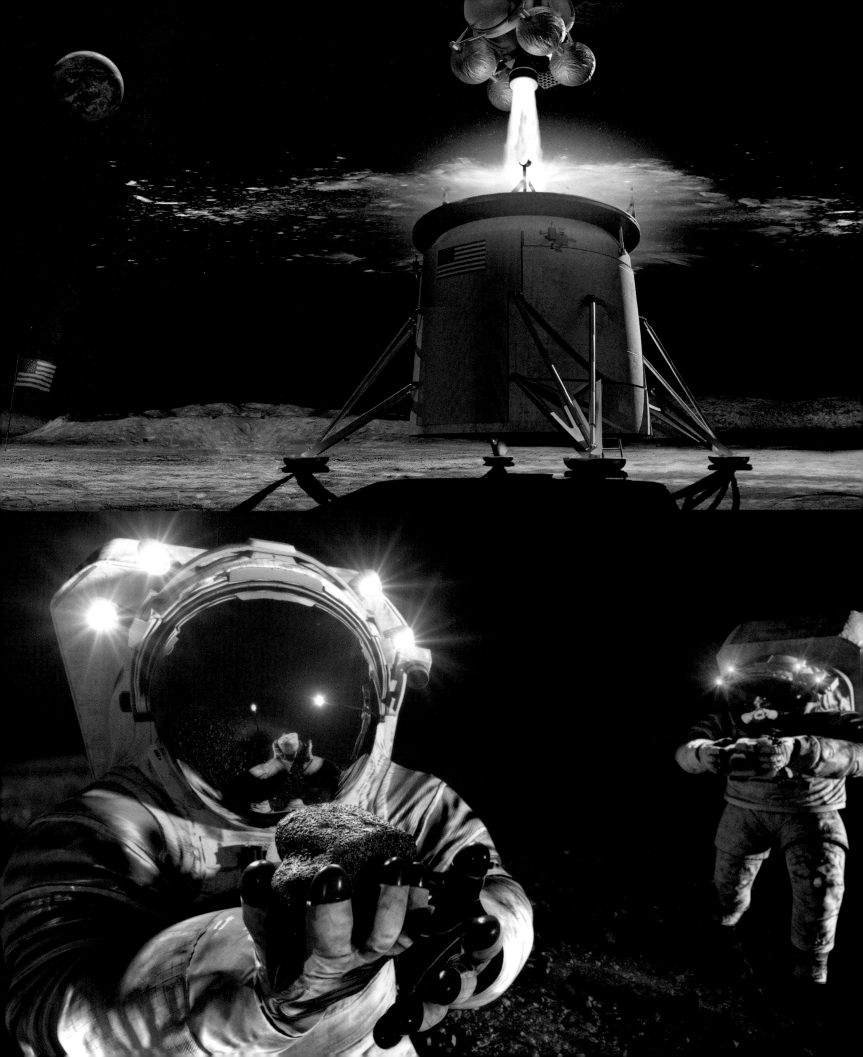

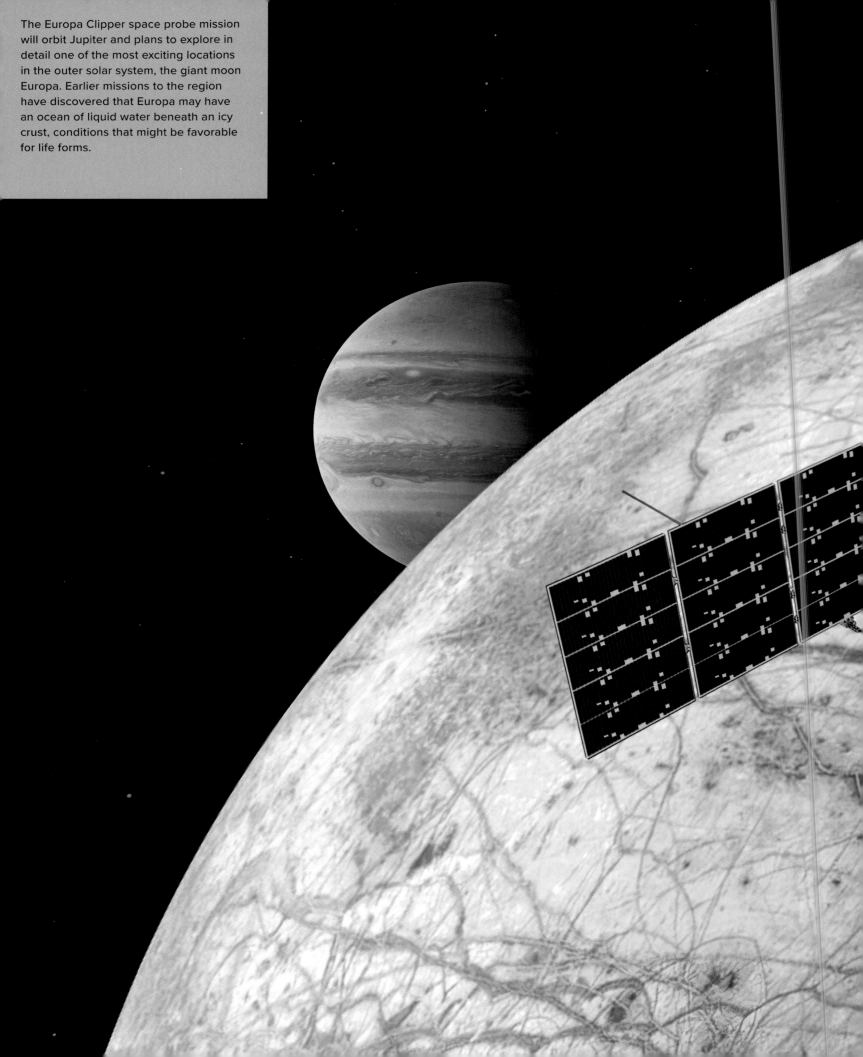

The Europa Clipper space probe mission will orbit Jupiter and plans to explore in detail one of the most exciting locations in the outer solar system, the giant moon Europa. Earlier missions to the region have discovered that Europa may have an ocean of liquid water beneath an icy crust, conditions that might be favorable for life forms.

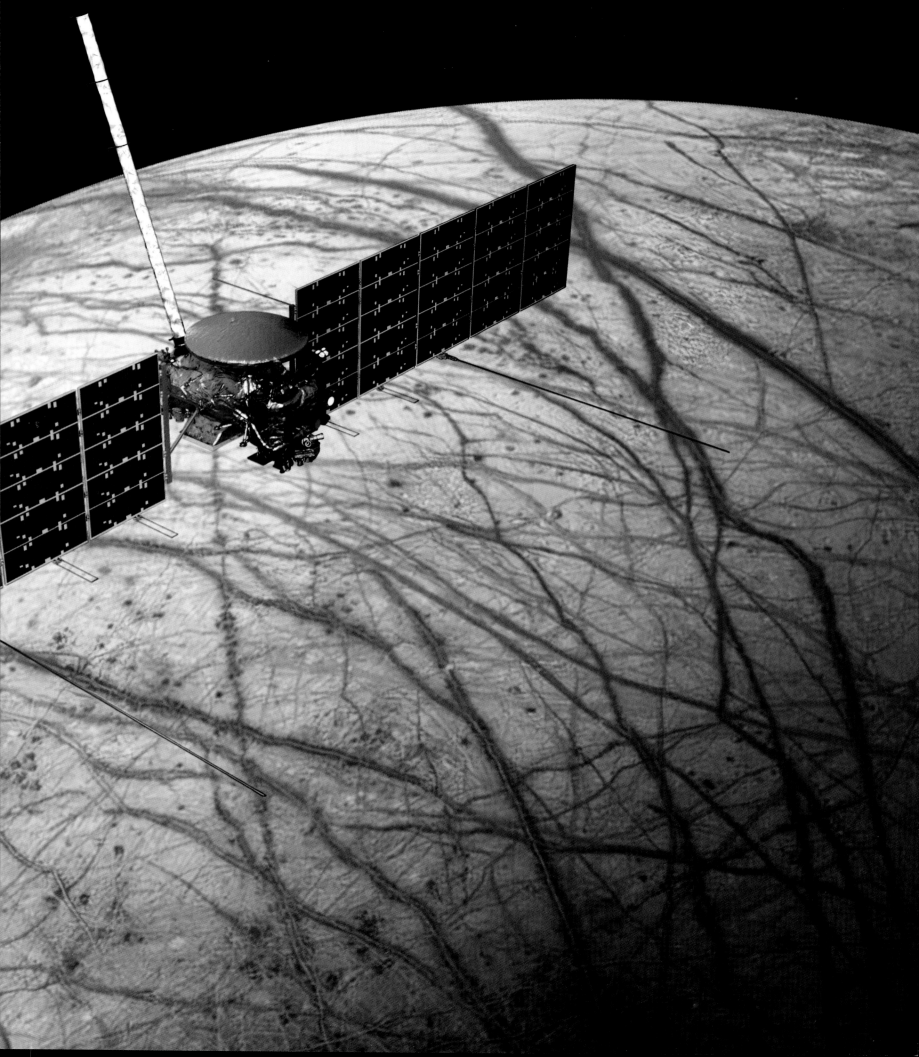

SUSTAINED LUNAR OPERATIONS

The Moon has long been a target for human exploration. In the first decades of this century, the desire to return there and carry out sustained operations has been irresistible for astronomers.

The desire to return to the Moon has been present ever since the Apollo programs of the 1960s and 1970s ended, but it was not until the 1990s that scientists determined there were very real possibilities for resource extraction—particularly of water-ice deep in polar craters—and a renewal of interest emerged. This interest helped spark the creation of the Google Lunar XPRIZE (offering $20 million for first place), which attempted to encourage a low-cost lunar landing mission by 2015. Twenty-seven teams entered the competition to build a lunar lander. Many of the teams felt a rover would be useful for, among other purposes, resource extraction on the Moon, and so built that into their efforts. While none of the teams were successful in claiming the prize, the competition stimulated considerable innovation in lunar technologies.

We have reached a convergence point where a range of national space programs and commercial firms have come to a consensus that lunar operations are both feasible and desirable. NASA is working to return astronauts to the Moon as part of the Artemis program—an uncrewed test flight, Artemis I, launched to the Moon on November 16, 2022, making two flybys before returning to Earth on December 11. Artemis II, the first crewed flight in the program, is slated for launch in September 2025 on a circumlunar flight, with Artemis III intended to launch in 2026 for a human return to the lunar surface.

But that is far from all that is taking place. China has engaged in robotic exploration of the Moon's rear side, and has announced an intention to land humans on the Moon in the 2030s. Other robotic missions are underway—although a Russian lander, Luna-25, unfortunately crashed in August 2023, there are future Russian missions in the works. India, moreover, has been sending robotic probes to the Moon and landed Chandrayaan-3, the third of its lunar exploration missions, in August 2023. Meantime, there are a range of commercial efforts to reach the Moon and to mine water-ice at the poles.

ABOVE The Moon rises above NASA's Space Launch System (SLS) rocket on November 14, 2022. Preparations were underway for the launch of the Artemis I mission, an uncrewed flight to test system components on a circumlunar mission. The Orion spacecraft is pictured at Launch Pad 39B.

TOP RIGHT Astronauts working on the surface of the Moon during a proposed Artemis mission

RIGHT An astronaut kneels to pick up regolith (lunar soil).

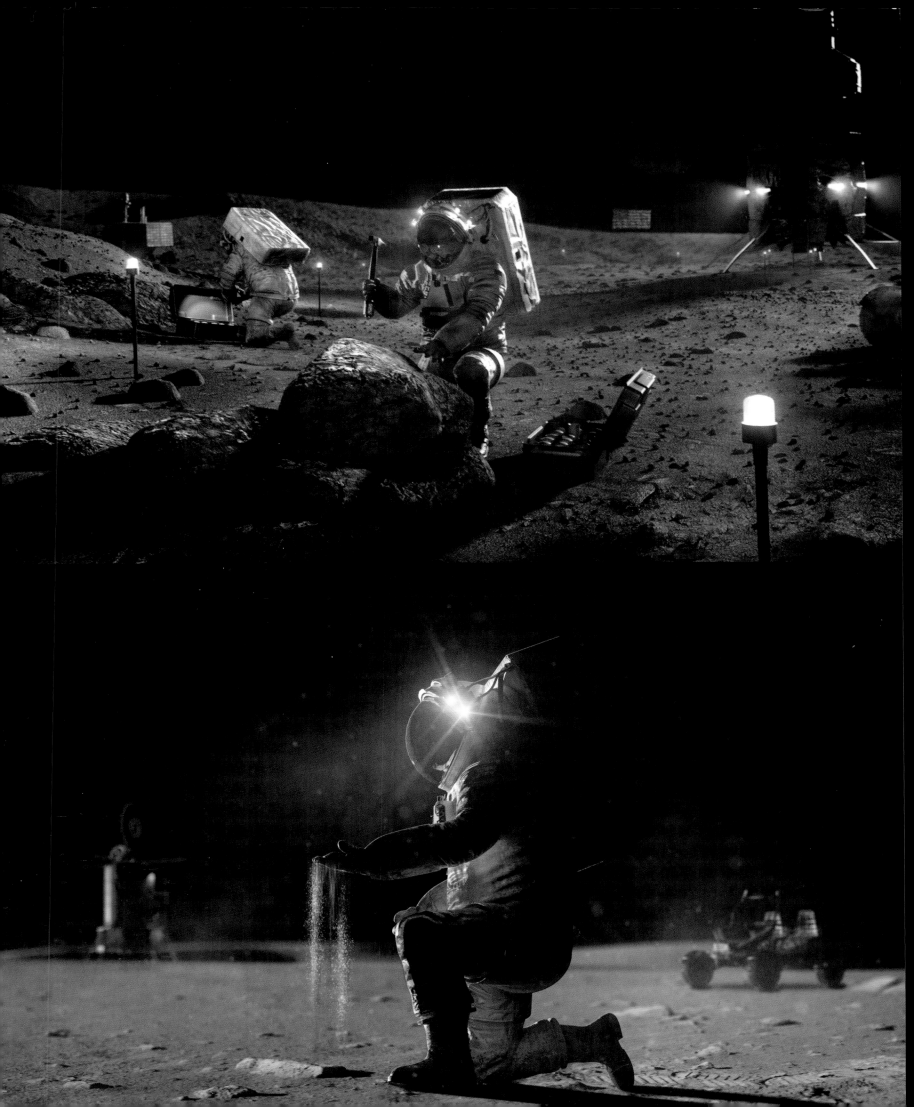

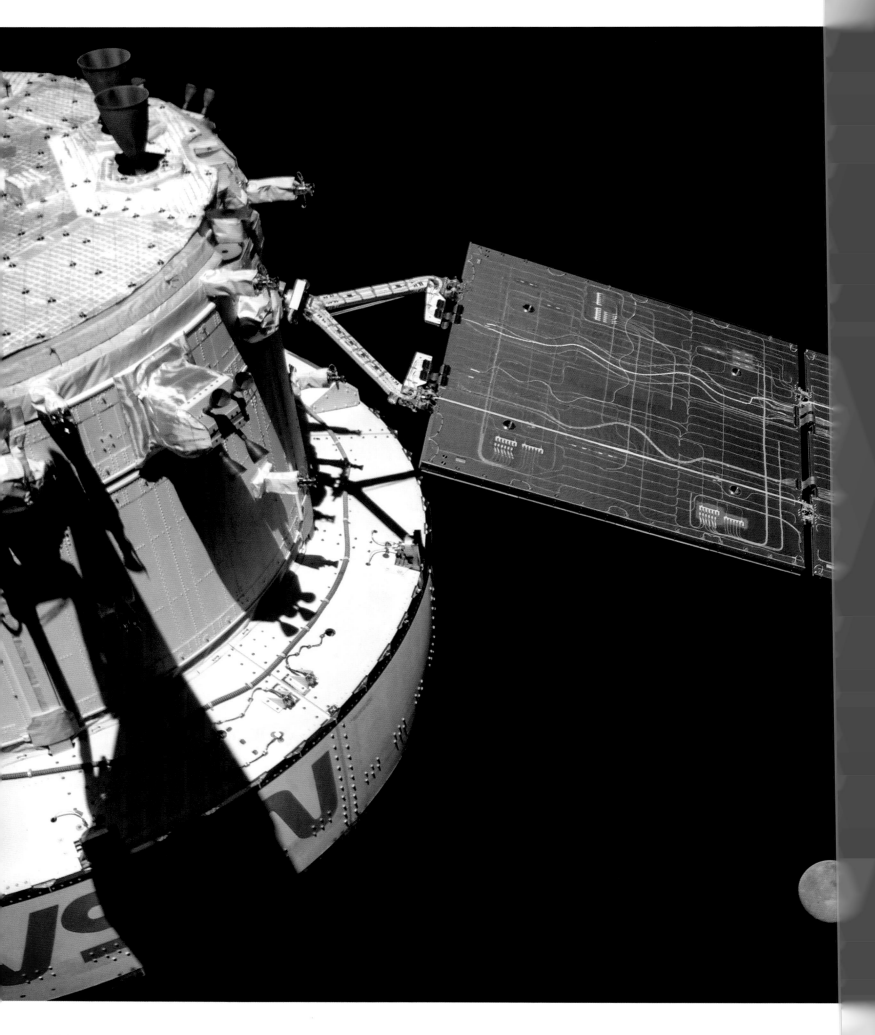

LEFT On flight day sixteen of the Artemis I mission, a camera mounted on one of Orion's solar arrays snapped this image of our Moon as the spacecraft prepared to exit distant retrograde orbit.

ABOVE In July 2019, Vice President Mike Pence visited NASA's Kennedy Space Center in Florida to announce the completion of the Orion crew capsule, which he signed.

RIGHT Phantom torsos wearing radiation detection vests were placed inside the Artemis I Orion crew module. On return to Earth, the torsos underwent post-flight payload inspections to determine the radiation risk for future manned missions.

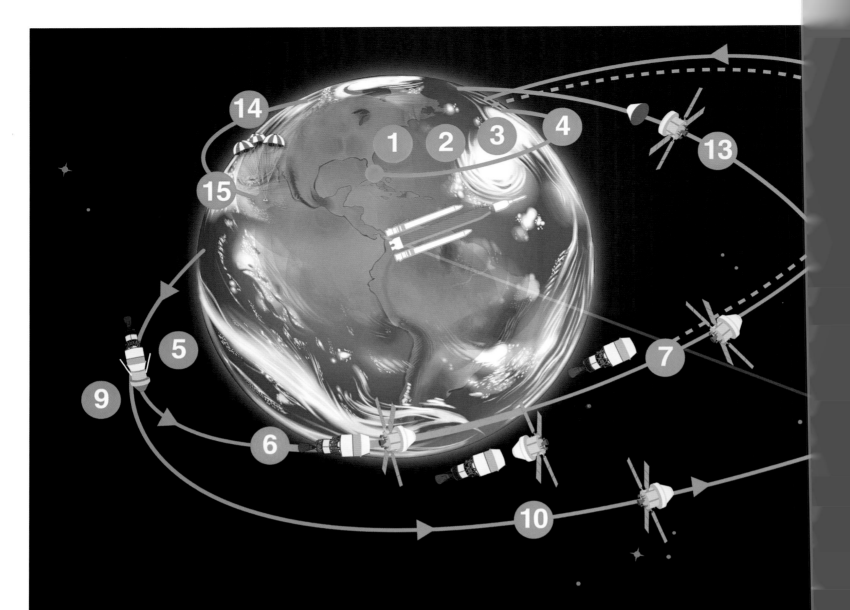

1. **LAUNCH**
 Astronauts lift off from pad 39B at Kennedy Space Center.

2. **JETTISON SOLID ROCKET BOOSTERS, FAIRINGS, AND LAUNCH ABORT SYSTEM**

3. **CORE STAGE MAIN ENGINE CUT OFF WITH SEPARATION**

4. **PERIGEE RAISE MANEUVER**

5. **APOGEE RAISE BURN TO HIGH EARTH ORBIT**
 Begin 23.5 hour checkout of spacecraft.

6. **ORION SEPARATION FROM INTERIM CRYOGENIC PROPULSION STAGE (ICPS) FOLLOWED BY PROX OPS DEMO**
 Plus manual handling qualities assessment for up to two hours.

7. **ORION UPPER STAGE SEPARATION (USS) BURN**
 Begin high Earth orbit checkout. Life support, exercise, and habitation equipment evaluations.

8. **PERIGEE RAISE BURN**

9. **TRANS-LUNAR INJECTION (TLI) BY ORION'S MAIN ENGINE**
 Lunar free return trajectory initiated with European service module.

10. **OUTBOUND TRANSIT TO MOON**
 Outbound Trajectory Correction (OTC) burns as necessary for Lunar free return trajectory; travel time approximately four days.

11. **LUNAR FLYBY**
 6,479 miles/10,427 kilometers (mean) Lunar farside altitude.

12. **TRANS-EARTH RETURN**
 Return Trajectory Correction (RTC) burns as necessary to aim for Earth's atmosphere; travel time approximately four days.

SMITHSONIAN ATLAS OF SPACE

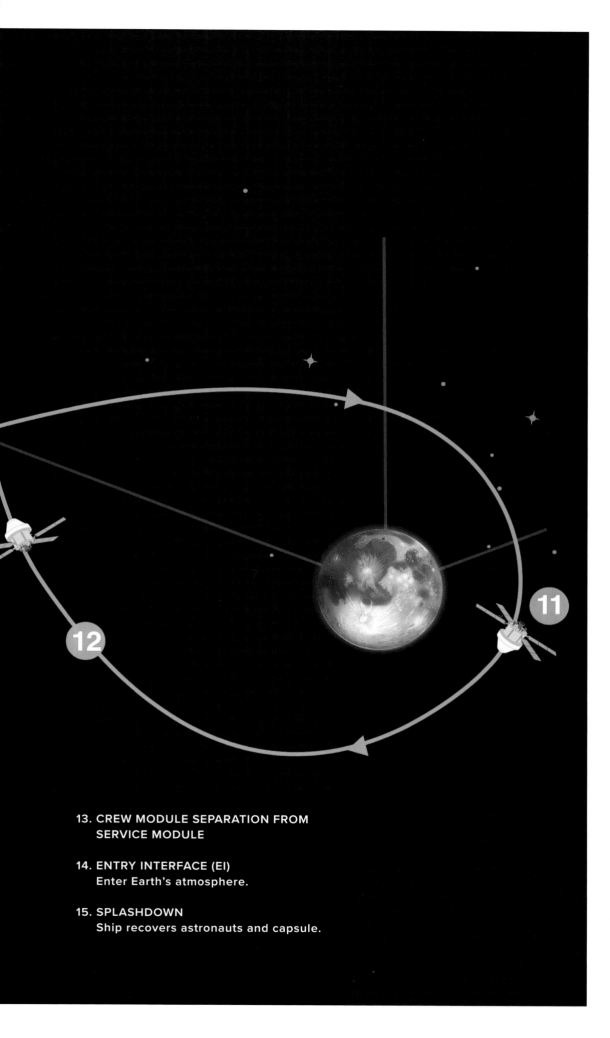

Artemis II, NASA's first flight with crew aboard, is scheduled for 2025. This trajectory map includes the launcher, SLS, and the Orion space capsule with a crew of four. It is intended as a circumlunar flight not unlike the Apollo 8 mission around the Moon in December 1968, and could pave the way for long-term operations at the Moon. Each point of the mission is denoted in the numbered diagram.

13. **CREW MODULE SEPARATION FROM SERVICE MODULE**

14. **ENTRY INTERFACE (EI)**
 Enter Earth's atmosphere.

15. **SPLASHDOWN**
 Ship recovers astronauts and capsule.

WHAT MIGHT THE FUTURE HOLD?

LEFT Artemis II crew members stand in front of their Orion crew module in the Neil Armstrong Operations and Checkout Building at NASA's Kennedy Space Center. From left are: Jeremy Hansen, mission specialist; Victor Glover, pilot; Reid Wiseman, commander; and Christina Hammock Koch, mission specialist.

RIGHT Many promotional posters have been produced for the Artemis II mission. This example features mission specialist Christina Hammock Koch. The Artemis II mission will be her second flight to space.

LEFT The Crew Module Test Article, a full-scale mockup of the Orion spacecraft, in the waters of the Pacific Ocean during NASA's Underway Recovery Test 10, designed to practice recovery procedures for crewed Artemis missions.

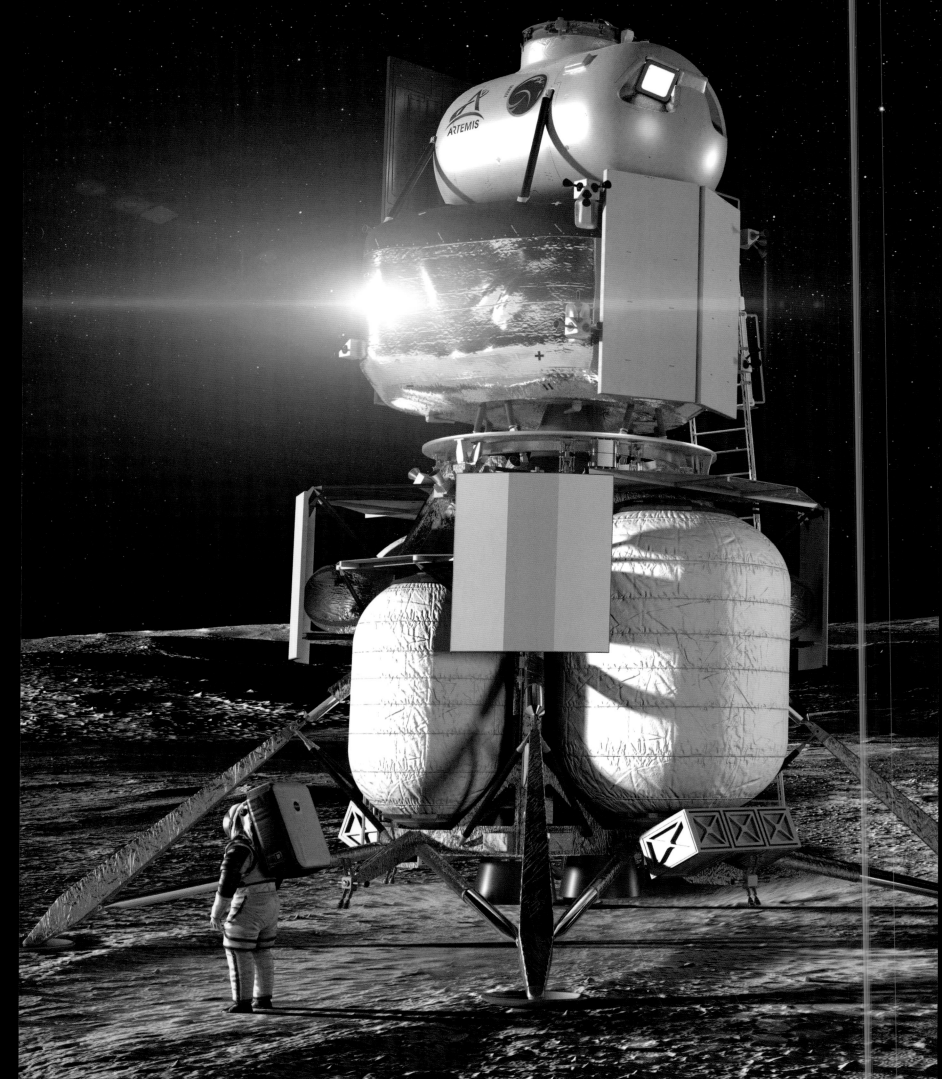

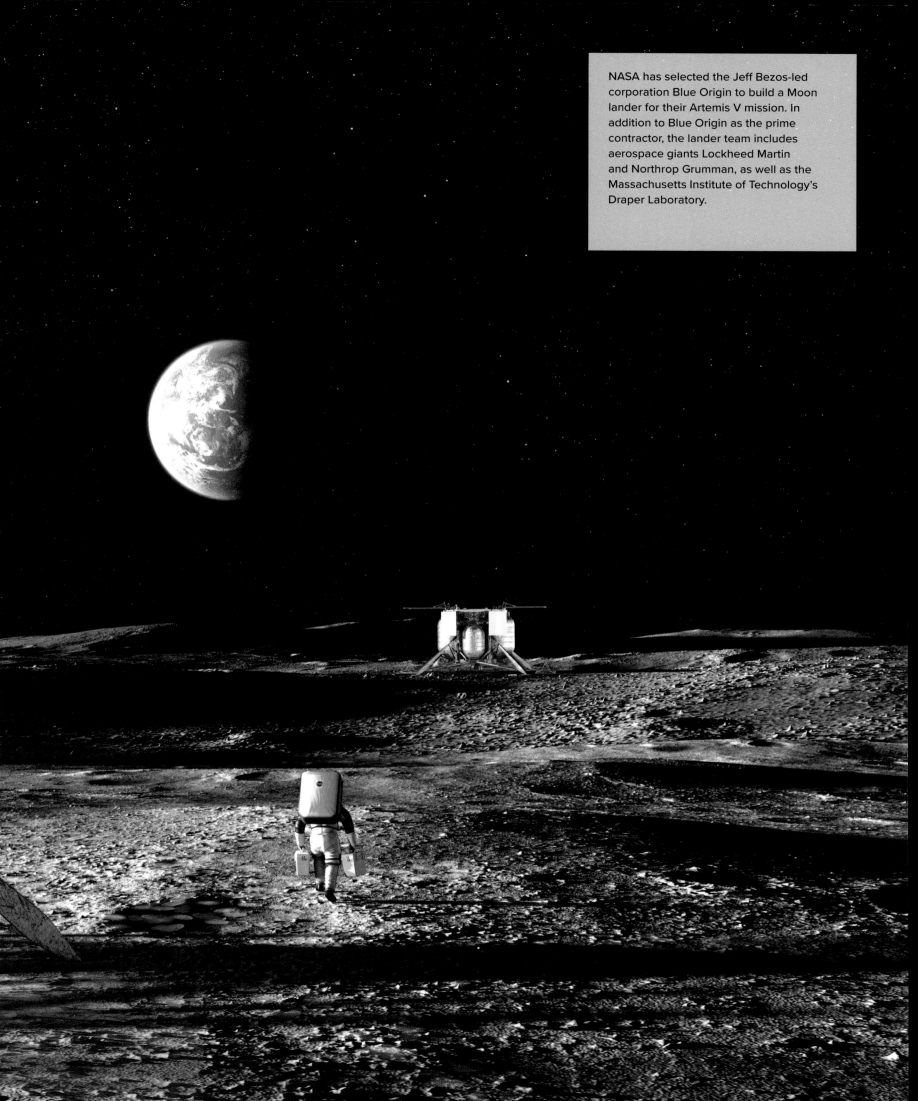

NASA has selected the Jeff Bezos-led corporation Blue Origin to build a Moon lander for their Artemis V mission. In addition to Blue Origin as the prime contractor, the lander team includes aerospace giants Lockheed Martin and Northrop Grumman, as well as the Massachusetts Institute of Technology's Draper Laboratory.

WHY RETURN TO THE MOON?

This is a critical question, especially since humans have already "been there, done that" on the Moon. Why not press on to Mars? The advantages of lunar development are considerable and practical, and the world's spacefaring entities recognize this truth as never before.

It can be argued that a return to the Moon is essential, for seven compelling reasons:

- It is only three days' travel time from Earth, making for relative safety in deep-space operations.
- It offers an ideal test bed for technologies and systems required for more extensive space exploration, and the stimulation of high-technology capabilities in all entities involved in the effort.
- It provides an excellent base for astronomy, geology, and other sciences, enabling the creation of critical building blocks in the knowledge necessary to understand the universe.
- It fosters international agreement on the use of the Moon for all humankind, extending the knowledge gained with the International Space Station (ISS) in peaceful international cooperation in space.
- It furthers the development of low-cost energy and other technologies that will be used not only on the Moon but also on Earth.
- It invites us to imagine a boundless future in which humankind is not limited to the surface of Earth, but could instead populate the solar system and beyond.
- It contains a wealth of mineral and other resources which may be extracted and used both for Earth activities and to support exploration beyond the Moon.

A LUNAR BASE

Once accessibility to the Moon becomes routine, building a human outpost there is possible, made all the more so because of the materials available. Using ice from the lunar poles, humans would be able to extract water, oxygen, and hydrogen. These are critical components for a permanent human presence, and they already reside on the Moon in abundance.

Any lunar base could look a lot like Antarctic research stations, at least in the short term. A base could start as a facility staffed by scientists, engineers, and technicians performing activities benefiting all. In so doing, it could enable continued peaceful and evolutionary international cooperation.

Space exploration is a complicated process. The hardest part of creating a lunar base is negotiating international agreements that extend what is already underway with the ISS. This requires successfully developing win/win political agreements between the spacefaring entities of the world. To date, those cooperative space endeavors have been both richly rewarding and overwhelmingly useful, from all manner of scientific, technical, social, and political perspectives.

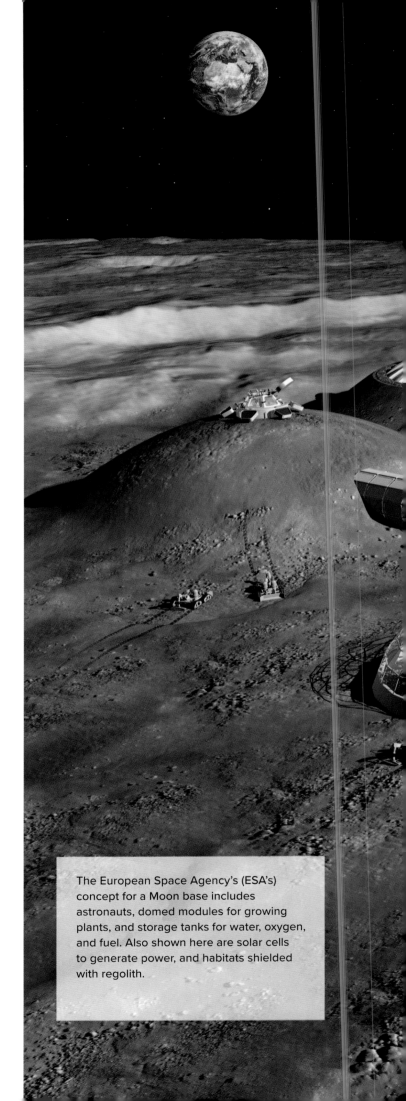

The European Space Agency's (ESA's) concept for a Moon base includes astronauts, domed modules for growing plants, and storage tanks for water, oxygen, and fuel. Also shown here are solar cells to generate power, and habitats shielded with regolith.

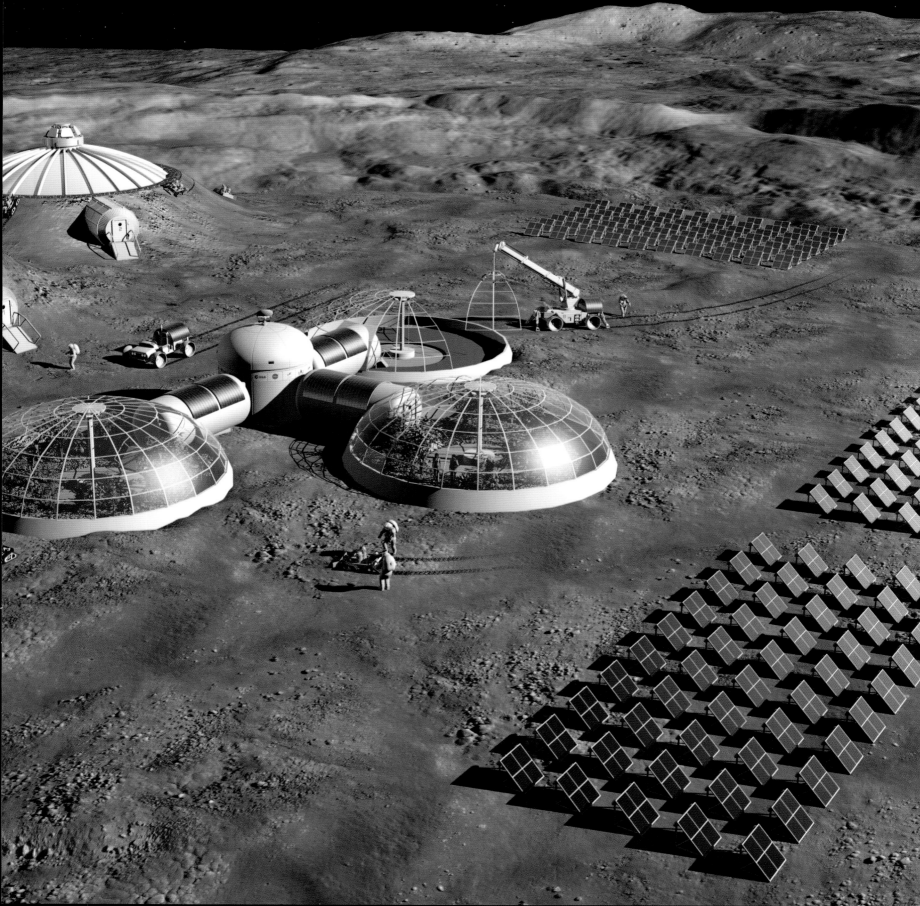

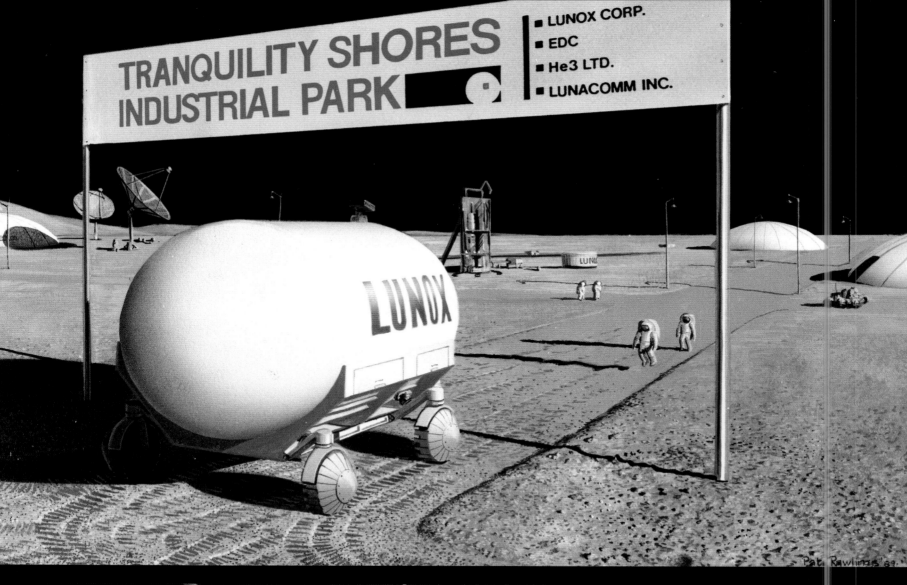

ABOVE With the establishment of a lunar base, commerce may develop on the Moon. As it does so tracts of the lunar surface may be dedicated to various industries such as lunar oxygen production, communications, and Helium-3 production.

LEFT One of the most creative and esoteric visions of a lunar future includes the possibility of the Lunar Olympic Games. Imagine the possibilities of pole vaulting, high jumps, and other competition in the Moon's one-sixth gravity.

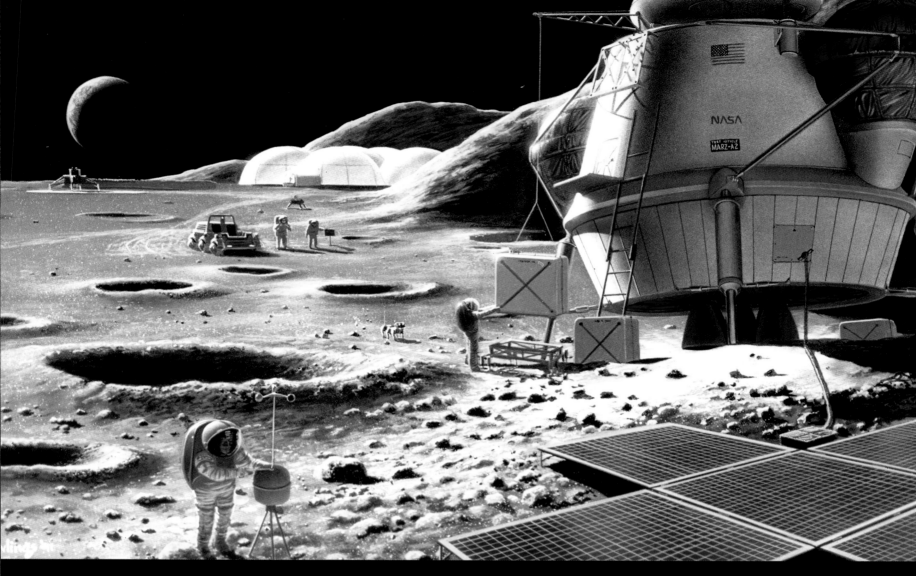

A 1995 concept for a Moon landing shows technologies strikingly different from what has emerged in NASA's Artemis program. Artemis, for example, envisions a space station in lunar orbit, which would serve as a location for deep space vehicles from Earth to dock before smaller landers were sent to the Moon's surface. Additionally, most of the habitats on the Moon would be built under the regolith, to shield humans from cosmic rays, rather than on the surface as depicted here.

"Once accessibility to the Moon becomes routine, building a human outpost there is possible, made all the more so because of the materials available. Using ice from the lunar poles, humans would be able to extract water, oxygen, and hydrogen."

WHAT MIGHT THE FUTURE HOLD?

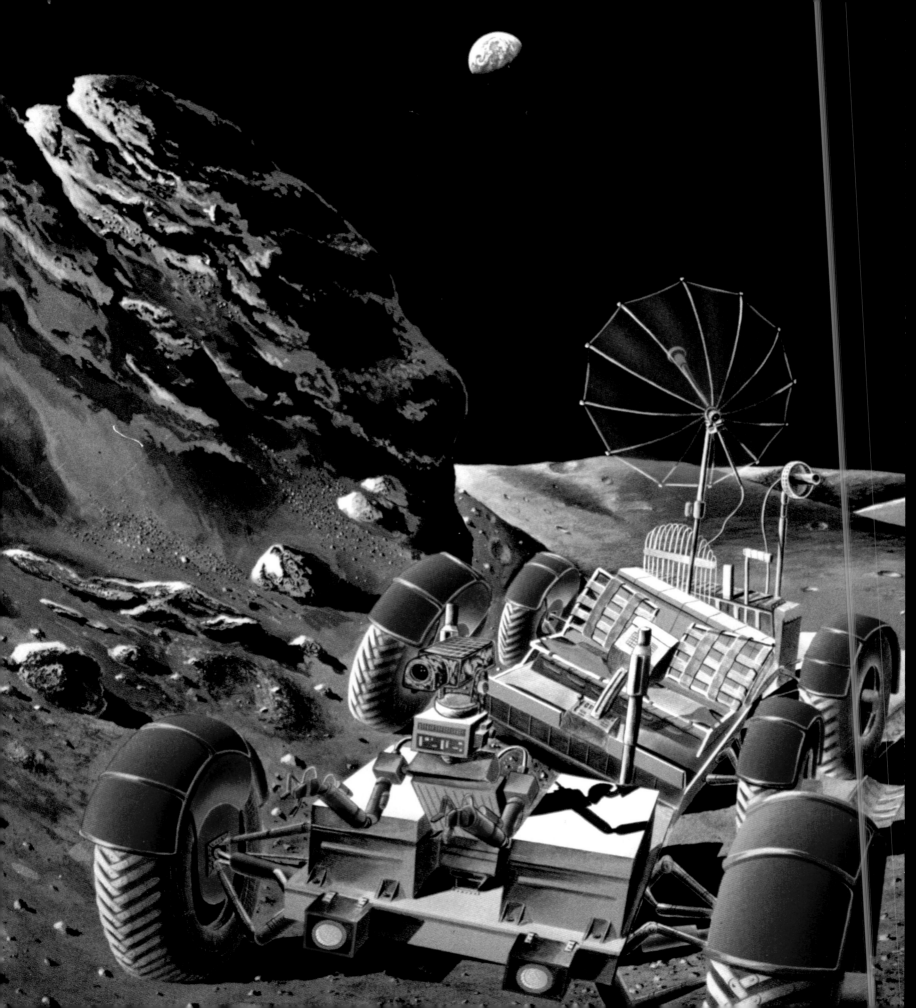

There is a long history of conceptual art for a Moon base. This one, from 1986, was included as an illustration in a summer study on potential future activities for NASA. It emphasized a roving vehicle similar to the one used on Apollo missions, as depicted in the foreground.

CONTINUING MARS EXPLORATION

Despite NASA's multiple failures to obtain approval for sending humans to Mars in the twentieth century, it remains an important goal for many as this new century unfolds. There is good evidence that sometime during the twenty-first century, humans will reach Mars.

A sustained effort to learn more about Mars has been underway since the dawn of the century, and robotic explorers have unveiled a rich and enticing world. A search for life on Mars—even in the form of microorganisms lying beneath its polar caps or in subterranean hot springs warmed by vents from the Martian core—fuels this quest. These endeavors will not abate as the century progresses.

Sending humans to Mars presents a significant challenge, even though it remains an inviting goal. But there are proposals that could work if astronauts were able to "live off the land." The first humans to Mars may well extract fuel and consumables from the Martian environment. Such a mission would require a two-year-plus timetable to fly to Mars, work on the surface, and then return to Earth. It would also require a vehicle for getting there, a lander with a scientific laboratory and habitat module, a power plant, rovers, a way to grow food, and, most critically, an ascent vehicle for leaving.

Fuel could be manufactured on Mars from the local atmosphere, which mostly consists of carbon dioxide. This gas could be split into its component elements in a reaction chamber. The process, first discovered by French chemist Paul Sabatier (1854–1941), produces methane and water. The methane would be pumped through a cryogenic cooler, which reduces it to a liquid state, and stored as rocket fuel. The water could be turned into hydrogen and oxygen for use by astronauts.

Upon arrival, humans would need to deploy a greenhouse, most likely inflatable, to grow food. Using rovers, the crew could begin exploration of the surrounding terrain. They would collect samples for analysis and drill into the Martian substrata in search of water and any subterranean life that may exist. They could also search for fossils and seek to confirm the existence of any other natural resources on Mars. Once their time on the planet ended, the crew would undertake a hundred-day trip back to Earth.

The technical problems of such a mission are considerable, but they can be overcome with sufficient time and resources. Engineers would need to develop low-cost, high-reliability technologies to make this a reality.

During such a trip, as well as on the surface, the crew would be exposed to diverse types of radiation. A fast transit time is the best protection against radiation, but solar flares could

There are many illustrations of possible human missions to Mars. This one, from 1990, envisions a landing on the Red Planet, ambitiously set for 2019. In the foreground, astronauts engage in scientific observations, in an environment romantic in tone and substance. As a dust storm approaches they will soon return to their lander for safety, which will eventually return the crew to a transfer vehicle, parked in Mars orbit, for the return trip to Earth.

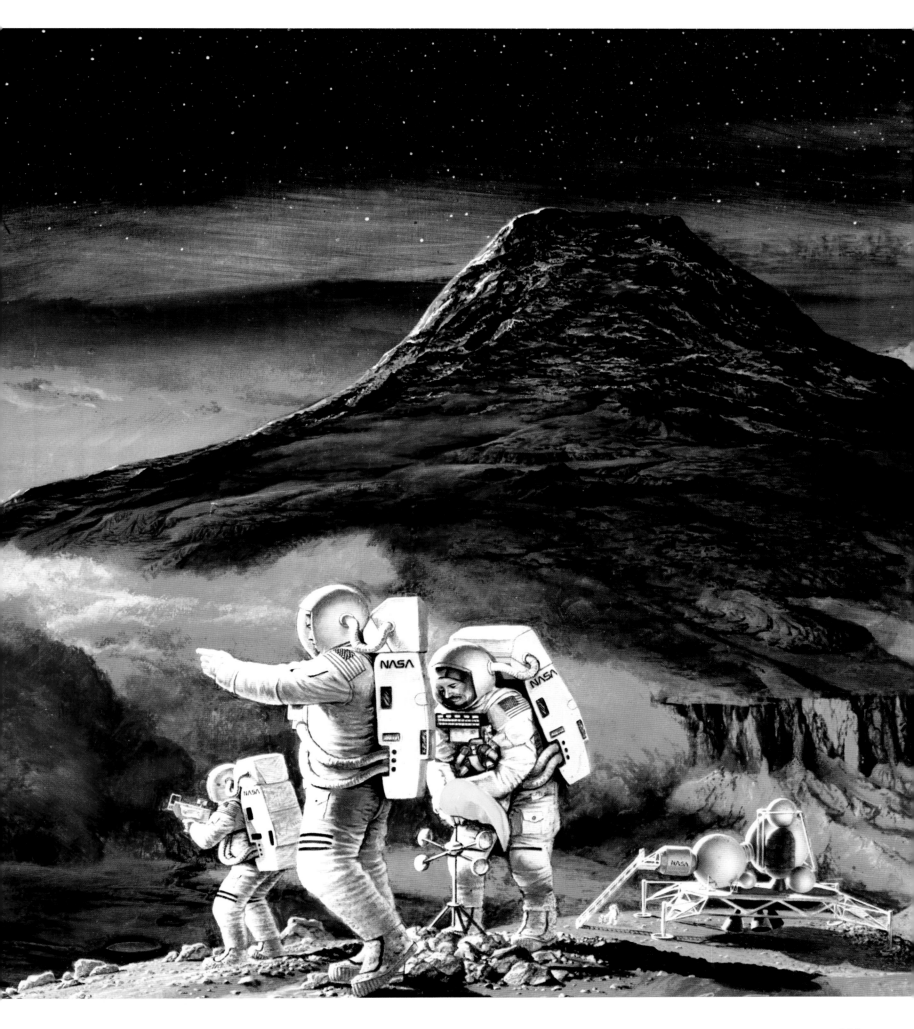

WHAT MIGHT THE FUTURE HOLD?

also be lethal, especially in the unprotected vacuum of space. Engineers would have to develop protective systems for the mission to be successful. It may also be necessary to maintain some artificial gravity on the spacecraft carrying the crew to and from Mars to help minimize biomedical problems associated with prolonged exposure to low-gravity environments. This could be accomplished by rotating areas of the vessel.

OVERCOMING OBSTACLES

If humans do go to Mars in this century, it will be because those on Earth are willing to expend enough resources to overcome these obstacles. At present, there is only modest public support for such expenditures.

Of course, we *could* send human expeditions to Mars. There is nothing magical about it, and a multinational mobilization to do so could be successful. But a human Mars landing would require a decision to accept considerable risk and to expend substantial funds over an extended period. Using Apollo as a model, anyone seeking a decision to mount a human expedition to Mars must ask a critical question: What political, military, social, or economic reason, cultural challenge, scenario, or emergency can they envision to which the best response would be a major commitment to sending humans to Mars?

In addition, with a record of accomplishment that includes numerous failures of robotic probes to Mars, are we willing to accept significant risk to humans on such a mission? Absent a major surprise that would change this equation, it is doubtful humans will land on Mars before the latter half of this century.

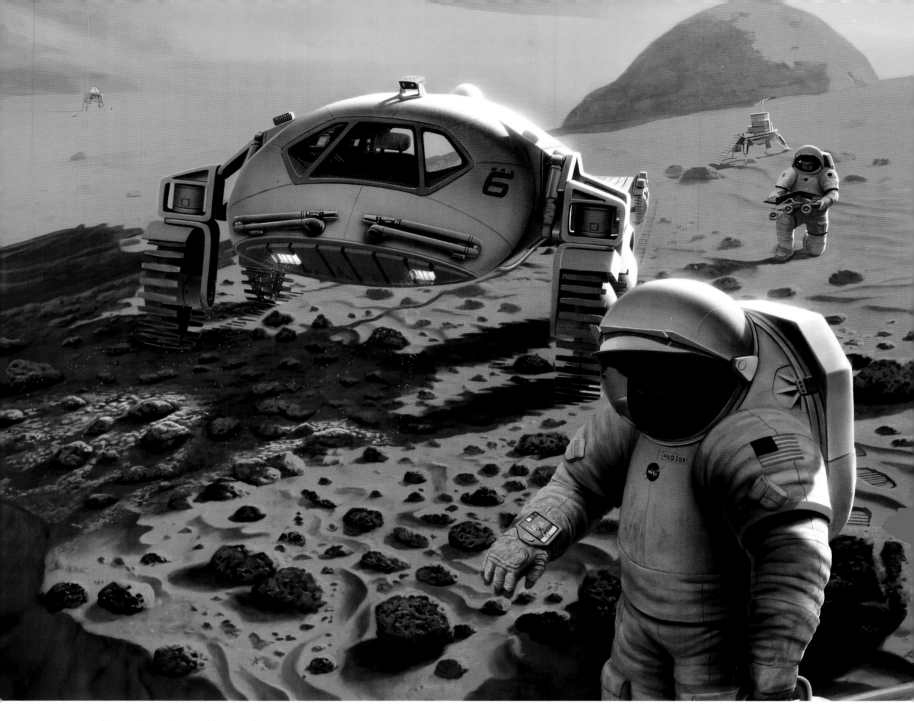

LEFT Two astronauts working on the surface during a human mission to Mars, while a helicopter similar to the Ingenuity Mars helicopter (see page 238) flies overhead.

ABOVE Two astronauts near a Ganges Chasma landing site on Mars, inspecting a robotic lander and its small rover.

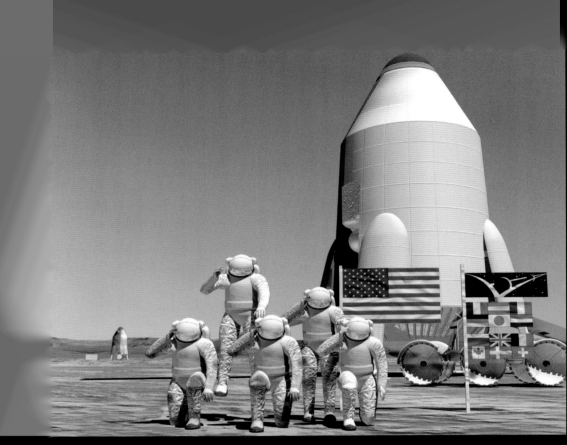

LEFT The landing of an international team of astronauts on Mars, with a ceremonial planting of flags.

BELOW LEFT The 1997 Mars rover, Sojourner, was named after former slave and famous abolitionist Sojourner Truth. Here, an astronaut and descendant of Sojourner recovers the spacecraft.

RIGHT The large shield volcano Pavonis Mons, located near the equator of Mars, could act as a landing site and research station on the planet's surface. Pictured here are rovers, habitats, a power station, greenhouses, launch and landing operations, maintenance facilities, and even a Mars airplane.

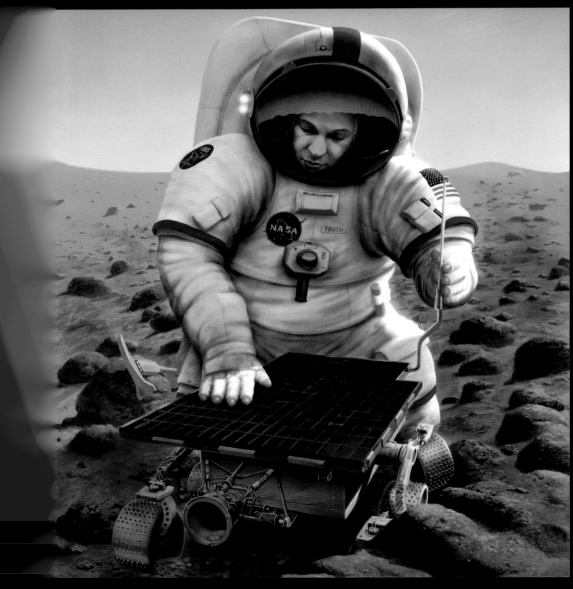

"The first humans to Mars may well extract fuel and consumables from the Martian environment. Such a mission would require a two-year-plus timetable to fly to Mars, work on the surface, and then return to Earth."

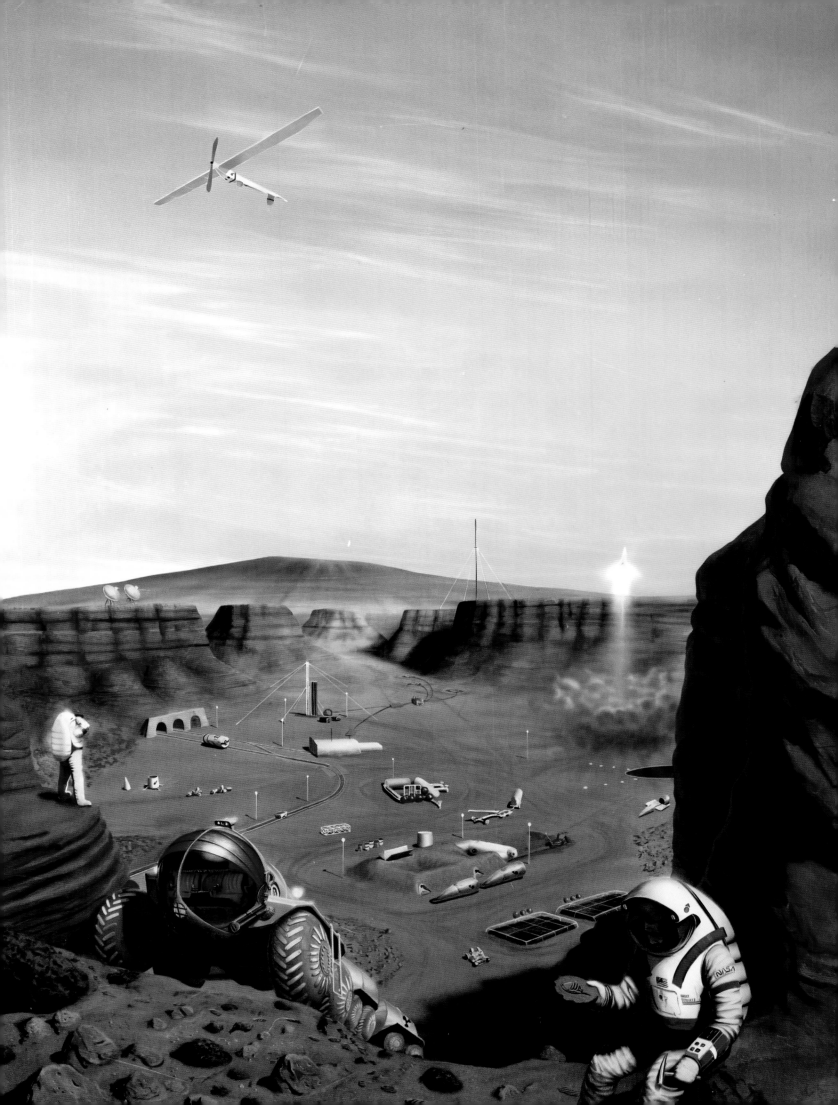

BECOMING A MULTIPLANETARY SPECIES

The movement of humans permanently beyond Earth has long been a priority for spacefaring advocates. While the challenges in doing so are daunting, the possibilities are boundless. Modest steps in this direction are already part of discussions about sustained activities on the Moon and Mars, and as the twenty-first century progresses, permanent space settlements may well receive increased attention and a higher priority.

Several possibilities exist for human migration into the solar system. The most immediate, of course, are the likelihood of settlements on the Moon and Mars, but there are also asteroids and the moons of some of the Jovian planets that might eventually be inhabited. These locations offer possibilities for realistic travel times of material, equipment, and people using various spacecraft; development of indigenous construction and outfitting using non-Earth materials; and establishment of settler families running businesses to support tourism and mining.

Space tourism will follow to any place in the solar system that humans inhabit. In its initial years, this tourism would look much like that underway in Antarctica today. It would start with small groups visiting research stations, but privately owned tourist facilities might follow. Could the Moon or Mars, for example, become the ultimate destination for those seeking adventure? Space tourism start-up companies are already selling suborbital space flights and preparing for the possibility of lunar tourism.

Beyond settlements on bodies in the solar system, there is also the possibility of self-contained colonies in space. Rather than live on the surface of a planet, settlers could reside inside gigantic cylinders or spheres. Each independent biosphere would hold a breathable atmosphere, as well as all the ingredients necessary for sustaining crops and life, and could rotate to provide artificial gravity. At sum, these could become cosmic arks with humans, animals, and plants living in equilibrium. Solar power could provide a constant source of nonpolluting energy. Interest in such space settlements has sparked studies of their feasibility, some of which have garnered support over time.

These visions of settlements beyond Earth are inviting and idyllic, but they are unlikely to happen before the latter half of this century. The prospect is intriguing, however, and has fostered visionary thinking around the globe on how such an opportunity might be realized.

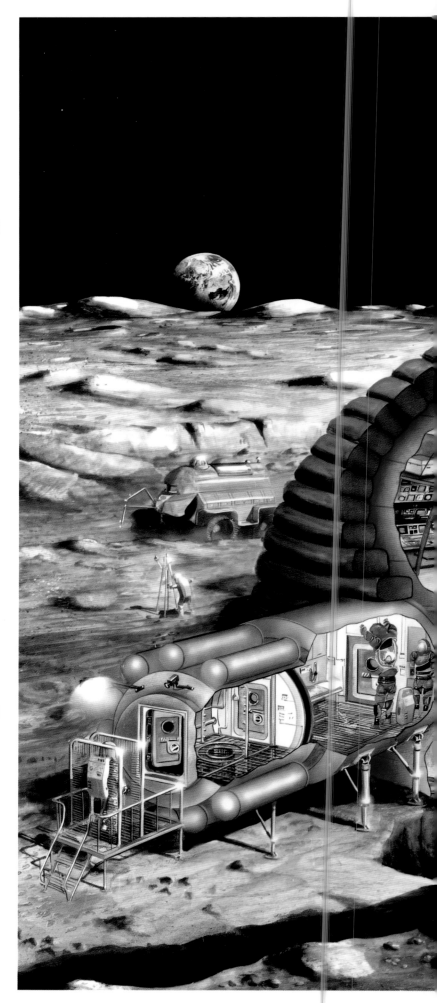

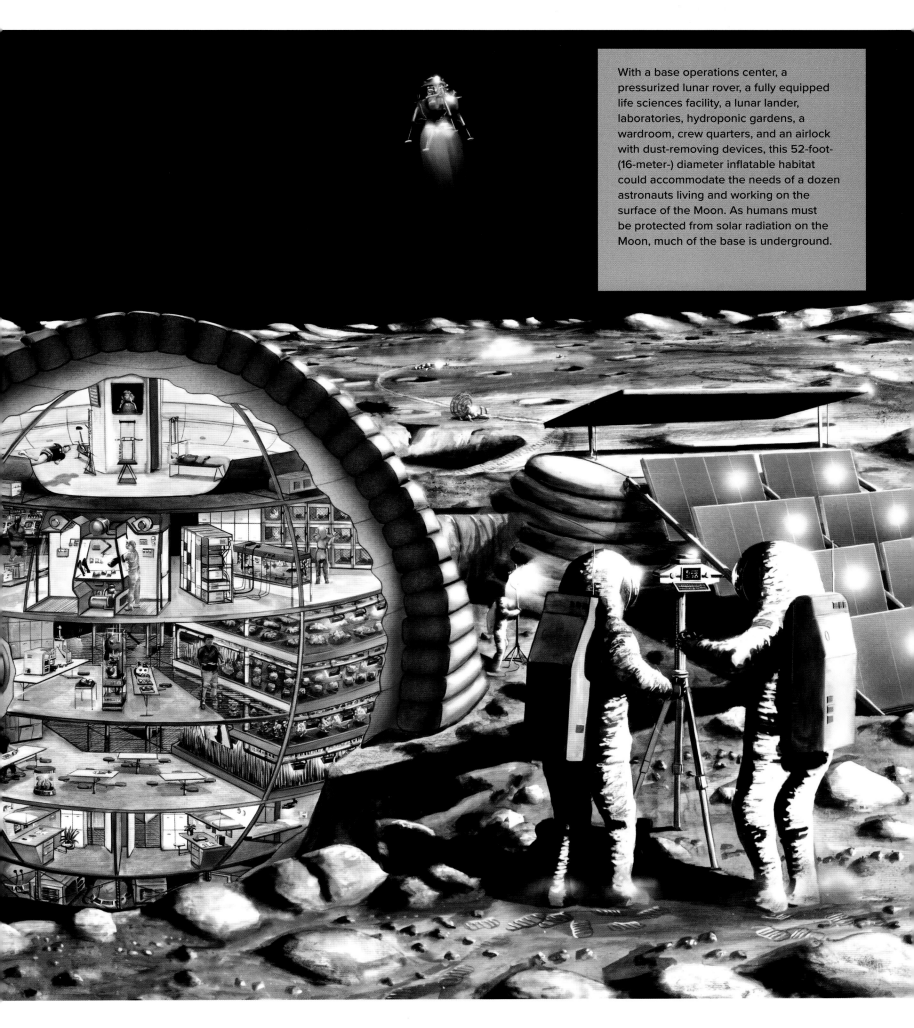

With a base operations center, a pressurized lunar rover, a fully equipped life sciences facility, a lunar lander, laboratories, hydroponic gardens, a wardroom, crew quarters, and an airlock with dust-removing devices, this 52-foot- (16-meter-) diameter inflatable habitat could accommodate the needs of a dozen astronauts living and working on the surface of the Moon. As humans must be protected from solar radiation on the Moon, much of the base is underground.

WHAT MIGHT THE FUTURE HOLD?

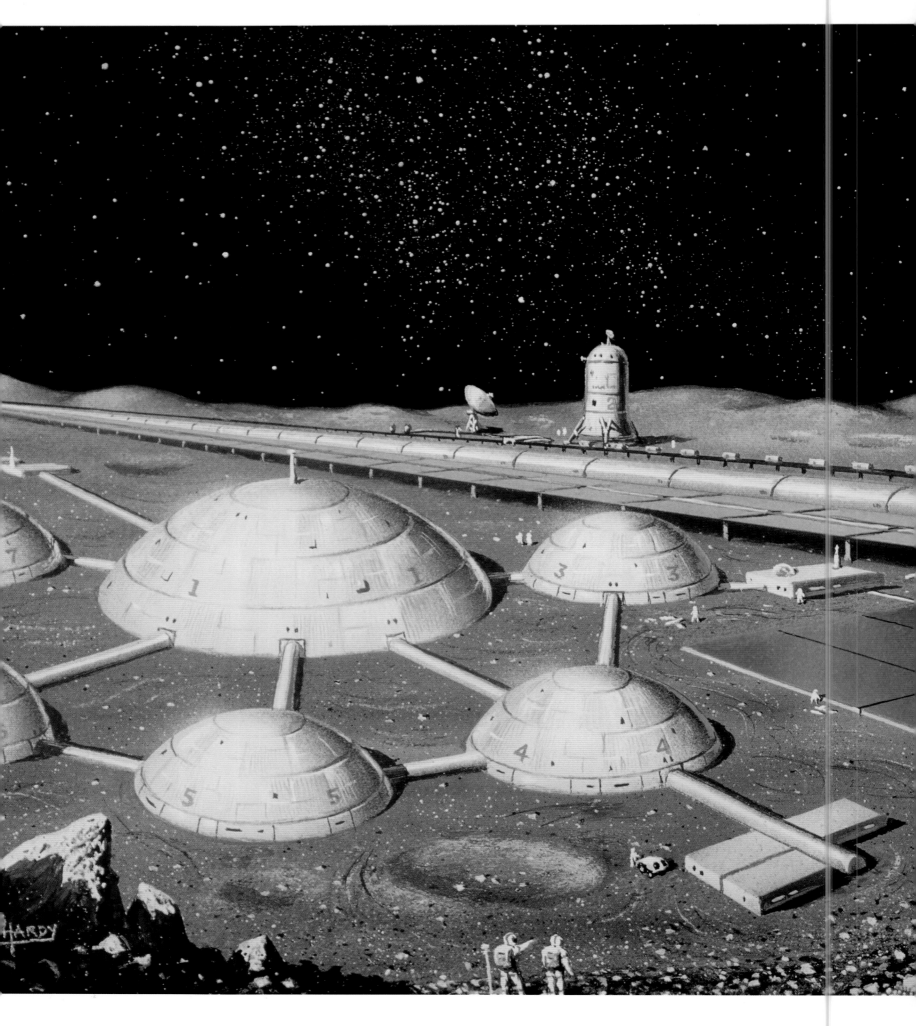

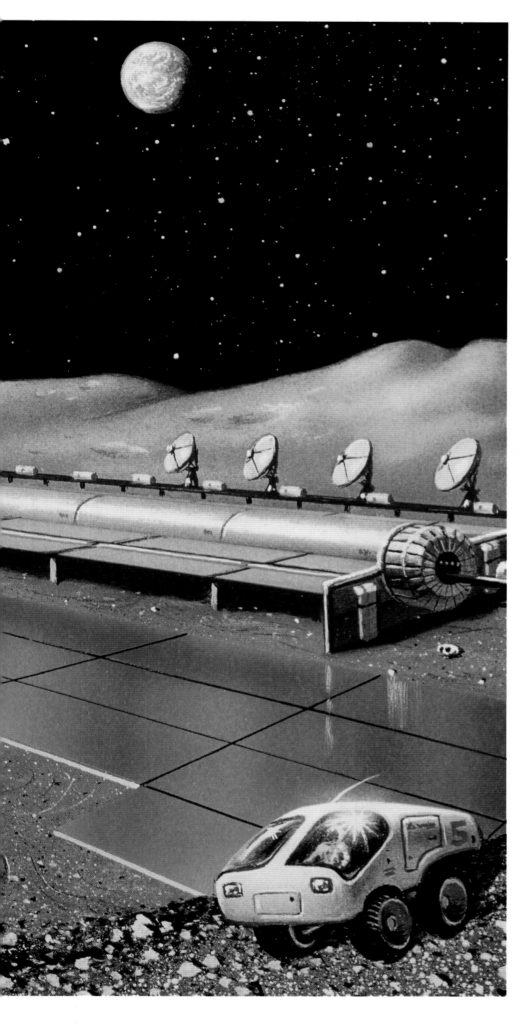

"Several possibilities exist for human migration into the solar system. The most immediate, of course, are the likelihood of settlements on the Moon and Mars, but there are also asteroids and the moons of some of the Jovian planets that might eventually be inhabited."

In another potential future base on the Moon, the domes at left are habitation and laboratory modules. The long tube running across the frame is a mass driver. This is a long series of powerful electromagnets. A cargo projectile is loaded at right, and is accelerated by the electromagnets firing in sequence. The projectile achieves enough velocity for a direct flight back to Earth, where it may be captured in orbit or re-enter the atmosphere by itself. Such techniques could be used for the cheap return of minerals or manufactured metals and drugs from the lunar colony.

WHAT MIGHT THE FUTURE HOLD?

ABOVE Astronauts at Phobos ensure a propellant-extraction machine is functioning properly. Might a sophisticated robot eventually take over this task?

TOP RIGHT An underground Mars colony, with racks of plants being grown for food.

RIGHT Resource extraction has long been viewed as a major activity for space colonies. This NASA concept art shows the mining of ilmenite, an oxygen-rich component of the lunar soil.

TOP An attractive economic enterprise in space involves tourism—we may one day see

ABOVE Automation will be key to space operations moving forward.

ABOVE The interior of an operations control room, with astronauts overseeing a lunar

"These visions of settlements beyond Earth are inviting and idyllic, but they are unlikely to happen before the latter half of this century. The prospect is intriguing, however, and has fostered visionary thinking around the globe on how such an opportunity might be realized."

ABOVE Various routes could be taken by vehicles as liquid oxygen (LOX) mined on the Moon is transported back to Earth and used to fuel a variety of vehicles. Some would travel to geosynchronous Earth orbit (GEO), where communications satellites can be serviced or replaced. Others would fly the route between Earth and the Moon, carrying liquid hydrogen to the lunar facilities and bringing liquid oxygen back to a low Earth orbit (LEO) facility.

1. Launch vehicle with Liquid Hydrogen Tank (LH2) and GEO spacecraft to rendezvous with LEO space station
2. LEO
3. GEO
4. 28½ degrees LEO
5. Space station/propellant depot
6. Orbital Test Vehicle (OTV) to GEO with communications satellite using lunar-produced LOX
7. Lunar ferry with LH2 from LEO
8. Outbound lunar ferry with lunar-produced LOX to LEO
9. Lunar module ascent with LOX
10. Lunar module descent with LOX
11. Lunar orbit space station

RIGHT In the summer of 1975, NASA Ames, ASEE, and Stanford University sponsored "Space Settlements; A Design Study" to look at all aspects of sustained life in space. Here, the resulting Torus Space Settlement proposal is depicted by three different artists. The proposed settlement consists of a torus or ring one mile in diameter, which would rotate once per minute to provide Earth-normal gravity for it's 10,000 inhabitants. The large assembly could be conducted in space.

WHAT MIGHT THE FUTURE HOLD?

383

The idea of a space colony was championed by American physicist Gerard K. O'Neill in his book *The High Frontier: Human Colonies in Space* (1976). The cylinder here measures 5.6 miles (9.2 kilometers) in diameter and 20 miles (36 kilometers) in length. Rotation about the long axis, at a rate of 689 feet/second (210 meters/second) at the surface, provides artificial gravity by means of centripetal force.

In 1976 and 1977 NASA sponsored summer studies on the feasibility of space colonies, not on a planet or moon but free floating in the solar system. It commissioned artist Rick Guidice to prepare a series of fanciful depictions of these facilities. This work depicts a self-contained Bernal Sphere, which rotates to create artificial gravity, with a residential area inside the central sphere. Farming regions are in the "tires." Mirrors reflect sunlight into the habitat and farms. The large flat panels radiate away extra heat into space, and panels of solar cells provide electricity. Factories and docks for spaceships are at either end of the long central tube.

WHAT MIGHT THE FUTURE HOLD?

ABOVE The possibility of automated mining in space raises the core issue of whether human presence is necessary at all. On the left is Robonaut 2, a dexterous humanoid robot which might become a surrogate for human astronauts.

RIGHT A proposed Bernal Sphere colony in space shows an interior not dissimilar to the San Francisco Bay area of Earth. This is not by happenstance, as the summer study that NASA sponsored on colonies in space took place at the Ames Research Center in the Bay area. This idyllic depiction of the interior of a rotating colony in space even has a hang glider at the center of the sphere, a location where weightlessness would be present.

"Rather than live on the surface of a planet, settlers could reside inside gigantic cylinders or spheres. Each independent biosphere would hold a breathable atmosphere, all the ingredients necessary for sustaining crops and life, and could rotate to provide artificial gravity."

WHAT MIGHT THE FUTURE HOLD?

INTERSTELLAR EXPLORATION: LOOKING BEYOND 2100

The intrigue of moving beyond this solar system compels us to speculate on the possibility, but the reality remains that it will not happen anytime soon. Interstellar migration to another star system is a far-off goal.

The distances between stars are so vast—the closest star system to Earth is 4.3 light-years away—that the prospects for interstellar space exploration by humans are exceedingly remote. Nonetheless, the inclination to contemplate travel to other stars, both distant and nearby, remains strong. Methods of travel to other systems is the stuff of science fiction—witness *Star Trek*'s "Warp Drive" and *Avatar*'s suspended animation—although sometimes it intrudes into serious technological investigation.

For example, in 2010 the US Defense Advanced Projects Research Agency, in cooperation with NASA, funded the 100 Year Starship study "to explore the next-generation technologies needed for long-distance manned space travel." Intended to jump-start innovation leading to interstellar travel, the Dorothy Jemison Foundation for Excellence, Icarus Interstellar, and the Foundation for Enterprise Development led the experiment. Several conferences reporting on research have discussed possibilities for distinct types of propulsion systems, methods of maintaining human statis over centuries, and the prospects of multigenerational spaceships, and some science teams have even worked on technology development for the project.

Though none of them yet exist, there are four methods that have been envisioned for travel beyond the solar system:
- Using some type of faster-than-light speed—186,000 miles per second (299,338 kilometers per second)—including hyper drive, wormholes, or some other exotic propulsion system.
- Developing some form of suspended animation process enabling humans to endure the incredibly long journeys between stars.
- Enhancing human life longevity through scientific or technological modification.
- Building multigenerational spaceships—space arks—capable of sustaining humans for the multiple of centuries' travel time it will take to reach another star at sub-light speeds.

Such challenges to interstellar migration may eventually be overcome. However, the practical difficulties are immense and will require technology that is far more sophisticated than the conventional rockets that have launched all space exploration efforts to date. It is possible that the scientific challenges may be met, but it is doubtful that it will happen in this century.

RIGHT A hypothetical spacecraft uses a "negative energy" induction ring to achieve a near speed-of-light velocity through a black hole. Negative energy is an enigmatic concept in quantum mechanics that involves gravity, nuclear fission, and other energies. Harnessing it may someday—far beyond the twenty-first century—enable future interstellar travel.

"The distances between stars are so vast—the closest star system to Earth is 4.3 light-years away—that the prospects for interstellar space exploration by humans are exceedingly remote."

WHAT MIGHT THE FUTURE HOLD?

Antimatter spacecraft use the energy released by the total annihilation that occurs when antimatter and matter meet. The efficiency is 100 percent as all the mass is converted to energy, producing 1,000 times the energy

"The immense distances between stars—the closest star system to Earth is 4.3 light-years away—are so vast that the prospects for interstellar space exploration by humans are exceedingly remote. Nonetheless, the inclination to contemplate travel to other stars, both distant and nearby, remains strong."

WHAT MIGHT THE FUTURE HOLD?

INDEX

Page numbers in *italic* refer to illustrations

A

Abbot, Charles Greeley 314
Abell 1689 *64*
Abell S1063 65
Akatsuki 318, 323
Albion 158, *159*
Aldrin, Buzz 272, *272, 277, 278–9*
All-Sky Survey 46
Allan Hills meteorite 248, *248*
Andromeda galaxy *33, 34–5*, 76, 79, 82, *82–3*
Annefrank, Asteroid 212
Antikythera mechanism *19*
antimatter spacecraft *392–3*
Apollo program 262, *271*, 272–87, 288, 296, 352, 370
 Apollo 8 *262*, 272, *274*, *357*
 Apollo 9 *275*
 Apollo 11 272, *272*, 276–9, *281*
 Apollo 12 *264, 280, 281*
 Apollo 14 *281*
 Apollo 15 *282, 283*
 Apollo 16 *284*
 Apollo 17 *284, 285, 286*
Apollo Telescope Mount 96, *96*
Aqua *307–8*
Aquarius/SAC-D *307*
Arianespace Ariane 5 rocket 49
Aristotle 22
Armstrong, Neil 272, *272*, *278–9*
Arp-Madore 2026-424 *79*
Artemis program 136, 289, *352*, 352–61, 365
 Artemis I 352, *352, 354–5*
 Artemis II 352, *356–9*
 Artemis III *349*
 Artemis V *360–1*
Asteroid Belt 154, 208, 211, *213*
Asteroid Redirect Mission (ARM) *348*
asteroids 156, 208, 211–19, *338*
 Annefrank 212
 Bennu *214*
 Eros 212, *215*
Atacama Large Millimeter/submillimeter Array (ALMA) *55*
Atlantis 130, *131*, 196
Axiom Space *349*

B

Babylonian cosmology 18, *18*
Bean, Alan *264, 280*
Bennu *214*
BepiColombo 328, *333*

Bernal Sphere *386–7, 388–9*
Big Bang 12, 32, 40, *40–1*, 46, 49, 68
Big Crunch 68, *70–1*
Big Dipper (Ursa Major) *38–9*
Big Freeze 68, *70–1*
Big Rip 68, *70–1, 72–3*
black holes 28, *69, 72–3*, 76, *101*, 112, *122–5*, *126, 390–1*
Blue Origin *360–1*
blue supergiants *100, 101*
bow shock *162–3*
Braun, Wernher von *224*
brown dwarves *100*

C

Calcium Aluminium Inclusions (CAIs) 210
Calisto 200, *204*
Carina Nebula *10–11, 20–1*
Carr, Gerald P. *96*
Cassini 190, 192–7, *193*, *206*
Cepheid variable stars 32, *42–3*, *44–5*, 54
Ceres 164, *208*, 211, 213
Cernan, Eugene *285*
Cerulli, Vincenzo 226
Chandra X-Ray Observatory *108*, *109*, *113*, *116*, 132, *132*
Chang'e 212, *270*, 289, 290
 Chang'e-2 *137*, 289
 Chang'e-4 *136*, 268, *270*, 291
 Chang'e-5 *136*
Charon 158, 164, *164*, 166, *169*, *170*
Chéseaux, Jean-Philippe Loys de *102*
China, cosmology of ancient 17, *17*
China National Space Administration 258, 352
 Chang'e *136, 137*, 212, 268, *270*, 289, 290–1
Chondrules 210
cis-lunar exploration 346
Clementine spacecraft 268, *268*, *269*, 288
climate change 294, *295, 300, 301*, 314
Collins, Michael 272, *272*
Columbia 132
comets 156, *157*, 158, 208–11, *338*
 Comet Grigg-Skjellerup *209*
 Comet Halley 158, 208, *209*
 Comet Shoemaker-Levy 9 196, *202*, 208
 Comet Wild 2 210, *210*, 211
commercial missions 346, *348*
Compton, Arthur H. 130, 131, *131*
Compton Gamma Ray Observatory (CGRO) 130, 131, *131*
Copernicus (ESA mission) *310–11*

Copernicus, Nicolaus 22, *24*, *26–7*
 Copernican model 24, *25*, 112, *113*
Cosmic Background Explorer (COBE) 46–8, *47, 48*, 49
Cosmic Seahorse *30–1*
cosmology 16
Curiosity 238, *242–3*, 245, *246–7*

D

dark energy 12, 62–7, 68, 69, *70–1*, 76, 126
dark matter 12, 62–7
Dawn 212, *213*
Deep Impact-EPOXI 210
Deep Space 1 208, 212
Didymos *216*
Dimorphos 211
Dorothy Jemison Foundation for Excellence 390
Double Asteroid Redirection Test (DART) 214, *216*
Drake, Frank 150, *151*
dwarf planets 154, 164
dwarf stars *108*

E

the Earth 22, 154, *178, 220–1, 223*, 274, *292–313*, 314, *338*, 346
Earth Observing System (EOS) 292, 294
Earth Science Division Operating Missions *304–5*
Einstein, Albert 12, 24, 28, 29, *29*, 84
Einstein ring *84*
Enceladus *177*, 190, 192, *195, 206*
Endeavour 126, 130, *297*
Eris *153*, 160–1, 164, *170*
Eros 212, *215*
Europa 198, *205, 350–1*
Europa Clipper *350–1*
European Southern Observatory's Very Large Telescope (ESO VLT) 54, *88–9*, *105*
European Space Agency (ESA) 140–1
 Cassini-Huygens 192
 Gaia Space Observatory *134*, *137*
 galaxies *78*, *81*
 Giotto 208, *209*
 Herschel Space Telescope *79*, *137*
 Lisa Pathfinder (LPF) *136*
 Mars missions 250, 256, 258, *371*
 Mercury missions 328, *333*
 Moon base concept *362–3*
 Moon missions 289
 Planck Space Observatory *42–3*, 46, *48*, *63, 79*, *137*

Rosetta 210, 212
 satellites *310–11*, *313*
 Solar and Heliospheric Observatory *136*
 space observatories 140–1
 Venus missions 318, *324*
 XMM-Newton 54, *59*
Event Horizon Telescope (EHT) *123*
exoplanets 142–9
extraterrestrial life 142, 150–1, 248–61

F

Fine, Oronce *18*
Ford, W. Kent 62
Foundation for Enterprise Development 390

G

G-type stars *98*
Gaia space observatory *78*, 134, *137*
galaxies 74–93
 aging 46
 collisions 79, 82, *82–3*
 formation of 54, 55, 76, 94
 furthest seen 56–7, *138*
 number of 40, 82
 oldest *58*
 size of 76
 types of 86–93
Galaxy Evolution Explorer (GALEX) *88–9*
Galileo 24, 126, 154, 180, 212
Galileo probe *4–5*, 190, *192*, 196–201, *206*, 208
gamma rays 130
Ganymede 200, *203*, 204
Genesis Rock *282*
Geostationary Operational Environment Satellite (GOES-8) *293*, *308*
geosynchronous Earth orbit (GEO) *382–3*
GHZ2/Glass-Z12 *55*
Gibson, Edward G. *96*
Giotto 208, *209*
Glover, Victor *358*
Google Lunar XPRIZE *352*
Grand Tour 172–9
gravity 62, *63*, 68, 76, 94, 135, 336, *390–1*
 gravitational fields 76, 112
 gravitational lensing *30–1*, *65*, *84*, *85*
Gravity Probe B (BP-B) 28, *29*
Great Andromeda nebula 32, *34*
Greek mythology *18*, 22
greenhouse effect 314
Grigg-Skjellerup, Comet *209*
Guidice, Rick *386–7*

H

Halley Armada 208, *209*
Halley's Comet 158, 208, *209*
Hansen, James E. 294, *294*
Hansen, Jeremy *358*
Haumea 164
Hayabusa 212
Hayabusa 2 212, *217*
heliosphere 156, 157, 158, *162–3*, 174
Herbig-Haro 46/47 *52–3*
Herbig-Haro 211 region *106–7*
Herschel, Sir William 180
Herschel mission *79*
Hinode mission *99*, 336, *337*
Hoffmann, Jeff *127*
Hubble, Edwin 32, *32*, 34, 46, 54, 62, 76
Hubble constant *42–3*, *44–5*, 62
Hubble Space Telescope (HST) 8, *37*, *42–5*, 48, *62*, *64–5*, 67, 68, *72–3*, *79*, *86–7*, *90*, *94–5*, *108*, *113*, 126–30, *139*, *143*, 160–1, *164*, *185*, *189*, *197*, *222*
Huygens *192*, *195*
hypergiants 94, 96

I

IC1613 *92–3*
Icarus Interstellar 390
ICE *209*
icy bodies 158, 208, 211
Ingenuity *244*, *370*
International Cometary Explorer/International Sun-Earth Explorer 3 208
International Space Station (ISS) *220–1*, *302–3*, 362
interstellar space 172, 174, *175*
 exploration of 390–3
Io 198, *202*, *205*
Irwin, James *283*
Italian Space Agency 192

J

James Webb Space Telescope (JWST) 8, *37*, 48–9, *50–1*, 54, 82, 132, 135, 137, *206*
 images from *6–11*, *14–15*, *30–1*, *52–61*, *84–5*, *105–7*, *207*
 Mid-Infrared Instrument *20–1*, *110–11*, *116–17*
 Near-Infrared Camera (NIRCam) *13*, *20–1*, *38–9*, *110–11*, *116–17*
Japanese Space Exploration Agency (JAXA) 55
 comets and asteroid missions 208, 212
 Hinode mission *99*, 336, *337*
 Mars missions 258
 Mercury missions 328
 Moon missions 268, *270*, 288, *289*, *291*
 satellites 313
 Venus missions 318
Jet Propulsion Laboratory 204, 228, 238, 262, *317*
Juno 190, *203*
Jupiter *2*, 22, 154, 196–207, 208
 magnetic field *338*
 missions to *4–5*, 172, *173–4*, *178–9*, 190, *193*, 196–207, *350–1*
 moons *26–7*, 198, 200, *200*, *202*, *204–5*, *207*

K

Kaguya mission 268, *270*
Kelvin, Lord 62
Kennedy Space Center 167, 172, *355*, *356*, *358*
Kepler, Johannes 24, 112, *112*, *113*
Kepler Space Telescope 142, *143*
Koch, Christina Hammock *358*, *359*
Kuiper, Gerard 158, *158*
Kuiper Belt 154, 156, 158, *159*, 208, 211
Kuiper Belt Objects (KBOs) *154–5*, 158, *158–61*, 166, *170*

L

Lagrange points 135, *135–7*
Landsat 292, 296, *296–8*, 312
Large Magellanic Cloud (LMC) *78*, *80–1*
Le Verrier, Joseph 180
Leavitt, Henrietta Swan 54, *54*
Lemaître, Georges Henri Joseph Édouard 32
Lindgren, Kjell *302–3*
liquid oxygen (LOX) *382–3*
Livio, Mario 82
Lowell, Percival 226
Lucy 214
Luna program 264, *265*, *267*, *271*, 288
Lunar Orbiter 262, *262*
Lunar Prospector 268
Lunar Reconnaissance Orbiter *286*, *287*, 289
Lunokhod program *265*, *266*, *267*, *286*

M

M14 Eagle nebula *104*
M16 Eagle nebula *104*
Magellan spacecraft 318, *318–22*
magnetars 120, *120*, *121*
magnetic fields 120, *121*, 174, 180, 328, *338*, *342*
Makemake 164, *170*

INDEX
395

Mariner program 228–31, *315*, *316–17*
 Mariner 2 316, *316*, *317*
 Mariner 3 *259*
 Mariner 4 228, *228–30*, *259*
 Mariner 6 228, *259*
 Mariner 7 231, *259*
 Mariner 8 *259*
 Mariner 9 228, *231*, *259*
 Mariner 10 288, *315*, 328, *329*
Mars 22, 154, *178*, 222–61, *338*, 346, *346–7*
 canals 226, *226*, *227*
 early missions to 228–31
 human missions to 368–73, 374, *379*
 landers, rovers, and flyers 232–47
 life on mars 248–59
 missions to 228–31, 259–61
Mars 2/Mars 3 Orbiters 228
Mars Express 250
Mars Global Surveyor (MGS) 248, *249*, 250, *251*, *254*
Mars InSight Lander 245, *258*
Mars Observer 232
Mars Odyssey 250
Mars Pathfinder 236–7
Mars Reconnaissance Orbiter (MRO) 245, 250, *250*, 252
Mather, John C. 12, 46, 48
Mayan cosmology 16, *16*
Mercury 22, 96, 154, *178*, 222, 318, 328–35
Mercury Dual Imaging System (MDIS) *334*
Mercury Magnetospheric Orbiter (MMO) 328, *333*
Mercury Planetary Orbiter (MPO) 328, *333*
MESSENGER 318, *322*, 328, *328*, 330–2, *334*, *335*
Messier 32 *34–5*
Messier 42 *6–7*
Messier 101 (M101) *74–5*, *86–7*
Milky Way *42–3*, 76, *77*, *78*, 82, *82–3*, 94, 96, 112, *122*, 130, 156, *302–3*
Mission to Planet Earth (MTPE) 292
the Moon *223*, 262–91, 296, *338*, 346, *349*
 Apollo and the lunar landings 272–88
 mission flybys and orbiters 288–91
 robots to the Moon 262–71
 sustained lunar operations 352–67, 374, *374–7*, *379–81*
Mullis, Dr. Christopher 54
Multi Unit Spectroscopic Explorer (MUSE) *105*
Musgrave, Story *127*

N
N132D *113*
Nancy Grace Roman Space Telescope 68, *69*
NASA 48, 54, 68, 172, 258, 272, 346, *366–7*, *371*
 age of the universe 44, *45*
 Chandra X-ray Observatory *116*
 extraterrestrial life 150
 galaxies 79, *82–3*, *88–9*
 Goddard Space Flight Center 112, 124
 Gravity Probe B (GP-B) 28, *29*
 Jet Propulsion Laboratory 204, 228, 238, *262*, *317*
 Kennedy Space Center *167*, 172, *355*, *356*, *358*
 Mission to Planet Earth (MTPE) 292, *307*
 Neil Gehrels Swift Observatory *121*
 space colonies *386–7*, *388–9*
 space observatories *121*, 126–39
 see also individual telescopes; missions and projects
National Oceanic and Atmospheric Administration (NOAA) *293*, 294, *309*
Near-Earth Asteroid Scout (NEA Scout) 214
Near-Earth Object Wide-Field Infrared Survey Explorer (NEOWISE) *157*
NEAR Shoemaker 212, *215*
nebulae 32, *101*
 see also individual nebula
negative energy *390–1*
Neil Gehrels Swift Observatory *121*
Neptune 154, 158, *159*, 172, *177*, *178*, *179*, 180–4
neutron stars *101*, 112
 types of 120–1
New Horizons 154, *165*, 166–9, 172, 190, 210
Newton, Sir Isaac 24, 28
NGC 346 *13*
NGC 1316 *90*
NGC 1792 *94–5*
NGC 3324 *60–1*
NGC 3610 *91*
NGC 5585 *66–7*
NGC 6822 *8–9*
NGC 6872 *88–9*
Nimbus 7 292
Norwood, Virginia T. 296, *296*
Nuclear Spectroscopic Telescope Array (NuSTAR) *99*, *337*, *342*
nurseries, star 94, *94–5*

O
observational limits 142
OMC-1 molecular cloud *6–7*
O'Neill, Gerard K. *384–5*
Oort, Jan Jenrik 156, *156*
Oort Cloud 154, 156, *157*, *170*
Opportunity 238, *240–1*, 250
Orion Nebula 94, *97*
Orion spacecraft *352*, *354–8*
OSIRIS-Rex 214, *214*
outer solar system 152–219
ozone layer *295*

P
Pandora's Cluster *56–7*
Parker Solar Probe *323*
Pathfinder 248
Perseid meteor *208*
Perseverance 238, *242–3*, *244*, 258, *371*
Phobos *378*
Pillars of Creation *102–5*
Pioneer program 288, *321*
 Pioneer 10 172, *172*, *173*, 190, *196*
 Pioneer 11 172, *172*, *173*, 190
Planck Space Observatory 43, 46, *48*, *49*, *63*, *79*, 137
Planetary Society 238, *238*
plantesimals 156
Pluto 154, 156, 158, 164–71
Project Surveyor 262, 264, *264*, 271
protostars *100*
Psyche (Discovery 14) 214, *218–19*
Ptolemy 22, *22–3*, 24, *25*, 32
pulsars 112, 120, *120*

R
Ranger project 262, *263*
red dwarves 94, *100*
red giants 96, *101*, *108*, 112
red supergiants *101*
redshift 32, 36, *44–5*, 46, 55
RELIKT-1 46
Ride, Sally 292
Riess, Adam 62
Robonaut 2 *388*
Roman, Nancy Grace 68, *68*
Roman mythology 22
Rosati, Dr. Piero 54
Rosetta 210, 212
Rosette nebula *26–7*
Rubin, Vera 62, *62*

RX J2129 *85*
Russia *137*, *258*, 352
 see also Soviet Union
Ryugu *217*

S

Sabatier, Paul 368
Sagan, Carl 314, *314*
satellites 292–313, *382–3*
Saturn 22, 154, 172, *177*, *179*, 190–7
Saturn V rocket *273*
Schiaparelli, Giovanni 226, *227*
Schmitt, Harrison (Jack) *284*
Scott, David R. *282*
Search for Extraterrestrial Intelligence (SETI) 150, *151*
Seasat 292, *299*
Sedna *170*, *171*
Shoemaker-Levy 9, Comet 196, *202*, 208
Shostak, Seth *151*
16 Psyche *218–19*
Skylab 96, *96*
Sloan Digital Sky Survey 46
SMACS 0723 *84*
Smooth, George F. III 46, 48
Sojourner 236, *236*, *237*, *372*
Solar Dynamics Observatory (SDO) *99*, 336, *337*, *342–3*
solar flares *96*, *339*, *343*, 368, 370
solar system 154
 farthest reaches of 156–63
solar wind 135, 136, 156, *157*, *162–3*, 174, *175*, 328, *338*
Southern Ring nebula (NGC3132) *110–11*
Soviet Union 346
 Lunokhod program 265, *266*, *267*, *286*
 Mars missions 228, 258
 Moon missions 262, 264, 265, *266*, *267*, 272, *286*
 RELIKT-1 46
 Soyuz program 288
 Vega 1 and 2 probes 209
 Venus missions 316, *325*
Soyuz program 288
Space Age 28, 126, 208, 222, 228, 258, 262, *262*, 314, 336
 phases of 346
space colonies 374–89
space exploration 344–93
Space Launch System (SLS) *352*

space observatories 126–41
space shuttles
 Atlantis 130, *131*, 196
 Columbia 132
 Discovery 129, 130
 Endeavour 126, 130, *297*
space tourism 374
space travel 344–93
 impact of Newton's laws on 28
Spirit 238, 239, *240*, 250
Spitzer Space Telescope *88–9*, *109*, *113*, 132, 133, *133*, *139*
starburst galaxies *94–5*
Stardust 210, *210*, *211*, 212
stars
 life and death of 94–111
 types of 94, 96, *98*
Stern, Alan 166, *166*
Stone, Edward C. 204, *204*
the Sun 24, 25, 96, *98*, *99*, *106*, 112, 154, 336–43
supernovae *69*, *101*, 112, *113*, *114–19*, *123*, 126
Surveyor 1 296

T

the Tarantula nebula *14–15*
Tarter, Jill 150, *151*
telescopes 16, 32, *37*, 46, 112
 see also individual telescopes
Terra *306–7*, *308*
Thompson, David 112
Tiros 292, *294*
Titan 190, 192, *194*, *195*
Titania *188*
Tombaugh, Clyde 156, 164, *164*
tourism, space 374
trans-lunar space exploration 346
Trapezium Cluster *6–7*
Triton 180, *182*, *184*

U

Ulysses 208
the universe 10–73
 age of 12, 46–51
 ancient ideas of 16–21
 end of 68–73
 expansion of 32, *33*, *36*, 40, *42–5*, 46, 62, 76, 126
 models of in Western civilization 22–7
 shape of 12

Uranus 154, 172, *177*, *178*, *179*, 180, 185–9
US Defense Advanced Projects Research Agency 390

V

V 372 Orionis *97*
variable stars 32, *33*, *42–3*, *44–5*, 54
Vega 1 *209*
Vega 2 *209*
Venera 316, 318, *320*, *321*, *325*
Venus 22, 96, 154, *178*, *193*, *209*, 222, *223*, 314–27
Venus Express *324–5*
Very Large Telescope 54, *88–9*, *105*
Very Large Array (VLA) 150, *150*
Vesta *208*, 211, *213*
Viking Mars landers 232–5
Viking Orbiter 238, *238*, *254*
Viking spacecraft *225*
Voyager spacecraft *26–7*
 Voyager 1 172, 174–9, 190–2, 196, *196*, 204
 Voyager 2 172, 174–9, 180, *181–9*, 190–2, *191*, 196, *196*

W

Webb, James 48
Western civilization, universe models 22–7
white dwarves 96, *101*, *108*, *110–11*, 112
Wild 2, Comet 210, *210*, *211*
Wilkinson Microwave Anisotropy Probe (WMAP) 46, *49*
Wiseman, Reid *358*
Wolf, Max *92–3*
wormholes 28

X

X-ray Telescope (XRT) *337*
XMM-Newton Space Observatory 54, *59*

Y

Yan, Haojing 54
Yutu-2 Rover 268, *270*, *286*

Z

Zeta Ophiuchi *109*
Zhurong 238
Zwicky, Fritz 62

ACKNOWLEDGMENTS

Whenever writers take on a book they incur a good many intellectual debts. I wish to thank the staff of the NASA History Office and the historians of the European Space Agency and other national space programs who helped track down information and correct errors. I also thank Emma Harverson for shepherding this work, Katie Crous for her editing work, and Gemma Wilson and the designers at Quarto for producing the book. I also thank Carolyn Gleason and her staff at Smithsonian Books for their support in this project. My deep thanks are due to all these fine people.

Most important, I acknowledge the support of Andrew K. Johnston, who collaborated with me to write an earlier atlas, *Smithsonian Atlas of Space Exploration* (2009), which focused on the exploration of the solar system and the major missions to learn about it, as well as to map launch sites around the world, and a host of other Earth-based artifacts of space exploration. Versions of some of the maps created for that earlier work have been modified and reenvisioned for use in this work as well.

In addition, I wish to acknowledge the following individuals who aided in a variety of ways: Daniel Adamo, Erik Conway, David H. DeVorkin, James Rodger Fleming, Jim Green, G. Michael Green, Wes Huntress, Dennis R. Jenkins, W. Henry Lambright, Jennifer Levasseur, John M. Logsdon, Howard E. McCurdy, Valerie Neal, Allan A. Needell, Michael J. Neufeld, Brian Odom, Asif A. Siddiqi, and Margaret Weitekamp. My greatest debts are to the women in my life, my wife Monique Laney and my daughters, Dana and Sarah Launius. All these people would disagree with some of the ideas and observations made here, but I hope they agree it is useful report on knowledge of the universe.

IMAGE CREDITS

Images on the pages listed below are reproduced by kind permission of the owners. The publishers have made every effort to contact the owners and apologise for any unwitting infringement. Specific acknowledgements are as follows (**t**=top, **b**=bottom, **l**=left, **c**=center, **r**=right):

Front cover, main image: NASA, ESA, CSA, STScI; **bottom row:** (left, centre left, right) NASA. (centre right) NASA/JPL-Caltech.
Back cover: (top) ESO/M. Kornmesser. (centre) NASA/JPL. (bottom) NASA, ESA, and J. Olmsted (STScI)
Front and back endpapers: NASA

10–11 NASA, ESA, CSA, and STScI. **12** Mark Garlick / Science Photo Library. **13** SCIENCE: NASA, ESA, CSA, Olivia C. Jones (UK ATC), Guido De Marchi (ESTEC), Margaret Meixner (USRA). IMAGE PROCESSING: Alyssa Pagan (STScI), Nolan Habel (USRA), Laura Lenkić (USRA), Laurie E. U. Chu (NASA Ames). **14–15** NASA, ESA, CSA, STScI, Webb ERO Production Team. **16** NYPL / Science Source / Science Photo Library. **17** Purchase, Fletcher Fund and Joseph E. Hotung and Michael and Danielle Rosenberg Gifts, 1989. The Metropolitan Museum of Art, New York, 1989.140. **18l** Library of Congress, Washington D.C. **18r** Adler Planetarium and Astronomy Museum. **19t** National Archaeological Museum, Athens/ Photo: Tilemahos Efthimiadis, via Flickr (CC BY 2.0). **19b** Tony Freeth, 2020, after Freeth, T., Higgon, D.,et al. *A Model of the Cosmos in the ancient Greek Antikythera Mechanism*. Sci Rep 11, 5821 (2021) https://doi.org/10.1038/s41598-021-84310-w. **20–21** NASA, ESA, CSA, STScI. **22–23** Bibilotèque Nationale de France, Paris. **24l** Smithsonian Libraries, Digital Collections (PDM). **24r** Smithsonian Libraries and Archives, Washington D.C., SI-A-56122. **25t, 25b** map from *Smithsonian Atlas of Space Exploration* (2009), background Shutterstock/alexkoral. **26–27** NASA. **28** Marco Giannini. **29tl** Courtesy of the NASA-sponsored Gravity Probe B program at Stanford University /text modified by Quarto Publishing plc. **29tr** NASA. **29b** Ferdinand Schmutzer / Wikipedia. **30–31** ESA/Webb, NASA & CSA, J. Rigby (CC BY 4.0). **32** Image from Edwin P. Hubble Papers, Huntington Library, San Marino, California. **33** Courtesy of Carnegie Institution for Science. **34l** Wikicommons. **34–35** David (Deddy) Dayag, **36–37** NASA, ESA, Leah Hustak (STScI)/(text modified by Quarto Publishing plc). **38–39** NASA/STScI/CEERS/TACC/S. Finkelstein/M. Bagley/Z. Levay. **40–41** Elisabeth Roen Kelly. **42–43** NASA, ESA, Ann Feild (STScI), and Adam Riess (STScI/JHU)/(text modified by Quarto Publishing plc). **44–45** NASA, ESA, Adam G. Riess (STScI, JHU)/ layout modified by Quarto Publishing plc. **46** M. Blanton and the Sloan Digital Sky Survey. Copyright © 2010-2013 SDSS-III / text modified by Quarto Publishing plc. **47t** NASA/JPL-Caltech/A. Kashlinsky (GSFC)/text modified by Quarto Publishing plc. **47b** NASA / WMAP Science Team. **48l** NASA/Science Photo Library. **48r** European Space Agency/Planck. **49** NASA/JPL-Caltech/ESA/ text modified by Quarto Publishing plc. **50** NASA GSFC/CIL/Adriana Manrique Gutierrez. **51** NASA/Goddard/Chris Gunn. **52–53** Image: NASA, ESA, CSA/ image processing:Anton M. Koekemoer and Joseph DePasquale (STScI). **54** Royal Astronomical Society/ Science Photo Library. **55t** NASA/ESA/CSA/T. Treu, UCLA/NAOJ/ J. Zavala/ T. Bakx, Nagoya University/text modified by Quarto Publishing plc. **55b** C. Mullis et al. / text modified by Quarto Publishing plc. **56–57** SCIENCE: NASA, ESA, CSA, Tommaso Treu (UCLA)/ IMAGE PROCESSING: Zolt G. Levay (STScI) / text modified by Quarto Publishing plc. **58** NASA, ESA, CSA, M. Zamani (ESA/Webb). **59** ESA-C. Carreau. **60–61** NASA, ESA, CSA, and STScI. **62** Courtesy of Carnegie Institution for Science. **63t** NASA/JPL-Caltech. **63b** jivacore/ Shutterstock.com; Alexander Owen/Shutterstock.com; Alex Mit/ Shutterstock.com. **64** NASA, ESA, D. Coe (NASA Jet Propulsion Laboratory/California Institute of Technology, and Space Telescope Science Institute), N. Benitez (Institute of Astrophysics of Andalusia, Spain), T. Broadhurst (University of the Basque Country, Spain), and H. Ford (Johns Hopkins University). **65** NASA, ESA, and M. Montes (University of New South Wales, Sydney, Australia). **66–67** ESA/Hubble & NASA, R. Tully SA/Hubble & NASA, R. Tully (Gagandeep Anand). **68** NASA, ESA. **69** NASA Goddard Space Flight Center. **70–71** Elisabeth Roen Kelly. **72–73** NASA, ESA, and J. Olmsted (STScI). **74–75** Hubble—NASA, ESA, K. Kuntz (JHU), F. Bresolin (University of Hawaii), J. Trauger (Jet Propulsion Lab), J. Mould (NOAO), Y.-H. Chu (University of Illinois, Urbana), and STScI; CFHT—Canada-France-Hawaii Telescope/ J.-C. Cuillandre/Coelum; NOAO—G. Jacoby, B. Bohannan, M. Hanna/NOAO/ AURA/NSF. **77** NASA/JPL-Caltech/R. Hurt (SSC/Caltech) / text modified by Quarto Publishing plc. **78t** ESA/Gaia/DPAC, CC BY-SA 3.0 IGO. **78b** NASA/ESA/JPL-Caltech/Conroy et. al. 2021. **79t** NASA/ESA/J. Dalcanton, B.F. Williams, and M. Durbin (University of Washington). **79b** ESA/JPL-Caltech/GBT/WSRT/IRAM/C. Clark (STScI). **80–81** Copyright © Robert Gendler/ESO. **82–83** Science Illustration: NASA, ESA, Z. Levay and R. van der Marel (STScI), T. Hallas, and A. Mellinger. **84t** NASA, ESA, CSA, and STScI. **84b** ESA/JPL medialab. **85** ESA/ Webb, NASA & CSA, P. Kelly / text modified by Quarto Publishing plc. **86l** Spencer Sutton/Science History Images / Alamy Stock Photo (details). **86–87** Hubble—NASA, ESA, K. Kuntz (JHU), F. Bresolin (University of Hawaii), J. Trauger (Jet Propulsion Lab), J. Mould (NOAO), Y.-H. Chu (University of Illinois, Urbana), and STScI; CFHT—Canada-France-Hawaii Telescope/ J.-C. Cuillandre/Coelum; NOAO—G. Jacoby, B. Bohannan, M. Hanna/NOAO/ AURA/NSF. **88–89** NASA's Goddard Space Flight Center/ESO/JPL-Caltech/DSS. **90–91** NASA/JPL-Caltech/SSC. **91** ESA/Hubble & NASA, Acknowledgement: Judy Schmidt. **92–93** NASA/JPL-Caltech/SSC. **94–95** ESA/Hubble & NASA, J. Lee. Acknowledgement: Leo Shatz. **96l** NASA. **96r** NASA. **97** ESA/Hubble & NASA, J. Bally, M. Robberto. **98** Wikimedia Commons. **99** NASA/JPL-Caltech/GSFC/JAXA. **100–101** Chandra X-ray Center / text modified by Quarto Publishing plc. **102** NASA, ESA, the Hubble Heritage Team (STScI/ AURA), and J. Hester and P. Scowen (Arizona State University). **103** NASA, ESA, the Hubble Heritage Team (STScI/AURA), and J. Hester and P. Scowen (Arizona State University). **104** Science: NASA, ESA, CSA, STScI. Image Processing: Joseph DePasquale (STScI), Anton M. Koekemoer (STScI), Alyssa Pagan (STScI). **105** ESO/M. Kornmesser. **106–107** ESA/Webb, NASA, CSA, T. Ray (Dublin Institute for Advanced Studies). **108** X-ray: NASA/CXC/SAO/; Optical: NASA/STScI, Palomar Observatory, DSS; Radio: NSF/NRAO/VLA; H-Alpha: LCO/IMACS/MMTF. **108–109** X-ray: NASA/CXC/Dublin Inst. Advanced Studies/S. Green et al.; Infrared: NASA/JPL/Spitzer. **110** NASA, ESA, CSA, STScI. **111** NASA, ESA, CSA, STScI, and the Webb ERO Production Team. **112** National Gallery, Prague/ Fine Art Images/Heritage Images/Getty Images. **113r** X-ray: NASA/CXC/SAO/D. Patnaude, Optical: DSS. **113b** X-ray: NASA/SAO/CXC; Infrared: NASA/JPL-Caltech/A. Tappe & J. Rho. **114–115** NASA, ESA, and the Hubble Heritage (STScI/AURA)-ESA/Hubble Collaboration. Acknowledgement: Robert A. Fesen (Dartmouth College, USA) and James Long (ESA/Hubble) (CC BY 4.0). **116** NASA/CXC/SAO. **117** NASA, ESA, CSA, STScI, Webb ERO Production Team. **118–119** NASA/ESA/Webb, NASA, CSA, M. Barlow (UCL), N. Cox (ACRI-ST), R. Wesson. (Cardiff University). **120** NASA/JPL-Caltech (details) / text modified by Quarto Publishing plc. **121** NASA, ESA, W. Fong (Northwestern University), and T. Laskar (University of Bath, UK) /text modified text by Quarto Publishing plc. **122t** NASA/JPL-Caltech / text modified by Quarto Publishing plc. **122b** ESA–C. Carreau. **122–123** Event Horizon Telescope Collaboration. **124l, 124c, 125** NASA/C. Henze. **126** NASA. **127** NASA. **128** MSFC-0102550 ASA/Marshall Space Flight Center)/text modified by Quarto Publishing plc. **131t** MSFC-9134213. **131br** Dr Seth Shostak / Science Photo Library. **132** NASA/CXC. **133** NASA/JPL. **134** ESA/Gaia/ DPAC (CC BY-SA 3.0 IGO). **135** Elisabeth Roen Kelly. **136–137** Elisabeth Roen Kelly. **138–139** © NASA/AOES Medialab (STScI/ESA) / text modified by Quarto Publishing plc. **140–141** Cosmic observers (updated 2023) © European Space Agency – ESA (CC BY-SA 3.0 IGO) / text modified by Quarto Publishing plc. **141b** NASA. **142** Originally created for the 2009 *Smithsonian Atlas of Space Exploration*. **143t** ESA, NASA, M. Kornmesser (ESA/Hubble), and STSc. **143b** NASA. **144** NASA/JPL-Caltech/ text modified by Quarto Publishing plc. **145** NASA/JPL-Caltech. **146–147** Elisabeth Roen Kelly. **148–149** NASA, ESA, and M. Kornmesser (ESO). **150** Andrew Clegg, NSF. **151tl** NASA. **151tr** NASA. **151bl** NASA. **151br** Dr Seth Shostak / Science Photo Library. **152–153** NASA Image no. PIA17801. Credit: NASA/ESA/STScI. **154–155** NASA, ESA, and G. Bacon (STScI). **156** National Archives, Netherlands /Anefo - Joop van Bilsen (detail). **157t** NASA/JPL-Caltech. **157b** NASA/ JPL-Caltech/JHUAPL. **158t** Everett Collection Historical / Alamy Stock Photo. **158b** NASA/text modified by Quarto Publishing plc. **159t** Marco Giannini, after map from *Smithsonian Atlas of Space Exploration* (2009). **159b** European Southern Observatory. **160–161** NASA Image no. PIA17801. Credit: NASA/ESA/STScI. **162–163** Elisabeth Roen Kelly. **164t** Science History Images / Alamy Stock Photo. **164b** NASA, ESA, and M. Showalter (SETI Institute), detail. **165** NASA/Johns Hopkins University Applied Physics Laboratory/Southwest Research Center/Chandra X-Ray Center. **166** NASA/Joel Kowsky. **167t** Johns Hopkins University Applied Physics Laboratory/Southwest Research Institute (JHUAPL/SwRI). **167b** NASA. **168** NASA/Johns Hopkins University Applied Physics Laboratory/Southwest Research Institute/text (modified by Quarto Publishing plc. **169** Johns Hopkins University Applied Physics Laboratory/Southwest Research Institute (JHUAPL/SwRI). **170** NASA/text modified by Quarto Publishing plc. **171** Caltech (details). **172** NASA. **173r** after map from *Smithsonian Atlas of Space Exploration* (2009). **173b** NASA. **174** NASA/JPL-Caltech/ text modified by Quarto Publishing plc. **175t** after map from *Smithsonian Atlas of Space Exploration* (2009). **175b** NASA/JPL-Caltech. **176–177** Elisabeth Roen Kelly. **178–179** NASA/JPL. **179t** NASA/JPL. **180** Marco Giannini, after map from *Smithsonian Atlas of Space Exploration* (2009). **181** NASA/JPL. **182tl** NASA/JPL/Universities Space Research Association/ Lunar & Planetary Institute. **182cl** NASA/JPL. **182tr** David Hardy / Science Photo Library. **182b** Marco Giannini, after map from *Smithsonian Atlas of Space Exploration* (2009). **183** after map from *Smithsonian Atlas of Space Exploration* (2009). **184** NASA/JPL. **185** NASA/JPL/STSci. **186t** NASA/JPL. **186c** NASA/JPL. **186b** NASA/ JPL. **187t** NASA/JPL. **187b** NASA/JPL/USGS. **188t** NASA/JPL. **188b** NASA/JPL-Caltech/ text and layout modified by Quarto Publishing plc. **189t** Marco Giannini, after map from *Smithsonian Atlas of Space Exploration* (2009). **189b** NASA/JPL/STSci. **190** NASA. **191** NASA. **193t** after map from *Smithsonian Atlas of Space Exploration* (2009). **193b** Marco Giannini, after map from *Smithsonian Atlas of Space Exploration* (2009). **194t** NASA/JPL-Caltech. **194b** NASA/JPL-Caltech. **195t** NASA. **195b** NASA/JPL-Caltech/ USGS. **196–197** NASA/JPL-Caltech. **198tl** NASA. **198tr** NASA. **199** NASA, ESA. **200** NASA. **201** Marco Giannini, after map from *Smithsonian Atlas of Space Exploration* (2009). **202** NASA. **203t** Marco Giannini, after map from *Smithsonian Atlas of Space Exploration* (2009). **203b** NASA/JPL-Caltech/SwRI/MSSS. Image processing by Thomas Thomopoulos © CC BY. **204–205t** NASA. **204b** NASA/JPL. **205** NASA/JPL. **206** Science: Geronimo Villanueva (NASA-GSFC). Illustration: NASA, ESA, CSA, STScI, Leah Hustak (STScI)/ text and layout modified text by Quarto Publishing plc. **207** NASA, ESA, CSA, Jupiter ERS Team; image processing by Ricardo Hueso (UPV/EHU) and citizen scientist Judy Schmidt/ text modified text by Quarto Publishing plc. **208** NASA, ESA, and (Vesta) L. McFadden (University of Maryland) and (Ceres) J. Parker (Southwest Research Institute)/ text modified text by Quarto Publishing plc. **209t** NASA/ESA/Giotto Project. **209b** Marco Giannini, after map from *Smithsonian Atlas of Space Exploration* (2009). **210tl** NASA/JPL. **210tr** NASA/JPL. **211** Marco Giannini, after map from *Smithsonian Atlas of Space Exploration* (2009). **212** NASA/JPL-Caltech. **213t** NASA/ JPL. **213b** Marco Giannini, after map from *Smithsonian Atlas of Space Exploration* (2009). **214l** NASA/ Goddard/University of Arizona. **214r** NASA/Keegan Barber. **215t** NASA. **215b** NASA/JPL/JHUAPL. **216** NASA/ Johns Hopkins APL/Steve Gribben. **217t** JAXA/illustration by Akihiro Ikeshita. **217b** NASA. **218–219** NASA. **220–221** NASA /JSC/Terry Virts. **222** NASA, ESA, Zolt G. Levay (STScI). **223** NASA/JHUAPL/ESA/MPS/UPD/ LAM/IAA/RSSD/INTA/UPM/DASP/IDA. **224** Detlev van Ravenswaay/Science Photo Library. **225** NASA/JPL/ USGS. **226** University of California Libraries. **227t** U.S. Air Force/Lunar and Planetary Institute / text modified by Quarto Publishing plc. **227b** Detlev van Ravenswaay/Science Photo Library. **228–229** Science History Images / Alamy Stock Photo. **230tl** NASA/Jet Propulsion Laboratory-Caltech. **230tr** NASA/JPL-Caltech/Dan Goods. **230bl** NASA/JPL-Caltech/Dan Goods. **230br** NASA/NSSDC/Mariner 4. **231t** NASA/JPL. **231b** Transferred from the National Aeronautics and Space Administration. **232-233** NASA/JPL-Caltech/University of Arizona. **234-235** NASA/JPL. **234t** NASA/JPL. **234b** NASA/JPL. **235b** NASA/ text modified by Quarto Publishing plc. **236-237** NASA/JPL. **237b** NASA/JPL. **238** NASA/JPL. **239t** NASA/JPL-Caltech/Cornell. **239b** NASA/JPL-Caltech/MSSS. **240** NASA/JPL-Caltech/ text modified by Quarto Publishing plc. **240tl** NASA/ JPL-Caltech/ modified text by Quarto Publishing plc. **241br** NASA/JPL-Caltech/MSSS. **241bl** NASA/ JPL-Caltech. **240–241** NASA/JPL-Caltech/Cornell University. **242–243** NASA/JPL-Caltech / text modified by Quarto Publishing plc. **244t** NASA/HRSC FUB/DLR/ESA **245t** NASA/JPL-Caltech/University of Arizona **244–255** NASA/JPL-Caltech. **246t** NASA/JPL-Caltech/MSSS / text modified by Quarto Publishing plc. **247t** NASA/JPL-Caltech. **246-247** NASA/JPL-Caltech. **248t** NASA/JSC/Stanford University. **248b** NASA/JSC/Stanford University. **249t** Julian Baum/ Science Photo Library. **249bl** NASA/JPL/MSSS. **249br** NASA/JPL/MSSS. **250** NASA/JPL / text modified by Quarto Publishing plc. **251** NASA/JPL-Caltech. **252** NASA/ JPL. **253t** NASA/Art by Michael Carroll / text modified by Quarto Publishing plc. **253b** Arizona State University/Ron Miller. **254t** NASA/JPL. **254b** NASA/JPL/MSSS. **254–255** Marco Giannini, after map from *Smithsonian Atlas of Space Exploration* (2009). **255** NASA/Art by Michael Carroll / text modified by Quarto Publishing plc. **256–257** NASA/JPL-Caltech/University of Arizona. **258t** NASA/ESA/JPL-Caltech. **258b** NASA/ JPL-Caltech. **259–261** Elisabeth Roen Kelly. **262** NASA. **263t** NASA. **263t** NASA. **263b** NASA / text modified by Quarto Publishing plc. **264tl** NASA. **264tr** NASA. **264b** after map from *Smithsonian Atlas of Space Exploration* (2009). **265** after map from *Smithsonian Atlas of Space Exploration* (2009). **266** NASA/ JPL-Caltech. After map from *Smithsonian Atlas of Space Exploration* (2009). **267t** Detlev va¬n Ravenswaay/ Science Photo Library. **268** BDMO/NASA/Lunar and Planetary Institute / text modified by Quarto Publishing plc. **269l** NASA. **269tr** NASA/ text modified by Quarto Publishing plc. **270t** China National Space Administration/Xinhua / Alamy Stock Photo. **270b** Marco Giannini, after map from *Smithsonian Atlas of Space Exploration* (2009). **271** NASA/Wikipedia. **272** NASA. **273t** NASA/MSFC / text modified by Quarto Publishing plc. **273b** NASA/MSFC/ text modified by Quarto Publishing plc. **274** NASA. **275t** NASA. **275b** NASA. **276t** after map from *Smithsonian Atlas of Space Exploration* (2009). **276b** NASA/GSFC/Arizona State University/ text modified by Quarto Publishing plc. **277** NASA. **278–279** NASA/Wikipedia **280t** NASA. **280b** NASA. **281** NASA/U.S. Geological Survey/Lunar and Planetary Institute. **282t** NASA. **282b** after map from *Smithsonian Atlas of Space Exploration* (2009). **283t** NASA. **283b** NASA. **284t** NASA. **284b** after map from *Smithsonian Atlas of Space Exploration* (2009). **286** NASA. **286t** after map from *Smithsonian Atlas of Space Exploration* (2009). **286-287** NASA/GSFC/Arizona State University. **287br** NASA/GSFC/Arizona State University. **290-291** Elisabeth Roen Kelly. **293** NASA. **294bl** NASA / text modified by Quarto Publishing plc. **294tr** NASA/Rye Livingston. **295t** NASA's Goddard Space Flight Center; Figure produced by Eric R. Nash, NASA/GSFC SSAI and Paul A. Newman, NASA/GSFC, Ozone Hole Watch / text modified by Quarto Publishing plc. **295b** NASA, Jacques Descloitres, MODIS Rapid Response Team at NASA GSFC. **296t** NASA/Rye Livingston. **296tr** NASA. **296b** NASA/JPL. **297t** NASA. **297t** NASA/JPL. **298** NASA/USGS/Landsat 5. **299** NASA. **300** NASA/Goddard Space Flight Center Scientific Visualization Studio; Blue Marble data courtesy of Reto Stockli (NASA/GSFC) / text modified by Quarto Publishing plc. **301t** NASA Earth Observatory image by Michala Garrison, using MODIS data from NASA EOSDIS LANCE and GIBS/Worldview. **301b** NASA's Scientific Visualization Studio, Key and Title by uploader (Eric Fisk). **302–303** NASA/Kjell Lindgren. **304–305** © ESA (CC BY-SA 3.0 IGO)/ text modified by Quarto Publishing plc. **306l** NASA/GSFC/METI/ERSDAC/JAROS, and U.S./Japan ASTER Science Team. **306r** NASA. **307tl** NASA. **307tr** Image courtesy of Shigeru Suzuki and Eric M. De Jong, Solar System Visualizaiton Project, NASA/JPL. **307b** NASA. **308t** NASA/Goddard Space Flight Center Scientific Visualization Studio. **308b** NASA. **309** NASA Earth Observatory image by Joshua Stevens, using Suomi NPP VIIRS data from Miguel Román, NASA's Goddard Space Flight Center. **310–311** © ESA (CC BY-SA 3.0 IGO). **314** NASA/JPL. **315** NASA/JPL-Caltech. **316** NASA/JPL. **317t** NASA/JPL. **317b** NASA/JPL-Caltech. **318–319** NASA/ JPL. **320t** NASA/JPL. **320b** NASA/JPL. **321** NASA/JPL/USGS. **322t** NASA/JPL-Caltech. **322b** NASA/Johns Hopkins University Applied Physics Laboratory. **323t** NASA/JAXA. **323b** NASA/JPL/APL/NRL. **324** European Space Agency (ESA) / AEOS Medialab / Science Photo Library. **325** Detlev van Ravenswaay/Science Photo Library. **326–327** Elisabeth Roen Kelly. **328** NASA/Johns Hopkins University Applied Physics Laboratory/ Carnegie Institution of Washington. **329tl** NASA/JPL. **329tc** NASA/JPL/GRC. **329tr** NASA/GRC. **329b** NASA/JPL/ text modified by Quarto Publishing plc. **330–331** NASA/Johns Hopkins University Applied Physics Laboratory/ Carnegie Institution of Washington. **332t** NASA/Johns Hopkins University Applied Physics Laboratory/ Carnegie Institution of Washington. **332b** NASA/Johns Hopkins University Applied Physics Laboratory/ Carnegie Institution of Washington. **333t** ESA/BepiColombo/MTM (CC BY-SA 3.0 IGO) / text modified by Quarto Publishing plc. **333b** ESA/ATG medialab. **334t** NASA/Johns Hopkins University Applied Physics Laboratory/Carnegie Institution of Washington. **334/Johns. 334b** Hopkins University Applied Physics Laboratory/Carnegie Institution of Washington/Byrne et al. **335** NASA/Johns Hopkins University Applied Physics Laboratory/ Carnegie Institution of Washington. **336** NASA/SDO/AIA. **337t** NASA/JPL-Caltech/JAXA. **337b** NASA/ GSFC/Solar Dynamics Observatory. **338** NASA's Goddard Space Flight Center/Mary Pat Hrybyk-Keith. **339t** NASA's Goddard Space Flight Center/S. Wiessinger. **339b** NASA/SDO/Steele Hill / text modified by Quarto Publishing plc. **340–341** Elisabeth Roen Kelly. **342t** NASA/JPL-Caltech/GSFC. **342b** NASA/Goddard Space Flight Center/SDO. **343** NASA/Goddard/SDO. **344–345** Mark Garlick/Science Photo Library. **346–347** NASA/Pat Rawlings. **348–349** NASA. **350–351** NASA/JPL-Caltech. **352** NASA/Bill Ingalls. **353t** NASA. **353b** NASA. **354** NASA. **355t** NASA. **355b** NASA/Kim Shiflett. **356–357** NASA/text modified by Quarto Publishing plc. **358t** NASA/Kim Shiflett. **358b** NASA/Frank Michaux. **359** NASA/Josh Valcarcel. **360–361** Blue Origin. **362–263** P. Carril/European Space Agency. **364t** NASA. **364b** NASA/Pat Rawlings. **365** NASA/Pat Rawlings. **366–367** NASA Imagery S86-27256 (June, 1986): Artist's concept of a lunar base. **368–369** NASA/Ren Wick. **370** NASA. **371** NASA/Pat Rawlings/SAIC. **372t** NASA/Jack Frassanito and Assocs. **372b** NASA/Pat Rawlings/SAIC. **373** NASA/Pat Rawlings. **374–375** NASA. **376–377** David Hardy/Science Photo Library. **378** NASA/Pat Rawlings. **379t** NASA. **378b** NASA/Pat Rawlings. **380t** Victor Habbick/Science Photo Library. **380b** NASA. **381** NASA. **382–383** NASA/text modified by Quarto Publishing plc. **384–385** Mark Garlick/Science Photo Library. **386–387** NASA/Rick Guidice. **388l** NASA. **388–389** NASA/Rick Guidice. **391** NASA. **392–393** Gregoire Cirade/Science Photo Library.

IMAGE CREDITS

HAS BEEN PURPOSELY DRAWN OUT OF SCALE
USTRATE THE MAJOR EVENTS OF THE MISSION

BIGELOW FREE PUBLIC LIBRARY
54 WALNUT STREET
CLINTON, MA 01510

(115) ORIENT CSM FOR PASSIVE THERMAL CONTROL
(113) 5TH MIDCOURSE CORRECTION
(112) SM ENGINE IGNITION (152:11:44)
(111) ORIENT CSM FOR MIDCOURSE CORRECTION
(109) CSM COMPUTER UPDATE FROM MCC-H (151:00:25)

(108) SYSTEMS STATUS CHECKS. EAT AND SLEEP PERIODS. DATA TRANSMIT PERIODS — 28 HOURS —

(107) ORIENT CSM FOR PASSIVE T
(105) 4TH MIDCOURSE CO
(104) SM E

(114) SM ENGINE CUTOFF (152:11:45)

(110) CSM GUIDANCE SYSTEM REFERENCE ALIGNMENT

SM ENGINE CUTOFF (122:11:45) (106)

NETWORK STATIONS

PE KENNEDY	(CNV)
ERRITT ISLAND	**(MIL)
TRICK AFB	(PAFB)
RMUDA	**(BDA)
AND BAHAMA ISLAND	**(GBM,GBI)
NTIGUA	**(ANG,ANT)
AND CANARY ISLAND	**(CYI)
CENSION ISLAND	**(ACN,ASC)
ADRID	***(MAD)
NANARIVE	(TAN)
RNARVON	**(CRO)
NBERRA	***(CNB)
AM	**(GWN)
WAII	**(HAW)
NT ARGUELLO	(CAL)
OLDSTONE	***(GDS)
AYMAS	**(GYM)
HITE SANDS	(WHS)
RPUS CHRISTI	**(TEX)
NS VANGUARD	**(VAN)
NS REDSTONE	**(RED)
NS MERCURY	**(MER)
NS WATERTOWN	**(WTN)
NS HUNTSVILLE	*(HTV)
OLLO AIRCRAFT	(ARIA)

* USB STATION - 12 FT. ANTENNA
** USB STATION - 30 FT. ANTENNA
*** USB STATION - 85 FT. ANTENNA

TRANSEARTH RF LINKS — [UNIFIED S-BAND: VOICE, TELEMETRY, RANGING, UPDATA, TELEVISION] — CSM

LUNAR RF LINKS — [UNIFIED S-BAND: VOICE, TELEMETRY, RANGING, UPDATA, TELEVISION] — CSM
— [UNIFIED S-BAND: VOICE, TELEMETRY, RANGING, UPDATA, TELEVISION] — LM

TRANSLUNAR RF LINKS — [UNIFIED S-BAND: VOICE, TELEMETRY, RANGING, UPDATA, TELEVISION] — CSM

CSM GUIDANCE SYST
REFERENCE ALIGNME

CONTINUOUS COVERAGE OF CS
EXCEPT WHEN MASKED BY MOO
(ALSEP COVERAGE DURING AN

(44) SM ENGIN
(51:40

(43)

(42) SM ENGINE IGNIT
(41) ORIENT S/C ATTITUDE FOR
(40) CSM GUIDANCE SYSTEM REFEREN
(39) CSM COMPUTER UPDATE FROM MCC-H (50:32:16)

SM ENGINE CUTOFF (04:44:04)
(36)
(38) SYSTEMS STATUS CHECKS. EAT AND SLEEP PERIODS. DATA TRANSMIT PERIODS — 45 HOURS —

(37) ORIENT S/C ATTITUDE FOR PASSIVE THERMAL CONTROL
(35) 1ST MIDCOURSE CORRECTION
(34) SM ENGINE IGNITION (04:43:56)

S/C ATTITUDE FOR MIDCOURSE CORRECTION
YSTEM REFERENCE ALIGNMENT

PSED MISSION TIME SHOWN AS
HOURS : MINUTES : SECONDS)

ABBREVIATIONS AND ACRONYMS

ALSEP	— APOLLO LUNAR SURFACE EXPERIMENT PACKAGE	ODOP	— OFFSET DOPPLER
CM	— COMMAND MODULE	RCS	— REACTION CONTRO
CSM	— COMMAND AND SERVICE MODULE	RF	— RADIO FREQUENCY
GOSS	— GROUND OPERATIONAL SUPPORT SYSTEMS	S/C	— SPACECRAFT
IU	— INSTRUMENT UNIT	SM	— SERVICE MODULE
LM	— LUNAR MODULE	USB	— UNIFIED S-BAND
MCC-H	— MISSION CONTROL CENTER - HOUSTON	USNS	— UNITED STATES NA
MSFN	— MANNED SPACEFLIGHT NETWORK	VHF	— VERY HIGH FREQUE
N.M.	— NAUTICAL MILE		